**ART AND
POLITICS
IN THE
WEIMAR
PERIOD**

ART AND POLITICS IN THE WEIMAR PERIOD

The New Sobriety, 1917–1933

JOHN WILLETT

With 212 illustrations

Pantheon Books, New York

to A.P.

Copyright © 1978 by John Willett
Illustrations and layout Copyright © 1978 by
Thames and Hudson Ltd.

All rights reserved under International and Pan-American
Copyright Conventions. Published in the United States by
Pantheon Books, a division of Random House, Inc.,
New York, and simultaneously in Canada by Random
House of Canada Limited, Toronto. Originally published
in Great Britain as *The New Sobriety: Art and Politics in
the Weimar Period, 1917-1933* by Thames and Hudson Ltd.

Library of Congress Cataloging in Publication Data

Willett, John.
 Art and politics in the Weimar period.

 Bibliography: p. 260
 Includes index.
 1. Germany—Politics and government—1918-1933.
2. Art and state—Germany. I. Title
DD240.W58 1978 320.9′43′085 78-51805
ISBN 0-394-49628-0

Manufactured in the United States of America

FIRST AMERICAN EDITION

CONTENTS

Glossary of abbreviations

ABC	Swiss architectural journal
AIZ	*Arbeiter-Internationale-Zeitung*. Illustrated weekly
AKh(R)R	Association of (Russian) Revolutionary Artists
ARBKD	German revolutionary artists' association
ASNOVA	Soviet modern architects' group
ATBD	(Till 1928, DATB). German workers' theatre league
BPRS	'Proletarian-revolutionary' writers' league
CC	Central Committee
CP	Communist Party
CIAM	Congrès Internationaux d'Architecture Moderne
DATB	See ATBD
DNVP	German National People's Party (Nationalist)
FEKS	Factory of the Eccentric Actor, a Leningrad group
GEHAG	Berlin Socialist building society
IAH	International Workers' Aid
IfA	Interessengemeinschaft für Arbeiterkultur. Communist cultural liaison organization
IATB	Workers' theatre International, later MORT
Inkhuk	Institute of Artistic Culture
ISCM	(German: IGNM) International Society for Contemporary Music
IVRS	Revolutionary writers' International
IZO	Art section of Education Commissariat
KAPD	German Communist Workers' Party
KPD	German Communist Party

LEF	Left Front of art. Soviet group and its journal
LITO	Literary section of Education Commissariat
MASch	Marxist Workers' School
MBRKh	International Revolutionary Artists' Bureau
MOPR	International Red Aid (parent of German Rote Hilfe)
MORT	International Revolutionary Theatre Organization (till 1932, IATB)
MUZO	Music section of Education Commissariat
NEP	New Economic Policy (Russia, 1921)
NRF	*Nouvelle Revue Française*
Obmokhu	Group of Young Artists (Moscow)
OSA	Contemporary Architects' Association
OST	Soviet 'Easel Painters'' group
RAPP	Russian Association of Proletarian Writers (later absorbed in VAPP, All-Union ditto)
RSFSR	Russia proper, largest component state of USSR
REF	Revolutionary Front of art. A refurbished LEF
SDS	German Writers' Defence Union
SPD	German Social-Democratic Party
TEO	Theatre section of Education Commissariat
TSIT	Gastev's institute for ergonomics
UFA	Universum Film Company, the main German firm
USPD	German Independent Social-Democratic Party
VOKS	Soviet society for cultural relations with foreign countries
WZPS	Soviet trade union theatre

APOLOGIA
AND
PLAN

1 Voices from underground

Nature and origins of the writer's interest in his subject, with acknowledgment to friends known and unknown.

In the summer of the Munich crisis my friend Tim Bennett went to look at the Weissenhofsiedlung at Stuttgart, that showpiece collection of thirty-three houses by outstanding modern architects from Behrens to Le Corbusier. He was then a student at the Architectural Association, where he incidentally wrote music for the annual pantomimes and helped found the magazine *Focus*; some three years later he was killed commanding a motor gunboat in the Second World War. I remember him bringing back a postcard which showed (gummed-in) lions and camels among the Weissenhof's flat-roofed, mainly white buildings, and mocked it as an 'Arab village' alien to the architecture of the master race.

This was the spirit in which the Nazis had held their great Degenerate Art Exhibition in Munich; Gropius's Bauhaus buildings in Dessau, which I saw myself about the same time, had already been embellished with National Socialist frills and in-

scriptions; in Düsseldorf a Degenerate Music Exhibition was supposed to follow. But in one of the three most uncompromisingly functional houses on the whole estate – those built by the Dutch Communist architect Mart Stam – Tim had been asked in to have tea and listen to the banned records of *The Threepenny Opera*. And I have before me the dingy grey book which his unknown host gave him: an English translation of *The Great Hunger* by the Norwegian novelist Johan Bojer. On the flyleaf is written 'Memento of an afternoon spent in Stuttgart in Mart Stam's house, to music by Kurt Weill. 13 Aug. 1938'. The signature looks like 'Martin Hallberg'.

Little appreciated in prewar England, this crudely stifled mid-European culture, with its hopefulness and consistency, was of enormous interest to me even then. I had no personal links with it, and my own subjects of study were deplorably remote. But stimulated by Hans Hess, whom I got to know around that time, and profiting unrepentantly from the splendid books which other refugees from Hitler were being forced to sell, I absorbed as much of it as I could: the writings of Brecht, Renn, Seghers, Hašek, the music of Eisler and Weill, the graphic work of Beckmann and George Grosz, the theatre of Piscator, Burian and the clowns Voskovec and Werich, the Bauhaus books. I also absorbed a political moral, for the Nazi attitude to this whole culture was clearly in line with the Nazi attitude to armies, uniforms, inferior races, women, the family and everything else; it was utterly monstrous and sooner or later would have to be fought, never mind what compromises our National Government might stoop to in order to postpone this.

Not that the war, when it at last came, made me a keen soldier: merely a private one, soon lance-corporal to the awkward squad, travelling weekly up to London at the army's expense to learn Czech in the hope of one day reading *Schweik* in the original. Though this hope remained unfulfilled I by now knew enough German to impress the War Office, who decided that sooner than get killed in the battle of France (like some of my fellow-recruits from my original squad) I should become an officer in military intelligence. Two years of tedium tempered by occasional misdemeanours followed, during which I did my best to pursue the same interests, aside from the Czech lessons to which I was no longer entitled. Then I was sent to the Middle East to deal at last with first-rate colleagues and situations that counted.

In Cairo my friend David Hicks (who is not the designer) was working for the British Council and editing a magazine called *Citadel*. At some point I had shown him the woodcuts of Franz Masereel, one or two of which he reproduced, with the result that he asked me to write a note on them for his readers. Unaccustomed as I was to public writing, I thought I might as well sum up my feeling about the whole mid-European world in which this Belgian artist had become absorbed thanks to the wide reception of his work there; so at 13 Corps headquarters in the Western Desert I took a looted German signal pad and filled it with a long essay called 'The Value to us of Central European Art'. This came out in *Citadel* in three instalments, starting in December 1942, but I subsequently lost my copies and now only have a German translation, published in Palestine by the Dada historian Willy Verkauf and made by Gerhard Cohn, who was then a South African soldier and now happens to be my local photographic dealer in London.

Looking through the faded pages I see that its argument rested on two assumptions which need modifying some thirty-five years later, even though it still seems in the main to accord with what I think. First of all, I was writing chiefly for English and Egyptian readers who might be expected to agree with the reigning art, book and theatre critics of the 1940s that the modern movement in the arts had its home in Paris and that the Weimar Republic had been of no real importance. Few are now quite so silly as to believe this. And secondly I thought that the Central European culture which concerned me had been effectively killed off and was now as dead as mutton even though it might turn out to be nourishing too. For I was writing at a time when the chances of its recovering from its suppression seemed very slight; and vivid as the example of that afternoon in Stuttgart still was to me it stood for a vanished civilization.

Luckily I was not entirely right: something survived unbroken. And I would very much like to think that Mr M.H. of the indistinct signature was one of the survivors. Alive or dead now, he probably long ago forgot so trivial an episode, harking back as it did to values which people like him had once taken for granted. In certain contexts however quite small gestures can make a very intense impression, even at second hand. His did so on me. And in trying rather more systematically to set down what I now know, I see it as close to the heart of the matter.

Cultural map of mid-Europe in the 1920's

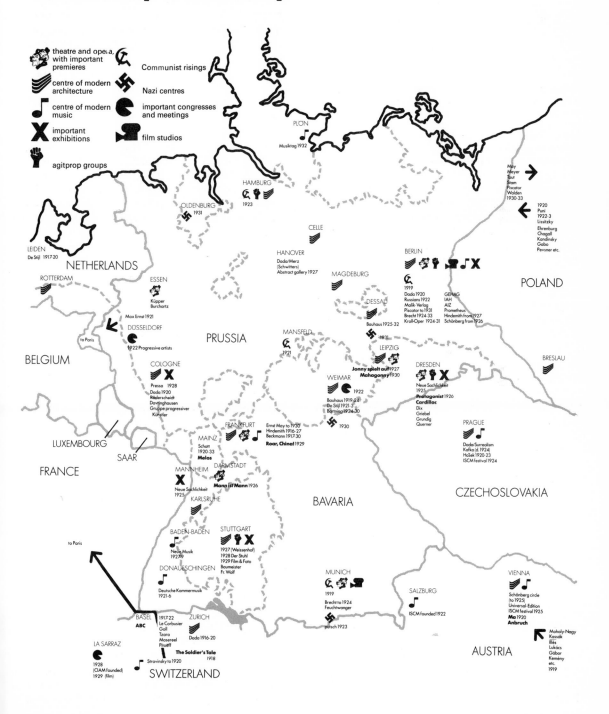

2 A story of contrasts

Limitations of the book. Not a history of 'Weimar culture' as a whole, but a specific quest. The consolidation of the modern movement and its penetration of a whole society: how the 20th-century renaissance reached a new plane. Plan of the inquiry. The two themes: an interlude of high civilization, contrasted with an underlying menace.

This then is a largely personal attempt to make sense of those mid-European works of art, in many fields and media, which came into being between the end of the First War and the start of Hitler's dictatorship in 1933. It is neither an art-historical study of movements and artistic innovations, nor a general cultural history of the Weimar Republic, but a more selective account which picks on those aspects of the period which the writer feels to be at once the most original and the most closely interrelated, and tries to see how and why they came about.

What was so apposite, for instance, about playing Kurt Weill records in a Mart Stam house? Was it the fact that both originated about the same time, 1927–8; or that they were both equally detested by the Nazis; or that both of them embodied certain aesthetic influences and/or socio-political attitudes? What, again, might link a Dutch Communist architect to a Left Socialist Berlin Jewish composer whom he apparently never met? Was it merely the fact that the two were of the same age, born seven months apart either side of the beginning of 1900, or were there deeper ties? Above all why should both alike stand in my mind (or my mind's eye and ear) for a whole brutally arrested modern civilization, centred on Weimar Germany and ranging all the way from sanserif alphabets to *Emil and the Detectives*? Once start wondering about such problems, and the history of the arts and society in the Weimar period comes to take a definite shape. But this can only be done by concentrating on what most clearly belongs together and neglecting much else that was going on at the same time. The reader, then, should be warned that he is not going to be given a full picture of the culture of that period, nor will he find it all that familiar a one. He will get an extensive, but always specific and limited quest.

There are existing studies that deal with the culture of the Weimar Republic between 1918–33 much more broadly. 'When we think of Weimar', writes Peter Gay in the preface to his *Weimar Culture*,

> . . . we think of *The Threepenny Opera, The Cabinet of Dr. Caligari, The Magic Mountain*, the *Bauhaus*, Marlene Dietrich.

More recently that other eminent historian Walter Laqueur has defined its *Zeitgeist* in very similar terms as 'the Bauhaus, *The Magic Mountain*, Professor Heidegger and Dr Caligari', at the same time qualifying this view by remarking that the Weimar culture of which he is writing 'antedates the Weimar Republic by at least a decade'.

In a sense this is bound to be so: the individuals and the artistic schools that largely dominated that culture had all been formed much earlier. Even if one ignores those men born in the 1860s and 70s who remained productive and influential after the fall of the Hohenzollern Empire in 1918 – people like Hauptmann and George in literature, Barlach and Kollwitz in art, Richard Strauss in music or Poelzig in architecture – it is a fact that the major artistic movement of the early 1920s was one that had first crystallized around 1910 but became established mainly thanks to the new Republic and the revolutionary ideas with which it set out. This was Expressionism, which only effectively got a grip of the public galleries, the art schools and the theatres in the early Weimar years and was still permeating the German cinema (as in Fritz Lang's *Metropolis*) in the later 1920s. All that was novel about Expressionism in this period was the extent of its acceptance and its success; thus when Alban Berg's opera *Wozzeck* had its premiere under Erich Kleiber in Berlin at the end of 1925 the really new element was the change in official acceptance and public taste, the work itself having been conceived as far back as 1914.

Most of the symptomatic names given by Gay and Laqueur are outside the more restricted scope of the present book, only the Brecht–Weill work *The Threepenny Opera* and the Bauhaus (of Gropius *and* the generally ignored Hannes Meyer) falling within it. Nor, by its lights, are such 'sacred monsters' of the 1920s as Marlene Dietrich and Josephine Baker or, for that matter, the great singers and conductors of more than atmospheric, essentially nostalgic relevance. For these people were not on the whole creative or particularly original, thereby differing from Charlie Chaplin, whose impact on the time was quite

extraordinary, and from the great jazz musicians. Even the abstract or near-abstract painters of the pre-1914 Blaue Reiter have to be taken for granted by the reader, despite their importance in the early, Expressionist days of the Bauhaus; for their roots lay in Symbolism and the German equivalent of Art Nouveau rather than in the new civilization around them, and if they were important in the Bauhaus after 1924 it was largely as a brake on the younger men.

What is more debatable perhaps is the book's exclusion of broader intellectual influences such as the new physics of Einstein, Planck, Heisenberg and Nils Bohr, with its undermining of the essential tidiness of quantified science; or the growing importance of psychoanalysis for ordinary human understanding, not just medicine; or Max Weber's sociology, with its linking of a society's economic and ideological aspects; or the new Hegelianism of the Frankfurt Institut für Sozialforschung, which likewise established some interesting, if also slightly mystifying relations between society and aesthetics; or again the newer philosophical schools ranging from the positivism of the Viennese logicians to the phenomenology of Martin Heidegger. Here too, it is true, much of the pioneering work dates back to before 1914, but it none the less determined the climate of ideas in Weimar Germany. The trouble is that the connection between ideas of this order and the arts cannot be established in a merely impressionistic way, by tossing in a number of significant pointers, but demands a profound study of a kind that we still have to see. Its absence must be regarded as one of the limitations of the present book, and it springs not only from the usual limitations of space but from my own limitations too.

Though Germany is at the heart of this story the material dealt with may well strike readers as untypical of that country. If so, then they have been misled; perhaps too great an emphasis on the passionate distortions of Expressionism (from Munch's *The Cry* onwards) at the one end of the scale and the chic decadence of *Cabaret* and the like at the other has allowed them to overlook what came between. Our quest now will be concerned rather with a particular constructive vision originating at the end of the First World War, a new realism that sought methods of dealing both with real subjects and with real human needs, a sharply critical view of existing society and individuals, and a determination to master new media and discover new collective approaches to the communication of artistic concepts. The constructive vision in question will be found applied in various fields – first in 'pure' art in two or three dimensions, then in photography, the cinema, architecture, various forms of design and the theatre – often according to principles derived, far more sophisticatedly than before 1914, from the rapidly developing technological sphere: that is, not from the outward appearance of machines so much as from the kind of thinking that underlies their design and operation. The critical vision comes out of Dada and the disillusionments of the war and the German Revolution; it is in effect a cooler and more sceptical counterpart to the optimistic humanitarianism of the Expressionists in the years 1916–19, and as this began deflating it moved into the gap, to become known under the slightly misleading title of The New Objectivity.

Here lay one aspect of the new realism: a cool attempt to look at things as they are, while using the artistic discoveries of all the modern movements from Cubism and Futurism to the impersonality of the Italian 'Metaphysicals' to convey them, and going on – in the novel, film and the theatre – to work out fresh means of depicting an increasingly complex environment, such as documentary, montage and the 'epic' drama. As for the collective approach, this was inherent in the development of highly evolved media like broadcasting and the cinema. At the same time it corresponded to men's experience of the war and the revolutionary movements that followed, and it became extended also into more traditional areas: into music with Hindemith, art education with Gropius, town planning with Ernst May, the theatre with Piscator, and so on.

What all this in effect amounted to was a new development of that mighty European renaissance in the arts that can be said to have begun with the French Fauves in 1905. Apart from Surrealism, which to some extent represented a reaction against the renaissance rather than an extension of it, each of its major -Isms had been effectively established by the end of the First World War; indeed some, like Futurism, Cubism and Expressionism, were already on the decline. By then even the youngest of the century's principal pioneers – Picasso, for example, or Stravinsky – were men in their late thirties, and as it turned out they were the last of their kind. For what the next generation achieved, with Germany as their main centre, was something of a rather different order which has remained largely unrecognized because it

does not fit into the accepted picture of the modern movement as a series of overlapping, but continually innovatory avant-gardes.

'The [Weimar] Republic created nothing', writes Professor Gay in *Weimar Culture*. 'It liberated what was already there.' This is too simple. For the younger generation's approach to the arts was at once less individualistic and more down to earth: while understanding the advances made by the pioneers (as their English contemporaries as yet did not) they tested and applied them in a fresh way, seeing how they related to the needs and shortcomings of postwar society and to the new technical devices and channels of communication even then being evolved. It was these people who did not so much liberate the modern movement as shift it on to a new, much wider and less personal plane where for the first time it

could affect the lives of whole communities, not just small cultural élites. How this happened is perhaps the principal, certainly the most cheerful aspect of the book.

The area covered can therefore be defined right away in terms of generations. Virtually all the writers, artists, musicians and film makers involved were born no earlier than 1893; only the architects were on the whole a decade older, no doubt because an architectural training takes so long to complete. Most of these people, then, were no more than twenty when the war broke out, so that its experience for them was even more decisive than for their elders, and it is here that our quest must start. This in itself will differentiate ours from other accounts of the period, for in most histories of the modern movement the four years of the First World War are

Symbolic centre of the Weimar renaissance: the Deutscher Werkbund's Weissenhof estate at Stuttgart, 1927. Frontispiece to their publication *Bau und Wohnung* of that year

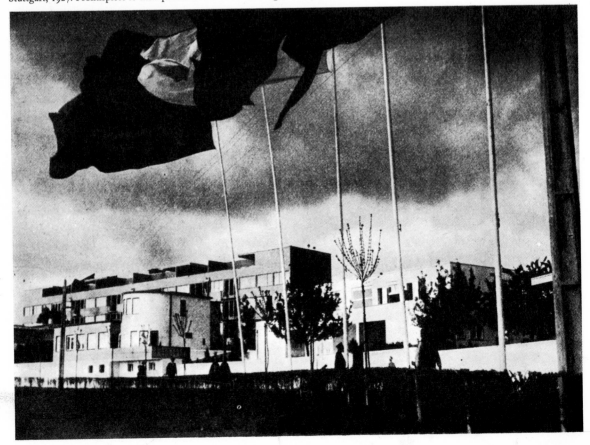

something of a blank, forming an interruption in a story that had begun five or ten years before rather than a starting point for significant new points of view. To the young Germans with whom we shall largely deal the war was, on the contrary, all-important, not only because of the intensity of the individual's personal experience (which could of course be matched elsewhere even though reactions differed) but also because the break in normal relations with Western Europe took so long to repair.

As a result Germany was brought closer than other nations to the Russian Bolshevik Revolution, which from then on loomed that much larger on their horizon. This is one reason why the Constructivism of the Russians had such an influence on many of them, as well as the collectivist spirit itself. Artistic developments in the neutral countries also played their part: the visual austerities of the Dutch *De Stijl* group, the near-nihilism of Zurich Dada with its contempt for every older generation, the musical reduction and simplification then being explored by Stravinsky. These were reinforced by certain corresponding new trends from France – as seen most plainly in the changed art of Léger, the technologically-based aesthetic of Le Corbusier and the music of Satie and his younger followers. What ensued was something very different at once from Expressionism, with its essentially egotistical, romantic outlook, and from all previously established standards of high German culture (as maintained, say, by Hesse and the brothers Mann). Taking place within Weimar culture as a whole, yet reflecting ideas and influences from far outside it, this was a development which has never been given a name of its own but stands out none the less clearly from the general background of other artistic movements and events.

This book, then, will start by describing the widely differing war experiences of some of those concerned, so as at least to suggest the shocks that changed them. Next the Russian and German revolutions are followed in order to show their crucial and in some ways parallel effects on the arts in both countries; these chapters being complemented by an account of relevant developments in France in the immediate postwar period, culminating in the powerful impact of Le Corbusier's and Ozenfant's magazine *L'Esprit Nouveau*, whose repercussions can be felt to this day. These preliminaries take us up to about 1921, which seemed to be the beginning of a major turning point, the first of two such in the book, when political,

economic and cultural factors of all sorts combined to transform the arts right across the board. Each turning point occupies a single long chapter, within which the different aspects of this wholesale transformation are dealt with in successive sections: the first and longer of them dealing with the period 1921–3, when wartime and immediate postwar influences from many quarters fused to make something like a new civilization, while the second outlines the changes of 1929–30 which forced that civilization to battle for survival.

In between the two turning points falls the central section of the book, covering its central theme: the character of that civilization which appeared to have established itself in Germany during the relatively calm years of reconstruction starting around 1925. This is described and illustrated in ten chapters that treat one art after another, framing them within an introductory discussion of the dominant outlook and its original forms of expression, and a concluding chapter on some of the reactionary factors already at work. The second turning point chapter then leads on to an account of the last two or three years of the Weimar Republic, a time when the polarization of politics gave the arts a new intensity and purposefulness while at the same time leading relentlessly to their collapse under the dictatorship which followed. So after the central interlude of hopefulness – a hopefulness with its feet well planted on the ground by comparison with the utopianism of the Expressionists – comes a moment of desperate struggle whose sad outcome calls even today for a post mortem.

Such, in rough outline, is the scheme which results from the book's choice of material. On the one hand it aims to show how the modern movement in the arts, under the influence of democratic social concepts and a new internationalism, was able to bloom into a civilization with a coherence and a seeming logic about it that have scarcely been matched since. Just for those few years the arts of the European avant-garde began to have what cultural pessimists, whether of the Right or the Left, normally accuse them of lacking: an audience, a function, a unity, a vital core. This is something whose obvious significance for the history of the arts in this century has never been properly explored; rather it seems to have been obscured by a cult of artistic 'originality', by revivalism and a nostalgia for what was most ephemeral in the past, and by a cloudy, Eldorado-like projection of the 'golden twenties'.

14

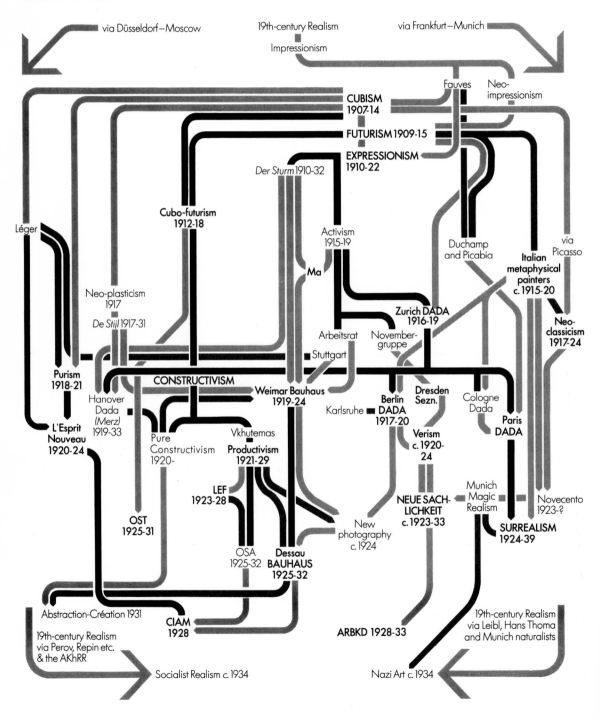

Art streams of the 20s: 1 The main movements

via Düsseldorf—Moscow

19th-century Realism

Impressionism

via Frankfurt—Munich

Fauves Neo-impressionism

CUBISM 1907-14

FUTURISM 1909-15

EXPRESSIONISM 1910-22

Der Sturm 1910-32

Cubo-futurism 1912-18

Activism 1915-19

Ma

Léger

Duchamp and Picabia

Italian metaphysical painters c. 1915-20

via Picasso

Neo-plasticism 1917

De Stijl 1917-31

Zurich DADA 1916-19

Neo-classicism 1917-24

Arbeitsrat November-gruppe

Stuttgart

Purism 1918-21

CONSTRUCTIVISM

Weimar Bauhaus 1919-24

Berlin DADA 1917-20

Dresden Sezn.

Cologne Dada

Paris DADA

Hanover Dada (Merz) 1919-33

Karlsruhe

L'Esprit Nouveau 1920-24

Pure Constructivism 1920-

Vkhutemas

Productivism 1921-29

Verism c. 1920-24

LEF 1923-28

Munich Magic Realism

Novecento 1923-?

OST 1925-31

NEUE SACH-LICHKEIT c. 1923-33

New photography c. 1924

SURREALISM 1924-39

OSA 1925-32

Dessau BAUHAUS 1925-32

Abstraction-Création 1931

CIAM 1928

ARBKD 1928-33

19th-century Realism via Leibl, Hans Thoma and Munich naturalists

19th-century Realism via Perov, Repin etc. & the AKhRR

Socialist Realism c. 1934

Nazi Art c. 1934

Art streams of the 20s: 2 Organizations and political links

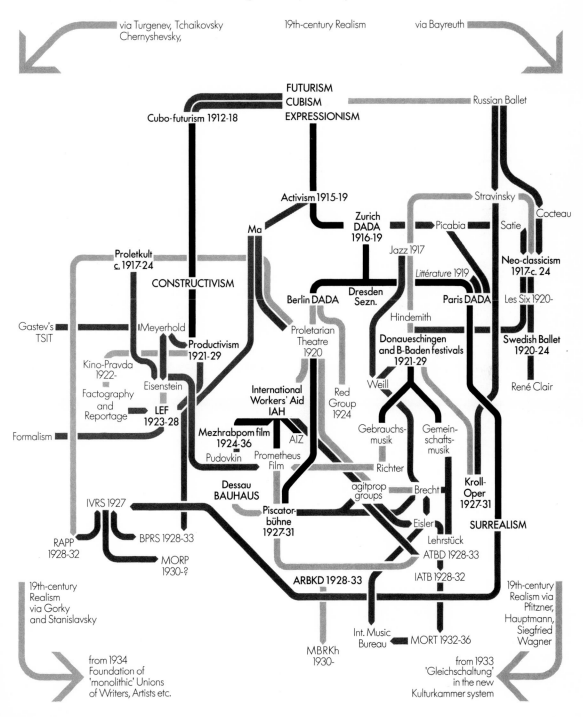

via Turgenev, Tchaikovsky
Chernyshevsky,

19th-century Realism

via Bayreuth

FUTURISM
CUBISM
EXPRESSIONISM

Russian Ballet

Cubo-futurism 1912-18

Activism 1915-19

Stravinsky

Cocteau

Ma

Zurich
DADA
1916-19

Picabia

Satie

Jazz 1917

Neo-classicism
1917-c. 24

Proletkult
c. 1917-24

Littérature 1919

CONSTRUCTIVISM

Berlin DADA

Dresden
Sezn.

Paris DADA

Les Six 1920-

Gastev's
TSIT

Meyerhold

Proletarian
Theatre
1920

Hindemith

Donaueschingen
and B-Baden festivals
1921-29

Swedish Ballet
1920-24

Productivism
1921-29

Kino-Pravda
1922-

Eisenstein

Weill

René Clair

Factography
and
Reportage

LEF
1923-28

International
Workers' Aid
IAH

Red
Group
1924

Gebrauchs-
musik

Gemein-
schafts-
musik

Formalism

Mezhrabpom film
1924-36

AIZ

Pudovkin

Prometheus
Film

Richter

Dessau
BAUHAUS

agitprop
groups

Brecht

Kroll-
Oper
1927-31

IVRS 1927

Piscator-
bühne
1927-31

Eisler

SURREALISM

RAPP
1928-32

BPRS 1928-33

Lehrstück

ATBD 1928-33

MORP
1930-?

ARBKD 1928-33

IATB 1928-32

19th-century
Realism
via Gorky
and Stanislavsky

19th-century
Realism via
Pfitzner,
Hauptmann,
Siegfried
Wagner

Int. Music
Bureau

MORT 1932-36

MBRKh
1930-

from 1934
Foundation of
'monolithic' Unions
of Writers, Artists etc.

from 1933
'Gleichschaltung'
in the new
Kulturkammer system

Alongside the civilization in question there was of course much else, which can be subsumed in the case of Germany under the general label of Weimar Culture, but whatever lies outside our main theme has to be taken as read; *The Blue Angel* and the like will not figure in this book. On the other hand there were forces actively combating and undermining this civilization which cannot be ignored. They can be seen at the outset demolishing the Expressionist utopia (by acts such as the brutal suppression of the Munich Soviet in 1919), expelling the Bauhaus from the city of Weimar, and thereby helping to form and harden the attitudes that followed. They were latent throughout the central period, when nothing was done to eliminate them, then surfaced again with the rocketing rise of the Nazis from 1929 on.

Here, sometimes explicitly, sometimes not, is the book's second theme: the hateful pressures, largely unique to Germany, which gave the younger artists and writers their uncompromising sense of urgency and in the end brought their civilization to a sudden stop. Even at the calmest and apparently sanest moments of the mid-1920s the more sensitive among these people reflected an uneasy precariousness which was often electrifying: 'I felt the ground shaking beneath my feet', wrote George Grosz in his autobiography many years later, 'and the shaking was visible in my work'. This febrile uncertainty is what distinguishes so many of the German reminiscences of the period, whether oral and private or literary and published, from their equivalents in other countries; not only the individual but the whole society around him can be felt to be desperately at hazard, often with fruitful effects for the arts.

Then at the end of the decade the commitment started to strengthen as the reaction developed: a reaction at once against the Republic, the modern movement and the internationalism on which both alike depended. From this point on the advanced arts which are at the centre of our story had, like democracy itself, to fight for life; and once again it looked like proving a stimulating process. But today we cannot forget that it was also a killing one, so that in the wave of curiosity about the committed art of that time it seems important not to overlook the obvious question: how far did this commitment succeed in its primary, political aims? The theme is complicated by the fact that the sharply polarized attitudes involved can no longer be seen as representing any clear conflict between right and wrong. For the 'progressive' line adopted by the extreme Left,

while inspiring a number of works which remain classic, was even then being vitiated on the one hand by wrong political appreciations and on the other by the growth of a new Stalinist aesthetic which many resolute anti-Nazis felt it would be disloyal to oppose.

It is this contrast between the positive and logical achievements of the new Weimar civilization and the frightful dilemmas of its ending that is meant to provoke the reader's thought. For both seem of relevance to the present age. We too, in the advanced industrial countries of today, have a similarly flourishing modern culture with an even more liberated artistic avant-garde, and yet we remain doubtful about its function and its sense and have never succeeded in absorbing it anything like so naturally into a coherent way of life.

If the central success story of the 1920s accordingly remains instructive so, certainly, does the ensuing tragic failure, not least because there is a tendency nowadays to overpraise the politically committed art of that time – the work of men like Grosz, Heartfield, Piscator and Eisler – on the grounds that it identified its enemies so sharply without weakening itself by those hesitations and qualifications in which many of us indulge. We need then to look carefully at both these aspects of the period, seeing at the same time how they relate to one another. Alas, this book provides no clear-cut answers for the immediate future. But I hope that by trying to work out in some detail what really happened in those productive and exciting days it may help its readers at least to see what problems they might themselves one day have to face.

WAR AND REVOLUTION

3

People in the war

The First World War as a formative influence. Its impact on certain key cultural innovators of the 1920s. Geographical displacements and their individual effects; the traumas of military service and front-line action; desertion and other forms of protest. Implications for the future Bauhaus, for modern art in revolutionary Russia, and for German painting and writing following Expressionism.

As sizeable volumes have before now been written on the subject of the Great War's impact on British writers alone it is clear that a mere couple of chapters cannot deal anything like fully with its implications for the whole modern movement in the arts. Many of its deeper effects indeed only became visible a decade or more after it ended. And even then there were individuals who, like Siegfried Sassoon in England, remained haunted by their war experiences for the rest of their working lives.

Broadly speaking three levels of influence can be distinguished; that of the general practical implications of a state of hostilities, that of individual reactions to new and traumatic experiences whether

at the front or elsewhere in the machinery of war, and finally that of certain new artistic movements, works and groupings which came about as a product of war conditions. The most easily accessible of these levels would seem to be the last, which will be left to the next of these wartime chapters since it leads directly into the story of the postwar years. The most interesting is certainly the second, since nothing could be more fascinating or more varied than a really profound investigation of the effects of such ghastly events on subtle and sensitive persons differing widely in nationality, outlook and artistic preconceptions. Unfortunately the state of our knowledge is far too rudimentary to allow anything so ambitious to be even attempted, and such superficial indications as we can give have to be limited to those writers and artists who are most relevant to the book's main themes. So before moving on to this more restricted aspect of the subject in the rest of the present chapter, let us start by outlining some of the war's effects in more general terms.

The war interrupted Germany's absorption of the newest Latin movements, to which prewar Expressionism had owed so much; it closed theatres and imposed a censorship which held up important new plays and books, forcing some of the more critical writers and editors to move to neutral soil. It turned internationalists into nationalists, often in the most unexpected way, starting of course with the bulk of the prewar socialist movement in all the belligerent countries, but also undermining the previous authority of such figures as Verhaeren and Apollinaire and Herwarth Walden of *Der Sturm*. It led to the temporary suspension or permanent transfer of key institutions; thus Diaghileff's Russian Ballet went touring across the Atlantic and thereafter never returned to Russia, while Jaques-Delacroze's eurhythmic institute had to leave Hellerau in Germany and the pioneering Rowohlt publishing house in Berlin closed down for six years. More materially still, it caused an interruption of modern building everywhere but in neutral Holland. This is why the most advanced architects remained so wildly unpractical right up to about 1924, though there were wartime structures like airship sheds and prefabricated huts to give them new ideas.

The war also killed a number of outstanding creative talents (like Franz Marc and Boccioni, Péguy and Wilfred Owen); others it interned as aliens or impounded their possessions (which is why D. H.

Kahnweiler's stock of Cubist pictures came to be sold off in Paris even after the peace treaties); others again became caught up in a vast process of displacement as they sought either to return to their own countries or to find neutral havens in which to take refuge. So Gleizes, Picabia and Duchamp of the Paris avant-garde went off to New York, Mondrian to his native Holland and the Delaunays to Spain, while Russia gained what amounted to a complete school of artistic pioneers with the return of its outstanding modernists: Kandinsky and the young Lissitzky from Germany, Chagall, Puni, Exter and Popova from Paris, and Tatlin from his sea travels with his still vivid awareness of Picasso's three-dimensional constructions which he had seen in France.

Even in these broad terms the effects varied from country to country. Thus with the English the art most influenced was certainly poetry, which was transformed as nowhere else by the need to express a suddenly altered world. In Russia the armed forces made fewer inroads on the arts than in other countries, thereby allowing the new movements to develop more quickly and with less concern for their immediate surroundings; it may also have helped that, for all the seeming backwardness of that vast land, a number of the leading artists there were women. In France, where a citizen army was fighting on its own soil for the second time in living memory, there was, at least among the intelligentsia, less querying of the sense of the war than anywhere else, and it was not until near its end that the few dissident voices (such as Romain Rolland's from near Geneva) had a perceptible echo. For the Germans on the other hand there was quite early on a strong nucleus of anti-war feeling centred on Franz Pfemfert's unique magazine *Die Aktion*; and with the decline of their hopes of victory and the elimination of the Russian monarchy, whose fall had for many been the one acceptable war aim, there was by mid-1917 a powerful pacifist, internationalist spirit which decisively influenced a good proportion of those concerned with the arts.

Above all this development helped to form the latter-day activist, utopian brand of Expressionism whose optimistic humanitarian rhetoric – expressed in words, images and impossible, romantically-conceived buildings – seemed somehow to match the new Independent Socialist Party (or USPD) that broke massively away from the pro-war Socialists in the spring of that year. What is crucial in the German case is the conflict between this great wave of feeling,

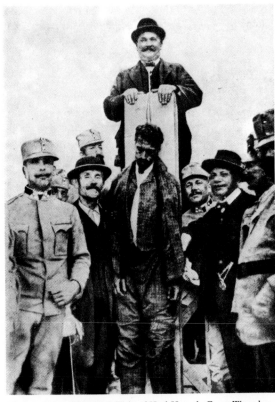

DIE LETZTEN TAGE DER MENSCHHEIT

TRAGÖDIE IN FÜNF AKTEN
MIT VORSPIEL UND EPILOG

VON

KARL KRAUS

ERSCHIENEN ENDE MAI 1922

VERLAG ,DIE FACKEL·, WIEN—LEIPZIG

The Last Days of Mankind. Title of Karl Kraus's Great War play, 1922 edition. The executioners are Austrian.

which found its most exaggerated formulations in the rhapsodic verse of Johannes R. Becher, and the more restrained scepticism bred by the actual experiences of the front. This contrast not only runs through the work of individuals, dividing those immediate expressive or angry reactions such as we reproduce in the following pages, for instance, from the cooler and more deliberate work that ensued; it also marks off the last phase of Expressionism from the sobering-up process which was beginning even then. The latter process was soon to receive a fresh impetus from the evident failure of Expressionism, with its lofty fraternal sentiments, to cope at all realistically with the mad cruelties of the German Right.

The decisive step in the creation of the future Bauhaus was taken when the Grand Duke of Saxe-Weimar in 1915 decided to make a military hospital of his Grand-Ducal Applied Arts School. Its then director, Henry Van de Velde, the Belgian painter–designer–architect whom Count Harry Kess-

ler had put in charge of all design matters in this small German state at the beginning of the century, had opted to remain there when the war came (something for which his countrymen proved reluctant to forgive him), thereafter leading a precarious life protected by psychiatric certificates and a makeshift German passport. Realizing that he had little hope of heading the school when it should eventually reopen, he thought it wise to recommend a successor, and in putting forward the name of Walter Gropius did much to determine the visual climate of postwar Germany, and thereafter of the whole modern Western world.

In making this choice he was aware of Gropius as the young architect of the elegantly functional Fagus factory at Alfeld, a key work in the history of twentieth-century architecture, and thus as a leading exponent of the industrially-based *Sachlichkeit* (a term signifying a mixture of utility, sobriety, practicality and objectivity) which the German Werkbund, still a relatively new design association linking industry and

progressive architects, had made one of its aims. At the same time Gropius had in some measure sided with Van de Velde in opposing the more extreme view of design put forward at the association's 1914 conference, where one faction proposed the virtual supersession of the designer's individual eye by the introduction of standardization and correct norms. This combination in the new director-designate of a functionalist and a believer in individual genius was of course to be crucial for the school's later development, in which first one element and then the other gained the upper hand. Meantime Gropius himself was serving in the war as a hussar officer, an experience which seems for some years to have stimulated his visionary idealism at the expense of his hitherto dominant practical side.

In 1917 Van de Velde became liable for conscription in the German army; however, thanks to Von Bode of the Berlin museums, he was instead given a mission to report on the conditions of German internees in Switzerland (from which he never came back). There he and one of his daughters were portrayed in splendid Expressionist woodcuts by E. L. Kirchner, who was treated by Van de Velde's psychiatrist, Ludwig Binswanger, after breaking down in the course of his military training near Frankfurt during 1915. With Kirchner henceforward more or less permanently a Swiss resident for the rest of his life, Erich Heckel serving as a medical orderly in Flanders and Schmidt-Rottluff on the Russian front (eventually in an army press unit along with the novelist Arnold Zweig), the Brücke group of German painters which they had helped form was

Art at the front. (1) Max Beckmann: *In Hospital*, East Prussia, 1914. From *Kunst und Künstler*, Berlin, December 1914

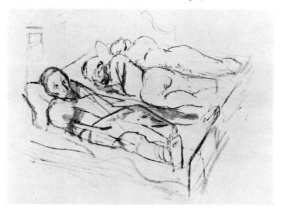

dispersed for good, though without any very marked change in the Expressionist style of their work.

Another who suffered a complete breakdown was Max Beckmann, then a rising German Impressionist of the same age as the Brücke artists, who was at first in a medical unit on the Russian front, then transferred to Flanders, to be discharged with shattered nerves in June 1915. 'Since being under fire', he wrote a month before this, 'I have personally experienced every shot, and have had the wildest visions.' The change is to some extent visible in his powerful sketches of his fellow-soldiers, at rest, in hospital or on the operating table. But after his return to Germany his painting took a completely new direction, as that of the Brücke artists did not: first in the great unfinished *Resurrection* which he painted in fragmentary, tortured style over the following two or three years, then in the harsh, tightly organized and almost mediaeval group of figures called *The Night*. With this a rigorous severity enters his work, marking it off from Impressionism and Expressionism alike.

None the less Expressionism, always so well suited to gruesome subjects and a passionate attitude on the recorder's part, remained the natural style even for younger, relatively unformed men to adopt for portraying their traumatic surroundings. So Otto Dix, as a front-line machine-gunner in Flanders and elsewhere, used splintery 'lines of force' and heavy distortions to convey his brutally twisted vision, and similarly the Hungarian László Moholy-Nagy, an artillery officer on the Isonzo front, filled his early sketches with dark rhythmic swirls. Both these men were then more or less self-taught artists whose style, like Beckmann's, was only worked out later. And perhaps we can already note a difference between the 'existential' shock of a shattered ego, which did not necessarily demand profound rethinking, and the more permanent changes caused in men impelled to look afresh at the hierarchies and values which had put them where they were.

Thus the apprentice actor Erwin Piscator, aged twenty when the war began, wrote later that everything began for him from that day: his first two years as a signaller in the Flanders trenches gave him a hatred of militarism and nationalism that characterized his whole later life as a leading theatre director. Immediately the effect was to make him write anti-war poems, one or two of which appeared in *Die Aktion*, allying him spiritually with other young contributors to that magazine, notably (as it turned

out) with those among whom the German Dada movement began. Another who reacted very similarly was the student Ernst Toller, an Expressionist poet of almost exactly the same age, who served for a year on the Western front as a volunteer, always applying for the most dangerous jobs, then was discharged after a physical breakdown. Back home he became an increasingly militant pacifist, helped organize a strike in Munich, and for the rest of the war was in and out of asylums and prisons, where he was able to read Marx, Bakunin and the Webbs as well as the poems of Franz Werfel whose Whitmanesque style helped to form his own. Still younger was yet another *Aktion* contributor, Carl Zuckmayer, who joined his local artillery regiment in Mainz, fought with it on the Western front, became a forward observation officer and was wounded when his spotting tower was shot down. His experiences did not exactly haunt him, he later said:

But the memory lives on.
It remains present in me like an integral part of my body, a scar, a chemical substance in my glands. At the same time it is detached from me, as if the whole thing had happened to someone else.

Among the writers of the various belligerent countries there were only two who at the time produced works of fiction giving a vivid and critical picture of the fighting. These were the Frenchman Henri Barbusse, whose *Le Feu* was finished by the end of 1915 and had appeared in both French and German by 1918, and the now forgotten Austrian Andreas Latzko, whose sequence of stories was published in Zurich in 1917 under the title *Menschen im Krieg* (Human Beings in the War). Both of these books differ from the Scotsman Ian Hay's two novels (which are in many ways admirable documents written with economy, humour and compassion) by entirely lacking the element of 'public relations' which seems to pervade Hay's work. Each in its manner is revolutionary, Latzko's by its blistering contempt for those whose profession is war, Barbusse's by its conclusion that pacifism may well entail fighting the ruling class, and that 'the future is in the hands of the slaves'; and both helped to generate the socially-conscious anti-militarism which so dominated the cultural development of the 1920s.

Otherwise however the major novels of the war only date from the end of that decade, German, American and English writers alike taking some ten years fully to digest and recreate the war experience;

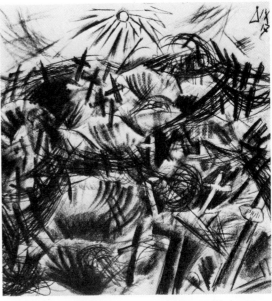

Art at the front. (2) Otto Dix: *Cemetery Between the Lines,* Western front, 1917. From a private collection

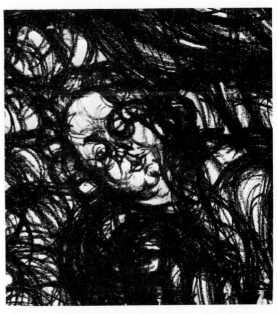

(3) László Moholy-Nagy: *Dying Soldier,* Isonzo front, 1916

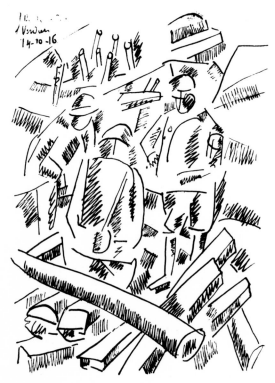

Art at the front. (4) Fernand Léger: *Verdun*, 1916

this holds as good for Remarque and Renn as it does for Graves, Sassoon and Hemingway. In the visual arts the time-lag was somewhat shorter – Käthe Kollwitz (whose son Peter had been killed in 1914 on his second day at the front) and Dix both producing their graphic cycles in 1923, while in France too the artist most profoundly affected, Fernand Léger, only seriously began assimilating what the war had taught him once he had returned to the studio in 1918. Far the quickest reaction came from the poets (with their minimal needs in the way of equipment), and if the prevalence of Expressionism among the Germans meant that their contribution here was much less individual than that of Owen or Rosenberg on the other side of the lines, there were already pointers towards a more explicit and much less inflated style of writing.

The seeds of this lay already among those younger prewar Expressionists who did not follow the more rhetorical, rhapsodic course pursued by such humanitarian visionaries as Werfel, Becher and in due course Toller. One of the best of the group was killed in the second month of the war: Alfred Lichtenstein,

who at twenty-five had already spent a year in a Bavarian infantry regiment. In a poem of his called 'Prayer before Battle' the troops, he says, 'sing with fervour, each for himself' as follows:

> God protect me from misfortune,
> Father, Son and Holy Ghost,
> May no high explosives hit me,
> May our enemies, those bastards,
> Never take me, never shoot me,
> May I never die in squalor
> For our well-loved fatherland.
>
> Look, I'd like to live much longer,
> Milk the cows and stuff my girl friends
> And beat up that lousy Josef,
> Get drunk on lots more occasions
> Till a blissful death o'ertakes me.
> Look, I'll offer heartfelt prayers,
> Say my beads seven times daily,
> If you, God, of your gracious bounty
> Choose to kill my mate, say Huber
> Or else Meier, and let me off.
>
> But suppose I have to take it
> Don't let me get badly wounded.
> Send me just a little leg wound
> Or a slight gash on the forearm
> So I go home as a hero
> Who has got a tale to tell.

His contemporary Kurt Tucholsky, author of a charming light novella called *Rheinsberg* and later to become one of the shrewdest social-political commentators of the Weimar Republic, wrote from a pioneer battalion on the Russian front:

> We young men have been thrown off our balance –
> We're serving out here on our own,
> We'd counted on our character and talents –
> and then the world went down.
>
> 'The world's all wrong!' Unlike those sums they
> set us
> where teacher always had the answer pat
> it's real enough: it took the things we honour
> and like a house of cards it knocked them flat.
>
> The young are told to see this through, poor
> creatures.
> Their job is to be brave, that's clear –
> but tell me, are their earlier, better features
> then bound to disappear?
>
> New values, new priorities, new courses,
> new hierarchies – you need the proper touch:
> it seems what counts is fists and swords and horses –
> the things we care for don't count much.

Is that a rule? No, we cannot regard this
as always so. We'll keep intact as men.
We'll see this through – to me it's far from cowardice
to be a soldier *and* a citizen.

So teach your boy the military virtues,
but through the clamour tell him, if you can:
he must keep fresh the dreams he had in childhood
and honour them, if he's to be a man.

Just how tough this very direct, seemingly quite
light and conventional style of writing could already
be is shown by some verses which Zuckmayer wrote
in 1917 and published only some fifty years after:

For seven days and nights I haven't eaten.
Shot one man through the forehead with my gun.
My shin's all ravaged where the lice have bitten.
In next to no time I'll be twenty-one.

Whenever I get drunk you'll find me smashing
My fist in some pale face. My song's a rage.
My beard has reached the early lettuce stage.
A strident blood wells up where I've been scratching.

And so I turn my hand to my own semen –
Look, Europe's future, this grimy-textured spawn!
A god drowns in the pool where toads lie sprawled –
And crap away my legacy to women.

Not everybody whose life and art were so affected
by the war experienced quite the same extreme shock
and squalor. Some did clerical jobs, like the Marxist
philosopher Georg Lukács (who worked in the
Budapest censorship), the painter–poet Kurt Schwit-
ters or the subsequent surrealists Paul Eluard and
Georges Ribemont-Dessaignes. Some had friends or
patrons to extricate them, as did the Expressionist
publisher Kurt Wolff, or the young French composer
Darius Milhaud, who became Paul Claudel's sec-
retary at the French embassy in Brazil. Some took up
medical studies which, for a time at least, exempted
them from being called up even though they were
dropped once the war was over; this was the case
with the poet Bertolt Brecht in Augsburg, and also
with the future surrealists André Breton and Louis
Aragon who met on a hospital course in Paris in the
winter of 1916, though Aragon was later posted to a
front-line ambulance unit where he won the Croix de
Guerre. One of the oddest war careers was that of the
slightly older Jean Cocteau, who entered the war
with bubbling enthusiasm and joined a more or less

amateur ambulance unit with various smart friends
before transferring to a form of bath unit under
Count Etienne de Beaumont's command. He man-
aged to spend a good deal of time in Paris, which was
after all not far from the fighting. Then during the
Battle of the Somme he had himself transferred again,
this time to full-time clerical work in the capital,
which apparently left him free to go to Rome and help
prepare Diaghileff's new ballet *Parade*. Finally in mid-
1917 he was invalided out.

Those artists and writers who most resolutely
pitted themselves against the military machine found
that to do so demanded a courage and a kind of
devious ingenuity which could be turned against
many aspects of peacetime society too. The Prague
writer Jaroslav Hašek, for example, who was
nominally an Austrian citizen, first won his emperor's
silver medal for gallantry by bringing in 300 Russian
deserters, then contrived to be himself among the
500-odd 'missing' from the 91st Infantry Regiment
after a Russian night attack. Thereafter he fought for
the Russians in their Czech brigade before the
October Revolution, writing for the brigade news-
paper a first instalment of *The Adventures of the Good
Soldier Švejk* (or *Schweik*), a work later to emerge as the

Schweik's army. The 91st Regiment on the Galician front, with
Lieutenant Lukáš (nearest camera) and Jaroslav Hašek (hatless,
seen over his shoulder)

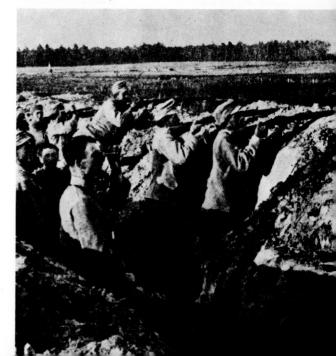

greatest and funniest of all war novels, and a lifelong influence on Piscator and Brecht.

More hazardously, the Berlin writer Franz Jung, another contributor to *Die Aktion* and an editor of the prewar Munich *Die Revolution*, took part in a small, far from popular early demonstration against the war, was sent by the police to the 5th Guards Grenadier Regiment, who put him almost untrained into the battle of Tannenberg; then likewise deserted. Making his way back to Berlin he was given a spurious medical certificate (by the eccentric Dr Walter Serner), then caught again in Vienna, to be put in a mental hospital from which he was rescued by the Schutzverband Deutscher Schriftsteller, a newly formed writers' protection society which was to become quite important in the Weimar period.

Wieland Herzfelde, another poet who had been published in the prewar *Die Aktion*, was discharged in 1915 as 'unworthy to wear the Kaiser's uniform'; he was not yet twenty. Called up again two years later, he made friends with Piscator at Courtrai in Belgium, where the latter had been posted to an army theatre unit. He was extricated from the front by Harry Kessler (the 'Red Count' who for a time was German cultural attaché in Berne), who set him, together with his brother Helmut Herzfelde and the draughtsman George Grosz, to work making an official satirical puppet film about the newly-involved U.S. army, by name *Pierre in Saint-Nazaire*.

Grosz, who had been brought up in a military environment and seemed outwardly the perfect big blond tough, had volunteered at the start of the war for the 2nd Guards Grenadier Regiment, which went to the Western front. Here, in his own words, he was

> bellowed at for so long that I finally developed the courage to bellow back. . . . The fight was literally one to the finish. It was sheer self-defence.

Falling ill with 'a combination of brain fever and dysentery', he was sent to hospital and discharged, only to be called up again in the winter of 1916–17 not long after he had begun contributing to the Herz-feldes' journal (for which see p. 28). A day after his recall on 4 January he was put in a 'hellish hospital' at Guben, then moved to an asylum at Görden near Brandenburg for observation. After about three months he was discharged, his will unbroken but his hatred of the system now hardened till it was as sharp as the spiky pens with which he wrote and drew. As for the last of this trio, Helmut Herzfelde too had started training at the same regiment's Berlin depot, but had

fallen sick and been discharged as unemployable. It was this still obscure commercial artist who, without having the least connection with England or know-ledge of the English language, was so repelled by the prevalent anti-English propaganda that he changed his name to John Heartfield by deed poll. The Imperial authorities, so his brother later recalled, at first rejected his application. 'A few years later the German people rejected the Empire. The name Heartfield turned out to be more durable.'

Such, in rapid outline, were the formative experiences of some who were to decide the postwar climate in the arts. At the same time of course there were others, including so outstanding a younger writer as Ernst Jünger, who drew very different conclusions from their war years, seeing war's primitive, more or less mystic aspects above all as a basis for spiritual regeneration. More significantly still, a distinction was quite commonly made between the selfless loyalty and courage of the men at the front and the shabby political intrigues of those at home – out of which grew the myth of the 'stab in the back' by which the latter had prevented the former from winning the war.

Admittedly very few of those who contributed at all positively to the Weimar Republic's culture were persuaded by ideas like these; nonetheless the widespread resentment – popular as well as conservative–official – against any mockery or even criticism of the German army was to remain a factor in many of the artistic controversies of the period. At the same time however there were indeed worthwhile lessons to be learnt from the military ethic, and in some cases they significantly changed the creative artist's sense of proportion, giving him a new capacity for teamwork, a distrust of rhetorical statements, an interest in previously unknown technologies and a greater respect for ordinary people. And this is something that came to apply more to politically left-wing writers and artists than to the not quite so talented and open-minded Right.

So far, it is true, the reactions which we have noted were very largely individual ones, expressed in isolation whether at the front itself or in spells at home. But once one or two rather more collective movements began to emerge – through publication, readings, exhibitions and mutual encouragement and support – then the first outlines of a distinctive new culture started to sketch themselves on the tattered European map.

4 Counter-offensive: Dada, Stravinsky, Parade, Chaplin and jazz

Wartime origins of the new European artistic movements. End of Futurism as an international force; birth of Dada in neutral Switzerland, its Expressionist, Activist, Cubist and Futurist components. Subsequent adoption of Dada by the Berlin anti-war group around the Malik-Verlag; initial hostility of Apollinaire and others in Paris. Fresh Parisian influences: Satie's *Parade*, Léger's changed vision. Economy of means in Stravinsky's *L'Histoire du soldat*. Austerities of *De Stijl*. Jazz, the cinema and other developments in the media, with Chaplin as their symbol.

Just one section of the prewar avant-garde had gone into battle as such, shouting patriotic cries. This was the Italian Futurists under Marinetti, whose idealization of war and war machines led them first to organize noisy pro-war demonstrations – Balla even designed an 'anti-neutral suit' in the national colours – then on Italy's entry into the war in 1915 to join the same unit, a cycle battalion which was put into the fighting that October. Two months later, for apparently unknown reasons, the battalion was converted into an Alpini unit and its leading Futurist members – Marinetti, Boccioni, Russolo and the architect Sant'Elia – returned home. The movement's supporters in Florence, notably Ardengo Soffici and the review *Lacerba*, had meanwhile fallen away; Severini had remained in Paris, where he at first painted semi-Cubist, semi-lettrist war pictures following Marinetti's instructions to 'live the war pictorially' inspired by 'the enormous military anti-Teutonic emotion' prevailing there; Carrà, after a spell of quite unbombastic lettrist collages which he termed *Guerrapittura*, abandoned Futurism altogether and was thereafter infected with the calm, classical, largely dehumanized 'metaphysical' art which Chirico had been practising in the Ferrara military hospital where the two men now met.

Looking at Futurism's subsequent decline, it is difficult not to conclude that its grip, both on the most gifted Italians and on the outside world, was broken as soon as Marinetti's right-wing values and slogans could be tested against the realities of war. Not that this seems to have affected either Marinetti's own physical courage, for he and Russolo both

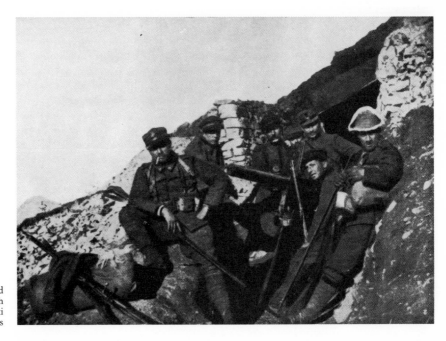

Marinetti's army. The Lombard Volunteer Cyclists in the north Italian Alps, with F. T. Marinetti (*left*) and other Futurists

returned to the front and were wounded, or his determination to go on advertising his ideas: there is, for instance, a preposterous Futurist Dance Manifesto of 1917 where a 'dance of the machine-gun' is accompanied by the ballerina's shouts of 'Savoia!' – that being, of all things, the name of the Italian royal house. But the deaths of Boccioni and Sant'Elia after they too had been recalled to the army – the former in an accident, the latter when leading a fighting patrol – deprived his team of its two oustanding artists, and although there were younger men like Prampolini who came to play a part in the wider movement of the 1920s they were not exactly Futurists in the hitherto accepted sense.

The first distinctive movement of the war years was born partly under the shadow of Futurism, even though its attitude to militarism and nationalism could hardly have been more different. This was Dada, two of whose founders, the young Germans Hugo Ball and Richard Huelsenbeck, had been brought together by a common interest in Marinetti's phonetic, telegraphic, typographic use of language, and had organized a reading in his honour in Berlin only two weeks before Italy's entry into the war. They were also both early contributors to Pfemfert's *Die Aktion*, whose role as a focus for anti-war feeling was so important, while Ball had been one of the founders of the short-lived Munich *Die Revolution*, which had been suppressed at the end of 1913 because of a poem of his called 'The Hanged'.

Not long after the Berlin reading Ball left for Switzerland with forged papers and once there made touch with Marinetti himself. At this time his views were essentially anarchist, and after settling in Zurich with the cabaret actress Emmy Hennings (another contributor to both journals, whom the Germans had briefly imprisoned for helping deserters), he saw a good deal of the forty-one-year-old Swiss doctor Fritz Brupbacher, a close friend of Kropotkin's, whose wife Lydia Petrovna had been involved in the 1905 Russian revolution. Through Brupbacher he appears to have made contact with Willi Muenzenberg, a revolutionary Socialist organizer from Stuttgart and a supporter of Lenin's, and written for his paper *Jugendgarde*. After a desperate struggle to make ends meet Ball took a job as pianist to a troupe of circus-style entertainers, then he and Hennings decided to open their own Zurich cabaret as a centre for any performers who might care to volunteer. This began functioning in a café in the Spiegelgasse – the street where Lenin and his wife were then living – in February 1916. They baptized it the 'Cabaret Voltaire'.

Huelsenbeck, who had likewise come to find Germany 'unbearable', thereupon got permission from the army to study medicine in Switzerland, and arrived just six days after the opening to find Ball playing – of all things – Brahms. The other founders of Dada had come on the first evening: the quite mature artist Hans Arp ('very different from any accepted definition of a Dadaist', Marcel Jancu calls him), together with what Ball termed 'an Oriental-looking deputation of four little men', in other words a group of Rumanians, whose country was still at that time neutral, including the two Jancu brothers and a twenty-year-old Zurich University student called Sami Rosenstock who had begun writing symbolist poetry under the name Tristan Tzara.

The result of this odd mixture of forces was unpredictable. Much of the cabaret's early material was Expressionist, symbolist or merely conventional; Arp, the one major artist of the group, went his own increasingly abstract way and took little part in the performances. Outsiders were liable to contribute almost anything, from balalaika music to French cabaret songs; the café proprietor was a Dutch ex-seaman; there was much rowdiness. But once Tzara and Huelsenbeck came together, with their polyglot 'simultaneous poems' for three voices, their dubiously authentic 'negro poems' and their thumpings on the big drum, then Ball felt the enterprise to be catching fire in a way that provoked thought. 'What we are celebrating is both buffoonery and a requiem mass' (diary note for 12 March), and a month later, 'Every word that is spoken and sung here says at least this one thing: that this humiliating age has not succeeded in winning our respect.'

Dadaism proper only really came into being once the magic word had been discovered. This happened in April 1916, when Ball and Huelsenbeck were seeking the right name for their planned periodical (though in fact the title given was at first *Cabaret Voltaire*, and it only became *Dada* with the next issue in mid-1917). Up to the introduction of this irresistibly simple four-letter word, with its polyvalent meaning so conducive to endless interpretations, the group were no more than the youngest and worst-behaved wing of Switzerland's growing colony of central- and East-European war opponents. Some of these supported the cabaret or were acquainted with Ball: the writer Leonhard Frank, for instance, and the

The nonsense of war. Dada in Zurich, with *(above)* Hugo Ball and Emmy Hennings, and *(below, from left to right)* Arp, Tzara and Hans Richter

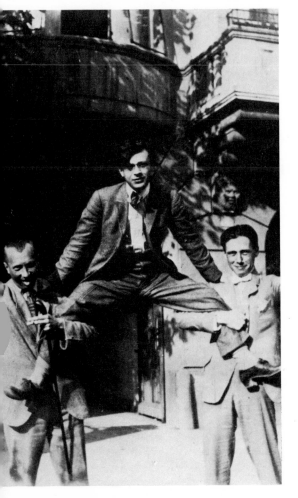

editors of the two anti-war monthlies which, less astute than *Die Aktion*, had been forced to move from Germany: Ludwig Rubiner of *Zeit-Echo* and René Schickele of *Die Weissen Blätter*. But neither Lenin nor Joyce, much of whose *Ulysses* was written in Zurich at this time, is known to have been at all aware of Dada, while the French exiles at the other end of the country, where Romain Rolland maintained a rather lofty moral leadership 'au-dessus de la mêlée', seem to have moved in an altogether different world from Ball and his friends. Even Masereel, who was to become so well known in postwar Germany for the particularly warm, humorous, socially critical humanitarianism of his Geneva woodcuts, seems to have made no impression on them. More surprisingly still, another *Die Aktion* poet, the Alsatian writer Iwan Goll, torn between two languages and sharing much of the Dadaist outlook, remained apart in Lausanne, though Tzara had some correspondence with him.

With the formal proclamation of Dada, most resoundingly in the manifestos of 14 July, the movement became at once more identifiable and more plainly aggressive. And this is where Marinetti's influence again made itself felt, not only in Ball's pure sound poetry which he delivered in a cardboard magician's costume at the cabaret's last performance, but above all in Tzara's entire approach. For Tzara now became the group's international link-man and propagandist, writing round Europe for support and contributions to the next issue of *Dada*. The cabaret closed, after an ultimatum from the Dutchman, who said he was losing money; Huelsenbeck withdrew to Germany, Ball to Italian Switzerland to write a study of anarchism. Then came a lull for some months till early in 1917 when, apparently through Arp, the group took over a gallery on the Bahnhofstrasse.

Here they held some very mixed exhibitions and four or five readings, including a *Sturm* evening featuring Marinetti's Manifesto of Futurist Literature, poems by Cendrars and Apollinaire and a performance of some of his own verses by the Expressionist Albert Ehrenstein; there was also a *Sturm* show and a lecture on Kandinsky by Ball. Thereafter, with Huelsenbeck gone and Ball losing interest, the leadership passed to Tzara, short, monocled, dapperly dressed with, by all accounts, a formidable energy and ambition to acquire an international name like Marinetti's. There were some significant reinforcements, starting with the painter Hans Richter, another *Aktion* contributor who

The sense of Dada. A wood *Torso*, since lost, by Arp, photographed against a large-scale calligraphy

became linked with Dada this was because much of it was formulated within the framework of Dada meetings; in its calm purposefulness however it is already very different, foreshadowing what was to come later. Thus Ball reports Arp in the early days of the cabaret attacking Expressionist bombast and calling instead for 'plane geometry':

> Sentiment must go, and so must analysis when it occurs only on the canvas itself. A love of the circle and of the cube, of sharply intersecting lines. He is in favor of the use of unequivocal . . . colors . . . and he is especially in favor of the inclusion of mechanical exactness. . . . If I understand him correctly, he is concerned not so much with richness as with simplification. Art must not scorn the things it can take from Americanism and assimilate into its principles; otherwise it will be left behind in sentimental romanticism.

The attitudes implied here are very remote from that 'farce of nothingness' which Dada came to represent; like Arp's art itself, they are on the contrary quietly serious and constructive. What was much more characteristic of Dada at this stage was its public-platform aspect, its demonstrative insulting of a despised outside world made up of the 'bourgeoisie', the warring governments and their armies, and (more immediately) the uncomprehending public out in front. This aggressiveness depended not merely on the continuation of the war but on the group's own position as a band of outsiders in a normally sedate city; it also derived, like other ultimately equivocal stances, from their view of 'bourgeois' as an aesthetic rather than a social category; a natural preference, perhaps, since as Jancu later wrote, 'we all came from nice middle-class families (some of us had even had governesses to bring us up)'. So as the first reports began filtering out from Switzerland their appeal to the younger rebels elsewhere already contained ambiguities, even if these did not immediately catch the eye.

arrived to see a Zurich specialist after being wounded on the Russian front and did not return; works by Max Ernst were now also shown for the first time, though Ernst himself was still on the Western front and his real Dada period began only later. But once the gallery closed that summer there were no manifestations for about a year. And manifestations were the movement's essence.

For this wartime Dadaism had not yet produced any distinctively Dadaist works. The simultaneous and phonetic poetry was just a development of what was already there, the shock use of collage and assemblage was yet to come, the artists were still being seen by critics as 'Zurich cubists'. Whether Arp's beautiful carvings, prints and collages owed anything to the movement as such is extremely doubtful; for to him the -isms were always primarily aids to getting his work shown, and in his subsequent writings about Dada he treated its theoretical pretensions with some flippancy. If his approach

Huelsenbeck, who seems to have felt something of this ambivalence in himself, reached Berlin at the beginning of 1917, by which time there were two potentially fertile beds ready for him to plant the seed in. The first was an erratic magazine started in 1915 by Franz Jung and others of the old Munich *Revolution* group, together with the poet Herrmann-Neisse, under the name *Freie Strasse*, with a philosophical-psychological bent; one of their collaborators was a young Austrian-born artist called Raoul Hausmann. The second was the monthly *Neue Jugend* which had

been started as a youth magazine, then resuscitated by the Herzfelde brothers, who saw this as a way of publishing an anti-war journal without having to apply for a new licence. Its issues from July 1916 (which marks the start of their regime) to the following February/March were dominated largely by the writings of Else Lasker-Schüler and Theodor Däubler, two older and more orthodox poets, as well as by the pacifist ecstasies of Johannes R. Becher, then writing in his utopian–expressionist vein ('Resound, O Word!' and so forth).

But the Herzfeldes had meantime fallen in with George Grosz, and it was he who, under editorial pressure, produced the drawings and poems that gave their magazine a decisive twist:

Worlds! Flames!
You lurching staggering houses!
Cakewalk on the skyline!
You negro melodies
Delicious as Ellen's blue eyes – – –
Worlds, rivers, continents!
Australia, thou land of sunshine!
Africa, with thy dark pri-pri-primaeval forests,
America, with thy expresstrain civilization,
Worlds, I'm calling, yelling!
Wake up, you slavishly kowtowing palefaces!
You sons of dogs, materialists,
Breadeaters, meatgobblers – vegetarians!
Headmasters, apprentice butchers, whiteslavers! –
 you scoundrels!
Imagine, my soul is two thousand years old!
 !!! Triumph !!!
God, father, son = Company Limited.

FRANZ
JUNG:
DER
FALL
GROSZ

15 Mark Ermäßigung
bei Subskription / Der Malik-Verlag, Bln.-Südende

'The Grosz case'. Introductory advertisement from the *Neue Jugend* 'prospectus' of June 1917. (The book never appeared.)

The drawings, lithographed separately in numbered editions, then collected in a *First George Grosz Album*, became the mainstay of the magazine, and when Wieland Herzfelde was called up for the second time Grosz, Heartfield and Jung turned it into a fortnightly of a far more outrageous nature, both typographically and in content.

Only two such issues appeared before the censor, who had already banned the *Neue Jugend* almanac, forbade any further publications. The first, dated May 1917, contained a long Expressionist-style statement by Huelsenbeck about 'The New Man' which took up half the paper. But by then Jung's aggressive–satirical style on the opening page had already set a more subversive tone, and in the second issue there were such truly Dadaist pieces by Grosz as 'Can you ride a bicycle?' and 'You've got to be an indiarubberman', while Heartfield splashed words, typefaces and random printers' symbols asymmetrically about the page. In the hope of misleading the censorship the firm meantime changed its name to Der Malik-Verlag, *Der Malik* being the title of one of Else Lasker-Schüler's characteristically cute–exotic stories.

In 1916 Herzfelde had been sent a copy of *Cabaret Voltaire*, which he recommended to his readers along with other Swiss-based journals such as *Die Weissen Blätter*, *Zeit-Echo* and Henri Guilbeaux's *Demain*. But he was chary of Dada, and since Huelsenbeck seemed to have returned from Switzerland somewhat disenchanted there was a certain lull before the formal Berlin launching of the movement in February 1918. What changed Huelsenbeck's attitude is unknown, but that month, before giving a reading from his own *Phantastische Gebete* in the Neue Sezession's rooms in the I. B. Neumann gallery, he spoke about the Zurich movement and the internationalism implicit in its name. Dada, he said, was something for

People with sharpened instincts, who realize that they stand at a historical turning point. Politics are only a step away. Tomorrow a ministry or else martyrdom in Schlüsselburg.

– Schlüsselburg being the Tsarist political prison.

The context of these remarks can only have been the October Revolution of 1917, and after the reading it was decided in various discussions between Huelsenbeck, Jung, Grosz, Heartfield and Raoul Hausmann, to found a 'Club Dada' which would hold its first public meeting in April. Here there was for

Apollinaire fights for France. Drawing by Picasso of the Franco-Polish poet in uniform, subject also of an Ingres-like pencil drawing after his wound

meetings, involving phonetic poems by Hausmann, a race involving a typewriter (manned by the poet Walter Mehring or Walt Merin) and a sewing machine operated by Grosz, as well as other more elaborate events, one or two of them staged by Piscator. The distinctive new element here lay in the Berlin manifesto's attack on the decline of Expressionism, which was already seen by its author (?Jung) as threatening to become part of the Establishment:

> The highest art will be that ... which one can see allowing itself to be bowled over by last week's explosions, which is repeatedly gathering its limbs together after the previous day's shock. The best and most unprecedented artists will be those who are ever collecting the shreds of their body from the confusion of life's cataracts, as they cling to the intellect of the age, with bleeding heart and hands.
> Has Expressionism fulfilled our expectation of such an art, one where our most vital concerns are at stake? NO! NO! NO!

By contrast those Parisians to whom Tzara began applying for interest and support in 1916 had little use for any international movement and reacted to Zurich Dada with patriotic vigilance. 'The only ones of your manifestations I can sympathise with', wrote the art dealer Paul Guillaume that April, 'are those of a Francophil or "allied" character.' Having met Apollinaire before the war, Tzara now sent several of the Dada publications to him, but that poet, wounded at the front and thereafter transferred to the censorship, was very conscious of his obligations to his adopted country and feared that Tzara in Zurich might be

> au-dessus de la mêlée, an inadmissible position at a time when material, artistic and moral progress are all threatened and have to be victoriously defended.

Tzara, however, already had his main eye on France, doubtless for the same highly un-Dadaist reason as drew him to Marinetti – that the Rumanians too are Latins – and during 1917 was sending his French-language poems to such avant-garde Paris reviews as *Nord-Sud* and Albert-Birot's *SIC*, using Apollinaire as a reference. Thereafter Apollinaire turned down further collaboration with *Dada* on the grounds 'that I don't find that review's attitude towards Germany clear-cut enough'. He felt, he said, that since his own position was vulnerable in view of his Polish origins, he could not afford to take part in

once no scandal: Else Hadwiger, Marinetti's translator, read various Futurist poems and one by Tzara; Grosz read his own poems, Hausmann an essay on 'New Material in Painting'; while Huelsenbeck delivered the Berlin Dada Manifesto signed by himself, Tzara, Jancu, Jung, Grosz, Haussmann and the composer Gerhard Preiss, though not by Heartfield or Herzfelde. This was followed over the next twelve months or so by some slightly livelier

any enterprise where Germans might be concerned. This did not stop him in his own work from pursuing Dada-like ideas, most notably in the short absurdist play *Les Mamelles de Tirésias*, which he described as a 'surrealist drama', a term to be taken up by André Breton some six years later.

On a higher social level there was a similar strain in the Cocteau–Satie–Picasso ballet *Parade*, which Diaghileff performed at the Théâtre du Chatelet in May 1917, with a programme note by Apollinaire describing it too as surrealist. This long-prepared piece of 'music-hall' represented an entirely new departure for the Russian Ballet, marking the beginning of its working relationship with the Paris avant-garde of the 1920s. Moreover in its use of megaphones, of shouted advertising slogans and nonsense syllables, of all kinds of realistic noise effects which Cocteau also wished included, it had been designed originally to make a Futurist–Dadaist use of sound.

Even without this, *Parade*'s effects were highly significant, for on the one hand the collaboration with Satie gave Cocteau the starting point for his essay *Le Coq et l'arlequin* of the following year, with its attack on 'Germano-Slav' music and its recommendation to young musicians of a clear, melodic, linear French tradition exemplified by Satie and the popular *café-concert*; while on the other the rehearsals in Rome stimulated Picasso to a new mock-classical style which now developed alongside his more simplified and abstract wartime Cubism. Here were the makings at once of a neo-classicism relating to the new traditionalism of Carrà and Chirico – their compatriot Severini in Paris being one of its chief practitioners – and of the 'crystal Cubism' associated with the remaining active Cubists, above all the Spaniard Juan Gris and Auguste Herbin whom the army had rejected.

This last main Cubist school, channelled through a new dealer, Léonce Rosenberg and his Galerie de l'Effort Moderne, was almost at once further transformed by Léger's return to work with a fresh concern for subject-matter prompted by his army experience. For it was the war, wrote his friend Cendrars, that gave Léger his 'sudden revelation of the *depth* of the present day':

> The sight of swarming squadrons. The resourceful private soldier. Then again and again fresh armies of workmen. Mountains of pure raw materials, of manufactured objects . . . American motors, Malaysian daggers, English jam, troops from all countries,

German chemicals, the breechblock of a 75, everything bears the stamp of a tremendous unity.

As soon as the right pictorial terms were found in which to convey this vision the Cubist movement would be over.

Two further developments in the neutral countries were related to these effects, though as yet their impact could hardly be appreciated. First of all the music of Stravinsky, which Cocteau on the basis of *Le Sacre du printemps* still rashly criticized as overloaded with 'theatrical mysticism', had taken an utterly different turn during his wartime isolation on the Lake of Geneva. Here, in the intervals of working on *Les Noces* – a ballet scored for pianos and percussion rather than the previous vast orchestra – he composed several smaller-scale works of a new type: the chamber opera *Renard*, the *Cinq pièces faciles* for unskilled pianists, a piece for mechanical piano, a

The astounding Cocteau. Character from his ballet *Parade*. Music by Satie, designs by Picasso; presented by Diaghileff in Paris, 1917

Ragtime for eleven instruments, and above all a travelling entertainment, designed to be played with minimal wartime resources, entitled *L'Histoire du soldat* which, with its ragtime rhythms and dance-suite form, is even less compatible with any kind of theatrical mysticism than is *Parade*.

The Russian director, Georges Pitoëff, who played in its one wartime performance at Lausanne in September 1918 – a production killed by the Spanish influenza epidemic which now swept Europe – was himself a refugee in Switzerland, where he had gone on his honeymoon in June 1914 to see Fernand Gémier's and Jaques-Dalcroze's pageant in honour of Geneva's adhesion to the Swiss federation. Interested in unorthodox forms of theatre and taking advantage of the presence of so many Russian exiles, he and his wife Ludmilla staged Russian and (from 1916) French productions in that city, one of their favourites being Alexander Blok's *The Fairground Booth*, a play whose theme and setting (notably in Vsevolod Meyerhold's trestle-stage St Petersburg production of April 1914) anticipate the Stravinsky and Satie works.

Secondly the dissolution of Cubism in a more simplified and seemingly rational art was already anticipated not only by Arp but more dogmatically (and hence perhaps more influentially) by Mondrian and his circle in Holland. Hitherto an orthodox Cubist. Mondrian had been working in Paris before the war, but had returned to his own country just before the Germans swept across Belgium and penned him in there. Partly influenced by a theosophically-inclined mathematician called Schoenmaekers he had decided that the Cubist attempt to analyse appearances was mistaken and that the kind of beauty and balance which he himself was trying to achieve could only be attained by creating it without direct derivation from the visible world. This process of 'nieuwe beelding' or new formation, new shaping (misleadingly rendered by 'Neo-Plasticism', the name by which the doctrine became known in France and the English-speaking countries), must use the simplest elements: horizontal and vertical lines, plus the three primary colours and black and white. Largely in order to propagate this discovery, which indeed led him to produce some perfect pictures, he joined forces in 1917 with the younger and more verbally articulate Theo Van Doesburg to publish the monthly magazine *De Stijl*.

By the end of the war Mondrian's statement 'De Nieuwe Beelding in de Schilderkunst' had appeared

A model of economy: Stravinsky's *L'Histoire du soldat*. Drawing by René Auberjonois from the single Lausanne performance of September 1918

there in twelve instalments, as had Severini's 'La Peinture d'Avant-garde' in six. However, although both essays were to influence L'Effort Moderne and its friends they were scarcely as important as J. J. P. Oud's much shorter article on 'Art and Machine'. For, for one thing, Oud was a practising architect at a time when Holland was one of the few countries actually building – in 1918 he became city architect of Rotterdam; for another it was in architecture and design rather than painting that *De Stijl* became most influential; and for a third he was a good deal more clear-headed than his colleagues, Van Doesburg included. Arguing that Ruskin and Morris had been wrong in their attitude to industrialism, he saw presciently that there were two trends involved in the effort to attain that collective *stijl* or style for which Van Doesburg was calling:

a *technical-industrial* trend, which might be termed positive and which seeks to give aesthetic form to the products of technology:
a second comparatively negative trend (though its mode of expression is just as positive) by which art tries to achieve objectivity [*Sachlichkeit*] by means of *reduction* (abstraction).
The essence of the new style lies in the unity of both trends.

This rapidly-developing scientific and industrial technology, which is no doubt what Arp meant by

'Americanism' and which certainly formed part of Léger's changed vision, was not yet being interpreted quite so acutely anywhere else. But already it was making itself felt, if only by changing the equipment and the media available to the creative artist. The cinema, most importantly, was now a practicable new art form; thus in 1917 Alfred Hugenberg in Germany formed Universum Film, or UFA, and Marcus Loew in America the nucleus of MGM; far off in California Hollywood was already establishing itself as the main U.S. film centre. Whereas in 1914 a group of German writers had treated the medium in a speculative, science-fiction spirit, producing a *Kinobuch* published by Kurt Wolff which outlined some often brilliant variants on the mechanically filmed stage dramas of the early movies, by the end of the war the possibilities were actually open, and in Charlie Chaplin, or Charlot, as he was known in France, the rest of Europe already recognized an artist who would dominate not only the cinema but the age. 'Charlot', wrote Cendrars, who was one of the first of the avant-garde to come under Chaplin's spell, 'was born at the Front' – in other words, through his impact on the troops – and again, 'The Germans lost the war because they didn't get to know Charlot in time.'

If the wartime development of radio had by contrast been fairly universal, though still confined to the transmission of messages, it was also true that the impact of jazz, like that of Chaplin, was mainly on one side of the lines. Among the first bands making records for the U.S. Victor company in 1917 was the Original Dixieland Band, who had come to Chicago that year; within a matter of months Cocteau was asking Gleizes in New York for examples of 'Negro ragtimes' while Ansermet, the conductor of *L'Histoire du soldat*, was bringing back similar (if still unidentified) music for Stravinsky. With the American forces in 1917 came the first black jazz musicians, some of whom played at one of Etienne de Beaumont's parties in August 1918. So far the possibilities offered by these great changes in the artistic framework could be appreciated only by a very small minority. And before they could lead much further there was the effect of one or two much greater social upheavals to digest.

Westentasche eine Okarina, setzt sich auf den Bürgersteig und spielt. Sein Auge wird klar. Seine Stirn hoch und ernst.
Die Straße ganz leer. Plötzlich erscheint im Hintergrund ein einzelner harmloser Polizist. Chaplin, aufblickend, bekommt Angst, wirft die Flöte weg und läuft, so schnell er kann, davon: Man sieht ihn, bis ihn die Perspektive verschluckt.

V.

Chaplin ergeht sich in dunklem Wald. Hohe Tannen. Brombeergestrüpp. Sonnenblumengroße Veilchen. Vögel kreisen um sein Hütchen. Er hat eine Botanisierbüchse um die Schultern gehängt.

Das Reh trippelt neben ihm, ein rosa Bändchen um den Hals. Chaplin bleibt hier und da stehn und blickt es gerührt an. Dann öffnet er die Botanisierbüchse und nimmt eine Versmaschine heraus. Nachdem er umständlich geträumt hat, tippt er auf einen Birkenstamm (Schrift im Film):

Alle Vögel
dem Frühling entzwitschert,
alle Bäche blond
dem Herzen Gottes entsprungen.
Was ist die Welt: Geliebte?
ich und du
erfanden sie nur!

(Das Reh verwandelt sich in ein junges Mädchen.)

REHA

Genug das Reh gespielt und poetisch getan!
Genug Sentimentalität gemimt!
Vor Sehnsucht wird man nur tuberkulös.

CHAPLIN

Ich glaubte an Träume:
Doch selbst die Nymphen wurden bürgerlich!

Zeichnung von Fernand Léger

Emergence of a mythical figure. Double page from *Die Chaplinade* by the bilingual Iwan Goll, another Swiss resident, with drawings by Léger

66

5 Revolution and the arts: Russia 1917–20, from Proletkult to Vkhutemas

The Bolshevik Revolution and its repercussions: Lunacharsky as Commissar of Enlightenment and his promotion of the avant-garde; roles of Mayakovsky, Kandinsky and others in the new cultural establishment. Tasks for the arts; exhibitions and productions; foundation of the Moscow Vkhutemas school and birth of Constructivism, symbolized in the Tatlin tower. The Proletkult's rise and reduction. Foreign intervention and the creation of the Third International.

'This book is a slice of intensified history – history as I saw it.' Thus John Reed, writing in New York after his return from Russia in 1918. The book was *Ten Days that Shook the World*, which even today remains an astonishingly vivid landmark, conveying the immense surprise and excitement of the Bolshevik revolution as it struck an alert outside observer at the time. It communicates this moreover by a new collage-like technique of documentary reporting that alternates first-hand evidence – speeches, articles, photographically reproduced proclamations with their heavy Cyrillic headings – with brilliant subjectively-charged description. Nothing, perhaps, could better symbolize the double impact of this vast event, which fired the imagination of all those who were most opposed, in one country or another, to the continuation of the war and the rulers associated with it, then introduced them (more gradually) to some inspired new phenomena in the arts. Many people were to change their judgements later, as their attention became focussed on the more brutal aspects of the revolution, or as the Russian artists found it harder to work and some of the new movements ran into the sand. There were also other types of repercussion, both through the emigration of White (or frankly anti-revolutionary) artists and intellectuals and through the political and diplomatic effects of revolutionary rule. But from 1917 to 1921 it was, for the rest of the world, as if an enormous explosion had gone off, followed by a succession of sporadic fireworks of varying sizes, some of them very beautiful and unlike anything ever seen before.

Luck, as much as anything else, had it that an alliance was soon struck between Lenin's new government and the cultural avant-garde. This avant-garde, consisting primarily of the so-called Cubo-Futurists (whose home-grown Futurism owed little to Marinetti), had been very active since 1914: thus Mayakovsky wrote *A Cloud in Trousers* and *Man*, Tatlin made his abstract counter-reliefs, Malevitch renounced Futurism in favour of a strictly non-objective Suprematism, the Opoyaz linguistic circle led by Viktor Shklovsky worked out its theory of Formalism; only Kandinsky seems to have been unsettled and unproductive in his own country. These people did not exactly leap to greet the revolution in November 1917, which they seem to have viewed with misgiving after the bourgeois revolution of the previous February; the Artists' Union formed at that time, for instance, was unwilling to cooperate with the new regime. But the young poet–painter Mayakovsky publicly welcomed it and seems to have carried his Futurist friends with him, while Blok and Meyerhold took part in meetings in its favour. Though this already caused a writer in the government paper *Isvestia* to warn the workers against the risk of such modernists infecting them with 'the putrid poison of the decaying bourgeois organism' it was clear that no one else among the more prominent writers and artists was going to support the proletariat at all.

At the same time it was fortunate that the responsible commissar was somebody with a closer knowledge of the avant-garde and their work than they had any right to expect. This was Anatoly Lunacharsky, who had returned from Switzerland in the second sealed train and who for twelve years was the Soviet Minister for Enlightenment, a term embracing education and the arts. A dramatist of some merit himself, he had known some of the young Russian artists in prewar Paris and had intervened critically in the lecture which Plekhanov gave there in 1912 mocking Cubism and specifically that influential work, Léger's *Femme en bleu*. Lunacharsky was not himself pro-Cubist, to judge from the 'Paris letters' which he wrote for the *Sovremennik*, but he knew such pictures and took pains to understand what the artists were aiming at. His own taste was more for the 'revolutionary romanticism' of Whitman and Verhaeren; and while there was nothing in the visual arts to correspond with this it gave him a capacity for enthusiasm and a wide-ranging curiosity from which the most extreme movements might profit.

In setting up a new administrative structure for the arts, therefore, Lunacharsky had few inhibitions about bringing in the avant-garde, along with the

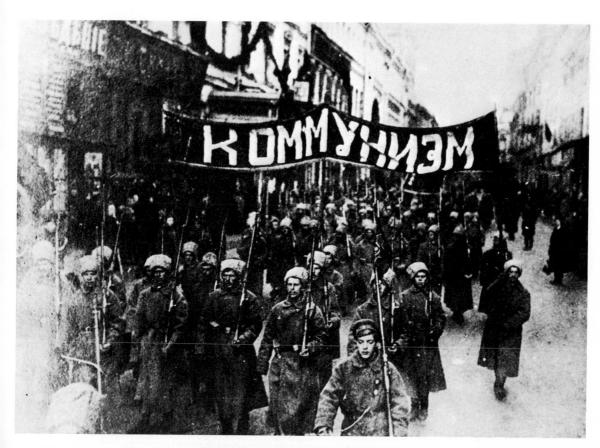

The Russian October Revolution of 1917 and its impact on the arts. *Top*: troops demonstrate in Moscow under the banner of Communism. *Below, left*: Ten days that shook the world. Bolshevik pass issued to John Reed and reproduced in his revolutionary reportage two years later. *Right*: Anatoly Lunacharsky, Lenin's Commissar for Education and the Arts, whose support of the artistic and theatrical avant-garde and later of the new Soviet cinema was crucial

Pass to Smolny Institute, issued by the Military Revolutionary Committee, giving the right of entry at any time.

[Translation]

ary Revolutionary Committee
attached to the
grad Soviet of W. & S. D.
Commandant's office
16th November 1917
No. 955
Smolny Institute

PASS

ven by the present to John Reed, correspondent of the American Socialist
until December 1, the right of free entry into Smolny Institute.
Commandant
Adiutant

wives and sisters of the other Bolshevik leaders – a mixture which perhaps explains the success and survival of his ministry against many odds. This structure began to emerge in the spring following the revolution, though its various sections took time to set up and one of the most influential offshoots, the Institute of Artistic Culture or Inkhuk (for short) was established only in spring 1920. Within the ministry (or commissariat) there was a museum department under Mrs Trotsky and a museum purchasing committee in which Kandinsky, Tatlin and Rodchenko all seem at one time or another to have been involved.

There was a theatre section known as TEO, initially headed by Mrs Kamenev (Trotsky's sister), with Meyerhold in charge of its Petrograd branch until he fell ill in spring 1919. MUZO the music section was under Arthur Lourié, a composer of no great distinction; perhaps it was unfortunate that Lunacharsky made no approach to the young Prokofieff, who had had a remarkable burst of creativity after the February revolution. A small film department was treated as part of education and came under Krupskaya, Lenin's wife, who was Lunacharsky's deputy for a time and thereafter one of the ministry's principal political–ideological supervisors; later it was run by another political figure, Lunacharsky's old friend Dmitri Leshchenko. The art section or IZO was headed by David Shterenberg, a modern but figurative artist whom Lunacharsky had known as a political (Bundist) refugee in Paris: Tatlin was in charge of the Moscow branch, Nathan Altman prominent in Petrograd, where its journal *Iskusstvo Komuny* was edited by Mayakovsky's close friend Osip Brik, a former law student who had worked briefly for the new secret police, the Cheka. Finally LITO, the literary section, was founded at the end of 1919 with a number of distinguished committee members including Gorki, Blok, Bryussov and Vyacheslav Ivanov. However, this had little influence and was a minor affair compared with the formation of Gosizdat, the state publishing house, the previous May.

The problems facing this hopeful, if profoundly untidy outfit were in the first place practical ones. 'Petersburg was sunny', wrote Shklovsky of the early days of *Iskusstvo Komuny*, 'because no smoke rose from the chimneys.' That, in short, was it. Theatres remained largely closed, films could not be made because the raw film was not there, books were not printed and poetry circulated largely by word of mouth. In all such circumstances of crippling shortage what primarily matters is not whether a new symphony gets performed but whether the second trombone has a ration card or not. So first and foremost the people involved in the arts had to be kept alive, and this led to purchases of pictures and sculptures – twelve works by Chagall, for instance, from one exhibition in 1919 – which naturally favoured the avant-garde and led to protests.

Then there was the question of nationalization of the means of production – theatres, film companies and so forth – in which Lunacharsky showed himself extremely cautious, nationalizing the embryo film industry but not the outstanding theatres like the Moscow Art and Tairoff's Kamerny Theatre, which now became 'autonomous state theatres' that the government would finance but not control. There were likewise the existing museums and monuments which had to be preserved not only against the effects

Lenin recording his voice. A photograph taken in the Kremlin on 29 March 1919

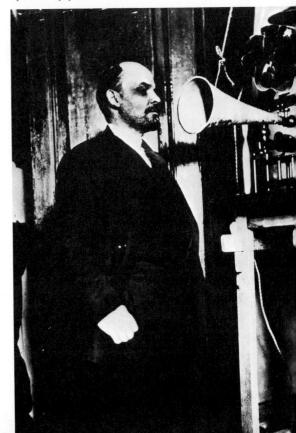

of the revolution and the civil war that followed but also against the enthusiasm of the avant-garde, who argued all too unreflectingly that these relics of bourgeois rule should be swept away. The same thing might apply to other artistic bodies; thus in 1920 Lunacharsky can be found intervening to save the Petrograd (later Leningrad) Philharmonic on the ground that it 'is the only exemplary symphonic institution of the Republic'.

Generally Lenin supported Lunacharsky, though his own personal tastes were a good deal more conservative. He himself was not in any way concerned with aesthetics or artistic trends but only with the political aspect of such things. Accordingly he was very early alert to the possibilities of the cinema, which he saw as an instrument of education, a concept that embraced both political education and industrial training. At some time in the winter of 1918–19 he also proposed what he called 'propaganda by monuments', that is to say the erection in Moscow, of

the new revolutionary capital, of statues commemorating ideas and individuals relating to the revolution; among much uneven work this produced an interesting, if short-lived Cubist memorial to Bakunin by Boris Korolyev and a Lipschitz-like project, 'Fire of Revolution', by Vera Mukhina very unlike her later work. Streets too were decorated, notably by Shterenberg himself, Ivan Puni and Vladimir Lebedev in Petrograd and by the Vesnin brothers and others in Moscow.

'The main reason', commented Ilya Ehrenburg in his memoirs,

> Why the streets of Moscow were decorated by the Suprematists and Cubists was that the academic painters were in opposition (political, not artistic).

In November the first 'agit-train' was sent off by Lenin to proselytize the countryside, gaudily decorated and with a coach showing films; in the summer of 1919 the good ship *Krasnaya Svesda* sailed

Revolutionary art and communication. The 'V.I.Lenin' agit-train, decorated and inscribed 'Soviet Cinematograph' and 'Theatre of the People'

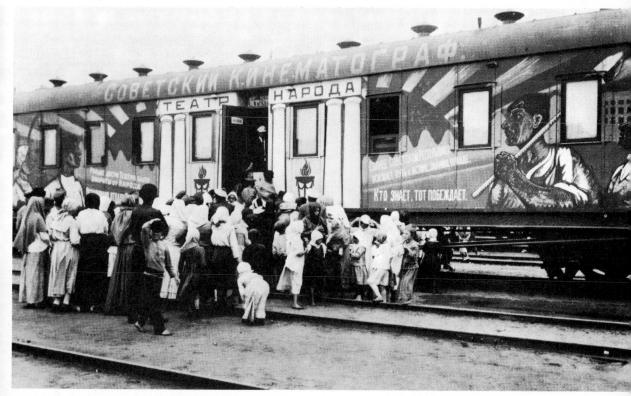

down the Volga under the direction of Krupskaya and a nephew of the composer Scriabine who had taken the revolutionary alias of Molotov. Around the same time the so-called ROSTA windows began appearing in different cities: propaganda window displays with stencilled posters, caricatures and verses, many of them the work of Mayakovsky (1500 in all, according to Shklovsky) and Lebedev.

Though it took time for the rest of Europe to see the results of so much activity, an infectious sense of great cultural upheaval could already be felt abroad. Books were barely appearing – even in 1920 there were only some 2000 titles published, as against 34,000 in 1913, and most of those were political – but the poems of Yesenin, Mayakovsky, Pasternak and Akhmatova circulated in readings and by word-of-mouth. Exhibitions were held, even if the galleries could not be heated: a memorial show of Olga Rosanova's work in December 1918, for instance, then the State Exhibitions of 1919 – the Fifth with abstract work by Kandinsky and others, the Tenth with Rodchenko, Malevitch, Popova and others under the banner of 'non-objective creation and suprematism' – followed next year by the younger Moscow artists banded together as 'Obmokhu'; all of this being far advanced by Western standards, even those of Mondrian or Arp.

In the cinema Lunacharsky's ministry might foolishly lose the best part of a million dollars thanks to an agent called Cibrario who was supposed to be buying film and eequipment for it in the USA, but the first newsreels were meantime being shot by Tissé and edited by Dziga-Vertov. In the theatre there was at first no obvious impact of the revolution, though Tairoff's Kamerny continued to devise exciting productions of a somewhat eclectic repertoire; but outside it the new revolutionary drama was establishing itself, starting with Meyerhold's open-air staging of Mayakovsky's topical, rhetorical pageant *Mystery-Bouffe* for the first anniversary of the revolution, which used Malevitch as scene designer. This mass theatre was carried on in Petrograd by Nikolai Evreinov, who with Altman and Iury Annenkoff staged further pageants including the re-enactment of the storming of the Winter Palace on the third anniversary. About the same time Meyerhold, now appointed head of the theatre section TEO in Moscow, announced a policy of 'October in the theatre', by which it was hoped that the theatres proper and their repertoire would be brought more into line with the new society. Almost the only result

seems to have been his own production of Verhaeren's play *Dawn* that November in a Cubo-Futurist setting. Meyerhold however was not allowed to touch the 'autonomous state theatres', now renamed 'academic', and within six months had resigned from TEO. This did not stop his insistence on the 'abandonment of literature, psychology and representational realism' from remaining widely influential.

Some of the most important developments lay in the field of art education. In 1918 Marc Chagall had been appointed head of the Vitebsk art school in Belorussia, with a staff including El Lissitzky and Malevitch, of whom the latter soon took over the school under the title Unovis, an abbreviation for 'confirmation of the new art'; it had an offshoot in Smolensk under the Pole Władysław Strzemiński and his wife Katarzyna Kobro. That year Alexandra Exter, who like Chagall had experienced the pre-1914 Parisian movements at first hand, was teaching in Kiev, with Tishler and Kozintseva (the future Mrs Ilya Ehrenburg) among her students. In Moscow and Petrograd the Tsarist schools were replaced at first by 'free art studios' (*Svomas*) in which the students, entering without any examination, could choose which teacher they went to, among these being Kandinsky, Pevsner and Tatlin in Moscow, and Altman, Matyushin and Puni in Petrograd. In David Shterenberg's view this quickly proved a failure, and his annual report to the ministry in 1919 proposed that there must be some common basis of teaching; only the staffs had changed, he felt, and the teaching methods remained as haphazard and individualistic as before. From the end of that year the students and the best of the teachers accordingly worked out a more structured curriculum based on a scientific analysis of light and colour and of art forms old and new.

The Moscow studios, which had originated partly in a design school, partly in the main pre-revolutionary school of painting, architecture and sculpture, were re-established by government decree as the Higher State Art–Technical Studio or Vkhutemas, with the task of training artists for the benefit of the national economy. The system now evolved here was for the student to spend his first year in the Basic Section or Workers' Faculty (set up by A. V. Babichev), which had three subsections for graphics, colour and spatial studies; then in his second year he would start devoting two-thirds of his time to his special faculty, after which he would concentrate entirely on this apart from any periods

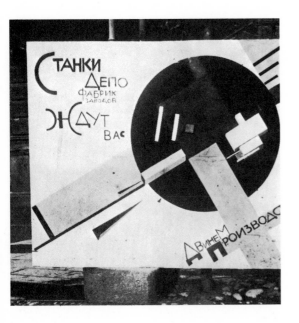

Malevitch's 'Unovis' school at Vitebsk. *Above,* one of their propaganda posters outside a local factory. *Below*, Malevitch himself, centre, with a group of students visiting Moscow

spent in industry. The faculties in question were architecture (where Ladovsky seems to have been the leading professor), sculpture (Lavinsky and Korolyev), graphics (Favorsky), woodwork, textiles, metalwork (Alexander Rodchenko) and finally painting, which was at first under Kandinsky and was subdivided into easel painting, monumental painting and theatre design, this last under Alexander Vesnin. There are said to have been about 1500 students in the entire school.

For some years the Vkhutemas was arguably the most advanced art school in the world, and together with Inkhuk, the ministry's new theoretical institute which was set up at about the same time (spring 1920), it became the cradle of Constructivism. This three-dimensional, sometimes kinetic art, entirely divorced from natural appearances and consciously using space as a medium along with more tangible materials, was worked out partly in debates in Inkhuk and partly in the exercises of the Basic Section whose results could be seen in the Obmokhu (or Young Artists') exhibitions of 1920 and 1921. Though Malevitch in Vitebsk never called himself a Constructivist, even he now put 'the economic principle' above the individual personality, arguing that 'all workshops should be equal, be they painters', tailors' or potters''. 'Three cheers', he said,

> for the overthrow of the old world of art.
> Three cheers for the new world of things.
> Three cheers for the common all-Russian auditorium
> for construction.

Antoine Pevsner, the painter–sculptor who taught in Kandinsky's department of Vkhutemas, wrote a Realistic Manifesto with his brother Gabo, proclaiming the new principles. Lissitzky, who arrived during 1921 from Unovis to teach briefly in the architecture department, showed his 'Prouns' or 'projects concerning the new art'. Tatlin, active mainly in Petrograd, completed the great model for a Monument to the (newly-formed) Third International which IZO had commissioned him to undertake in 1919. This grandest, best known and most utterly unpractical of all Constructivist works was shown in December 1920, when Ehrenburg saw it and

> eventually went out into the street deeply shaken: it seemed to me that I had glimpsed the twenty-first century.

Meanwhile Inkhuk had rejected the scheme of studies drawn up for it by Kandinsky, which proposed

'Proletarian culture'. (1) A troupe of actors off to perform at a factory

investigating the psychological effects of the various coordinates of artistic form, and instead decided to take the autonomous, concrete object as a basis for analysis and practical 'laboratory' work. Kandinsky, being out of sympathy with Constructivism of any sort, resigned from the institute, and a group led by Babichev, Rodchenko and his wife Varvara Stepanova took over. The result of their laboratory work was shown in Moscow in 1921 under the title '5 × 5 = 25'.

This ceaseless quest for new solutions in the arts was neither deliberately inspired by the politicians nor yet restrained by them; it sprang rather from the impact of swift and sweeping social change on creative artists often of a somewhat manic-depressive temperament

but tremendous speculative daring. Though everything was ruthlessly argued and fought over, often in political terms and by men prominent in the Party, neither Lenin, Trotsky nor Bukharin thought it the Party's business to impose an aesthetic line of its own, and within the sphere presided over by Lunacharsky, though loyalty to the new State was essential, Party affiliations were not all that important. Lunacharsky himself had not been a Bolshevik till a few weeks before the revolution, nor was he ever a member of the Central Committee; his real political strength was that Lenin liked and tolerated him. Meyerhold joined the Party in 1918, as did Brik; Rodchenko became a candidate member, Tatlin evidently belonged too. But Mayakovsky was a fellow-traveller for many years, Malevitch was more or less an anarchist,

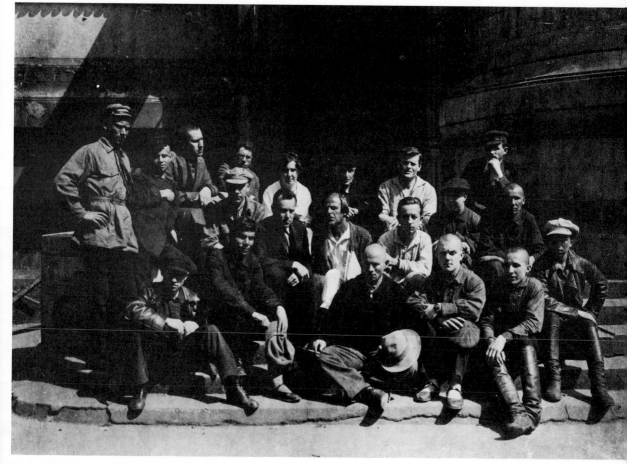

'Proletarian culture'. (2) A Proletkult art class in Moscow (photographs brought back by Huntly Carter)

Shterenberg refused to change political allegiances to suit his official position, while Lissitzky, though devoting himself to agitprop from the outset, wanted Unovis to constitute a party of its own. Others were even less committed.

However, there was at the same time an important arts organization which had originated, like the new Communist Party itself, in the prewar Social-Democratic movement and which aimed for a time to be the Party's cultural counterpart. This was the Proletkult, whose theoretical basis had been laid around the turn of the century partly by Lunacharsky but above all by his brother-in-law Alexander Malinovsky, an old Bolshevik under the name of Bogdanov who served as an army medical officer during the war. Partly conceived as a workers'

educational organization with a strong arts bias, like others founded in Western Europe following the examples of Ruskin and Morris, the Proletkult was also intended to become a third force in the revolutionary state, balancing the political element (the Party) and the industrial element (the trade unions) and ultimately serving to create a new working-class culture to replace that of the bourgeoisie.

It was Bogdanov's concept of 'proletarian culture' that seems to have been uppermost in Lunacharsky's mind at the time of the revolution, for he referred to it in his first ministerial policy statement and immediately beforehand had called a foundation meeting in Petrograd; a Moscow meeting under Bogdanov himself followed. Criticized by Trotsky

and others, but supported by Bukharin as editor of the Party daily *Pravda*, the idea quickly caught the imagination of revolutionary sympathisers abroad, who for a long time saw it as the new Russia's main contribution to the arts. Indeed the Proletkult organization initially flourished, gaining a membership of 300,000 (as claimed by one of its directors in a report of January 1921 in *The Plebs*, an organ to the left of the English Workers Educational Association), starting classes in the various arts, forming factory cells and developing an administration parallel to Lunacharsky's ministry, of which it remained fiercely independent. Early in 1919 it founded its own Proletarian University in Moscow with 450 students.

However, the Central Committee within a few months decided that this should be fused with the Party's proposed Sverdlov University for political training, and ordered that it should be shut down that August; after some delaying action this was done. At the same time Lunacharsky had to resist the Proletkult's largely destructive approach to existing works of art, which was not unlike that of the Cubo-Futurists whom they despised. Krupskaya too was opposed to the Proletkult's total independence, which she thought already in 1918 offered too much opportunity to the enemies of the revolution: 'if you don't work with the Soviets you go and work for Proletkult'. There was perhaps something in this, though the movement could point to revolutionary poems like those of A. K. Gastev, secretary of the Moscow metalworkers' union, who had known Bogdanov in exile and been a follower of Lunacharsky's courses in Paris before 1914:

When the morning factory hooters sound in the
 workers' districts it is no summons to slavery. It
 is the song of the future.
Once we worked in dismal workshops and started
 work at different times of the morning.
But now each morning at eight the hooters call to
 an entire million.
Now we start together at exactly the same minute.
The entire million takes up its hammers at the
 identical second.
Our first hammer-blows resound in unison.
What are the hooters singing of?
– It is a morning hymn to unity.

For Lenin, who anyway saw the workers' first task in a time of shortage as basic organization rather than the practice of art, the idea of any large movement parallel to the Party was intolerable, all the more so since it echoed the kind of utopian humanism for which he had previously attacked Bogdanov and Lunacharsky in his *Materialism and Empiriocriticism*. He told Lunacharsky therefore to make it clear to its first national ('All-Union') conference in October 1920 that the Proletkult would in future have to be subordinate to the ministry, and specifically to a strong Chief Committee for Political Education which would take over from the ministry's own adult education department. When Lunacharsky failed to do this the Politburo ordered the conference to subordinate itself, which it reluctantly did. Thereafter Bogdanov was pushed out of the Proletkult and the ministry itself was reorganized, in a spirit clearly critical of Lunacharsky. All the same the aesthetic ideas of the Proletkult remained autonomous, and in the reshuffle of personalities which followed became a good deal more open to the (essentially non-proletarian) avant-garde.

The amazing thing about all these developments during the first revolutionary years is that they took place not merely under conditions of great physical hardship but in a country invaded by its former allies and torn by a widely-dispersed civil war. Though the revolution had largely sprung from the common people's wish for peace – a peace apparently achieved when Trotsky signed the Treaty of Brest-Litovsk with the German Empire in March 1918 – serious fighting of one sort or another only ended when the invading Poles had been pushed out and General Wrangel had been defeated in the Crimea late in 1920; this left only the Japanese force in the Far East to be dealt with, and one or two other minor foreign incursions. As early as January 1918 therefore a new Red Army was founded, among those who volunteered for it being the student Sergei Eisenstein, the writer Mikhail Zoshchenko and, for part of 1919, Meyerhold; the Futurist poet Sergei Tretiakoff meantime deserted the White forces in the Far East in order to work for the Cheka. Hašek too, who had been part of a Czech Soldiers' and Workers' Council in Kiev, deserted from the Czech Legion when it was put in on the White side in Siberia and went over to the 5th Red Army, where for two years he was a political commissar. Other sympathisers from among the war prisoners and the foreign communities in Russia, including the Hungarian journalist Béla Kun and the Polish–German revolutionary James Reich (known as Thomas), were now formed into national sections of the new Communist Party.

This socialist internationalism, epitomized in the person of Karl Radek (or Sobelson), with his German–Polish–Russian–Jewish affiliations, was frowned on by the German and the Entente governments alike, but was entirely consistent with the spirit of brotherhood bred by the various campaigns against the 1914–18 war. It was also a very important aid for the Bolsheviks in the desperate years now facing them. From their point of view the foundation of the Third International in March 1919 by a congress of like-minded parties was well worth a monument, even though Tatlin's design for its offices was never built and probably far exceeded the technical capacities of the Soviet construction industry. In recognition of the weight now attached to the left wing of the German socialist movement, and at the same time to the one major country not involved in the allied invasions, the proceedings of this first Comintern congress were conducted in German.

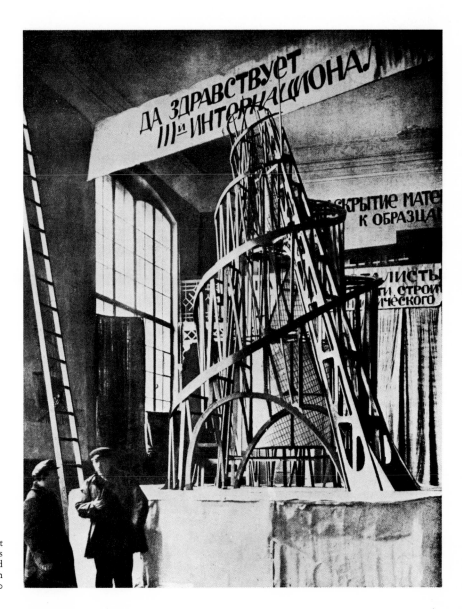

'A glimpse of the twenty-first century'. Tatlin's model of his tower for the Third International, as shown in December 1920

6 Revolution and the arts: Germany 1918–20, from Arbeitsrat to Dada

The German Revolution, its similarities and differences from the Russian. Initial participation of artists and writers. New artists' organizations: the Novembergruppe and the Arbeitsrat. Failure of the Spartacists and the Munich Soviet, leading to reaction and disillusionment; Nationalist violence and Socialist complicity. Parallel events in Hungary, resulting in emigration of Moholy-Nagy and other cultural avant-gardists. The new Socialist-dominated cultural establishment in Prussia and elsewhere: the Berlin Staatstheater and modern art gallery, foundation of the Weimar Bauhaus. Growing opposition of Dada and the Malik-Verlag group; satirical heyday of George Grosz; the Berlin Dada exhibition. New signs in German music, writing and theatre; 'proletarian culture' and first reports from Russia.

The German revolution of November 1918 came almost exactly a year after the Russian and resulted largely from a similar disillusionment with the war, particularly once the prospect of victory had receded. Accordingly for some years the Bolshevik leaders expected it to go through the same stages as their own. But although the Expressionist writers had been even more deeply committed to the anti-war cause than their Russian counterparts, the socialist movement as a whole (including the left-wing USPD as well as the main SPD) was far more domesticated and anxious to restore the old society; moreover its revolutionary wing was comparatively insignificant and its best leaders soon to be killed. Against that the militarist, nationalist machine was a lot stronger and more ruthless than it ever had been in Russia, and would have been harder to dismantle even if there had been any revolutionary politician willing and able to tackle it. Between these two forces, we can now see, there was every likelihood of a terrible disillusionment for those hopeful German intellectuals who had followed *Die Aktion* and the rest of the anti-war press or, like Becher, joined the USPD.

But if the experienced revolutionaries in Moscow were deceived by the outward similarities, who could expect young poets and artists to know better in the climate of release and excitement that followed the armistice? Outwardly the pattern seemed to be repeating itself: the revolutionary sailors, the red flags, the taking over of public buildings, above all the formation of Workers' and Soldiers' Councils, or Soviets. So Zuckmayer, Piscator, the painter Heinrich Vogeler, the art critic Carl Einstein, the doctor–playwright Friedrich Wolf, even for a while the student Bertolt Brecht became soldiers' representatives on these councils; the poet Oskar Kanehl was elected to their executive in Berlin, Toller became deputy chairman of the Central Council in Munich, while Theodor Plievier briefly edited a paper for the sailors at Kiel, printing Lenin's appeal 'To All!'. To conform with the general trend, Kurt Hiller of the Expressionist Neuer Club founded a 'Council of Intellectual Workers' with the playwright Rudolf Leonhard and the middle-aged journalist Arthur Holitscher, which soon however broke up. At *Die Aktion* Pfemfert too formed a short-lived party with Zuckmayer and Hans Siemsen: Franz Jung records an excited, crowded public meeting where everybody had his say, till Pfemfert decided to sum up, telling them that it was for each of them to make the revolution and that it could not be left to the politicians and party officials who were getting ready to move in. At this, says Jung, there was silence:

> The meeting, where a moment before everyone had been shouting at one another, dispersed as if touched by an icy breath, a vision of its own fate . . . they hurried away in all directions, already gripped by panic.

A Novembergruppe of artists, formed under mainly Expressionist leadership, held its first meeting on 3 December. Its object was given as

> bringing together radical artists – painters, sculptors, architects, for the representation and promotion of their artistic interests.

In the guidelines which it adopted, however, it denied wishing to be a mere exhibiting society (which is what it in effect became) and staked a claim to help shape official policy throughout the visual arts, specifically with regard to town planning, art school reform, popularization of the museums and provision of exhibition space. Among its more Cubist–Abstract members were the sculptor Rudolf Belling and the Stuttgart painter Baumeister; Dix and the Karlsruhe artist Rudolf Schlichter led its more socially-critical wing; while Erich Mendelsohn was its leading architect. This body however was not so fertile in new ideas as the architect-dominated Arbeitsrat für

The German November Revolution of 1918. Orderly citizens gather in Berlin.

a great architecture', that this architecture moreover was 'the business of the entire People'. A first exhibition to educate them in this sense was held that April, but confined to entirely utopian projects in view of the cessation of actual building. An exhibition for 'proletarians' in the east end of Berlin followed at the end of the year.

Except in Bavaria the council system virtually ceased to exist after the Rätekongress (Congress of Councils) in Berlin in December 1918, which set up the Constituent Assembly at Weimar, source of the constitution of the new republic and hence of its name. The first Soviet representative in Berlin having been expelled on the eve of the revolution for taking too active a part in planning it, the new Socialist ministers now refused to readmit him; however, the congress invited a Soviet delegation to attend, and although most of its members were turned back by the army, Radek got through. He was an old colleague of Rosa Luxemburg and of Leo Jogiches, who with Karl Liebknecht were leaders of the USPD Spartacist group which now constituted itself the KPD or German Communist Party; among the small number of original members were Grosz, Herzfelde, Heartfield and Piscator. On 5 January the Spartacists found themselves in charge of an unprepared and unpromising Berlin rising, which the SPD minister Gustav Noske could suppress without difficulty by calling in the military. Unhappily a lot of these troops were not the Reichswehr, or army proper, but irregulars (or Freikorps) under extreme reactionary commanders, and on the 15th Liebknecht and Luxemburg were arrested (by unauthorized busybodies) and disgustingly murdered; Radek too was gaoled and Jogiches shortly afterwards killed in prison.

Two months later there were further strikes and riots in Berlin which prompted Noske to authorize the immediate shooting of anyone found bearing a weapon. Among those butchered on this pretext was a perfectly innocuous detachment of thirty revolutionary sailors who had been collecting their pay. 'The shootings continue', wrote Count Kessler laconically in his diary. The unbelievable thing was that the killers in such cases were not judged by revolutionary tribunals, nor even by the ordinary courts, but by courts martial manned and managed by the army. Of the dozen or so Freikorps officers and 'vigilantes' involved in the Liebknecht–Luxemburg murders one was sentenced to four months in gaol,

Kunst (Working Council for Art), which issued its programme at the end of the year as well as a characteristic fraternal appeal 'To All Artists of All Countries', which De Stijl took up and reprinted the following July.

Whether the Arbeitsrat was supposed to have any role in the national structure of councils seems doubtful; that structure indeed was already crumbling when it came on the scene. But Bruno Taut, who at first headed its architectural committee, used it to discuss his utopian projects; Otto Bartning drew up a plan for arts and crafts training which would abolish professorships and restore the old master–apprentice relationship; while Gropius, who became chairman of the whole council in February 1919, argued that 'the arts must be brought together under the wing of

Murdered by the Berlin and Munich counter-revolutions. Woodcuts by the Rhenish artists Angela Hoerle, Seiwert, Abelen and Räderscheidt commemorating (1) Eugen Léviné (3) Rosa Luxemburg –

another to three, another to one, a fourth to six weeks' confinement to quarters, a fifth to a 500-mark fine; only the sole private soldier involved, who had beaten Luxemburg unconscious before she was shot and thrown into the Landwehr canal, was gaoled for two years and dismissed the service. A moving report of the trial by Tucholsky appeared in the weekly *Weltbühne*, an independent journal always sharply critical of the German Right. It remains relevant not only because these things took place under a socialist government (and so explain the growing disillusionment with the revolution) but also because they point the way forward to 1933.

In Bavaria the Socialist prime minister Kurt Eisner, a cultivated man who had made Toller his aide and who contributed to the revolutionary artists' pamphlet *An alle Künstler!*, was assassinated by a right-wing student, a Count von Arco-Valley, on 21 February. Arco too got a light sentence. As in the country as a whole, the Socialists in this beautiful but eccentric southern province had won only a minority of the votes in the first parliamentary elections, but popular feeling after the assassination was so strong that a new Bavarian Socialist government was formed in Munich, backed by the Workers' Councils, who still claimed to be the real source of power. On 7 April this gave way to a Räterepublik or Soviet republic which dispensed altogether with the elected

parliament in favour of a central council chaired by Toller (of which a revolutionary artists' council formed part) and which appointed people's commissars in place of the former ministers. Education came under Gustav Landauer, a scholarly anarchist; economics under Otto Neurath; while a minor post was given to the cabaret poet Erich Mühsam who had known Hugo Ball and contributed to *Revolution*. In the seething confusion that ensued reformers and prophets of all kinds surfaced, notably a mysterious Dr Lipp who became commissar for foreign affairs – on the strength of knowing the Pope, said Toller, though it also appears that he had been in German wartime intelligence – and proved to be mad.

When after a week the deposed government tried to recapture control the KPD, who had at first opposed the Räterepublik on the grounds that it would not be viable, unexpectedly felt itself bound to organize popular resistance. Called in by the deposed Socialist government, Reichswehr troops and, once again, Freikorps irregulars defeated the newly-created Bavarian Red Army, captured the city and took reprisals. Communist leaders like Léviné (a survivor of the Russian 1905 revolution) and the sailor Eglhofer were shot. Landauer was whipped and killed; Mühsam was sentenced to fifteen years' prison, Toller to five, Neurath and the publisher Bachmair (who had brought out *Revolution* in 1913

(4) Karl Liebknecht (5) Gustav Landauer (6) Kurt Eisner. All portrayed in 1919, along with (2) the assassinated French Socialist leader Jean Jaurès

and commanded the Red artillery) to eighteen months each, Frida Rubiner of the KPD propaganda committee to a suspended sentence of twenty-one months; Oskar Maria Graf too of *Freie Strasse* was arrested and released. The wholly apolitical Rainer Maria Rilke twice had his flat searched by troops, just because he was a poet.

Overlapping with the Munich Soviet – in time, that is – and largely inspiring it was the Budapest Soviet of 1919. Here, no further from Munich than the distance from London to Edinburgh, Béla Kun the ex-prisoner from Moscow had united the Socialists and Communists that March and taken power bloodlessly from the Hungarian Republic which had followed the fall of the Hapsburgs in November 1918. Once again, a system of Soviets was created, but here the regime was more radical, nationalizing (though never actually distributing) farm land and organizing revolutionary tribunals. The philosopher Georg Lukács, who had spent part of the war years in Heidelberg and wrote most of his works in German, was deputy commissar for education, taking over as commissar in June; the writer Béla Balázs and the playwright Gyula Hay, then aged nineteen, were among those working under him. Publishing firms and theatres were nationalized; May Day was celebrated with public poetry readings and Cubist–Expressionist street

A poet accused of high treason. The Munich police 'Wanted' notice for Ernst Toller, 15 May 1919

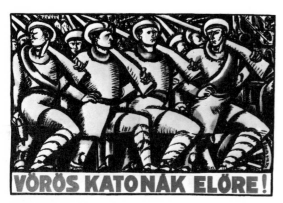

'Forward, Red Soldiers!' A Hungarian revolutionary poster of 1919
by Béla Uitz

decorations; a 'Proletarian' art course was started,
but as in Russia no aesthetic line was imposed. Even
to the hard-headed Lenin it now appeared that the
world revolution was on the way, and he foretold 'the
victory of the international Soviet republic' by mid-
1920.

However, no physical link could be established
between Hungary and Bavaria, since the Austrian
workers' councils were dissuaded from rising by their
more sceptical socialist leaders, nor was the strong
Czech socialist movement – one of the few outside
Russia whose majority was communist – inclined to
do anything that might help the Hungarian Red
Army seize Slovakia. Meanwhile the Rumanians
invaded in the east and installed a counter-
revolutionary administration under Admiral Horthy
in Szeged, with French support. A policy of Red
Terror was adopted as a defensive measure, but its
effects were certainly later exaggerated. Once the
Rumanians entered Budapest in August this could be
taken as the justification for a much more extensive
and efficient White Terror which caused a wholesale
emigration of left sympathisers, including the leading
contributors to the review *Ma*, which under Lajos
Kassák's editorship had been the Hungarian counter-
part to *Die Aktion*. It was not only Kun, Lukács and
the economist Eugen Varga therefore who now
escaped to Vienna, but also writers like Balázs,
Sándor Barta, Béla Illés, Alfréd Kemény and Andor
Gábor, together with such painters as Kassák
himself, Moholy-Nagy and Sándor Bortnyik. Several
of these people were soon to play a role in Germany,
though Bortnyik and Kassák later returned.

Three successive defeats may not have been enough
to disillusion the Soviet leaders, who had just set up
the Comintern and were as yet in no position
seriously to promote a world revolution. But
between them they transformed the whole outlook of
a great many German artists, writers and in-
tellectuals, who could now see that nationalism and
militarism were a lot stronger than they had thought,
the counter-revolution bloodier, the majority soci-
alists less idealistic, the trained Marxists less clearsigh-
ted and their own wartime hopes correspondingly
more futile. The ensuing disillusionment was largely
to undermine the kind of art and poetry most closely
identified with those hopes, in other words Ex-
pressionism and in particular its Activist, utopian
wing. Yet this occurred just at the moment when
Expressionism, from being a series of individual
outcries, had developed into a powerful movement
able at last to penetrate the cultural establishment: the
private theatres, the publishing houses, the cinema
and the whole official art structure. Ironic as it may
seem, the new administrative pattern in the arts was
worked out at a time when the individual impetus of
the movement was already starting to flag. And so to
the younger generation it was now suspect in a way
that Lunacharsky's Russian establishment was not.

Certainly this new pattern was a predominantly
socialist one, notably where Berlin and the greater
part of Germany (including Kassel and the Rhine-
land) were concerned. For culture and education
were a *Land* rather than a State responsibility, and in
Prussia, which was by far the largest *Land*, the
government remained in SPD hands right through
the 1920s. Unfortunately the SPD had no Luna-
charsky, and instead the minister in charge was a
pompous ex-teacher called Konrad Haenisch whose
statement of policy (on 3 February 1919) dealt mainly
with educational questions and the need for more
'German personalities' at a time when 'Czechist,
Polish, Russian-Bolshevik hordes' were hastening to
tear the flesh from the Fatherland's twitching body.
Under him and his state secretary Carl Heinrich
Becker music was looked after by Leo Kestenberg, a
versatile man of socialist convictions who had
worked in publishing and been pupil and secretary to
Ferruccio Busoni, whom he now induced to take
over Richard Strauss's old master class at the
Academy. At the State Opera Max von Schillings was
elected Intendant by the staff, evidently against
Kestenberg's wishes. In the theatre, which was the
responsibility of an ex-lawyer called Ludwig Seelig,

Leopold Jessner, another Socialist, was appointed to the State (formerly Court) Theatre, where he became the outstanding Expressionist director, known particularly for his use of great flights of steps. Art came under an official called Nantwig, with the art historian Wilhelm Waetzold as his adviser. Ludwig Justi, an imperial appointee whom Kessler termed 'loyal to the revolution', remained at the National Gallery, where the Kronprinzenpalais was opened that autumn as a gallery for modern art. The new gallery was headed by the Arbeitsrat member Walter Kaesbach who (again according to Kessler) intended Expressionism to predominate.

Walter Gropius, who had been expecting to take over the Applied Art School at Weimar in accordance with Van de Velde's recommendation, now got authority from the new Socialist coalition in Thuringia to rename it 'State Bauhaus', following the Arbeitsrat principle of the subordination of all art to 'der Bau', or building. As with the Moscow Vkhutemas (whose relation to Inkhuk somewhat parallels that of the Bauhaus to the Arbeitsrat) it was decided that the Applied Art School and the Art School proper should be fused, and in the spring of 1919 Gropius made his first appointments: Lyonel Feininger the Cubist–Expressionist painter and Gerhard Marcks the neo-classical sculptor, both of them Arbeitsrat members. The third new 'master', as the Bauhaus professors were to be called, was the Austrian Johannes Itten, who came on the strong recom-

Hungarian exiles at the Bauhaus, 1922. Sándor Bortnyik's painting of the architect Fred Forbat and his wife; now lost

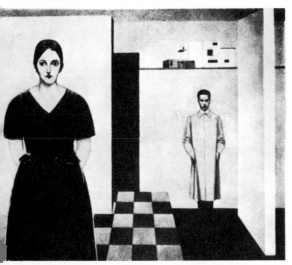

mendation of Gropius's then wife, the former Mrs Gustav Mahler, a romantic–mystical *grande dame* accustomed to moving among geniuses. The prospectus issued that April bore on its cover Feininger's utopian wood-engraving of 'The Cathedral of Socialism', a star-surmounted gothic church against a splintery background. Under this symbol, itself reminiscent of the mystic–architectural fantasies of Taut, Gropius proclaimed the supremacy of 'der Bau' (as exemplified in the new secular 'cathedral'), and insisted that the relevant arts could be learnt only in the workshop; 'Architects, sculptors, painters, we must all go back to the crafts!'

This emphasis on handicrafts was part hangover from the old Grand-Ducal policy, part mediaeval guild romanticism. But Gropius now also presented it as a method of overcoming the 'arrogant class distinction' that sought to put a barrier between artist and craftsman. He promised further, as logically he had to, that a department for architecture ('Baukunst' or 'building-art' rather than 'Architektur' was the word used) would be grafted on to the new combined school: something that was not in fact to be fulfilled for several years. From the first he put each craft department – weaving, pottery, bookbinding, carpentry, followed by metalwork, mural painting and stage design – under two teachers: a technical instructor and a 'teacher of form', i.e. an artist. The artists in question included several associated in the public mind with Expressionism: Feininger, Klee (from 1920), Lothar Schreyer of the *Sturm* circle, later Kandinsky, with whom Gropius was even then in correspondence.

Already at the end of 1919 local nationalists were accusing the Bauhaus of promoting 'Spartacist-Jewish tendencies' and favouring Jews and foreigners at the expense of true Germans. True, Feininger was an American by birth, Klee a Swiss and Itten an Austrian, while among the students were the Hungarians Farkas Molnár, Marcel Breuer and Fred Forbat, of whom the last-named had just been deported by the Bavarian government. What seemed even clearer at that time was the school's left-wing, almost revolutionary political orientation. 'Since we now have no culture whatever', wrote Gropius in answer to a questionnaire in 1919,

merely a civilization, I am convinced that for all its evil concomitants Bolshevism is probably the only way of creating the preconditions for a new culture in the foreseeable future.

– and again, in an article for the *Deutsche Revo-lutionsalmanach*: 'The intellectual bourgeois . . . has proved himself unfit to be the bearer of a German culture. New, intellectually undeveloped levels of our people are rising from the depths. They are our chief hope.'

In March 1920 the so-called Kapp Putsch against the new Republic provoked the school to its most partisan stance. This seizure of power by the Freikorps and their friends, which actually forced the government to leave Berlin for a few days, was frustrated by a nation-wide general strike combined with an obstructive attitude on the part of the civil service and, in Thuringia and the Ruhr, armed working-class resistance. In Weimar nine workers were killed in the fighting, and the Bauhaus turned out in force for their burial, for which the students painted slogans and banners of a 'Left radical' nature. Gropius himself seems to have been restrained from taking part by Mrs Mahler, and certainly he criticized the students for compromising the school, having

Gropius's monument to the Weimar workers killed in March 1920. A Bauhaus leaflet of May 1922

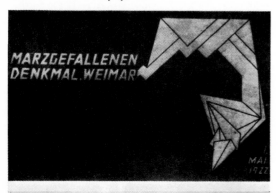

already learnt how damaging such gestures can be. None the less he accepted the local Trades Council's commission to design a monument to the nine, and this action, while applauded by the Left, met with less opposition than might have been expected. One reason perhaps was that in the administrative reorganization following the putsch the Art School, with its disgruntled staff, was given its independence, thus removing a major source of internal dissension.

To the aggressive group around Herzfelde's Malik-Verlag this whole new establishment already seemed misdirected, and there were various ex-Expressionists for whom the Dada alternative had begun to have an attraction. Dada however meant different things according to how and where one made contact with it; thus of Ernst, Dix and Schwitters, who all stopped painting expressionisti-cally in 1919 and were looking for a fresh approach, only Dix followed the Berlin group, Ernst in Cologne linking up with Zurich while Schwitters in Hanover, spurned by the Berliners, had to devise his own private Dada movement (which he termed *Merz* after a collage of that year) using some of the ideas of Futurism filtered through the *Sturm* gallery where he showed. As for the Malik writers and artists, they were already going in two main directions – even discounting Johannes R. Becher who, after joining the KPD at the outset like Grosz and his friends, kept away from all disturbances and pursued a neo-classicism not uninfluenced by Stefan George. One direction was that of the Dada movement proper, which continued well into 1920 with manifestations based on the accepted formula of nonsense poetry and insults to the audience, enlivened now by the more serious antics of a lunatic called Baader, whom Huelsenbeck later described as 'a mixture of Anabap-tist and circus owner'; under Hausmann's editorship a magazine *Der Dada* also appeared.

Herzfelde, Heartfield and Grosz however, while willing to publish and up to a point to contribute to *Der Dada* and similar publications, had come to view the bourgeoisie no longer primarily by aesthetic standards, as contemptible philistines, but in political terms, as the killers of Liebknecht and Luxemburg, likewise of Léviné, a personal friend. Dissatisfied with *Die Aktion* because of its idealist and Ex-pressionist associations, they founded a succession of short-lived political–satirical journals (*Jedermann sein eigner Fussball* in February, followed by the six issues of *Die Pleite* till January 1920, thereafter to be absorbed in the monthly *Der Gegner*). Kessler, who

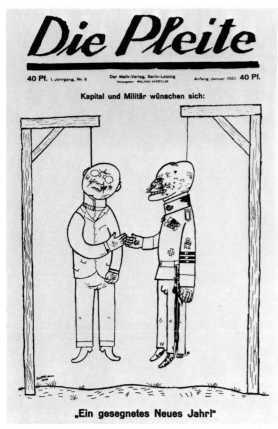

Die Pleite

40 Pf. 1. Jahrgang, Nr. 6 Der Malik-Verlag, Berlin-Leipzig Anfang Januar 1920 40 Pf.
Herausgeber WIELAND HERZFELDE

Kapital und Militär wünschen sich:

„Ein gesegnetes Neues Jahr!"

Grosz versus the counter-revolution. 'Capitalism and the military exchange wishes for a Blessed New Year.' From Herzfelde's *Die Pleite*, January 1920

'light' note in his publications, he said. The result was an increasing seriousness in *Die Pleite* and the launching of a 'little revolutionary library' including Zinovieff's short life of Lenin, the Malik-Verlag's first venture into purely political publishing.

Grosz too was now changing. The quasi-childish, graffitic element of scribble in his drawings diminishes, as to some extent does their overlapping simultaneity, till by 1921 many of them are coldly literal, though as critical as ever. Bits of machinery appear in the collages, some of which, like the now vanished 'Dadamerika' of 1919, are joint productions with Heartfield signed 'Grosz–Heartfield mont.', on the analogy of the classical 'pinx'. Who actually invented photomontage, or where the line is to be drawn between it and collage, is not very important: but certainly around this time Hausmann and Hannah Höch were using it too, and it is quite possible that Lissitzky in Russia had independently arrived at a similar technique. The important thing for the future was, rather, the mechanic-like role envisaged for the *monteur*, together with the wide possibilities which the technique itself suggested.

In the same impersonal spirit Grosz signed a number of his 1920 watercolours with a rubber stamp, introducing into them the dummy-like inhumanity of the Italian Metaphysical painters, but now using the word 'constructed' (*konstruiert*) instead of 'mont.'; if this was an echo of Russian Constructivism it was a remarkably quick one. In January 1921 he wrote of these watercolours in *Das Kunstblatt*, the most socially conscious of all Europe's serious art magazines, that

> anybody attempting to evolve a clear, simple style is bound to end up close to Carrà.

Even before Grosz Max Ernst in Cologne can be found close to the Metaphysicals in his first important set of prints, the 'fiat modes, pereat ars' of 1919. But if his eye and his judgement were similar it is not certain whether he had the same reservations about the Italians' bourgeois idealism as Grosz, who went on to explain:

> Man is no longer depicted individually with subtle psychological delineation but as a collectivist, almost mechanical concept. Individual destinies are no longer important.

It is a curious trick of the time that the examples of Tatlin, the Dadaist mechanical fantasies of Picabia (strongly developed in Ernst's monotypes immediately following 'fiat modes') and the neo-classic

visited Grosz's studio on 5 February and saw his painting *Deutschland, ein Wintermärchen* – this being the day when news came of the final defeat of the Spartacist rising in Bremen – noted that

> At bottom Grosz is a Bolshevik in painting. He is nauseated by painting, by the pointlessness of painting up to now.

Instead it was Grosz's aim to be deliberately objective (*gegenständlich*) and moralistic. 'Reactionary and revolutionary', commented Kessler, 'a phenomenon of the times'.

During the March state of siege Herzfelde was arrested. Released after eight days, he went straight to Kessler (who had taken up his case) to describe the brutalities he had witnessed with army officers standing tolerantly by; he could no longer strike a

The 'metaphysical' streak in German Dada. The pictures by Grosz *(left)* and Chirico *(right)* are on facing pages of the *Book of New Artists*, compiled by Kassák and Moholy-Nagy in Vienna in 1922.

Dummies with a social purpose. *War Cripples*, a drypoint of 1920 by Otto Dix, relating to the big painting seen in the Berlin Dada Fair *(overleaf)*, subsequently in the Dresden city gallery and now probably destroyed

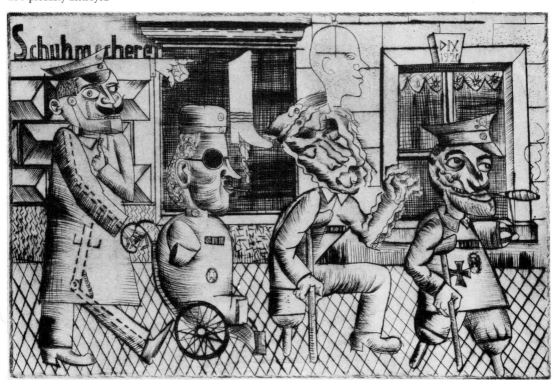

inhumanism of Chirico and Carrà could all converge to promote what Raoul Hausmann in the *Dada Almanach* of 1920 called a 'Return to Objectivity [*Gegenständlichkeit*] in Art'. But this is what was happening at the time of the big Berlin Dada Fair (or Dada-Messe) of June 1920, which brought together the different threads of German Dada, both more and less political, for the first and last time. Of the 175 or so items more than half were provided by the Berlin nucleus, that is Grosz, Hausmann, Heartfield, Hannah Höch, Wieland Herzfelde, Baader and Grosz's brother-in-law Otto Schmalhausen; and among these were Hausmann's photomontage 'Tatlin at home', two 'Tatlinist plans' and a 'Tatlinist mech. construction' by Grosz, also a photograph of Charlie Chaplin, one or two boxing photographs, 'Dadamerika' and a work of 1919 by Grosz and Heartfield called 'Life and activities in Universal City, 12.05 o'clock midday' (from the collection of 'Lämmle, California'). There were three works by Picabia, a few by Arp, some by the Cologne Dadaists Ernst and Baargeld, four by Hans (?Paul) Citroen, an item by Ben Hecht (who had met Grosz when in Berlin as a reporter) and one in memory of the original 'Musikdada', Preiss.

There were also six items by Rudolf Schlichter, who was then working at Karlsruhe, and one by his brother Max, proprietor of a Berlin restaurant subsequently much favoured by Brecht and his friends. Otto Dix from Dresden had two, one of them the 'Butcher's Shop' in which he seems to be echoing the snarling savagery still associated with Grosz. From Magdeburg a W. Stuckenschmidt, described as 'Musikdada II', contributed four works including 'The Impotence of Herr Dr Pfitzner'; this sounds like H. H. Stuckenschmidt, the alleged illegitimate son of the former Crown Prince, who was then a young composer. Floating above the first of the two rooms, attached to the ceiling, was a 'Prussian Archangel', a pig-faced figure in army uniform who can be seen in the surviving photographs, along with Dix's painting of war cripples (which used to be in the Dresden City Gallery), Grosz's *Deutschland, ein Wintermärchen* and the placard saying:

> Art is dead
> Long live the new machine art of
> TATLIN

The one conspicuous absentee from the whole affair was Huelsenbeck, who around May appears to have fallen out with Hausmann and abjured Dada in order to complete his medical studies.

Nobody greeted this show with much enthusiasm. Tucholsky thought the visitors were not all that shocked, and dismissed it as trivial apart from Grosz's anti-militarist graphics. The KPD's daily *Die Rote Fahne* warned the workers against Dada's attacks on the 'cultural heritage', saying that such people had no business to call themselves Communists. To round things off, the police, inspired by Tucholsky's description of Grosz's works, raided the gallery and the Malik-Verlag offices and a few months later prosecuted Grosz and Herzfelde for insulting the armed forces. At the same time the kind of objectivity sought by Grosz and Hausmann was already finding an echo in a slightly more grown-up context. Thus the Berlin cabaret 'Schall und Rauch', an offshoot of

Dummies are 'objective'. A plate from Max Ernst's set of eight Dada lithographs 'fiat modes, pereat ars' of 1919, showing that he too assimilated the example of Chirico and Carrà. This set was financed out of the unemployment relief fund of the Cologne municipality.

Max Reinhardt's new Grosses Schauspielhaus, where Walter Mehring's early songs were performed, used Grosz as designer and occasional performer, while for three years Heartfield was on Reinhardt's design staff at the Deutsches Theater. In 1919 Hausmann had begun showing in the Novembergruppe section of the big Grosse Berliner Kunstausstellung in the Lehrter railway station; Dix and Schlichter were already affiliated to the group, and Grosz, though apparently shunning its exhibitions, seems also to have become a member.

Elsewhere although Expressionism was emerging as the new established school there were already some marked departures from it. Some of these were in the direction of the neo-classicism now becoming predominant in Italy, an influence visible in the fashionable if indeterminate eclecticism of Carl Hofer. The somewhat kindred Derain too, with his Italianate prewar portraits and placid still-lifes, was recommended to German artists by Kahnweiler in

the 1920 *Jahrbuch der Jungen Kunst* as the best model for them in their still isolated situation. Around the same time there does seem to be an element of Grosz-like objectivity in some of the less allegorical pictures being painted in Frankfurt by Max Beckmann: his city views, for instance, from 1919 on, may topple and foreshorten in an Expressionist manner, but they have a plainness of texture and a firmness of outline that is quite new. The neat unassertive German-script signature too, akin to Schlichter's, seems deliberately prosaic: often a telltale sign. Much as these artists would no doubt have disliked the idea of any kind of connection between them, it was possible by the end of 1920 to foresee not only the decline of Expressionism but something of the cooler and more impersonal approach which would generally supersede it.

In the German musical world this trend was as yet barely perceptible, though in Vienna Arnold Schönberg had now started his Verein für Musikalische

The Berlin Dada Fair of June 1920 at the Burchard Gallery. *Left to right*, Raoul Hausmann, Hannah Höch *(sitting)*, Burchard, Baader, Wieland and Margarete Herzfelde *(at back)*, Otto Schmalhausen (Grosz's brother-in-law, *sitting*), Grosz and John Heartfield. On the left, Dix's *War Cripples*; on the end wall, Grosz's *Deutschland, ein Wintermärchen*; floating overhead, the dummy that provoked the subsequent prosecution

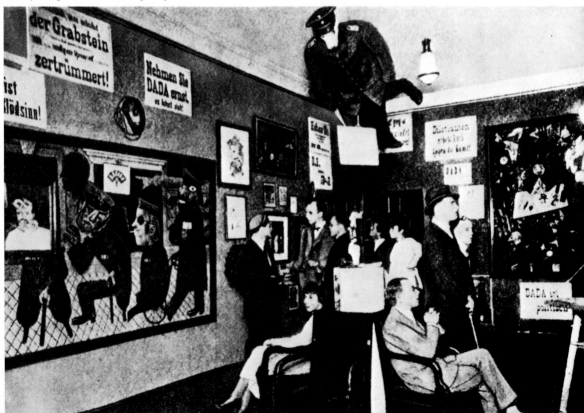

Franz Jung

Die Rote Woche

Roman
mit 9 Zeichnungen
von
George Grosz

Der Malik-Verlag / Berlin

Diese Leute, die auch nur für ihr Brot dienten, hatten sich dazu verkauft, über ihre Mitmenschen herzufallen, wie bissige Hunde.

The Red Week, one of the Malik-Verlag's 'Red Novel Series' of 1921. The caption to Grosz's drawing reads: 'These people, who were likewise serving simply in order to earn their bread, had sold themselves to attack their fellow men like savage dogs.'

Privataufführungen as a private society for the performance of unfamiliar new works. These were by no means confined to the compositions of himself and his followers, but embraced Debussy, Ravel, Reger and Stravinsky (especially his recent pieces); in the spring of 1921 moreover there was a remarkably flippant programme of nineteenth-century Strauss waltzes, arranged and performed by Berg, Webern and other members of the Schönberg circle – an echo perhaps of the Dada spirit. Soon after the war, too, Schönberg acquired two new pupils in Karl Rankl and the recently demobilized Hanns Eisler, who in 1919 became spare-time conductor of a socialist choral society named after Liebknecht (Webern likewise conducted a Workers' Choral Union in the early 1920s). Generally speaking however the musical scene was then still largely dominated by Richard Strauss and Busoni, with Hans Pfitzner in Munich as a more conservative (and strongly nationalist) influence. The young Paul Hindemith was only just beginning to surface as a composer of short operas to Expressionist texts.

Nor was there yet any marked change in German writing other than the development of the light but pointed social criticism of Mehring, Tucholsky and other cabaret writers, such as the ex-sailor Hans Bötticher who now made his first appearances at 'Schall und Rauch' under his stage name of Joachim Ringelnatz. For a while the red hope, as it were, of prose fiction looked like being Franz Jung, who produced the first such stories to be published by the Malik-Verlag, sometimes with illustrations by his friend Grosz. Certainly he was an adventurous and erratic figure, for he became prominent for a while in that dissident half of the communist movement which broke off under the name Communist Workers' Party or KAPD, then hijacked a ship to take him to Russia in the spring of 1920, got the KAPD affiliated to the Third International, returned and was gaoled for piracy, only to be released just in time to help Béla Kun organize the so-called 'March operation' of 1921. This was a somewhat hopeless rising in the Mansfeld area of central Germany commanded by the dashing Max Hölz, perhaps the one really able man of action on the extreme Left. Its prompt suppression by the Reichswehr earned Hölz a life sentence and a national reputation, at the same time giving Jung material for a somewhat perfunctory short novel called *Die Rote Woche* (The Red Week). Unfortunately it was only many years later that Jung's literary gifts began to match the interest of his experiences: nothing in his fiction can compare with

the autobiography which he published forty years later.

During the first years following the Russian revolution there was in Germany a good deal of critical debate about the problems of Proletkult and proletarian art, in which Jung for one was involved. Typically, this theoretical issue, centring as it did on an intriguing new word, interested the critics a good deal more than did the actual nature of Soviet avantgarde art. How, indeed, the Dadaists came by their knowledge of Tatlin is a matter for speculation, since his great Monument had not yet been publicly shown and the only advanced Soviet artist to arrive in Germany during 1920 was, so far as we know, Ivan Puni who had a show at the *Sturm* gallery the next year. However, at some point during 1920 Kiepenheuer (with Hans Goltz of Munich) published Konstantin Umanskij's excellent survey *Neue Kunst in Russland 1914–1919*, which seems to have been the first serious account of the new developments to come out of Russia (Umanskij himself was reputedly involved in arts administration there and later became ambassador to Mexico).

Three Germans also reported on their visits to Russia around this time and went on to become significant figures in the whole development of cultural–political relations between the two countries: Alfons Paquet, the *Frankfurter Zeitung*'s correspondent in the early days of the revolution, Alfons Goldschmidt the economist, editor of an ephemeral *Berlin Rätezeitung*, and finally Arthur Holitscher who was invited to Russia by Radek (then still in Moabit prison), and went there to report for a Swiss-based news agency for whom he wrote, among other things, about the Proletkult, the shortage of artists' materials and the crumbling (by 1921) of the Futurist street decorations.

It was Holitscher, Goldschmidt and Ludwig Rubiner who together founded a Berlin League for Proletarian Culture in the spring of 1919 and later a Proletarian Theatre. Though the latter only staged a single production (of an obscure play called *Freiheit*), its producer Karl Heinz Martin was a figure of some consequence even though his own politically conceived theatre Die Tribüne (with Rudolf Leonhard and the young actor Fritz Kortner) was strongly

'The whole thing is over by nine o'clock.' Rolland's revolutionary play *Danton* at Max Reinhardt's Grosses Schauspielhaus in 1920, the subject of Tucholsky's bitter poem (text, *right*)

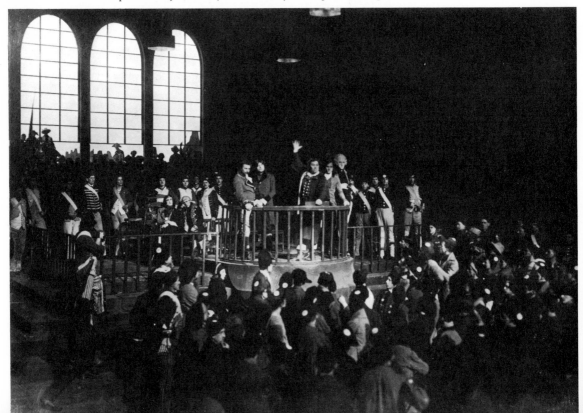

Expressionist. Moreover the enterprise seems to have paved the way for Piscator's much more interesting Proletarian Theatre of the following spring. Here, with an anonymous company performing in various Berlin halls and an audience drawn largely from the two Communist parties, Piscator directed a succession of mainly agitational plays by Jung, Karl Wittfogel and the Hungarian exiles Gábor and Barta; among the designers were Heartfield and (for a play by Upton Sinclair) Moholy-Nagy, who had moved to Berlin from Vienna before January 1921. Heartfield's settings, with his use of maps and inscriptions, contributed a certain documentary element even if the general effect was amateurish. Moholy's work can unfortunately be judged only from a small line drawing in Piscator's book.

Elsewhere in the theatre Expressionism held the stage. This applied even to Reinhardt's spectacular new attempt to create a mass theatre in the Grosses Schauspielhaus, the former circus building which he got Hans Poelzig to adapt for 5000 spectators and opened in November 1919. Though this was a logical development of his prewar stagings of *The Miracle*, in some ways paralleling the new Russian experiments, such rhetorical productions of revolutionary plays could not long hold a growingly sceptical audience, and by 1923 it had declined to a house for operettas. While the critics applauded Reinhardt's magnificent staging of Romain Rolland's *Danton* in February 1920 – for which the Viennese Oskar Strnad created unforgettable stage designs – Kurt Tucholsky left the theatre to sit down and write a poem called 'Danton's Death':

> Act Three was great in Reinhardt's play –
> Six hundred extras milling.
> Listen to what the critics say!
> All Berlin finds it thrilling.
> > But in the whole affair I see
> > A parable, if you ask me.
>
> 'Revolution!' the People howls and cries
> 'Freedom, that's what we're needing!'
> We've needed it for centuries –
> our arteries are bleeding.
> > The stage is shaking. The audience rock.
> > The whole thing is over by nine o'clock.
>
> The day looks grey as I come to.
> Where is that People – remember? –
> that stormed the peaks from down below?
> What happened to November?
> > Silence. All gone. Just that, in fact.
> > An act. An act.

7 Paris postwar: Dada, Les Six, the Swedish Ballet, Le Corbusier

The foreign influx, specially Russian exiles and Americans. Arrival of Dada and its transmutation into a Parisian literary movement; swansong of the Futurists. The Théâtre des Champs-Elysées as a centre; the new Swedish Ballet; Cocteau, popular influences and the music of 'Les Six'. Chauvinist aspects of the 'recall to order' in art and music. Neo-classicism, Léger and technology, the latter-day Cubism of L'Effort Moderne. The Purism of Ozenfant and Le Corbusier; their engineering backgrounds and the emergence of their magazine *L'Esprit Nouveau* as an international force, spreading Le Corbusier's technologically-based aesthetic throughout Europe.

But in France after the armistice there was neither a November nor an October, and no social upheaval took place. There, so Georges Ribemont-Dessaignes was to recall in his memoirs, 'a pre-revolutionary fever was quite visibly seething, but it aborted. Society life went on'. Though nineteenth-century Paris was the city which first identified the political with the artistic 'avant-garde' (coining the term indeed) and treated 'bourgeois' as an aesthetic rather than a purely social category, such revolution as there now was took place only within the arts.

Exciting as the climate at first seemed, it was very different from that in Berlin, because there was nothing to cause the same wounds and the same embitterment. Part of the excitement on the contrary was that so many foreigners now settled in France, whether to get away from revolution elsewhere or to recover from the isolation and pressures of wartime. Thus the Diaghileff Ballet came to base itself on Monte Carlo, with Larionov and Goncharova settling in Paris, and Stravinsky in mid-1920 leaving Switzerland for the Paris suburb of Garches. They were followed by Rolf de Maré and the Swedish Ballet trained by Fokine, which made Paris its headquarters. Koussevitzky established himself there on leaving Russia, followed by Prokofieff after his 1919 tour of the United States, while the Pitoëffs now began working in Paris as well as in Geneva. Iwan Goll in 1919 became the Paris representative of the Zurich Rhein-Verlag; Rolland too returned to France that spring and was involved in a Declaration

The Dada spirit infects Paris. Summer 1921: the Swedish Ballet visit the location of *Les Mariés de la Tour Eiffel*, an entertainment by 'Les Six' and Jean Cocteau, here seen seated, with paper. To his right is Rolf de Maré, clean shaven, with stick.

of the Independence of the Mind (as was Goll) and the foundation of Barbusse's *Clarté* movement. Both of these arose from the opposition to the war.

A great many other Russians arrived as refugees – various less eminent musicians and dancers, also the Futurist poet Ilya Zdanievitch (or Iliazd) and the painter Serge Charchoune; other artists were to come slightly later, by which time the concept of an all-embracing Ecole de Paris was there to accommodate them. Finally, as a quite new element, there were the Americans who had been attracted partly by the exchange rate and partly as a result of their army experience. Yet if all this made for a considerable ferment in the first years after the war the structure of artistic patronage was not substantially altered; the

movement for popular diffusion of the arts was actually less influential than it had been a generation earlier, and there was no logical reason why anybody should start either addressing his work to a new public or assailing the old one.

This was the weakness of Paris Dada: it was based on a contempt for bourgeois taste but not on any real opposition to bourgeois society. The makings of some such movement had already been there before the armistice, in the shape partly of the wartime work of Francis Picabia and Marcel Duchamp (who were essentially Parisians even if they had spent those years in New York) and partly of the younger followers of Apollinaire, who had himself died in 1918 in the same

influenza epidemic as halted performances of *L'Histoire du soldat*. Then orientated largely towards Paul Valéry and the *Nouvelle Revue Française*, in other words to the most distinguished high bourgeois avant-garde, their leaders were Breton, Aragon and Philippe Soupault, young men already of a certain *prestance*.

In March 1919 these three launched a similar review called, indicatively, *Littérature*; a month later Jean Paulhan introduced them to the fourth of the team, the poet Paul-Eugène Grindel who took the name Paul Eluard. From Zurich Tzara had by then sent his first peacetime issue of *Dada*, number 3, containing his own Dada manifesto which he had read during the Tzara evening the previous July; this made a great impression. His next issue in May 1919 accordingly came out in two editions, French and German, the French one (called *Anthologie Dada*) being printed in Paris and including for the first time poems by Breton and his three friends, with others by Reverdy, Ribemont-Dessaignes and Jean Cocteau, who contributed '3 Pièces faciles pour petites mains', these being the three poems later known as 'Co-cardes' which contained lines such as

> Poster crime in colour Mechanical piano
> Nick Carter that's pretty

and

> Cinema latest muse.

By now Tzara, tiring of Zurich, was not only in correspondence with all these people but had at last met Picabia. This wealthy Cuban who moved in chic Paris society had come to French Switzerland to see a neurologist early in 1918 and remained there for over a year. He did not as yet know Breton and his group, and in the absence of Duchamp (still in New York) the one Paris artist/writer he respected was Ribemont-Dessaignes. But Tzara and Arp were impressed both with his poems and with the very original nonsense–mechanical fantasies which he was then painting, and the former was keen to join forces with him. Though Picabia did not much care for *Littérature* he thereafter agreed to contribute to that magazine, so that by January 1920 when Tzara arrived to stay with him in Paris all three elements of the last Dada movement were ready to go into action: first and foremost Breton's group; then Ribemont-Dessaignes and Mrs Picabia's pianist cousin, with Picabia lurking in the background; finally the dynamic animator from Zurich with a monocle in his eye and nearly four years of combat experience behind him.

Dada in Germany was then almost over – it had six months to go before the Berlin Dada-Messe – Dada in Switzerland only faintly twitching. So what was the target now to be? Ribemont-Dessaignes (the only one of these people who could look back later with something of the devastating scepticism of the Germans) poses this question and is not really sure; he recalls their sense of collective intoxication and feels that its focus may have been 'at the heart of culture to show the end of an intellectual conception, the collapse of the Absolute'. If nothing else, the Dadaists could feel this to have

> served bourgeois thought as a funeral announcement of its own decrepitude. Henceforward it would realize that no affirmation, construction or hope could be anything but provisional, on parole; that it itself was under suspended sentence of death.

From the first series of manifestations that spring to the eventual breakup of the movement it was evident that French Dada's component parts were tugging different ways, and there would be problems as soon as the first intoxication of insulting an audience wore off. Breton and Soupault already were more interested in automatic writing and the mysteries not merely of the imagination but of the unconscious and the occult; the former had an inbuilt sense of his own value which could only be shed under the influence of extreme anger; while the 'bourgeois thought' he most wanted to demolish was that which had most influenced him (and Aragon too), the highly literate nationalism of the near-Fascist deputy and academician Maurice Barrès. Though more flippant, and to that extent more Dada, Picabia's destructiveness, unlike that of Ribemont-Dessaignes, had from the first an element of condescension; he was not really implicated, and after a year (in which he had two one-man shows) he formally broke with the movement.

This left Tzara, who at first seems simply to have gone along with the others without any very clear idea of what, if anything, he himself wanted to attack in this city which had been his literary goal. Already he allowed the *Littérature* group to determine who were to be admissible as allies and who not, ruling out first Paul Dermée and then Jean Cocteau, despite the latter's friendship with Picabia and initial interest in the movement (had Cocteau not written 'If you accept the Jazz Band you should also welcome a literature that the intelligence can savour like a cocktail'?). In Paris Tzara was made aware of being a foreigner in a way that he had not been in Switzer-

land; indeed in the French assimilation of Dada, nationalism was from the first a factor long to distort the view taken of it even by its adherents and historians. 'Go back to Zurich!', shouted Florent Fels at the opening manifestation on 23 January 1920, and again in March at the Théâtre de l'Oeuvre there were shouts of 'À Berlin! À Zurich!'.

It was easier for the painters, who did not have to express themselves in French; thus in May 1921 Max Ernst made a lasting impact with his first exhibition in the Dada bookshop Au Sans Pareil; for Breton indeed Ernst was the artist he had been looking for. But apart from him and Arp, with whom in Zurich Tzara still kept closely in touch, there was no effective contact with the German side of the movement, neither with the Berliners nor with Schwitters in Hanover. Tzara himself might in due course become absorbed into French literature, but he had not done so yet, and even he had to be eliminated from Dada before the movement could become a truly Parisian affair.

A centre for much of the most interesting activity at this time was the Théâtre des Champs-Elysées, which had been built before the war by Auguste Perret with Van de Velde as consultant architect, and opened in 1913 as perhaps the finest new theatrical complex in the world. Unlike the Berlin Volksbühne of a year later it had been conceived by Gabriel Astruc for an international public of extremely wealthy patrons – the committee that raised the money was headed by the Queen of the Belgians and included Pierpont Morgan and Otto Kahn – and its first season embraced an opening programme by Pavlova, the premiere of Fauré's opera *Pénélope*, Mussorgsky's *Khovantchina* with Chaliapine, and the historic premiere of *Le Sacre du printemps*. On the eve of the next season the money ran out, and the theatre closed (Jacques-Emile Blanche partly blamed the *Sacre* scandal), to remain empty all through the 1914–18 war. In 1919 an operetta impresario planned to reopen it, but this came to nothing and in 1920 a certain Jacques Wilford took over, presenting a Russian Season that summer with a company late of the St Petersburg Imperial Theatre.

Then in the autumn it was seriously reopened by a fresh management under a tall young newcomer called Jacques Hébertot. The first programmes in the main theatre were given by a new company, the Swedish Ballet organized by the thirty-two-year-old Rolf de Maré, on whose family estate in south Sweden Diaghileff's chief choreographer Michel Fokine had been living. For some years this was their theatre. Diaghileff too used it as an alternative to the

A Dadaist and his patron. Francis Picabia, *left*, with the collector/couturier Jacques Doucet. The picture is his *Cure-dents*, collage, 1920

Paris Opéra, presenting a revival of *Parade* there that December, in addition to *Le Sacre* and *The Three-Cornered Hat*. Russian choirs sang, Koussevitzky's concerts were given there, Loie Fuller danced. On 8 May 1921 The Most Famous American Southern Syncopated Orchestra performed under its conductor W. H. Wellman with a mixed programme ranging from Brahms to Coleridge-Taylor via spirituals to a demonstration of jazz drumming, along with a bunch of soloists seemingly unknown to jazz history.

Under the same roof there was also a smaller theatre called the Comédie des Champs-Elysées, as well as a still smaller studio. At the former Fernand Gémier mounted a few productions including Crommelynck's *Les Amants puérils*, while at the same time trying more or less vainly to establish the first Théâtre National Populaire at the Trocadéro. The Pitoëffs, who were later to take the Comédie over from him, now started alternating their Geneva productions with performances at the Paris Théâtre des Arts; they were also in touch with the Autant-Laras and their 'Laboratoire Art et Action', which gave some important private avant-garde performances right into the 1930s. As for the Studio des Champs-Elysées, it appears to have been empty until Hébertot allowed the Dadaists to hold an exhibition there in the summer of 1921.

In January 1921 Marinetti arrived, apparently on his first postwar visit, somewhat short of new ideas but none the less anxious to re-establish his Parisian reputation. In a lecture at the Théâtre de l'Oeuvre he launched his latest, slightly desperate doctrine of 'Tactilism' ('wear gloves for several days, during which time the brain will force the condensation into your hands of a desire for different tactile sensations'; indeed yes). By now however even Italy had a small Dada movement led by Giulio Evola with the support of A. G. Bragaglia's once Futurist gallery in Rome, and Tzara himself could agree that Marinetti had become old hat. Three days before the lecture the French Dadaists issued a manifesto called *Dada soulève tout* containing some contemptuous remarks about Italy and asserting Dada's superiority to more dogmatic movements; then on the night they booed and barracked from the moment of Marinetti's entrance. In the spring other Dada manifestations followed, including the rather solemn mock-trial of Barrès which was conducted by Breton and bored Picabia into walking out, this being his final break with the movement.

Then in June Hébertot gave the Studio des Champs-Elysées over to them for their 'Salon Dada' which for the first time showed work by the American Man Ray, some of the Italian Dadaists, the Germans Ernst, Baargeld and Mehring (now living in Paris), likewise by Arp, as well as by all the French Dada writers except Breton. During this show the main theatre was occupied for three evenings by Marinetti and the Russolo brothers with a concert of Futurist Noise-Makers. Despite the intriguing names given to their machines ('Hululeurs, Grondeurs, Croasseurs, Glouglouleurs' and the like), these appear to have been used only to punctuate more conventional music, and the Dadaists again chose to interrupt. Asking if Paris had turned 'reactionary', Marinetti thereupon taxed them with insulting a trepanned war hero (one of the Russolos), after which a spectator who recognized Ribemont-Dessaignes shouted to ask just what had he done in the war. 'Avoided getting clobbered for shits like you' was the smart answer. Tzara and he were thrown out, and the Salon Dada shut down; a day later they took their revenge on the theatre by booing the Swedish Ballet's performance of *Les Mariés de la Tour Eiffel*, Jean Cocteau's most nearly Dadaist work.

Cocteau, with his success, his chic, his homosexuality and his tendency to identify flair with art, was a *bête noire* of Breton's. None the less he was at this time, for better or worse, part of a movement of more consequence for central Europe than was Paris Dada. This was the group of young composers which came together after Milhaud's return from Brazil in the winter of 1918 and a few months later was labelled by a critic 'Les Six'. How far these people were actually influenced by Cocteau's *Le Coq et l'arlequin*, with its *Parade*-inspired demand for clear French music, is difficult to say, but it seems likelier that Cocteau was just voicing something that was in the air. From then on, however, he was associated with them, just as they themselves, though already friendly enough with one another, were even closer once they had been tied up and labelled: they started giving recitals together and for two years used to meet every Saturday evening, when they would dine, go to popular fairs or the Cirque Médrano, and finish by making music, which normally included Poulenc's *Cocardes*. Satie, said Milhaud, was their mascot. To Poulenc, who saw the group as widely diverging in most ways, what its members shared was 'a return to melody, counterpoint, precision, simplification'.

So Poulenc claimed to 'want music that is healthy, clear, robust and as openly French as Stravinsky's is Slav'. Honegger, the one symphonic structuralist of the group, was by origin Swiss and perhaps for this reason more accessible to German music; unlike Georges Auric he was not interested in the café-concert type of music recommended by Cocteau. Milhaud on the other hand hated Wagner and loved popular tunes; in the summer of 1920 he heard his first jazz, played by Billy Arnold at the Hammersmith Palais de Danse. He was extremely prolific and appreciated a public scandal (like that of the *Sacre*) as much as any Dadaist, whereas Louis Durey, oldest of the six, was withdrawn and his work seldom performed. Among the characteristics which they shared however was a considerably more up-to-date taste in poetry than their Viennese opposite numbers. So Poulenc at that time set Apollinaire's *Bestiaire*, Auric texts by Cocteau and Radiguet, Honegger poems by Cocteau and Apollinaire as well as *Le Roi David* by his friend René Morax, Milhaud a variety of words, ranging from major texts by Claudel to catalogue descriptions of farm machinery which he set for a singer and seven instruments as a matter-of-fact utilitarian tribute to the land.

When the 'Les Six' article appeared in January 1920 Milhaud had just completed what he called a 'cinéma-fantaisie' (it was conceived as a possible accompaniment for a Chaplin film) based on Brazilian popular melodies. This was *Le Boeuf sur le toit*, itself a title borrowed from a Brazilian song. Cocteau promptly took it up and decided to turn it into a 'spectacle–concert', mimed by the Fratellinis, the three clowns from the Cirque Médrano, and set in an American speakeasy; the players were masked and the story highbrow slapstick. To go with it Satie wrote his *Trois petites pièces montées* for the orchestra of twenty-five, while Poulenc's *Cocardes* and Auric's *Foxtrot à New-York* were also given; in February there were three performances at the Comédie des Champs-Elysées, one of them being largely for the Count de Beaumont's guests. That October the Colonne orchestra under Gabriel Pierné performed Milhaud's second orchestral suite from the incidental music to *Protée*, an absurdist 'farce lyrique' which Claudel had written before the war but which had never been staged, though Gémier in 1916 had a plan to do it in a circus. The suite's polytonality – in other words its clashing ambiguity of key – led to an uproar, as did the following year's performance of the *Cinq Etudes* for piano and orchestra under Vladimir

Heyday of the Théâtre des Champs-Elysées. Jean Cocteau at the megaphone, reading the deadpan text of his *Les Mariés de la Tour Eiffel* in June 1921

Golschmann, which at one point has four fugues going at once in three different keys.

What was truly influential about Milhaud's music however was not its new approach to tonality (for the Viennese were already going much farther and thinking more intensively about this) but the unpretentious scale and level of its concern with popular entertainment. That this involved a certain touch of the Dada spirit could be seen in the stylized flippancies of *Les Mariés de la Tour Eiffel*, for which all six wrote pieces. Here, placed under the (literally) towering shadow of a great engineering masterpiece which was also the main Paris radio transmitter, was a modish but drily written piece of absurdity, mimed

by near-dummies and spoken through megaphones. Unlike Marinetti's noises it was light entertainment for the machine age, of a still uncommercial, experimental kind.

While there was no comparable new movement as yet in the visual arts, there was a somewhat similar appeal to national values. This occurred not only in Italy, where the postwar magazine *Valori Plastici*, with Chirico and Carrà among its contributors, preached the virtues of the classical Italian tradition, but also in the *Nouvelle Revue Française*, whose editor Jacques Rivière in June 1919 sought a new outlet for 'the creative instinct of our race', and thought the solution might be found in a classical renaissance, accordingly appointing as art critic André Lhote, an ex-Cubist of sympathetic views. Two factors were now combining to drive Cubism into increasingly conventional channels: first the impact of the newly reopened Louvre, which had been closed throughout the war, and secondly the fact that so many prewar Cubist masterpieces remained among Kahnweiler's confiscated pictures and had never been publicly seen. To them can be added Picasso's oscillation between 'crystal cubism' and his new naturalist and neo-classical styles, together with the 'rappel à l'ordre' which Lhote (still in June 1919) thought he could read into Braque's first postwar show; in another vein Matisse too struck observers as notably tamed.

Classicism in Lhote's sense did not mean a direct return to the past, despite the neo-classicism of Picasso and the Italians, or the analogous musical trend exemplified in Prokofieff's *Classical Symphony* and Stravinsky's use of eighteenth-century material in *Pulcinella* (which Diaghileff presented on 15 May 1920 at the Opéra with an eclectic setting by Picasso). Though this kind of revivalism was soon to become increasingly important throughout Europe the traditional values could also be attained and the required 'intelligence' displayed via non-classical channels. To Lhote, as to Kahnweiler in his *Junge Kunst* writings, the main model here was Derain; yet there were much less obvious forms which could be handled with the same supposedly 'French' qualities of precision, logic and taste.

This is what Léger could reasonably be held to be doing by his increasingly masterly control of geometric and machine-like elements to convey the life around him, or what a third ex-Cubist, Mondrian, achieved by manipulating an even more restricted geometric repertoire after his return to Paris in 1919.

The main channel for this modified Cubism was Léonce Rosenberg's gallery L'Effort Moderne, which in some measure filled the gap left by Kahnweiler. As for its philosophy, this was largely formulated by the painter–theoretician Amédée Ozenfant, designer of a remarkable Hispano-Suiza Special for the 1911 Paris Motor Show. Ozenfant, who had married a Russian and was the son of an engineer who had helped pioneer the use of reinforced concrete for building, now teamed up with the unknown young Swiss architect Charles-Edouard Jeanneret, a protégé of the Théâtre des Champs-Elysée's designer, Perret, to write a manifesto called *Après le Cubisme*. Here they lamented Cubism's appeal to the snob public won over by *Parade*, attacked its new prettiness and sought to restore 'une rigueur grave' by applying its principles to a set of scientifically established invariables. Though the Purism which they launched by a joint exhibition in December 1918 was at first not very impressive they too supported L'Effort Moderne. In 1920 Jeanneret met Léger, and the same year adopted the pseudonym Le Corbusier for all his writing.

The principles of Purism were seen to be effective only at the second Purist show, which was held in Paris at Druet's gallery in January 1921. But although the paintings which the two friends exhibited there remain not unworthy to hang alongside the work of, say, Léger or the ex-metaphysical Giorgio Morandi, they nonetheless derive from much the same purely French tradition as Lhote had put forward: a line running right back from Léger and the 'crystal cubists' through Cézanne, late (pneumatic) Renoir, Seurat, the Corot of the figure paintings, Ingres and Poussin as far as Fouquet. Their 'rappel à l'ordre' may have been heard even in distant Moscow, where Boris Ternovetz of the Museum of Modern Western Art later said that Purism had 'great influence', but this term now applied to them by Maurice Raynal still echoed the more limited *Rappel à l'ordre* which Cocteau took as the title for his book of theoretical writings.

However, there was no suggestion of nationalism or classicism about the architectural ideas which Le Corbusier had already begun outlining, and still less about the wider framework which the whole complex was henceforward given in the Ozenfant–Le Corbusier monthly magazine *L'Esprit Nouveau*. For, starting in October 1920, their 'international review', as they named it, not only serialized four of their

Léger

Lukasztógep

Fernand Léger, the acknowledged artist of the machine age. Another page from the Kassák – Moholy-Nagy *Book of New Artists*, 1922, showing his *La Ville* (1919, now in the Philadelphia Museum) compared with a mechanical punch

seminal books on architecture, painting, town planning and interior design, but also made their message part of a broad yet consistent approach to modern life and the arts such as no other movement of the time could match. Aside from the one tradition in painting there was nothing narrow here, no modishness; nothing relevant to the arts was ignored. The basic assumption was that, as the opening statement put it,

> There is a new spirit: it is a spirit of construction and of synthesis, guided by a clear idea.

This, the hopeful, progressive spirit of the postwar age, must be seized and studied in all its manifestations, which would prove to have some unitary principle in common. 'Factories, music halls, laboratories', wrote Le Corbusier's friend Dr Winter in an article actually devoted to sport; 'exhibitions of paintings or motorcars, circuses and cinemas – L'Esprit Nouveau wants to see everything'. And sure enough they did: new machines relating to the arts (like the player-piano), new scientific interpretations of aesthetic factors, new engineering and building techniques, finally the new expansion of the popular arts; it was all grist to their brilliantly laid-out mill. So the cinema was discussed for them by such outstanding critics as Jean Epstein and Louis Delluc, while Elie Faure the aesthetician wrote on Chaplin as

> a poet, not to say a great poet, creator of myths, symbols and ideas, obstetrician to a new world.

The unitary principle behind all this was derived from no national cultural tradition but from the editors' thoughts about engineering. Unlike Marinetti, they were less impressed by the dynamism of the machine than by the logic and economy underlying its often austerely impressive appearance. '*Economy*', they wrote in connection with the second Purist exhibition,

> is the law of natural selection.
> The fact that it is also the great law controlling what we term *mechanical selection* is easily measured.

Economy, efficiency, purity: these are in turn the product of intensely constructive thinking, and for the observer to grasp this kind of disciplined inspiration together with its success provides 'the highest gratification of the human spirit ... the perception of order'. It is in this sense that *L'Esprit Nouveau* represents a return to order – not to a dictated or preordained order rooted in a particular

tradition, but to a process of ordering; and it is in this sense that a house is, in Corbusier's famous phrase, a machine for living in – not something that need look like a machine but a piece of architecture that has to fulfil its task as economically and well as must a machine. Clearly these principles would be valid in any machine civilization, and their lively, always pertinently illustrated formulation was to become influential far beyond the frontiers of France.

Here, for the first time in French postwar history, was a truly supra-national movement, based not only on imaginative technological thinking but also on a positive effort to understand what was going on elsewhere. Where Dada, the new music of 'Les Six' and the orderly development of painting were all tinged with a chauvinism notably lacking in Germany and Russia except among cultural conservatives, the readers of the first issues of *L'Esprit Nouveau* could learn from Puni (now Jean Pougny) about Constructivism or from the bilingual Iwan Goll about how the German Expressionist theatre, with its three great authors Wedekind, Kaiser and Sternheim, its

Purism spreads. Jeanneret (Le Corbusier)'s *Vertical Guitar* from the La Roche collection (Basel Museum) was reproduced in the Russian *Veshch*, 1922.

« L'Aquitania » Cunard Line.
La même esthétique que celle de votre pipe anglaise, de votre meuble de bureau, de votre limousine.

'The same aesthetic as that of your English pipe, your office furniture, your limousine.' An example from *L'Esprit Nouveau* no. 8, later taken into Le Corbusier's *Towards a New Architecture* 1922, English edition 1926). *Below*: Towards the mobile home. Temporary housing devised in the war, and made by the Voisin aircraft firm. From *L'Esprit Nouveau* no. 2

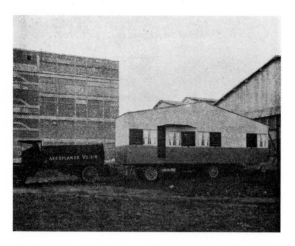

modernist designers and intelligent actors, made that of Paris look antediluvian:

> The German stage is at least fifteen years ahead of the French theatre from every point of view.

True enough, the French theatre throughout this period generally lagged behind. Yet already there were critics like the magazine's own music hall correspondent René Bizet, who could see some hope for it in those same popular elements as 'Les Six' had come to admire. The *littérateur* might despise these, wrote Bizet, but

> They will prove to be the source of all those liberties we cherish, and it will be they that free the art of the drama from its chains. It is through the music hall that the public will be made ready for a new theatre.

Both Goll and Bizet were right, and perhaps this illustrates why *L'Esprit Nouveau* was such a remarkable paper. It took the evidence of the modern world, indigenous and foreign, highbrow and low, artistic and materialistic, and interpreted it in the light of a technologically based aesthetic which could be seen to prove itself by fine, original works of art. Its message was intelligible wherever a similar judgement was at work – in the Bauhaus, at the Vkhutemas, among the contributors to *De Stijl* and a mass of younger people. And so, on the eve of a huge transformation in the whole European cultural scene, its early issues already indicate how a rational and consistent core of the modern movement might be found.

THE TURNING POINT

8 1921–3

The crucial period 1921–3: international relations and development of the media; Lenin and the New Economic Policy; Stresemann and German stabilization; Soviet Constructivism and its spread to Germany; the transformation of the Weimar Bauhaus; developments in German Communist art; emergence of Verism or the new naturalism; new voices in the German and Russian theatres; the first elements of functional architecture; the last fiascos of Paris Dada. The old avant-garde -Isms abandoned in favour of objectivity, utilitarianism and economy.

Politics, radio, cinema

The major political changes in Russia, Italy and Germany. International realignments and freeing of physical movement. Establishment of broadcasting services, new developments in sound recording and the cinema. Landmarks in the arts around 1922.

The recall to order was now to be heard with a vengeance on an altogether different plane. Between the spring of 1921 and the middle of 1924 there was throughout Europe an attempt in various ways to overcome the disorders, tensions and unresolved anomalies of the previous years. Thus in Russia the

A crucial year as seen and heard by a key figure. Hindemith's own drawing for his jazzy 1922 piano suite

New Economic Policy, or NEP as it came to be called, introduced a measure of private trading and profit-conscious public accounting as a means of getting the economy re-established after the end of the Civil War. In Italy the new nationalist, demagogic Fascist movement under Mussolini marched on Rome, took over the government and began a campaign of violence against the Left, whose strikes and political indiscipline were hampering economic recovery. In Germany a final revolutionary attempt by the Communists and a first futile putsch by the new Fascist-type National Socialist Party coincided with the stabilization of the headlong currency inflation by Gustav Stresemann. In all these countries there was a major change, one way or another, of political and economic policy which caused repercussions right through the system, affecting not only the administration of the arts but also the fortunes of publishers, galleries and other cultural middlemen, the interests and ideals of countless individual artists and indirectly the whole climate of the time. On top of this came a general reordering of international relations after the war years: first the Rapallo agreement between Germany and the USSR, then in 1924 the recognition of the latter by Britain and France, finally the Locarno Treaties which marked the normalization of these countries' relations with Stresemann's Germany. Though Italy was a sadly prophetic exception the arts now became much less inhibited by nationalistic hang-ups. Suddenly a great deal of physical movement seemed to take place.

It is as though, in any field involving elaborate preparatory work, it must have taken the same interval of four or five years for the immediate postwar upheavals to lead to fresh conclusions. For, coinciding in time with the politico-economic 'rappel à l'ordre', there were many other new developments affecting the social and technical framework of the arts. Radio, for instance, which had hitherto been treated as a communications medium, whether as part of the postal services or as an instrument of war, now turned into the public broadcasting service for which a far-sighted minority had been pressing: first in the United States, where commercial stations began springing up towards the end of 1921, then in England with 2LO and the establishment of the BBC under Reith in 1922, followed by Germany in October 1923. Linked with this, and equally important where music was concerned, was the improvement in gramophone reproduction: electrical recording began in the early 1920s, and the results were on the market by 1925; the first two-sided (non-electrical) records appeared in 1923. As for the cinema, while Lenin in Moscow was concerning himself with its future in the context of his new policy and the Germans were at last permitted to import the Chaplin shorts, the first truly modern films were beginning to appear: Robert Flaherty's *Nanook of the North* (documentary), Abel Gance's *La Roue* (involving Cendrars, Léger and Honegger) and Chaplin's *A Woman of Paris* (his first independent venture).

Nor can it have been entirely a coincidence that a number of crucial masterpieces in the other arts were completed just at this time, works which had certainly germinated over a number of years: Joyce's *Ulysses*, Kafka's *The Castle*, Eliot's *The Waste Land*, Valéry's *Le Cimetière marin*, Rilke's *Duino Elegies*, Hašek's *Adventures of the Good Soldier Švejk*, Svevo's *The Confessions of Zeno*, Berg's *Wozzeck*. Similar landmarks were Schönberg's *Serenade* op. 24, which inaugurated the dodecaphonic technique, and Picasso's *The Three Musicians* which marked the end of his Cubist period. None of these new classics can be seen as a product of the turning point that took place around 1922-3; far rather they served as signposts and additional factors making for change. More than at any moment since 1910 the arts now seemed to be in the balance, ready to move in a number of ways according to the factors which impinged on them most strongly. Right along the line, from great institutions like the Bauhaus down to the single individual, they were never the same again.

The burgeoning media. *Above*: Lauritz Melchior, the Wagnerian tenor, broadcasting from Chelmsford. *Below*: Chaplin in 1922 directing *A Woman of Paris*, which he did not himself act in

The NEP, International Workers' Aid Rapallo

Impact of Lenin's New Economic Policy on the arts; birth of the Soviet cinema. Russian famine and the establishment of Muenzenberg's International Workers' Aid. Secret agreements and creation of a special relationship between Russia and Germany.

One effect of NEP in the USSR was vastly to reduce the state expenditure on the arts. Printed matter and theatre tickets could no longer be given away free, independent publishing businesses once more sprang up – 300 in Moscow and Petrograd by May 1922, it is said – while a number of theatres had their subsidies withdrawn. So too for a time did the State Publishing House (Gosizdat) together with the film and photographic section of Lunacharsky's Commissariat. In January 1922 the Proletkult likewise lost its subsidy, after which it was forced to abandon its central Moscow theatre to a private entrepreneur. In the course of that year one theatre in three went bankrupt. The 'academic' theatres, including the Bolshoi and the Moscow Art Theatre, remained subsidized; however, in September 1921 Meyerhold was made to close his RSFSR Theatre no. 1 on the grounds of extravagance. When he reopened in the old Sohn Theatre the following year it was with a collective of his students from a new teaching workshop, who seemingly could balance the books only by doing most of the backstage jobs themselves.

In the visual arts the effect of the cuts in patronage was if anything worse, for as Lunacharsky said:

> Who has the money to buy art? Almost nobody but the speculator. That means that so-called free art will go into dependence on the speculator. He is a neo-bourgeois, tasteless, and thirsting to enjoy himself on his newly-won wealth.

It was at this point, when the Constructivists were abandoning the easel picture altogether, that the naturalist painters once again surfaced, with Isaac Brodsky as their most capable representative, to form the AKhRR, or Association of Russian Revolutionary Artists, dedicated to the portrayal of Soviet personalities and themes. Similarly in literature some attempt was made to bring back pre-Revolutionary writers, though the only substantial figure to return from exile appears to have been Alexei Tolstoy.

But if this made for something of a new conservatism Lenin's concern with building a film industry emphatically did not. There were two issues here, the need to re-equip the film and photographic section (which by mid-1921 had a mere 5000 metres of negative film left) and the problem of what to show in the reviving free-enterprise cinemas all over the country. Lenin's view, expressed in a set of directives of January 1922 and elaborated in a talk with Lunacharsky, was that within certain (censorable) limits it did not much matter what the feature films were like so long as enough good propagandist documentaries and newsreels were shown. Accordingly that year, while the NEP cinemas of Moscow showed imported works like *Daughter of Tarzan* and *A Night of Horror in the Menagerie*, Dziga-Vertov's first *Kino-Pravda* magazine films started to appear. With them the documentary movement was born.

In 1922 for the first time no mention was made of the world revolution in the Moscow May Day slogans, but this does not mean that party leaders' hopes of a communist revolution in Germany had yet been laid aside. 'Unless all tokens deceive', said Zinovieff at the Fourth Comintern Congress at the end of the year, 'the path of the proletarian revolution leads from Russia through Germany.' However, while still doing their best to further this cause, the Russians were busy developing their links with Germany in quite other ways, with almost immediate implications for the exchange of ideas in the arts. Thus, to start with, the disastrous harvest of 1921 and the ensuing famine in the Volga basin forced Russia

Animator of the documentary. Lenin composing a speech to the Third Comintern Congress, filmed by Dziga-Vertov in 1921

to accept an unforeseen degree of foreign help via the Red Cross and the American Relief Administration. To offset this politically Lenin called in Willi Muenzenberg, recently appointed head of the Communist Youth International, whom he commissioned to found a new organization of International Workers' Aid. Sponsored by a committee that included Einstein, Bernard Shaw, Alfons Paquet and George Grosz, the IAH (to give it its German abbreviation) set up its headquarters in Berlin and reported not to the KPD but direct to the Comintern, which had also established a Western Secretariat there. Piscator became secretary of its Künstlerhilfe or appeal to artists with the painter Otto Nagel as his aide; in January 1922 and again two years later a number of the Bauhaus painters contributed works to their sales. Jung too, escaping to Russia after the 'March Action', was made Moscow representative and launched a quite unrealistic plan for developing agriculture in the Urals with IAH and other resources. Since propaganda was a fundamental part of the organization's job other artists and writers, such as Käthe Kollwitz and the worker–poet Max Barthel, were immediately drawn in, thereby laying the basis of Muenzenberg's new Soviet–German communications empire, which was to continue growing long after the IAH's original task was finished.

On the heels of the IAH came a plan to form an international committee of intellectuals interested in strengthening relations with the new Russia. During 1922 this took Grosz and the Danish novelist Martin Andersen-Nexö (under haphazard arrangements) to Moscow, where they joined a mixed delegation led by Holitscher which helped pave the way for the foundation of the Society of Friends of the New Russia in Berlin the following June; for Grosz, who met not only Lenin, Radek and Lunacharsky but also Tatlin it seems on more than one ground to have been a somewhat disillusioning experience. Meanwhile at the official governmental level (which was becoming almost schizophrenically detached from that of the Comintern) the Russians at Rapallo had established diplomatic and economic relations with the country against which they bore no grudges and entertained no reparations claims, and which like themselves had suffered from the policies of the English and French. This outwardly natural conjunction had in some measure been prepared by Radek's interviews, when in gaol, with Walter Rathenau, now the German foreign minister, and his partner at the electrical firm AEG, Felix Deutsch. Under the respectable (if to the Entente powers not wholly palatable) surface of this important agreement a much more surprising deal was worked out with the German General Staff – this time with Radek playing a leading part – by which the war factories and military training establishments forbidden to the

The Comintern's man on Germany. The polyglot Karl Radek in the 1920s

Germans under the peace treaties would be jointly set up on Soviet soil for the benefit of the armed forces of both countries.

Altogether then the years 1921–2 saw the creation of no less than five new sets of ties between Germany and Russia, even aside from that existing through the Comintern and the KPD. Given the generally increased willingness in the NEP context to let Russian citizens travel abroad this made almost overnight for more traffic between Moscow and Berlin, and not just because of the diplomatic recognition (which France and England by contrast had failed to grant) but also because enough revolutionary fellow-feeling still prevailed for those citizens not to be all that uneasy about leaving Communist territory. It was what we in our country call a special relationship (as we gaze wistfully across the Atlantic), and it remained one long after the Russians had acknowledged the German revolution to be a dead duck.

German stabilization

Ruhr occupation and the 1923 German economic crisis. Failure of planned Communist risings in Thuringia and Hamburg, also of Hitler's Munich 'beer-cellar putsch'. Currency stabilization by Stresemann backed by American capital; consequent ending of the boom in Expressionist art, theatre etc.

Trusting in their own ability to guide it – and much underestimating the power of the Reichswehr and the ruthlessness of the German Right – the Russian leaders in 1923 saw a revolutionary situation developing and actually set a date for the German revolution, to take place symbolically just six years after their own. Rathenau had been murdered by anti-semitic nationalists on Midsummer Day 1922, and a wave of pro-Republican feeling resulted; the same year the Malik-Verlag published a devastating book by E. J. Gumbel, a statistician friend of Tucholsky's, whose bald summary of *Vier Jahre politischer Mord*, four years of political killings, showed irrefutably how, from the Spartacist rising on, the irregular forces had been given free rein by the courts while left-wingers like Toller and Hölz had been swingeingly punished. In this new climate, where it looked as if the days of the Freikorps might at last be numbered, the occupation of the Ruhr by the French (for non-payment of reparations) drew the whole country together in a remarkable if also ruinous passive resistance. Though the KPD's policy towards its

fellow-parties was at first far from clear – the USPD meanwhile having split and its membership divided between the KPD and the SPD – the Ruhr conflict led Radek to proclaim a new policy of 'national Bolshevism'. This was intended to attract rank and file German nationalists to communism.

By now the slide of the German Mark had begun, carrying it from a rate of 10,000 Marks to the dollar at the start of the occupation to 25,000 in April, 1923, 110,000 in June, 4.6 million in August, and so on down. That month a general strike threw out the government, and although another took its place, led by the conservative Stresemann and with SPD participation, a special meeting of the Soviet Politburo accepted Trotsky's view that revolution was on its way. Advised by Radek on the spot and by the Soviet military experts who had been setting up paramilitary units called 'Red hundreds' since the beginning of the year, the Communists under Heinrich Brandler were supposed to enter the Saxon and Thuringian provincial governments and launch the revolution from there; risings throughout Germany would follow.

In the event, however, Brandler's appeal for a general strike fell flat even among the Communist rank and file; after five years of disillusionment their fighting spirit had gone. The whole operation was called off apart from the Hamburg rising under Ernst Thälmann, which was embarked on because of a misunderstanding and suppressed after two days, among those gaoled being a twenty-two-year-old worker called Willi Bredel. And perhaps coincidentally, certainly ironically, the coup which did take place almost exactly on the prescribed date was that led by Hitler and Ludendorff in Munich, the Nazi 'beer-cellar putsch', which was just as efficiently put down.

So Stresemann began his domination of German politics over the next six years with severe blows to the extremists of both Right and Left. With great courage he called off the passive resistance in the Ruhr, then stabilized the currency: a policy which worked, thanks partly to a change of government in France the following spring but above all to the so-called Dawes Plan for an international loan by which a stable German economy would be enabled to pay adequate reparations and at the same time made attractive to foreign (i.e. mainly American) investment. What this meant in terms of a changed internal climate will be seen in due course. Among its practical results was the deposition of the Thuringian

The inflation of 1923. A wine bottle
and its 1000-Mark label

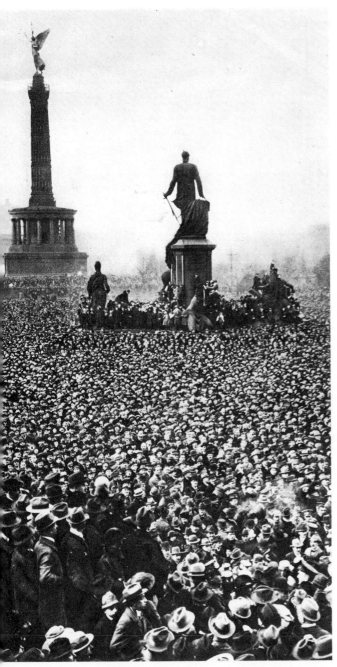

Impact of the Ruhr Occupation. A vast crowd protests in Berlin,
June 1923, beneath the Victory Column of 1870-71.

Leader of one of that year's failed coups: Herr Adolf Hitler, as he
first appeared in the *Illustrated London News*

provincial coalition on which the existence of the Bauhaus depended – Gropius's own flat had been searched in November by the army – while the effects of the currency crisis on the whole apparatus of the arts were not unlike those of NEP in Russia.

This applied particularly to the theatres, for whom 1923 was a disastrous year, forcing a widespread reorganization. In Berlin Piscator's second venture, the would-be popular Central-Theater, collapsed in the spring, as did the Grosses Schauspielhaus; that autumn a new Intendant, Fritz Holl, took over at the stagnating Volksbühne. In the provinces, where the bulk of the local theatres had remained in private hands after 1918, a wave of failures now forced municipal authorities to step in and take them over. Thus whereas in 1914 only sixteen out of 120 so-called Stadttheater, or city theatres, had been municipally owned, by the late 1930s there were hardly any that were not. With this process, which largely completed the transfer to public ownership that had started with the state theatres after the revolution, went something that, for Berlin at least was even more significant: a reorganization of many theatres' repertoires, resulting in a search for new directors and a different sort of play.

At the same time the market for Expressionist graphics, which had boomed during the whole postwar inflation, as industrialists and business men tried to find solid investments for their profits, suddenly petered out; new, more internationally minded dealers like Alfred Flechtheim came to prominence, while publishers almost overnight turned away from Expressionist works and began looking in new directions. This applied not only to the question of illustrations but also to imaginative writing, which likewise suffered something of a slump as the fashion for the 'Sachbuch', or factual book, began. The firm of Rowohlt, for instance, who in 1920–21 had published two of the chief Expressionist anthologies, now scored a great success with the popular historical works of Emil Ludwig and the memoirs of the opera singer Leo Slezak, and in 1923 embarked on a big Balzac edition. Kurt Wolff, hitherto the leading Expressionist publisher, lost one of his main authors, Franz Werfel, who found inflation Marks of little use to him in Vienna; feeling generally disillusioned with modern German writing, Wolff launched a major edition of Zola.

The Malik-Verlag cut itself loose from Dada, publishing its last works by Jung in 1923 and going over instead to the novels of the great foreign Socialists, first Upton Sinclair then Gorki; it also inaugurated the long series of photomontaged book jackets for which Heartfield became famous. Finally, with book prices after the stabilization proving quite out of the ordinary wage earner's reach, two unique book clubs were set up in 1924. These were the 'Bücherkreis' inspired by the main educational committee of the SPD and the Büchergilde Gutenberg which was founded by the German printers' union. Both combined a high typographical standard with a broadly Socialist commitment, and once again took many of their novels from abroad. Indeed the Büchergilde's first publication was a book by Mark Twain.

Russians in Berlin, *Veshch*
Predominance of the Productivist wing in Soviet Constructivism, and emigration of many revolutionary artists. The Soviet Art Exhibition of 1922 in Berlin; arrival of Lissitzky and others. The magazine *Veshch* (or 'Object').

The new close relations between Germany and Russia began coming into effect just as Soviet Constructivism was splitting into two branches. With Kandinsky no longer taking part, the theoretical argument within Inkhuk continued intensively throughout the second half of 1921, till by November that body could agree that since 'the last picture has been painted' it was the duty of its members to go over to what Brik termed 'productivism', in other words utilitarian graphics and industrial design. So Rodchenko, Tatlin, Popova, Stepanova and their followers from now on abandoned 'art' for textiles, furniture, clothing, stage design, photography and photomontage of various kinds, along with typography and film tinting, and applied the skills evolved in their 'laboratory' work to such new objects and materials. Similarly the theorists Arvatov and Kushner took their anti-psychological, behaviourist view of art into the Proletkult, which became much more modernist as its old members left.

However, those Russians who carried the constructivist message to Germany (and thence to the rest of the world) had left before or because of this development, or had simply not followed it. Thus Kandinsky decided to accept an invitation to teach at the Bauhaus, and left for Berlin as soon as Radek allowed him to. Pevsner and Gabo, who had opposed the new direction, similarly went to Berlin when they

found that the former's Vkhutemas studio had been closed. Ilya Ehrenburg, a not entirely convinced supporter of Constructivism, had already been allowed to go that spring to write a novel in Paris, taking along his painter wife Kozintseva who had been studying at the Vkhutemas and a stack of copies of *Unovis*, *Iskusstvo Komuny* and other now slightly outdated publications. Thrown out by the French authorities, they too arrived in Berlin at the end of the year, to meet up with Lissitzky, who had been sent to help mount the first big exhibition of modern Soviet art under the auspices of Lunacharsky's Commissariat and the IAH. Later Shterenberg and Altman also came in connection with this show, while Chagall used his involvement in it as a pretext to leave the country for good.

In the course of 1922 a number of other Russians arrived: Bely, Yesenin, Marina Tsvetaeva, Shklovsky, likewise the young Russian-born American Louis Lozowick who studied at Berlin university. In the autumn came Mayakovsky and the Briks, who had been seeing a Riga publisher with whom they hoped to produce a Futurist art journal. Many émigrés of course were already there, including the Nabokovs, the monarchist poet Khodasievitch, the sculptor Archipenko and Lili Brik's sister Elsa who had left Russia during the allied Intervention with a Paris gentleman rider called André Triolet; back from the United States, Prokofieff too settled in Bavaria for eighteen months; while Alexander Dovzhenko left his job in the Russian consulate in Berlin to study painting with Erich Heckel. Mayakovsky's plan for a journal fell through, to materialize instead in the form of *LEF*, a substantial review of the arts which Gosizdat in Moscow began publishing the following spring. All the same various Russian publishers were active in Berlin, notably Helikon, which now published Ehrenburg's comic novel *Julio Jurenito* and Tsvetaeva's *Razluka*, and the Skythen-Verlag which published partly in German with the deliberate aim of linking the two cultures.

It was with Skythen that Ehrenburg and Lissitzky now planned a journal called *Veshch* ('Object') aimed, so its first issue said in April 1922

1. To acquaint creative workers in Russia with the latest Western art.
2. To inform Western Europe about Russian art and literature.

Veshch would stand, said Lissitzky, for 'constructive art, whose task is not to decorate our life but to

1922: when the Russian avant-garde descended on Berlin. *Above*, photograph of Mayakovsky by Alexander Rodchenko. *Below*, cover of *Veshch. Gegenstand. Objet*, a trilingual magazine edited by Ilya Ehrenburg and El Lissitzky from Berlin that year. Under the heading 'Art and Socialness' is a tribute to Malevitch and the ideas of *L'Esprit Nouveau*.

organize it', and among its contributors were Yesenin, Hausmann, Mayakovsky (translated into French by Tsvetaeva), Fernand Divoire, Louis Delluc and the architect Ludwig Hilberseimer. Under (1) it recommended such writers as Aragon, Cendrars and Proust, the Purist painters and the review *L'Esprit Nouveau* (which it called 'best in Europe'); under (2) Prokofieff's Third Piano Concerto and the Berlin-published writings of the Serapion Brothers, i.e. the Petrograd group of novelists which included Pilnyak and Zamyatin. The cover of the May issue, the last to appear, shows that while the title and layout were Constructivist the allegiance expressed was rather to a mixture of Malevitch and *L'Esprit Nouveau*; 'Technical object – =Economy – Suprematist Object' being the slogan linking a railway snowplough to a Malevitch circle and square.

Berlin Constructivism

Moholy-Nagy and the first works of German-Hungarian Constructivism under Lissitzky's influence.

Even before the big Russian exhibition the impact of Constructivism had been felt by a number of German-based artists, and by none more powerfully or more fruitfully than László Moholy-Nagy. Then painting, it seems, partly in a Dadaist, partly in a geometrical-abstract vein, he must have met Lissitzky early in 1922; thus Mrs Lissitzky recalls seeing him, Hausmann, Hannah Höch, and the young motor mechanic Werner Graeff together with Hans Richter who since leaving Zurich had been working on scrolls and animated film projects with Viking Eggeling. These, along with Schwitters from Hanover, formed the nucleus of German Constructivism, and to Moholy the Russian example was a revelation: 'This is our century', he wrote in *Ma* that May:

> technology, machine, Socialism ... Constructivism is pure substance. It is not confined to picture-frame and pedestal. It expands into industry and architecture, into objects and relationships. Constructivism is the socialism of vision.

Of his fellow-Hungarians in exile Alfréd Kemény, a close friend with whom he wrote a kinetic sculpture manifesto that year based on that of Pevsner and Gabo, had just come back from Russia after lecturing Inkhuk on modern German art; he must therefore have been aware of the productivist trend. The sculptor László Péri in Berlin was another convert,

while Kassák in Vienna joined Moholy to compile 'Book of New Artists' (*Uj müvészek könyve*) who illustrations juxtaposed works of art ranging fro Klee to Constructivism with industrial buildings ar machines in a manner not unlike Le Corbusier's. Y another Berlin artist of similar convictions was t Pole Henryk Berlewi, who had met Lissitzky on h way through Warsaw and now developed a Mohol like form of geometrical painting which he call 'mecano-fakturen'.

Moholy himself at this point began makin photograms and his characteristically linea geometrical photomontages; he also produced son paintings on metal by the deliberately imperson means of ordering them from a sign factory usin coordinates, a colour chart and squared paper. In th same spirit he wrote (or got his wife to write, since h German was not very good), an article for the July *L Stijl* under the title 'Production-Reproduction which proposed using the new reproductive tech niques directly as artistic media: e.g. cutting one own grooves directly in a master recording disc. Fil also came under this heading, and here he thought th greatest progress to date had been made by Eggelin and Richter.

International Constructivism

Van Doesburg's Weimar period. The Düsseldorf an Weimar artists' conferences as creating a form c 'Constructivist international' on the eve of th Soviet exhibition. Alliances of Lissitzky, Van Does burg and Schwitters; differences from Soviet Con structivism.

From the middle of 1921 Van Doesburg had bee living in Weimar, trying to counteract what h considered Johannes Itten's unduly cranky influenc at the Bauhaus; and as a result *De Stijl* now somewha detached itself from the Dutch movement an became a more international journal. Van Doesbur himself was never on the Bauhaus staff, but amon the pupils whom he collected for a *De Stijl* course o that school's doorstep were Peter Röhl and Werne Graeff. In October he published a manifesto b Moholy, Puni, Hausmann and Arp whose 'Appea for an Elementary Art' already prefigured som Constructivist ideas, as indeed had some of the earlie Dada notions. Then at the end of May he, Graef Richter, Arp, Hausmann, Schwitters, Berlewi and th architect Cornelis van Eesteren, together wit Lissitzky, all met at a vast International Congress o

The spread of Constructivism. Another opening from the *Book of New Artists*, 1922, in which work by Rodchenko and his school, *left*, faces an early Moholy-Nagy, probably painted in Berlin

Progressive Artists which the Novembergruppe and allied societies had called at Düsseldorf.

Like much else to do with the Novembergruppe, this was evidently a somewhat boring affair – Hausmann indeed walked out – devoted to exhibitions, rates of payment, the art market and the like; Graeff's youthful comment being that the members seemed to be neither international, progressive nor artists. Lissitzky on behalf of *Veshch* made a statement against the concept of art as a priesthood and the use of its works for decorative purposes. Richter spoke for 'groups of constructive artists from Switzerland, Scandinavia, Rumania and Germany', i.e. Baumann, Eggeling, Jancu and himself, and also joined with Van Doesburg and Lissitzky to sign a statement on behalf of 'the international fraction of Constructivists' which was subsequently published in *De Stijl*. This defined art as 'an implement of the universal working process' and the progressive artist

as one who denies and opposes the dominant place of subjectivity in art, founding his works not on any basis of poetic arbitrariness but on the principle of new creation, using systematic organization of means to achieve universally intelligible expression.

However, the 'international fraction' was as yet a notional scheme, and in July an appeal came from the *Ma* group, signed by Kassák, Moholy, Sándor Barta, the critic Ernst Kállai and others, suggesting that *Veshch*, *Ma* and *De Stijl*, being evidently kindred spirits, should form a committee to set up an 'international organization of creative persons of revolutionary outlook'. Arp was just then holidaying in the Tyrol with the Ernsts, the American Matthew Josephson (for whose magazine *Broom* Lissitzky had designed a cover), the Eluards and Tzara from Paris; and that September he brought Tzara to its meeting.

This was held in Weimar in a spirit, possibly, of somewhat more levity than that at Düsseldorf (one

incidental aim no doubt being to shake up the Bauhaus), and its alignments seem to have been: Zurich Dada – Tzara and the Arps; Berlin Dada – Mehring; *Veshch* – Lissitzky; *Ma* – Moholy-Nagy and Kemény; *De Stijl* – the Van Doesburgs and van Eesteren; Hanover – Schwitters and Max Burchartz; plus Graeff and Richter and some of Van Doesburg's students. A 'constructivist international' was in effect set up, with a provisional committee based on Berlin and consisting of Van Doesburg, Lissitzky, the Belgian Karel Maes, Richter and Burchartz; though how far this ever functioned is not clear. The Russian exhibition in Berlin followed in October; it was held at the Van Diemen Gallery on Unter den Linden, not far from the Soviet Embassy, and represented every trend of the new Russian art from the prewar 'Jack of Diamonds' group via Kandinsky and Malevitch to Constructivism; there were also individual exhibitions of Kandinsky, Alexandra Exter and Kozintseva at the *Sturm* and other galleries during the course of 1922.

Schwitters, who saw the show at Lissitzky's invitation, appears from his catalogue notes to have been particularly taken with the work of Altman,

Constructivists at the Düsseldorf Congress of Progressive Artists, 1922, showing, *from the left*, Graeff, Hausmann, Van Doesburg, Burchartz standing, also Lissitzky in a check cap. The apposite sign is for an exhibition of Municipal Cleansing.

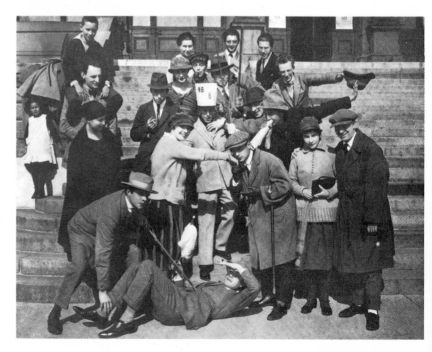

The Dada–Constructivist meeting at Weimar, autumn 1922. *Front, left to right:* Graeff (with stick), Nelly and Theo Van Doesburg, Tzara (gloved and monocled), Sophie and Hans Arp. *At the back:* Lissitzky (check cap), the Moholy-Nagys and Kemény (smiling)

Gabo, Malevitch, Rodchenko and the 'Obmokhu' sculptor Medunetzky. And from now on there is a strong Constructivist flavour to all Schwitters's designs, including the *Merz* magazine which he launched in January 1923. It was also Schwitters who brought Lissitzky and his work to Hanover, where the Russian fell in love with Sophie Küppers of the Kestner-Gesellschaft, found private and industrial patrons and established his German base, thereafter collapsing with tuberculosis so that he had to be sent to Switzerland at the end of 1923.

Yet the Dada spirit was not all that dead, and when Schwitters and Van Doesburg organized their manifestations – first in German provincial cities after the Weimar meeting, then in Holland where Tzara joined them and Lissitzky came with the Russian Exhibition – they used the old Dada ingredients: phonetic poems, insults to the audience, Mrs Van Doesburg at the piano, and the rest. 'While the French were occupying the Ruhr with guns and tanks', Schwitters wrote in *Merz 1* (subtitled 'Holland Dada'), 'we were occupying the Dutch art world with Dada.' As *Merz* came in effect to take over from Van Doesburg's Dada magazine *Mécano* there was a new fusion of the visual austerities of Lissitzky, Arp and the Dutch with an inspiredly Dadaist sense of fun. *De Stijl* in this context was becoming less a movement, more a channel of communication for the other main currents of the time.

Ehrenburg left Berlin for Prague and Moscow late in 1923, having completed a number of books including *The Love of Jeanne Ney* ('my sentimental novel', he termed it), *Trust D.E.* and the stories in *Thirteen Pipes*. He also wrote some acute reports on life in Germany: 'I had spent two years in Berlin', say his memoirs,

> with the constant feeling of a gathering storm, and suddenly I realized that the wind had died down. To tell the truth I was dismayed . . .

Not only would there be no revolution, it appeared, but the émigré publishers were by now bankrupt and the Russian colony largely dispersed. Some returned to their own country (Mayakovsky for one arriving home loaded with Western art publications); others moved on to Paris.

Back in Russia Alexei Gan, who had made himself the first theoretician of Constructivism with a manifesto datelined 'Moscow-Tver 1922–23', now added a postscript to differentiate Soviet Constructivism from the views not only of *L'Esprit*

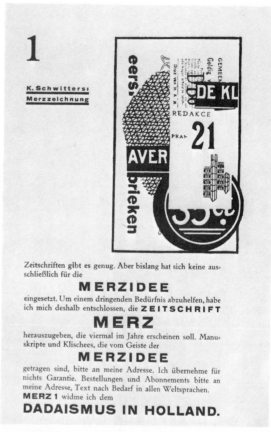

Opening page of the first issue of Schwitters's *Merz*, January 1923, devoted to 'Holland Dada'

Nouveau and *De Stijl* (which he had evidently followed) but also of Ehrenburg and Lissitzky. While he saw a common postwar tendency at work in Europe, he objected to its identification with such figures as Léger, Chaplin, Meyerhold and the music hall artists, accusing critics outside Russia of 'not knowing how to detach themselves from Art' and therefore 'fraternizing' with it instead: 'a policy of conciliation, the endemic malady of the West'. A rival manifesto published by *Merz* and *De Stijl* was called 'Against Committed Art' or 'Prolet-art Manifesto', and directed apparently against Moholy-Nagy. Signed by Van Doesburg, Arp, Tzara, Schwitters and his Hanover friend Christof Spengemann, and dated 'The Hague, 6.3.23', it argued that art, Constructivist or not, had no class basis whatever:

> The art we want is neither proletarian nor bourgeois, since the forces developed by it are strong enough to

'Art and Technology – a new unity', 1923. The Bauhaus before and after Gropius's change of policy. (1) The head of the Basic Course. *Above*: Johannes Itten, who left in Spring 1927. *Below*: his successor László Moholy-Nagy.

influence the whole of culture and not to be influenced by social conditions.

[. . .]

Thanks to their conservative liking for old, out-moded forms of expression and their incomprehensible aversion to modern art [the proletarians] are preserving just what their programme demands they should combat, i.e. bourgeois culture . . . communism is just as bourgeois an affair as is majority socialism, in other words capitalism in a new guise.

That June yet another Constructivist magazine, *G* (the 'G' standing for '*Gestaltung*' or 'formation', what *De Stijl* had meant by '*beelding*'), was launched in Berlin by Richter with Lissitzky's support and a number of new collaborators including Graeff, Hilberseimer, the Austrian stage designer Friedrich Kiesler and Mies van der Rohe. The bias of this was more towards film (Richter) and architecture (Mies and Hilberseimer), and although modern architecture in Germany was still almost entirely confined to paper projects Mies's down-to-earth attitude gave the paper a functional emphasis which, while still politically neutral, ran against the theorizing of *De Stijl* with its penchant for non-utilitarian art.

Between these divergent Constructivist streams there were the independents like Willi Baumeister in Stuttgart, then painting abstract–geometrically, while Moholy-Nagy too continued working outside the German groups.

The Bauhaus at Weimar

The Bauhaus's abandonment of utopian Expressionism and pseudo-religions; arrival of Moholy-Nagy and the policy of 'Art and Technology – A New Unity'. Closure of the school on politico-economic grounds by the new Thuringian provincial government.

The Bauhaus was meanwhile undergoing a double transformation. In 1921 the school was still a mixture of Expressionism and Arts-and-Crafts, its architec-tural style being set by the Cubist–romantic Som-merfeld House which Gropius and his partner Adolf Meyer built in Berlin, while its members from the top down were susceptible to pseudo-oriental cults and wandering prophets like the ex-champagne salesman and self-proclaimed superman Louis Haeusser who lectured there that year. Plievier, who came to the Weimar youth hostel a few months later as a preaching Tolstoyan, recalls several such peripatetic 'Inflation Saints', as he termed them: Leonhardt Stark (a hippy figure depicted in Hans Wingler's big

Bauhaus book), Christ II, Zarathustra, Genghis Khan and other fringe mystics of the time. The unworldly credulousness then prevailing, like the vegetarian diet imposed on the school's kitchens, was traceable above all to the influence of Itten, and it seems to have been with this in mind that Gropius's partner Adolf Meyer, though not himself involved in the running of the school, helped Van Doesburg to establish his unofficial course.

Oskar Schlemmer, who had taken over the wall-painting workshop at the end of 1920 and was himself strongly influenced by Carrà, is a good barometer for the ensuing change in Gropius's own attitude. After feeling initially that the Bauhaus was 'a beautiful façade' with no real results to show, Schlemmer came by the end of 1921 to regard Itten and Gropius as opposite poles:

> On the one hand, the influence of oriental culture, the cult of India, also a return to nature in the *Wandervogel* [or youth-hostelling] movement and others like it; also communes, vegetarianism, Tolstoyism, reaction against the war; and on the other hand, the American spirit [*Amerikanismus*], progress, the marvels of technology and invention, the urban environment.

Another six months, and the diet was back to normal; Itten had agreed to leave, and Schlemmer could sum up: 'Retreat from Utopia. . . . In lieu of cathedrals the machine for living in. In short, retreat from mediaevalism'. To a great extent this must have been due to the influence of Van Doesburg (along with the writings of Le Corbusier), but Gropius thought the former too opinionated to put in Itten's place; and after the Dada–Constructivist meeting he seems to have stopped giving his course and played no more part at the school. The balance of the teaching altered further with Kandinsky's arrival to take over wall-painting in the middle of the year; this allowed Itten's functions in the sculpture and woodworking departments to be assumed by Schlemmer, and by the end of 1922 Gropius had decided to get rid of Itten altogether and bring in Moholy-Nagy instead. The crucial changeover took place in the spring of 1923, Moholy then taking charge of the Basic Course and the metal workshops, and thereby becoming the almost exact opposite number to Rodchenko at the Vkhutemas. Schreyer too left at this time, his theatre workshop being put under Schlemmer, who made it one of the most vital parts of the school.

Gropius's political position was now one of avoiding any kind of embroilment with the parties,

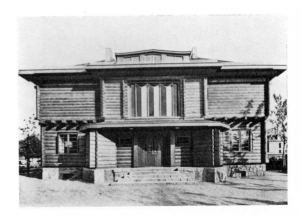

(2) Two houses. *Above*: house by Gropius and Adolf Meyer for the Berlin builder Adolf Sommerfeld, 1921. *Below*: exhibition house of 1923 by Adolf Meyer and Georg Muche

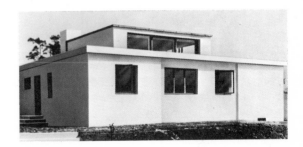

whether Left or Right. This he felt to be the best way of safeguarding the school's existence against the kind of reactionary attacks to which it had been subjected, even though they had largely subsided since the election of a new Thuringian Landtag in the autumn of 1921. For about two and a half years thereafter the province had a Socialist government backed by the Communists; the Education Minister was a former Independent Socialist called Max Greil, while the school's syndic (or administrator) Alfred Lange was likewise a member of the SPD. On May Day, 1922, Gropius's monument to the dead workers was officially unveiled. All the same the new government was anxious for the Bauhaus to justify itself in the public eye, and began pressing it to hold an open show, not least in view of the complaints of such international journals as *De Stijl* and *L'Esprit Nouveau* who found it too decorative and individualistic. The result was the Bauhaus Exhibition of August and September 1923, which almost exactly coincided with the climax of the inflation. Here

Gropius announced the school's change of line under the slogan 'Art and Technology – a New Unity', and from now on he seriously concerned himself with trying to market its products.

Herbert Bayer was commissioned to design one- and two-million Mark banknotes for the state; under Moholy's direction the first Bauhaus Books appeared. The typography became functional or Constructivist; an experimental house (by the painter Georg Muche) was built with an austerely rect- angular appearance and a flat roof; Marcel Breuer, still a student, designed some *De Stijl*-like chairs; Schlemmer and his class painted murals in the school buildings. In the exhibition itself, which flowed over into the Provincial Museum, there was a show of advanced architectural designs including Mies van der Rohe's project for a glass skyscraper thirty storeys high, while a 'Bauhaus Week' of entertain- ments featured Schlemmer's *Triadic Ballet* with its globular doll-like costumes and Kurt Schmidt's *Mechanical Cabaret* to a score by Stuckenschmidt as well as more orthodox modern works. All this had an effect far beyond the immediate public relations objective. For even though traditional crafts like weaving and pottery continued to play a major part in the school's work such things as Joost Schmidt's typography and the metal workshops' first electric lamps only date from now.

Though the change of direction was permanent, the improvement in the school's fortunes was short- lived. After the decision of the KPD to enter the Thuringian government in October 1923 and the failure of the rising which was supposed to follow, the army moved in, the government fell and the provincial assembly was dissolved. Not only was Gropius's flat searched by the troops but he even had to apologize to General von Seeckt for complaining. The ensuing elections returned a predictably right- wing assembly dominated by a so-called law-and- order alliance of the nationalist and liberal parties whose election manifesto had singled out the Bauhaus as a threat to the middle class. Try as he might to remain 'unpolitical' there was not much that Gropius could do. Backed now not merely by a group of eminent German 'Friends of the Bauhaus' but also by the different Constructivist groupings and *L'Esprit Nouveau*, he could only fight a rearguard action. In September the new government gave the whole staff notice; in December the budget was cut to an unworkable level; by April 1925 the school must close down or move.

Grosz and political art

Evolution of the Malik-Verlag group. George Grosz's abandonment of Constructivism in favour of political cartooning on the one hand and a gallery contract on the other. Development of Schlichter, Heartfield and others into committed Communist artists.

Further to the Left were those who were neither surprised by the final failure of the revolution nor quite so innocently outraged at the results. As long ago as September 1919 Johannes R. Becher had dismissed the German revolutionary proletariat as interested only in material things, arguing according to Kessler that 'a communist revolution in Germany would only be feasible once links were established with Russia, using Russian leaders and Russian Red Guards'. A period of unpolitical writing ensued during which (so Becher later said) he could easily have moved to the Right like Gottfried Benn; police records show that despite his KPD membership he paid no political dues between 1921 and 1923. Then came what he called the 'caesura' in his work, when he joined a party cell in Berlin, to emerge with the book *Vorwärts, du Rote Front!* in 1924 as a still windily rhetorical but now wholly committed communist writer:

> All you artists who during the four war years
> fought with such courage, endurance and
> integrity against the madness of war,
> you revolutionary singers when November began,
> where are you now?

Grosz, to whom this kind of hectoring Whit- manese was quite alien, was extremely productive in 1922–3, publishing such albums as *Das Gesicht der herrschenden Klasse* (The Face of the Ruling Class, which Lenin liked), *Abrechnung folgt!* and *Ecce Homo*, and illustrating no less than twenty-one books including the masterly version of *Tartarin de Tarascon* designed by Heartfield. The Malik-Verlag survived the currency reform by turning itself into a limited company with capital from the Argentine grain exporter Felix J. Weil, a patron of Grosz's who also founded the Frankfurt Institut für Sozialforschung in 1923; Herzfelde moved the firm into West End premises with a special gallery for Grosz's work, to become a major publisher of Russian and other left- wing fiction. Once again he and Grosz were prosecuted, this time for the alleged obscenity of *Ecce Homo*; though defended by the deposed KPD leader

Paul Levi and supported by distinguished witnesses from the art establishment they were fined 6000 (new) Marks.

By then however Grosz too had undergone a radical change. How far the disillusionment of his Russian trip contributed to this, how far his new domesticity, how far sheer over-commitment is difficult to say; but during 1923 he accepted a contract from the smartest of Berlin dealers, Alfred Flechtheim, who gave him a show that year including sixteen of the large watercolours which he was now beginning to paint. The next spring he made his first postwar trip to Paris, where he met such newcomers as Pascin (returned from America), Masereel (from Geneva) and Tucholsky (just moved from Berlin). Masereel's dealer Joseph Billiet introduced Grosz's work there in the autumn, and for a while one part of him seemed to be on the fringes of the Ecole de Paris. From then on his big watercolours came to relate as much to 'Society' as to society, and the line in his drawings visibly softens up.

At the same time the other half of Grosz appeared to be going further to the Left. In mid-1921 the Novembergruppe had allowed the Prussian Ministry of Culture to ban paintings by Dix and Schlichter from the big exhibition in the Lehrter Bahnhof, and an 'opposition' thereafter split away, including also Grosz, Hausmann, Hannah Höch and Schlichter's Karlsruhe contemporary Georg Scholz, to announce its 'solidarity with the proletariat'. 'The aim', said their statement in Herzfelde's *Der Gegner*,

> must be to abolish the trade in aesthetic formulas either by means of a new objectivity (*Gegenständlichkeit*) born of a revulsion against bourgeois society and its methods of exploitation, or else by conducting preparatory experiments in non-objective optics which likewise reject the aesthetics and society in question with the aim of discarding individuality in favour of a new human type.

For Grosz this almost Constructivist position did not last long; for his last mechanical-constructive collages appeared in the album *Mit Pinsel und Schere* (With Scissors and Brush) in 1922, and he is a notable absentee from all the Constructivist debates in that year; nor did he care for the non-objective works in the Russian exhibition. He had already nailed his flag to the mast with his statements that 'art today is an utterly secondary affair', that the artist should get out and help the workers so as to become himself 'a clear, healthy worker in a collectivist society', and above all that (in contradistinction to Leonhard Frank's

Grosz for the well-to-do. His new dealer Alfred Flechtheim, portrayed by Otto Dix in 1926. Now in the West Berlin National Gallery

famous wartime book *Der Mensch ist gut*) 'der Mensch ist nicht gut – sondern ein Vieh!': Man isn't good, but disgusting. Mayakovsky evidently met Grosz in Berlin through the Malik-Verlag, and took three books of his drawings back to Russia, publishing some of them in *LEF*; while Grosz also identified himself with the appeals of the IAH and did some drawings for it. A little later he embarked on political cartooning, lithographing with a brush and spray technique rather than the old venomously exact pen, for a new KPD satirical journal called *Der Knüppel* (The Truncheon, a descriptive title) which appeared under Heartfield's editorship in 1923.

Schlichter, a much underrated draughtsman, joined him in this work, as did Hans Bellmer, a Dresden artist then following in Otto Dix's footsteps, and Grosz's own brother-in-law Otto Schmalhausen. Thereafter a new 'Red Group' of KPD artists was formed in June 1924, with Heartfield and Schlichter as its secretaries and Grosz in the chair. Among its members were Dix, Otto Nagel and the Dresdener Otto Griebel, yet another former Dadaist.

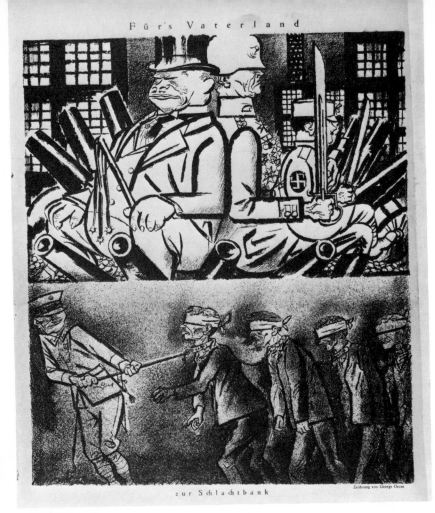

Für's Vaterland

zur Schlachtbank

Zeichnung von George Grosz

Grosz for the proletariat. A page
from Heartfield's magazine *Der
Knüppel* ii/4, 25 July 1924

A new naturalism

**Conscious emergence of a 'new naturalism' or
Verism in the painting of Dix and Beckmann.
Contacts of the new Munich realists with Italian
groups, including the Fascist-favoured Novecento.**

When Lissitzky and Arp compiled their book on the
-Isms during the former's Swiss convalescence, they
chose to describe 'Verism' by a definition borrowed
from Grosz:

> The Verist holds a mirror to his contemporaries' ugly
> snouts. I drew and painted from a spirit of con-
> tradiction, and tried by means of my works to convince
> the world that it is hideous, sick and dishonest.

In 1922 the Berlin art magazine *Das Kunstblatt* had
detected 'a new naturalism' arising from the ashes of
Expressionism; in 1923 G. F. Hartlaub, director of
the municipal gallery at Mannheim, began soliciting
works for an exhibition that would display a clear-cut
attitude to what he termed 'a positively tangible
reality'. He cast his net wide, writing among others to
Lissitzky, who however refused to show in anything
but a Russian exhibition, as well as to Grosz, Dix,
Schlichter, Max Beckmann and Georg Scholz. Dix by
then had gone through a more or less 'proletarian'

period (embracing his first portrait of his parents)
before being taken up by the Düsseldorf dealer
Johanna Ey; moving to that city he had gone over to
the themes by which he is best known: portraits with
a technical-professional setting, paintings of social
(largely night-) life like a cruder version of Grosz's
drawings, and war paintings and etchings that are
either horrifyingly expressive or creepily surreal.
Beckmann too in Frankfurt was going his own
patient, isolated way.

At the same time Hartlaub turned to the two artists
who in 1922 were most under Italian influence: the
Munich painter Carlo Mense, contributor of an
Expressionist Madonna to Herzfelde's *Neue Jugend*,
who that year showed under *Valori Plastici*'s auspices
in Milan, and the former *Freie Strasse* collaborator
Georg Schrimpf, who was also in Italy and in touch
with Carrà. Though on the surface this kind of
painting had nothing to do with the newly estab-
lished Fascism (hitherto much more logically iden-
tified with Marinetti's brand of combative bombast),
the Novecento Group which developed from it in
1922, with tame neo-classicists like Funi and Casorati
supported by the critic Margherita Sarfatti, was to
enjoy Mussolini's personal approval and become the
cradle of official Fascist art.

End of theatrical Expressionism

Abandonment of Expressionism on the German stage: Brecht, Pirandello, changes in Kaiser and Barlach. Piscator enters the Berlin Volksbühne. Meyerhold in Russia: theatrical Constructivism and 'biomechanics'; his recruitment of Eisenstein and Tretiakoff, leading to *Engineer Glumov's Diary* and *Gasmasks*, two signposts for the cinema.

Both in Germany and in Russia the theatre too reacted – dramatically is perhaps the word – to the same assorted stimuli. Though Expressionism still had a good grip on the German stage as late as 1922 (for the more complex a medium is, the longer it takes to absorb new movements), Brecht's first staged play *Drums in the Night* was instantly seen by the more far-sighted as significant both for its novel language and for its comparative realism. With this (so his next two plays showed) went a much more restrained form of staging and a new, low-toned, down-to-earth décor; and in the box-office crisis of 1923 a whole group of the young Munich innovators – Brecht the writer, Erich Engel the director and Caspar Neher the designer – was invited by Reinhardt to Berlin. So for that matter was the Rhinelander Carl Zuckmayer, whose writing at this point was still somewhat Expressionistic and confused. Iwan Goll too, who in Paris had written four outstanding short German absurdist 'superdramas' in the Apollinaire tradition – *Die Chaplinade, Die Unsterblichen, Der Ungestorbene* and *Methusalem, der ewige Bürger*, saw three of these published by Kiepenheuer, while in 1922 the last-named was due to be staged in Königsberg with

costumes by Grosz, though for some reason this plan fell through.

The real turning point here was Georg Kaiser's 'people's play' or 'Volksstück 1923' *Nebeneinander*, which had its Berlin premiere on 3 November 1923, two weeks before the currency stabilization. Kaiser had previously been thought of as an Expressionist, but in this key work his curt, comic dialogue served a lighthearted story of the Berlin inflation, centring round the tragic figure of an idealistic pawnbroker. It too was among the few plays designed by Grosz, and it introduced another new director, Berthold Viertel, then briefly running his own company 'Die Truppe'. 'Georg Kaiser', said the review in the *Weltbühne*, 'has left the cloud that used to surround him, and landed with both feet on the earth.'

The same year Barlach's plays found their first effective director, with Jürgen Fehling's production of *Der arme Vetter*, another work that is a far too subtle mixture of comic and tragic to seem at all like an Expressionist play. Then in 1924 Reinhardt himself came back from Vienna to stage a succession of brilliant non-Expressionist productions, including Shaw's *St Joan* and Pirandello's *Six Characters in Search of an Author*; William Dieterle directed the Goll *Methusalem* (but without Grosz's designs); while Brecht's Munich production of *Edward II* introduced a fresh way of looking at the classics. That spring Piscator established himself at the Volksbühne with his politically committed, documentary production of Paquet's 'epic' play *Fahnen*, which no other director had been prepared to tackle. And finally on

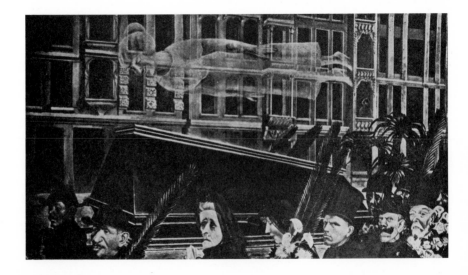

The Verist Dix. *Death and Resurrection*, a painting of 1922 reproduced in *L'Esprit Nouveau* no.20 and subsequently lost from view

16 July, having served just one day less than his sentence, Ernst Toller at last left gaol.

Though Piscator always denied any Russian influence in his formative period Ehrenburg claims to recall Mayakovsky in Berlin talking to him about Meyerhold's theatre. The Soviet company which was actually seen in Berlin (and in Paris) during 1923 was however Alexander Tairoff's much less radical Kamerny Theatre – his book too was published in Germany that year with a cover by Lissitzky – nor did its programme include *The Man who was Thursday*, with its influential Constructivist setting by Vesnin, which was staged in Moscow only that December. What Meyerhold was doing at this time was attempting to assimilate the language of productivist Constructivism into the theatre. Possibly it was the pressures of NEP which gave him good economic reasons for leaving the back wall of his stage exposed, using objects (Veshch, Gegenstand) rather than a full-scale set, and giving his actors dungarees to wear instead of costumes. But visually the result still seems breath-taking: Popova's wooden structure for the Belgian writer Crommelynck's rustic–sexual farce *The Magnificent Cuckold*, with its rotating mill machinery; Stepanova's scattered bits of apparatus for Sukhovo-Kobylin's nineteenth-century satire *Tarelkin's Death*; then in 1923 Popova's last major job (aged only 35, she died in May 1924) *The Earth in Turmoil*, an adaptation of the verse play *La Nuit* by the French pacifist–Communist Marcel Martinet, this time with real utilitarian objects on a bare stage, and realistic costumes.

To go with his now almost functional approach Meyerhold had devised for his students a technique of acting which he termed 'bio-mechanical'. Practically speaking it seems to have involved a large admixture of gymnastics and circus-like acrobatics, and to have been particularly successful in grotesque and slapstick contexts. Theoretically it was related to the experiments in what we should now call ergonomics being conducted in the bio-mechanical laboratory of Gastev's Institute for the Scientific Organization of Work and the Mechanization of Man. Gastev was the former Proletkult poet who also launched a campaign against time-wasting; he wrote his instructions to workers in telegraphic style and has been credited (if that is the word) with inspiring the characteristic Soviet abbreviations, of which Inkhuk for Institute of Artistic Culture and Mezhrabpom for International Workers' Aid are among those relevant to this book.

Just around this time Meyerhold recruited two new collaborators. First Eisenstein, who had been working with the Proletkult Theatre, joined him in 1922 as a designer (for an unrealized production of Shaw's *Heartbreak House*) and worked as his assistant on the production of *Tarelkin's Death*. Then during the same year the slightly older Tretiakoff arrived in Moscow from the Far East, where he had been deputy Minister of Education in the Far Eastern Republic and managed the state publishing house. After helping to write Meyerhold a revue which was not publicly performed, he went on to adapt the translation of the Martinet play, cutting it (he said) by 35 per cent, removing rhetoric and over-elaborate psychology, substituting real speech-rhythms for those of the verse and creating a 'speech-montage' in which the important sentences were stressed so as to make 'poster phrases'. After its production both Tretiakoff and Eisenstein moved over to the Proletkult's First Workers' Theatre (which was actually the ballroom of a private house), taking with them the actor Grigori Alexandrov with whom Eisenstein had been developing a still more radical theory of acrobatic acting.

Already before leaving Meyerhold these three had started planning a centenary production of Ostrovsky's *Enough Simplicity in Every Wise Man*, which Tretiakoff's 'free text composition' now updated so as to make the central figure Glumov (played by Alexandrov) into a Paris émigré who returns to Russia to take advantage of NEP. Using a minimal set, Eisenstein staged this in March 1923 in slapstick circus style, with acrobatics, a tightrope act over the audience's heads, female impersonations and musical parodies, finishing up with a 120-metre film, *Engineer Glumov's Diary*, which Eisenstein made in one day with Alexandrov and his fellow-actor Maxim Straukh. The show opened with Tretiakoff explaining the story – necessary, said one critic, since 'the play is structured without a basic plot and complications – along the straight line of the slow unfolding of the path of events' – and closed with Eisenstein's appearance on the screen, bowing to the audience's applause.

A second collaboration followed the same autumn, when Tretiakoff wrote another piece called *Listen Moscow*, which Eisenstein again staged: an 'agit-guignol', this time celebrating the expected success of the German October risings, and timed with inappropriate optimism to be performed on 7 November, actually two days after Hitler's 'beer-cellar

Right: End of the German
Expressionist theatre. Georg
Kaiser's *Nebeneinander* staged
in Berlin by Berthold Viertel,
1923, with sets and costumes
by Grosz. *Below*: Meyerhold
and the Constructivist
'object'. *Tarelkin's Death*,
designed by Rodchenko's
wife Stepanova in 1922

Eisenstein and the 'montage of attractions'. His acrobatic production of Ostrovsky's *Enough Simplicity in Every Wise Man* as adapted by Tretiakoff at the Proletkult First Workers' Theatre in 1923

The 25-year-old director with a poster advertising the play as 'Eisenstein's montage of attractions: staging, script [?direction . . .], costumes, props'. In some Soviet reproductions of this photo Tretiakoff's name as adaptor has been blotted out.

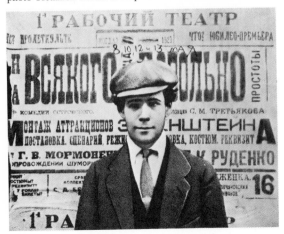

putsch'. Finally at the end of February 1924 the Proletkult put on *Gasmasks*, a further short agitational 'melodrama' based by Tretiakoff on a newspaper report and staged by Eisenstein inside a Moscow gasworks. The grandeur of this real-life setting, for Eisenstein, so contrasted with the unrealities of the play that, in his famous phrase, 'the cart fell to pieces and the driver dropped into the cinema'. As for the playwright, he dropped into a chair of Russian at Peking University, where he remained for the next two years.

La Création du monde, Hindemith, mechanical instruments

Music and the smaller festivals. Spreading influence of Schönberg (especially *Pierrot lunaire*) and Stravinsky (*L'Histoire du soldat*). Milhaud and the impact of jazz; Antheil and machinery. Questions of scale: Hindemith's 'chamber music', Stravinsky's alienation from Diaghileff. The appeal of mechanical instruments.

At the same time there was a considerable shift of balance in the musical world, thanks largely to the new international traffic. As yet this did not greatly affect Russia, where no interesting composers had emerged and such experimenting as there was took place more on the social-industrial plane: for instance, the creation of the Persymfans conductorless orchestra which gave its first concert in February 1922, and the organization of a factory-siren concert at Baku that autumn. Moreover Stravinsky's works since *Petrouchka* were curiously shunned in his own country, though the absent Prokofieff was better appreciated, Mayakovsky for one admiring his works. But certainly Germany and Austria at this point became a lot more important on the musical scene.

In part this was due to the new institution of avantgarde festivals: both those of the International Society for Contemporary Music, which was founded in 1922 as an offshoot of Max Reinhardt's revived Salzburg Festival, and the Donaueschingen chamber music festivals which began under the patronage of Prince Fuerstemberg the previous year. These latter introduced the work of such young composers as Ernst Křenek, then a student under Schreker in Berlin, and Paul Hindemith, the viola player of the Amar Quartet from Frankfurt, where Hermann Scherchen was now conducting and organizing the museum concerts. The work of the Vienna school too

now began to circulate, for in the summer of 1922 Poulenc and Milhaud came to see Schönberg together with the singer Marya Freund, played him a four-handed arrangement of *Le Boeuf sur le toit* and discussed *Pierrot lunaire*, which had recently had four performances in Vienna and which they now tried out in both French and German; to his brother-in-law Alexander Zemlinsky, who meanwhile was setting up a Prague branch of the Verein für Musikalische Privataufführungen, Schönberg wrote afterwards that Milhaud, like him or not, was by no means 'insignificant' (as Zemlinsky must have suggested) but highly talented and 'the most significant representative of the school now prevalent in all the Latin countries, polytonality'.

Outside Vienna Schönberg's current pre-occupations were as yet barely known but the prewar *Pierrot lunaire* now began a triumphal progress, being performed not only in Prague but also under Scherchen at Winterthur in Switzerland, again at the Berlin Hochschule führ Musik in October, and then in December under Milhaud at the Théâtre des Champs-Elysées. *L'Histoire du soldat*, its (almost literally) opposite number, written on a similar scale, had its first German performance under Scherchen in Frankfurt in June 1923, followed by one at the Bauhaus Week, which also included first performances of works by Busoni, Hindemith and Křenek; Stravinsky himself came to this, and thereafter was increasingly often in Germany. Just before, Kandinsky had written to Schönberg to ask if he would come as director of the Musikhochschule in Weimar and help widen the Bauhaus's range. However, Schönberg had heard from Mrs Mahler that two of the others there (the names have been charitably expunged in Erwin Stein's edition of his letters) were anti-semites. And from his anger it appears that Kandinsky must have excused them, blaming the Jews for Communism and citing the Protocols of the Elders of Zion.

In Paris the organizer of the remarkable series of concerts in which *Pierrot lunaire* was included, along with Stravinsky's recent works, Alois Hába's quarter-tone music and Billy Arnold's band, was Marya Freund's son Jean Wiéner, a composer who played the piano in the Rue Duphot nightclub patronized by Cocteau and his friends and christened by them *Le Boeuf sur le toit* after Milhaud's piece. Wiéner (whose name means 'Viennese') himself wrote sophisticated jazz (for example *Toccata Dance* and *Sonatine syncopée*), but he was a good enough

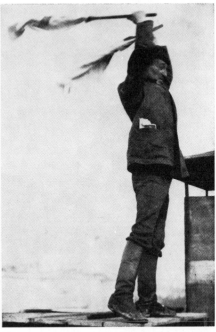

Revolutionary music in Baku, 1922. Conducting a concert of factory hooters in the open air

pianist to play Schönberg and Stravinsky in the concerts and had been a fellow-student of Milhaud's at the Conservatoire. Milhaud for his part seems to have got to know a more authentic kind of jazz during his visit to the United States earlier in 1922; for he came back having heard not only Paul Whiteman but also an evidently more interesting band at the Hotel Brunswick in Washington, and above all the New Orleans jazz currently being played in the Capitol on Lenox Avenue in Harlem. With him he brought negro jazz recordings under the Black Swan label and jazz tutors from The Winn School of Popular Music.

Having been commissioned to collaborate with Cendrars and Léger on a work for the Swedish Ballet, he at once contacted both men and, he says, 'remained more closely in touch with my collaborators than for any other of my works'. Cendrars at this point had just compiled his *Anthologie nègre*; Léger, who had designed *Skating-Rink* to Honegger's music for the company's previous season, shared the common Cubist interest in negro art; Milhaud wanted to use the jazz style and the scale of orchestra heard in Harlem. The result was *La Création du monde*, which had its premiere in October 1923, one of the best and

least superficial of the 'serious' adaptations of the jazz idiom, despite its somewhat artificial remoteness from the contemporary urban context where that idiom was properly at home. Sharing the bill with it was a ballet by Cole Porter called *Within the Quota* – about a Swedish immigrant trying to enter the United States – whose story and almost pop-art setting were by the expatriate American artist-cum-socialite Gerald Murphy, follower of Léger and friend of Porter and Scott Fitzgerald.

Immediately before, a piano recital was given by the young Polish–American George Antheil, who had come to Europe in the wake of a girl and now played his own *Airplane Sonata*, *Mechanisms* and other works in front of Léger's set. He told his friends that he was writing a *Ballet mécanique* for which he wanted a 'motion-picture accompaniment': an idea that Léger was soon after to take up. Satie, who was also there, added that he too was going to write a mechanical ballet – to be called *Relâche*. As for Antheil's 'Musico-mechanico Manifesto', which was published in *De Stijl*, its subject was not so much machine noises as the future replacement of the orchestra by 'vast music machines in every city' whose outpourings would 'open a new dimension in man', create new psychic rhythms and make the people vibrate: an all too prophetic view.

Jazz was likewise being used at this time by Hindemith. He had heard a certain Sam Wooding in 1921 (presumably in Germany) who had come, in Heinrich Strobel's words, as 'a revelation'; Hindemith accordingly included jazz movements – foxtrot, shimmy and the like – in his *Kammermusik* op. 24 no. 1 and the *1922* suite for solo piano. Among the various young central European composers heard at Donaueschingen, who tended to operate within the same economical 'Kammermusik' framework and reflect similar neo-classical and polyphonic influences, Hindemith stood out for his extreme fluency and instrumental skill. What is more, he was a comedian, which perhaps made him even more exceptional. In *L'Esprit Nouveau* Adolf Weissmann, the *Berliner Tageblatt* critic, presented him to French readers as an unsentimental sceptic, while Stravinsky welcomed him as representing 'a principle of health and luminosity among so much darkness'. For Stravinsky had become largely preoccupied with analogous questions of scale and economy of means, which took him in a different direction from the Diaghileff ballet, though for a time he still worked with it on its classical revivals.

Thus when Diaghileff mounted *Renard* and the equally small-scale chamber opera *Mavra* at the Paris Opéra in June 1922, the former with a marvellously simple yet evocative setting by Larionov, they were lost in the vast house with its audience of wealthy balletomanes. The *Wind Symphony* for a dozen players was likewise misplaced in the framework of a Koussevitzky concert; in fact both it and *Mavra* satisfied their composer only when performed in Jean Wiéner's series. And similarly with *Les Noces*, which Stravinsky, after scoring two scenes for a combination of mechanical piano, mechanical organ and two czimbaloms, orchestrated in 1923 for four pianos and percussion: for he wanted it to be a 'divertissement' like *L'Histoire du soldat*, with the musicians visible on the stage, rather than a quasi-anthropological examination of marriage customs (executed, as it turned out, in somewhat bio-mechanical style). Diaghileff, so Stravinsky was to recall later, 'could never stomach' *L'Histoire du soldat*, and from this point the two men drifted apart. Not that Stravinsky's experiments at a less grand level were altogether successful, for when he orchestrated some of his pieces for a Paris music hall sketch in 1921 the band's sloppy treatment of his work, degenerating as the show progressed, convinced him that such establishments were not to be trusted. But he did become seriously interested in mechanical music, and the firm of Pleyel now gave him a studio in which to work on pianola-roll recordings for their Pleyela mechanical piano. Indeed the second Wiéner concert in the winter of 1922 was devoted to Stravinsky's own pianola version of *Le Sacre du printemps*.

Architectural beginnings
New ideas in German architecture and planning; their first realization at Celle. Taut at Magdeburg. Le Corbusier's La Roche house in Paris.

In architecture the economic problem remained dominant, and although there were some major new commercial buildings, like Erich Mendelsohn's stores and offices in Germany, it was only in Holland that they reflected the post-Expressionist developments. Perhaps the most important single event in this field was the introduction by the Socialist municipality in Vienna of its *Wohnbausteuer* or housing tax, which allowed a large-scale rehousing programme to be started in September 1923. Le Corbusier's scheme for a 'Contemporary City' of

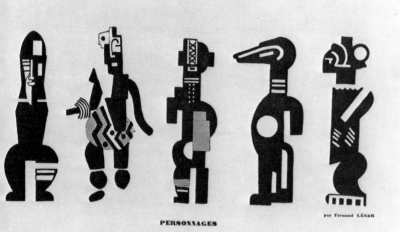

PERSONNAGES

par Fernand LÉGER

Jazz double bill at the Théâtre des
Champs-Elysées by de Maré's Swedish
Ballet, 25 October 1923. *Left*: Léger's
figures for *La Création du monde*,
Milhaud's negro ballet on a Cendrars
libretto. *Below*: Set by Gerald Murphy,
Léger's American pupil, for Cole
Porter's *Within the Quota*, a 'ballet-
sketch' about the US immigration laws

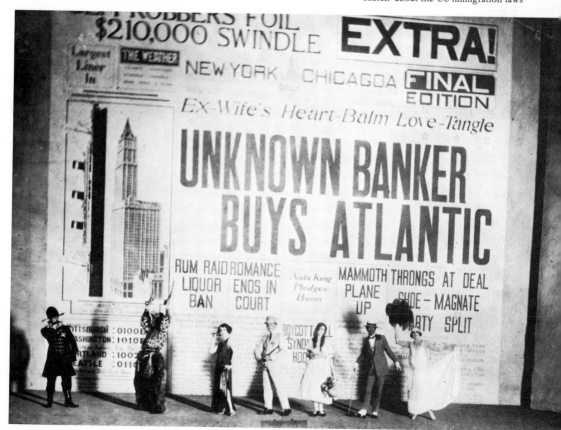

Mechanical music. The Pleyela player-piano as taken up by Stravinsky and featured in *L'Esprit Nouveau* no.22

'Italienischer Garten' estate was the first of its kind in Germany; and other schemes by him followed.

In Russia there was just a handful of modern constructions in the All-Union Agricultural Exhibition the same year, notably Konstantin Melnikov's Mahorka tobacco pavilion. In Paris Le Corbusier had no following in his profession and no hope of any official jobs, but in 1922 he went into partnership with his cousin Pierre Jeanneret to build his first two postwar houses: one for Ozenfant in 1923, then the double house for his own brother Albert and the Swiss banker Raoul La Roche which was completed in 1924. This was virtually an embodiment of *L'Esprit Nouveau*, since not only was Albert Jeanneret that magazine's main music critic and La Roche one of its backers, but the heart of their house was a gallery for the paintings which La Roche had bought. These came mostly from the Purist exhibitions and, on Ozenfant's and Le Corbusier's advice, from the sales of Kahnweiler's confiscated Cubist paintings (under the heading 'Vente des Biens Allemands') in the second half of 1921.

End of Paris Dada

Accusations of chauvinism cause collapse of André Breton's Congrès de Paris; decline of Dada. Its final fling with *Relâche*, another signpost for the cinema.

It is symptomatic, perhaps, that in the year when the first international congresses and festivals of the modern movement were being held in the German-speaking countries the plan to mount one in Paris should have failed. For although that city could absorb almost anything and anyone on its own terms the ineffectiveness of the political Left, combined with the dependence of the arts on the patronage of a still largely aristocratic Parisian élite, imposed a certain parochialism which was to become increasingly cramping. The plan in question was for an 'international congress to determine directions and defend the modern spirit', and it was launched by Breton at the beginning of 1922 with the support of Auric, Delaunay and Léger, Ozenfant, Paulhan and Roger Vitrac, they being leading representatives respectively of 'Les Six', the former Cubists, *L'Esprit Nouveau* and *La Nouvelle Revue Française*. This was a powerful front, even if it self-evidently contained no foreigners.

However, some of Breton's Dada friends saw so ambitious an undertaking as inconsistent with the

three million inhabitants, shown at the 1922 Salon d'Automne, remained a project only, with its tower blocks, urban motorways and generous open spaces, as did the architectural exhibit mounted by Van Doesburg and van Eesteren at L'Effort Moderne the following year. This was in effect the swansong of *De Stijl* as a movement, though the magazine itself struggled on.

In Magdeburg in northern Germany the utopian theorist Bruno Taut, one of the founders of the Berlin Arbeitsrat, became chief architect to the Socialist municipality in 1921. He was only able to build one important building, an exhibition-cum-market hall, and the rest of his work remained on paper. Helped by a group of left-wing artists, however, he launched a scheme for introducing colour in the streets, painting façades, kiosks and trams with gaudy abstract designs and encouraging the populace to do the same in residential districts. The reception was mixed, Ehrenburg for one reporting with a shudder that 'we have become too sober' for that kind of visual affront. Certainly the effect seems to have been to sober Taut himself up, for he resigned in 1923 and wrote *Die neue Wohnung*, a sensible, instructive book on home planning and furniture which sees any real improvement in taste as being bound up with the liberation of women. There was also another city architect who had visited Magdeburg and that year embarked on a more effective programme of rehousing: Otto Haesler at Celle near Hanover. His

spirit of their movement, and Tzara for one decided to take no part. At that Breton and all his fellow-organizers except Paulhan issued a press statement warning the world against 'the actions of a character known to be promoter of a so-called movement originating in Zurich'. Among those outraged by such apparent xenophobia were Satie, Eluard and Ribemont-Dessaignes, who joined Tzara in summoning a meeting at which over forty signatories, including Brancusi and many other foreign-born artists or writers, protested at the phrase 'originating in Zurich' and formally withdrew their confidence from the congress. Paulhan thereupon said that the *NRF* could no longer be involved, and in April Ozenfant had to tell Breton that the plan was off.

Dada at this stage was dormant; *Littérature* was losing subscribers; Breton had become interested in table-turning and other spiritualist occupations. It was just the opposite of what was happening at the Bauhaus. 'Let it not be said', wrote Breton that September, while Tzara was away among the Constructivists at Weimar, 'that Dadaism served any end but to maintain us in that state of perfect availability in which we are and from which we shall now move lucidly away to that which is beckoning us.' If this new vocation meant that the movement was virtually over it was not to fall apart bloodlessly. On 6 July 1923 a Russian émigré manifestation organized by Zdanievitch was billed to include not merely an assortment of avant-garde items such as short films by Richter, Man Ray and the American Charles Sheeler, all to a piano accompaniment by Antheil, but also some poems by Cocteau and Tzara's short play *Le Coeur à gaz*. This was violently and by all accounts unprovokedly broken up by Breton and his friends (Eluard having meanwhile changed allegiance); the police were called in; Tzara sued for damages, and Dada was visibly at an end.

All the same its spirit had one last posthumous fling at the Théâtre des Champs-Elysées, when in 1924 Picabia, despite the modishly decorative trend in his painting at this time helped to turn Satie's ballet *Relâche* into the major French Dadaist work. This was partly due to the absence in Brazil of Cendrars, who had sketched out the first scenario and called it merely *Après-dîner*. Picabia took the project over under the new mystifying title – which means 'No performance tonight' and looked good on the posters and press advertisements – devised a unique setting of lamps and reflectors to dim or brighten in accordance with the music, and wrote a short interlude film in which he got Satie, Duchamp and Man Ray to act with the Swedish Ballet's principal dancer Jean Borlin. The film was made in three weeks that June by a young writer whom Hébertot had recruited as a film critic for his magazine *Le Théâtre* at the end of 1922. It was called *Entr'acte* and its maker was René Chomette, otherwise known as René Clair.

1921–3: Summary

The turning point summarized: ending of the pre-1918 -Isms; assimilation of Purism and Constructivism in a wider, nameless trend; the pressure of technical changes. Stagnation of the Comintern's World Revolution. Creation of a calmer, more open and tolerant German climate from 1924, temporarily free from nationalistic excesses.

All this adds up to a complex and far-reaching transformation, which affected many other people and fields; one has only to think of any artist – Picasso, Chirico, Kirchner, Masereel – and compare his work before 1921 and after 1923 to see what a universal change there was at this point. Universal, but far from uniform, for there were back-pedalling influences at work as well as processes of simplification, cross-fertilization and extension, so that it is not easy to make sensible generalizations about it and all we can do is to sum up its most obvious features.

These years, to begin with, saw the effective end of the main avant-garde movements which started before 1918: Cubism, Futurism, Expressionism and Dada. The Metaphysical period in Italy ended; Purism ran its term; *De Stijl* shot its bolt; Russian Constructivism revised and reduced itself, leaving

De Stijl in architecture. Construction office by Oud, Rotterdam 1922–3, painted in red, yellow and blue. Photo from *Bulletin de l'Effort Moderne* no. 4, 1924

one half of the movement to continue elsewhere. What emerged was a still nameless double trend, one part Abstract–Constructivist, the other concerned with 'real' down-to-earth things, both of them marked by those main movements through which the artists had passed. Classicism, simplicity, impersonality: such undramatic ideals were in the air, together with a much deflated but still persistent concern with social change. At the Bauhaus, utopianism and mysticism were to a great extent discarded and the way cleared for a closer engagement with technological society, to be pursued in a more favourable setting after the school's expulsion from

Last echo of Paris Dada, swansong of the Théâtre des Champs-Elysées. Jean Borlin and Edith von Bonsdorff in the Satie – Picabia *Relâche*, December 1924

Weimar. Elsewhere too the technical pressures were felt, sometimes pushing the creative artist towards soberer, more practical, and utilitarian solutions, sometimes bringing him new instruments with which to experiment, continually giving him fresh standards by which to judge his own work.

Lenin died in January 1924 after having been largely incapacitated for more than a year; in May the Soviet economist Eugen Varga (yet another member of the Hungarian diaspora of 1919) told the Russians in a pamphlet that the acute social crisis of capitalism was by and large overcome. So the communist revolution in the West was temporarily stagnant, though as yet there was no new policy of Russian self-sufficiency and the exchanges between that country and the outside world could continue to be as free as they had become in 1922. The new phenomenon of fascism as a form of nationalist, populist oligarchy had been seen to be internationally important, even though the murder of Matteotti and the final establishment of the Italian dictatorship still had to take place. The relationship between it and the similar German movements had been grasped; indeed in 1923 the KPD had symptomatically organized an 'anti-Fascist week'. However, in the relatively stable situation that now developed in Germany the latent strength of such extreme nationalist feelings was difficult to appreciate, particularly for foreign observers; there too internationalism seemed on the face of it to have prevailed.

For the new German cultural developments had now begun moving into the centre of a whole international movement which would leave France somewhat to one side, particularly where architecture and design were concerned. German society might be highly industrialized like its Western neighbours, but it had a special tradition of cultural decentralization and of strong public patronage with a Socialist slant, and the fact that it was in a sense a new society, with everything to rebuild after a disastrous war, made it more accessible than others to the new ideas from both East and West. Given a clear run, even for as little as five years, it could fuse and digest these into a coherent culture. Until another equally drastic moment of change came along, the old violent nationalist sentiments could be safely pushed underground, with nothing but the occasional small flare-up to keep the more enlightened alert.

THE NEW SOBRIETY

9 Weimar builds: USSR, Americanism, the city, technology, sport

German prosperity between 1924–9. Death of President Ebert and return of the old balance of political forces under Field-Marshal von Hindenburg. Continuance of cultural links with Russia: Mayakovsky's *LEF* as a centre and a symptom. The new fashion for 'Amerikanismus'. Berlin as a modern city, development of an intensely urban culture; sport as a theme for the arts. Technology and the changing nature of machine art. The new school of socially-minded critics.

It was during the second half of the 1920s, therefore, that the threads which we have tried to follow were drawn together to form something very like a new civilization, with the Stuttgart Weissenhofsiedlung in 1927 as its temporal centre. This was a time of seeming stability in Germany, starting with a shift of about two million voters from the extremist parties to the SPD during 1924 (when there were two Reichstag elections); nor was there any great change for the following three-and-a-half years, after which the Socialists again increased their vote. The Mark remained steady, thanks largely to American investment following the Dawes Plan, and there was a high level of public spending; thus Stresemann in 1927

The vigour of the later 1920s: S.
Krasinsky's *Tennis* from the
Moscow camera magazine
Sov'etskoe Foto no.6, 1928

singled out the 14 million Marks for reconstructing the Berlin State Opera and the expenditure on the forthcoming Pressa Exhibition at Cologne and the Dresden Museum of Hygiene as evidence that might make other countries feel that Germany was doing rather too well.

Provincial and municipal authorities at last embarked on major schemes, particularly under the SPD-dominated governments of Prussia, Hesse and Hamburg; in February 1924 a new Hauszinssteuer, or 15% tax on rents, was introduced throughout the country as a means primarily of financing the building societies. An unemployment insurance scheme was instituted in 1926, though working hours remained long; wages, to judge from Arthur Rosenberg's figures, seem roughly to have doubled for skilled workers between 1924 and July 1928. The SPD throughout this period virtually abandoned such socialist aims as it still retained, in favour of trying to make capitalism work more justly. In this it was perhaps helped by the capitalists' own wish not to outrage their American creditors by brutal measures. Admittedly there were still those like the nationalist newspaper owner Alfred Hugenberg who

opposed the Republic as such, but henceforward the Freikorps were defunct except in Bavaria, having given way to legalized paramilitary bodies of both Right (the Stahlhelm) and Left (the SPD's Reichsbanner and the KPD's Roter Frontkämpferbund or RFB); nor were these as yet very active. In 1925 President Ebert, a symbolic survival of the German revolution, died and was succeeded by Field-Marshal von Hindenburg, who was backed by less than 50 per cent of the electorate but got in thanks to the KPD's insistence on maintaining its own candidate. When three years later Hindenburg's old chief of staff Groener became the Minister of Defence the balance of forces in the country seemed not all that unlike what it had been before 1914.

This barely affected the close ties with Russia, since the SPD were already regarded there as virtual Fascists and Ebert had even been kept in ignorance of the secret military agreements. That country too was by now primarily concerned with building up its own economy – it is noticeable that in both countries actual building, of the kind involving architects, began just about the same time – and having finally recognized that there would be no immediate revolution in the West her main aim was to keep a peaceful balance. The Locarno Pact of 1925 in some measure disturbed this, since it drew Germany towards the Western powers; Poincaré's return to office the next year however checked the process, while for some time there was a German ambassador in Moscow who believed firmly in the Eastern orientation. In 1924 both Trotsky and Radek lost their seats on the Comintern executive, and from then on the former's power declined till in 1928 Stalin could successfully exile him to Siberia: this being the major issue in internal Soviet party politics during those years.

Within the KPD too the Russians organized the fall of the 'Left' leadership under Ruth Fischer and Arkady Maslow (himself a Russian, and seemingly all the more distrusted for that) in favour of the Hamburg worker Ernst Thälmann in 1925: part of a general Comintern manipulation to get Trotsky's supporters out. As a result there was a certain swing away from that party to the SPD, though one which affected the working class on the whole more than the intelligentsia, on whom the lessons of 1919 had made a still indelible impression. Both the practical and the cultural links with Russia continued; thus Germans were the leading applicants for foreign concessions

under NEP, while Zuckmayer recalls

> a continually fluctuating influence of eastern, Russian character on Berlin's intellectual life, something much more stimulating and productive than the bulk of what came from the West in those days.

So Lion Feuchtwanger in his novel *Success* could end his story of the inflation period in Bavaria by making the young engineer–poet Kaspar Pröckl leave for a job in Nijni-Novgorod. Brecht, on whom this character was based, in fact only went as far as Berlin, where his lifelong engagement with Marxism was about to begin. His friend the director Bernhard Reich however settled in Moscow in 1924 with the young Lettish revolutionary Asja Lacis and became a Soviet citizen.

Culturally speaking Russia and Germany were still moving more or less in parallel; moreover with bodies like the IAH and VOKS (the new Soviet organization for cultural relations with foreign countries) in operation it was if anything easier than before for artists of all kinds to travel from one to the other. At the Education Commissariat Lunacharsky remained in charge, and although all artistic controversies were of course conducted in largely political terms neither state nor party as yet aimed to

Back to normal. Hindenburg sitting to Professor Arthur Fischer, the Berlin 'Photographer and Royal Portrait Painter'. From the factual report in *Das Kunstblatt* xiii, 1929

LEF's Moscow office in 1924 with, *left to right*, Pasternak, Eisenstein, Olga Tretiakova, Lili Brik and Mayakovsky

favour any particular aesthetic trend. The overwhelming impact during this period was made by the new Soviet cinema, which hit Berlin in the spring of 1926 with Eisenstein's *The Battleship Potemkin*. In *Success*, again, Feuchtwanger has his right-wing Bavarian Minister of Justice see this film, of which he gives a graphic description:

> . . . his breathing is troubled, the huge man sits still as a mouse. It is stupid to censor this sort of thing. It's there, it's in the air one breathes, it exists in the world, it exists in a world of its own; it is madness to close one's eyes.

Between 1923 and 1928 Brik's and Mayakovsky's magazine *LEF*, though it seems to have had little direct influence outside Russia, stood for a policy of lively exchanges between progressive artists in all countries, resuming the 'Left' culture of the time somewhat as the more polished *L'Esprit Nouveau* had done earlier. Thus Rodchenko much later recalled Mayakovsky bringing the latest publications from abroad and handing them out to the contributors in Brik's room, he himself for instance getting books on Grosz, Picabia and Picasso. The very existence of the magazine however depended on Mayakovsky's

personal influence, so that from 1925 to 1927, when he was often out of the country, its appearance was interrupted. But it tried to group together the tendencies represented by Inkhuk, the Vkhutemas school, Meyerhold's theatre, the Formalist critics and the new cinema of Dziga-Vertov and Eisenstein; it supplied them with a theoretical basis in the critical–sociological studies of Brik, Arvatov, Tretiakoff and others; and by publishing Grosz's work alongside that of Rodchenko, by criticizing Karl Wittfogel's plays, above all by thinking about the same problems as many Germans, it played a role in the sober, functional, technologically conscious, socially orientated mid-European culture of this time.

Along with this continuing Russian element went the new influence of America. Even in cultural terms this was in some measure practical; thus when the chief German film firm UFA got into financial difficulties in 1925 it was helped by Paramount and MGM on condition that it gave them quota certificates allowing their films to be imported, together with the transfer of a number of cinemas and the loan to Hollywood of such talents as Murnau, Jannings, Pola Negri, Erich Pommer and others who thereafter made a lasting mark on the American industry. At the same time, much more than the Russian, this influence was something in the air: *Amerikanismus*. Indeed it was felt as far as Russia itself, where Stalin reputedly called in 1924 for a combination of American matter-of-factness and Russian revolutionary spirit in order to get industry moving, a mixture also recommended by Gastev's institute, which was itself inspired by Taylor's labour-rationalization methods in America.

In Germany the new vogue could link up with the already existing myth of a skyscraper-cum-cowboy civilization across the Atlantic – as seen in wartime drawings by Grosz like 'Old Jimmy' and 'Memory of New York' – to determine the whole climate of the period. That Americanism which earlier, as in Arp's case, had stood for advanced technology, now became a way of looking, acting and doing things; thus Feuchtwanger's businessman Daniel Washington Potter who arrives with an eye to investing in Bavaria in 1923:

> He saw quite clearly whatever they showed him, and still more clearly what they wanted to conceal from him. He talked, too, with the people of the country, and if he did not understand at first, then he asked a second and a third time. He was a cute man . . .

That other cute man Henry Ford's autobiography came out in Germany in the very month of the stabilization; by the end of the decade it is reckoned to have sold 200,000 copies there. So the first Upton Sinclair novels from the Malik-Verlag were followed by a long succession of others, while in 1925 Kurt Wolff published Sinclair Lewis's *Martin Arrowsmith* and *Babbitt*, which Tucholsky greeted as an American *Buddenbrooks*; after which in 1928 Rowohlt took Lewis's books over, also introducing Hemingway in German.

Feuchtwanger, once more, parodied the American love of exact information in a book of poems called *Pep. J.L.Wetcheeks amerikanisches Liederbuch*: thus the one called 'Music'):

> In executing modern music the turnover of energy
> is immense.
> Whereas for a song by *Brahms* the energy expended
> has been reckoned
> At 32 to 35 kilogram-metres per minute, that
> required for a *jazz hit* has been found to be
> much more intense,
> Amounting *in the case of the drummer alone* to
> between 48 and 49 kilogram-metres *per second*.
>
> Against that, the Dutch ornithologist Jaap ten
> Klot has established that when *hens* of whatever
> nationality
> Hear music, particularly when played on the
> mouth-organ, the *increase in their egg output* will
> be sizeable.
> So in view of its admirably hygienic effects on
> both animal and human vitality
> A certain amount of musical activity would seem
> to be by no means inadvisable.

Precision, efficiency, the no-nonsense approach: these were the American qualities, now added to the more picturesque earlier American myth. So Brecht after moving to Berlin in 1924 could become fascinated by such ruthless millionaire figures as Dan Drew and Pierpont Morgan and other characters from Gustavus Myer's *History of the Great American Fortunes*, while at the same time elaborating his private America as a framework for what he had to say about themes nearer home. For 'Mahagonny', his imaginary sucker-catching city somewhere between Florida and Alaska, like his other vision of 'cold Chicago', was really only a topical disguise for his judgements about Berlin.

In 1927 Ilya Ehrenburg, returning to Berlin after five years' absence, wrote that the impact of that city was like 'an encounter with my time'. Such was the

Gastev's slogan: 'Let's take the storm of the Revolution in Soviet Russia, unite it to the pulse of American life, and do our work like a chronometer!'

effect of the new practical inventions which he found there, along with the smoothly functioning municipal organization. Berlin, he said, 'is an apostle of Americanism'. A year earlier the architect Erich Mendelsohn had published his photographs of the United States under the title *Amerika. Bilderbuch eines Architekten*. Like the pictures which Brecht (who knew this book) put in the published version of his Chicago play *In the Jungle of Cities*, these are city and industrial scenes, of New York, Chicago, Detroit. And indeed the whole texture of the arts in this period is overwhelmingly urban, with Berlin most consciously at the centre.

Some loved the place, like Zuckmayer, who found that

> The air was always fresh and spiced up, as it were, like in the Fall in New York; one did not need much sleep and never got tired. There was no place where you felt in such good form, nowhere where you could take so much, could stand up to so many right hooks without being counted out.

Some wrote about it, like Frank Warschauer, who helped coin the term 'asphalt literature' (after the

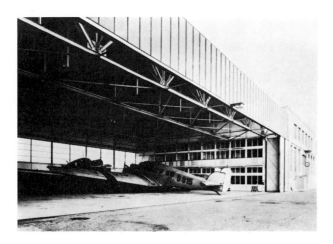

Berlin, the first modern city. *Top left*, a montage from Ruttmann's documentary *Berlin – the Symphony of a Great City*, 1927. *Right*, an advertising totem by Rudolf Belling on the Avus motorway (*above*) and the long shadow of the Funkturm, or main radio transmitter (*below*). *Bottom left*, one of Heinrich Kosina's hangars at Tempelhof, still the most centrally located city airport in Europe

asphalt used for tarring the Berlin streets) with such verses as this:

Man without stars, you, asphalt faced,
how you carry the greasy evenings around with you,
grey mist, stale air, petrol's corroding steam,
tar fumes, stink of filth and decay from basements,
night without wind and day without light,
away,
man without stars, you, asphalt faced.

Tucholsky, Ringelnatz, Walter Mehring all wrote Berlin songs with a wry twist to them, Mehring's 'Wenn wir Stadtbahn fahren' having a particularly lulling rhythm and use of repetition. Others like Erich Kästner, who arrived from Dresden in 1927, adopted an ironic precision, as in his 'Berlin in Figures':

Let's look at Berlin in statistical terms.
You can find all you want within this city's bounds,
such as 190 life insurance firms
and 916 hectares of burial grounds.

53,000 Berliners die each year
while a mere 43,000 are born and survive.
The city won't be hurt by that discrepancy, never fear,
since 60,000 newcomers to Berlin also arrive.
Hurrah!

900 bridges is roughly what the Berliners need
and their consumption of meat has topped its 303 millionth kilogram.
Every year Berlin sees some 40 attempted murders succeed.
And its widest street is known as the Kurfürstendamm.

In Berlin 27,600 accidents are annually recorded.
And 57,600 of the inhabitants cease to believe in their religions.
Berlin has 606 bankruptcies, part honest part sordid,
as well as 700,000 geese, chickens and pigeons.
Hallelujah!

There are 20,100 licensed premises, likewise there are known
to be 6,300 doctors and 8,400 ladies' tailors in this city,
also 117,000 families who would like to have a place of their own.
However, they have not got one. Pity.

Do you think it does any good to read statistics in this way?
Or are they inconclusive and should their evidence be doubted?
Berlin is inhabited by 4,500,000 people, so the figures say,
and by 32,600 pigs – which is not overcrowded.
Well, how about it?

In the new German art and literature of these years, as in the socialist and communist thinking, it is rare to find much reflection of the countryside; Brecht for instance, whose early poems are soaked in the south German landscape, henceforward wrote as a city-dweller right up to the Second World War, at which point he was suddenly surprised to find his old 'feeling for nature' returning; in fact part of Zuckmayer's success was that he was one of the rare exceptions. With Dix and Grosz, landscapes seldom occur before 1933, except as a background to violence or to the antics of city-dwellers on their Sunday outings. In the whole great wave of modern building which now began, and which forms one of the outstanding features of the period, there was just one contemporary-style farm building, Hugo Häring's very interesting Gut Garkau (which the Lissitzkys went to visit).

But artist after artist reflected the city. Thus Masereel, whose widest public was always in Germany, published *Die Stadt* with Kurt Wolff in 1925, a hundred woodcuts, followed by the 112 drawings of *Bilder der Grosstadt* with Carl Reissner the following year, not to mention another laconically-captioned set of urban drawings, *Capitale*, in France after 1933. Gustav Wunderwald, a former scene designer, began painting those pictures of shabby Berlin buildings and streets that earned him the name of 'the Berlin Utrillo' (quite misleading for his approach was much more unflattering). Kurt Jooss, the Essen choreographer, devised the ballet *The Big City* to music by Alexander Tansman. The former painter Walter Ruttmann, with Carl Mayer (of *Caligari* fame) as his scriptwriter, compiled the documentary *Berlin. Symphonie einer Grosstadt*, following Karl Grune's *The Street* and a whole succession of other German 'street' films, or films about women of the streets (one obvious way of romanticizing and spicing up the urban scene) or films from the 'milieu' of Heinrich Zille, a draughtsman of working-class scenes much loved by the Berliners.

In 1931 Robert Seitz and Heinz Zucker published *Um uns die Stadt* 'Eine Anthologie neuer Grosstadt-

dichtung', an anthology of new big-city poetry including work by Max Barthel, Feuchtwanger, Herrmann-Neisse, Kästner, Mehring, Ringelnatz, Tucholsky, Erich Weinert and others. The most powerful of these verses came from the unfinished cycle called 'A Reader for Those who Live in Cities' which Brecht wrote during his first two years in the capital: a spare, unsentimental statement of big-city morality as it struck him on arriving from the deceptive geniality of Bavaria. No other work shows quite so strongly how the city theme imposed its own economical, impersonal style:

> When I speak to you
> Coldly and in general terms
> With the driest words
> Not looking at you
> (Seemingly I fail to recognize you
> In your particular nature and difficulty)
>
> I speak to you merely
> Like reality itself
> (Sober, not to be bribed by your particular nature
> Tired of your difficulty)
> Which it seems to me you fail to recognize.

This crushing brutality, with its weakest-goes-to-the-wall ethos, demanded new distractions: cinema, jazz and sport; all three associated largely with the Anglo-Saxon world. So the first two become part of the imagery of the period, as well as a source of new artistic forms, while sport becomes a source of artistic forms as well as a theme. Like the big city itself this was international (Léger's paintings of 'La Ville', Martinů's *Half-Time*, Honegger's 'symphonic movement' *Rugby*, 1928), and can be found reflected both in west European and in Russian art. But nowhere was the myth of sport more potent than in Germany, where a whole series of sporting terms like 'k.o.', 'training', 'form' and (as Brecht spelt it) 'panjjing ball' now entered the language. Grosz and Heartfield were photographed sparring with one another; Piscator had a miniature gymnasium in his flat (designed by Gropius and Breuer); Anton Räderscheidt painted his big blonde nudes toying with a tennis racket or swinging on the parallel bars, always observed by a gloomy man in a bowler hat. Baumeister, again, did a whole series of paintings and collages on sporting and athletic themes, while Grosz made a portrait of Max Schmeling the heavyweight in his boxing kit.

It was a cult that could easily be pushed to absurd lengths, as in a case quoted by Helmut Lethen, who

Artists and the new myth of sport. (1) A soccer montage by Willi Baumeister, from Graeff's book of 1929. (2) Photogram by Lissitzky, 1930

links it with what became called 'Girlkultur', the precision drill of the Broadway-style chorus line. To *Die Literarische Welt*, a monthly magazine started by Rowohlt, such things were symptoms of 'the platinum age' when the amazon would come into her own and

> from her splendidly trained flanks would now and again unleash a child as if driving a Slazenger ball with her racket.

Brecht, himself extremely unathletic, wrote a long boxing poem, a story called 'Hook to the Chin' and part of a ghosted autobiography of the middleweight champion Paul Samson-Körner which appeared in a short-lived sports magazine called *Die Arena* edited by Franz Hoellering and designed by Heartfield in 1926; other contributors included Huelsenbeck, Erich Weinert and the reporter Egon Erwin Kisch. Brecht's aide Elisabeth Hauptmann, too, translated Ferdinand Reyher's play *Don't Bet on Fights*, which was performed at the Staatstheater in 1929. For her and Brecht sport was a form of entertainment whose principles ought to be taken over by the theatre, with the stage as a brightly lit ring devoid of all mystique, demanding a critical, irreverent attitude on the part of the audience.

More than ever it was an age dominated by technology. This was in the first place quite practical, part of the whole process of industrial expansion and reconstruction in both Germany and Russia; indeed one of the most successful novels of the time in both countries was Gladkov's *Cement* (1924), which centres on the rebuilding of the Novorossisk cement works under NEP. But the changed economic background also gave a certain fillip to the old machine romanticism of such late nineteenth-century innovators as Verhaeren and Kipling and, following them, the Futurists. Léger's machine paintings, his film *Ballet mécanique* and the Antheil music, Prokofieff's ballet *Le Pas d'acier* with its constructivist setting, Honegger's *Pacific 231* and Karl Čapek's robot play *RUR*, particularly as staged in Vienna with Kiesler's 'electrically-controlled' kinetic set: all these appeared as part of the new 'Machine Age' which *The Little Review* celebrated in a New York exhibition in 1927.

The danger here was that machines would go on being looked at romantically instead of being accepted for what they were: thus Ezra Pound, writing about Antheil's music:

Machines are not literary or poetic, an attempt to poeticize machines is rubbish. . . . The lesson of machines is precision, valuable to the plastic artist, and to literati.

Le Corbusier thought that the mistake of the Constructivists (apparently he was as yet unaware of the 'productivist' wing associated with *LEF*) was to think that art has merely to look (or sound) like a machine; the more profound aesthetic was one of 'purity and exactness, of dynamic relationships that set the mathematical cogwheels of our intelligence to work'. Lissitzky again, in the 'Nasci' (or Birth) number of *Merz* which he compiled in mid-1924, argued that 'We've had quite ENOUGH machine/machine/machine/machine'; since after all

> The machine is simply a paintbrush, and a very primitive one at that, for shaping the canvas of our picture of the world.

In other words the impact of the machine in the late 1920s was a much subtler and more penetrating one, ranging from a Corbusier-like precision through all the externals of machine art (sometimes very imprecisely rendered, as in Becher's poems *Maschinenrhythmen* of 1926), to a practical engagement with industry, as seen in the development of Russian

(3) Grosz's portrait of the German heavyweight Max Schmeling, who became world champion in 1930. Now in Axel Springer's collection

Artists and technology. (1) Clip from the Léger/Dudley Murphy film *Ballet mécanique*, 1923–4

productivism and of the Bauhaus, and in the artists' own concern with new technical tools. This last manifested itself in all kinds of ways: the branching out of painters into photography (Rodchenko, Moholy-Nagy, and the many others who took the trouble to master that technique); the films of Hans Richter; the post-Gutenbergian typographical ideas of Lissitzky; the theatre technology of Piscator with its new machinery and its blending of traditional stage methods with sound reproduction and photographed or animated film; the interest shown by Hindemith and other composers in developing the use of mechanical instruments. In 1926 the *Kunstblatt* published an article called 'Praise of the Gramophone' by Stuckenschmidt, who was now emerging as a leading music critic, pointing out that by means of that device one could now hear Stravinsky's principal works – Stravinsky had also just written a *Serenade* specifically for recording – as well as 'the best jazz bands in the world, Paul Whiteman's and Bill Arnold's', and claiming that the gramophone record would help to evolve

> a generation which will understand better than us the real sense and purpose of the machine, and treat technology as an ideal means of simplifying human existence rather than as an object of breathless adoration.

All these different aspects of the machine age could be found reflected in the work of one artist, as in the case of Brecht, who could write a 'Song of the Machines' every bit as naïve as Gastev's Proletkult poem quoted earlier, while using the new machinery himself – he was one of those still fairly rare poets who write direct on the typewriter – and trying in essays like 'The Radio as an Apparatus of Communication' to make sense of the technological revolution in the arts. Already the standard of theatre criticism in Berlin and certain other major cities was amazingly good, with articles as shrewd and thorough as have ever been seen elsewhere. From 1925 on however the same perceptiveness was also turned on the products of this revolution, as in Kurt Weill's reviews of broadcast music and the now classic writings of Kracauer, Béla Balázs and Rudolf Arnheim on the cinema. Perhaps because so much was developing so fast, and the society itself was in some ways still a new one, there was little sense among such critics of any hierarchy in the media, with some art forms counting as high and others too profane to be intelligently discussed.

10 Impersonal art, the collective, facts, reportage, montage

Devaluation of 'personality' and the human figure; unimportance of artistic individualism. Collectives and collective art. The emphasis on facts: Kino-Eye, reportage in Russia and Germany, Piscator's documentary theatre. Montage as the corresponding structural principle: effects on Eisenstein of Dadaist photomontage. Its analogies and repercussions in the new writing, from Joyce to Brecht. Annexation of lowbrow forms: circus, revue, jazz. No new -Ism but a closely interlocked modern culture, ranging from Chaplin to Le Corbusier.

Everything combined to make this culture a consciously impersonal one. First and foremost there was still the revolutionary sense of belonging to a huge community, whether this was 'the masses', the proletariat or the Communist party. This, combined perhaps with some realization of the powerlessness of the artist in any such vast social context, was what gave men like Grosz their conviction that individuality was outdated and must be 'discarded'. Then there was the concern with the object, the 'Veshch' or 'Gegenstand', and the objective art which would deal with such things. By definition subjectivity, the personal viewpoint, was very largely ruled out; nor was much room left for the human

being even as a theme for art. He had already been intuitively mechanized by the Italian Metaphysicals (one reason perhaps for their influence on other postwar artists), and much the same marionette-like interpretation of the human figure can be seen in Goll's farces, Schlemmer's ballets and Meyerhold's neutrally-clothed 'biomechanical' actors; these too are on their way to being animated robots, objects on legs. The machine itself largely dwarfed the people operating it, while its laws seemed to leave no room for individual inspiration, no margin for error. In the arts as elsewhere machines could in extreme cases dispense with humanity except in so far as humans were needed to start or stop them. It did not, for instance, make much difference what kind of a personality had his feet on the pedals of the Pleyela.

As for mechanical reproduction in the visual arts, the very idea of multiplication of the work of art seemed likewise to demand an abdication of individualism: 'Who cares about personality?', Graeff had written in a *De Stijl* article of 1922 calling for 'photomechanical reproduction':

> We have buried all names.
> Starting with our own.

So Willi Wolfradt, in a critique of Baumeister's paintings of athletes in 1929, wrote that the concept of impersonality was 'no ephemeral slogan but a phenomenon of the reality of our time, no intellectually posed demand, capable at once of being intellectually contradicted, but the result of technical

(2) Still from Dziga-Vertov's *The Man with the Movie Camera*

The impersonality of the athlete. Two pictures by Baumeister: *above*, a montage from *foto – auge*, 1929; *below*, *Woman Skipping*, a lost painting of 1928 reproduced with Willi Wolfradt's article in *Der Cicerone* no.10, 1929, cited overleaf

and sociological processes'. He saw one such process in the ironing-out of physical idiosyncrasies by sport.

Logically Lissitzky could omit both Klee and Braque from his choice of illustrations for the 'Nasci' *Merz* on the ground that 'much as I respect the individual touch it must have no personal element': in other words, originality must emerge despite the artist's will, almost against it. The prevalence of such views, in flat contradistinction to those of a Zola or of a Picasso with their focus on 'temperament', was such as to have visible repercussions on the art of the time. Thus first of all the 'handwriting' of the individual became deliberately played down: the painter's more or less calligraphic brushstrokes, the musician's vibrato, the stylistic quirks of the writer. Then the search for new forms had to slacken off, for what mattered was not so much how you expressed yourself but what you were expressing and whether it was understood. Again, if the personality of the creative artist was no longer of much importance, then there was that much the more reason to study the work of art itself and find out as precisely as possible what laws it seemed to obey; so in their 'Bauhaus books' Klee and Kandinsky tried to codify the rules of their respective kinds of art, much as *L'Esprit Nouveau* had published researches into different aspects of aesthetics and the Russian Formalists had discarded 'biographic' criticism of past writers in favour of detailed analysis of texts. Finally a similar approach was adopted to the subject-matter of art, where the human individual, in so far as he was unavoidable (e.g. in the novel or the theatre), must in consistency be dealt with without psychological interpretations, in terms of what he could more or less objectively, 'concretely' and in line with the new behaviourist psychology be seen to do.

This in turn led on to that dissection of personality which gave Pirandello his particular relevance, even to an attack on the very notion of personality such as Brecht launched in his play *Mann ist Mann*. 'We Marxists', wrote Lunacharsky's deputy M. N. Pokrovsky in an effort to explain the importance of Lenin,

> do not see personality as the maker of history, for to us personality is only the instrument with which history works. Perhaps a time will come when these instruments will be artificially constructed, as today we make our electric accumulators.

The corollary of this approach was the development of collective works of art: the Grosz–Heartfield

collaborations, the collective dramaturgy of Piscator's theatre, the theatre ensembles like the later Piscator-Kollektiv and the Gruppe Junger Schauspieler, the blurring of literary identities by Brecht with his unacknowledged borrowings and his group of backroom collaborators, finally Gorki's great scheme for a history of factories and the collective report on *The White Sea Canal* which he was to preside over. To those who saw things in this way the organizing of such elaborate new creative apparatuses as a radio programme or a film production was clearly as much of a challenge as the mastering of the mechanical techniques involved. It was worth some sacrifice of individuality to get them working right.

'The collectivizing of work on books strikes us as a progressive development', wrote Tretiakoff in 1928. This, to him and to other *LEF* critics, was part and parcel of the new literature of fact, the 'factography' that was to supersede escapist fiction, the 'biography of things' replacing the biography of more or less heroic individuals.

> Books like *Forests, Bread, Coal, Iron, Flax, Cotton, Paper, Locomotive, Factory* have yet to be written. We need them, and the only satisfactory way to write them is on 'biography of things' lines.

Though nothing quite so original was done – for *Cement* is an old-style romantic novel conflicting with an inhuman new ethos of personal and family relationships, its title and setting being partly symbolic – the prevalence in the later 1920s of reportage and documentary techniques is mainly due to Russian influence. 'I am Kino-Eye', wrote Dziga-Vertov in his manifesto in *LEF*. 'I am a mechanical eye.' This was both a response to Lenin's demands of the new medium, and a reaction against the rubbishy feature films imported under NEP: in Dziga-Vertov's words, 'the film drama is opium for the people'. Instead there must be what Tretiakoff termed a 'fact factory' to deal with the collection, analysis and piecing-together of factual material.

Taking Reed's *Ten Days that Shook the World* as their first model, the Russian leftists accordingly built up a rich corpus of documentary work in different media. Tretiakoff, who had spent his two years in China as a part-time *Pravda* correspondent, based his play *Roar, China!* on the Wan Hsien Incident of 1924, when a British gunboat took reprisals for the murder of an American businessman called Hawley; and also wrote a 'bio-interview' of a Chinese student under the title *Den Shi-hua*. Eisenstein used lay actors and real

Reportage and the literature of fact. Rodchenko's photograph of the *LEF* critic Osip Brik.

settings to reconstitute great historical events; Vertov progressed from newsreels and short documentaries to the full-length 'film poem' *A Sixth of the Earth* (1926). Esther Shub, closest of the film makers to the ideas propounded by *New LEF*, made her *Fall of the Romanov Dynasty* entirely out of old newsreel material. This movement could be extended and decentralized, for, as Tretiakoff put it,

> Each boy with his camera is a soldier in the war against the easel painters, and each little reporter is objectively stabbing *belles-lettres* to death with the point of his pen.

Reportage as a genre and as a term seems first to have hit Germany through the writings of the Communist journalist Egon Erwin Kisch: *Der rasende Reporter* in 1925, and *Zaren, Popen, Bolschewiken* about the new Russia immediately following. 'Nothing is more imaginative than matter-of-factness', said the introduction to the former, which cited Schopenhauer as proof that 'given the right material perfectly ordinary or boring people can produce extremely important books'. Long before Isherwood, Kisch presented himself as an impersonal screen, a neutral observer letting the facts speak for themselves. Tucholsky, who knew him well, at first shot down this unduly mock-modest claim, but came to feel that the genre was worth pursuing further, and later wrote regretting that there was not more reportage based on the same combination of knowledge, observation and style.

Translations of some of the best Russian reportage followed: Larissa Reisner, Ilya Ehrenburg. At the

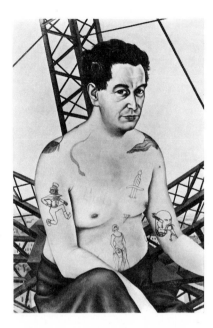

Two portraits of Egon Erwin Kisch. *Above*: by the ex-Dadaist Christian Schad 1928 (now Hamburg Kunsthalle). *Below*: by the Berlin photographer 'Umbo'

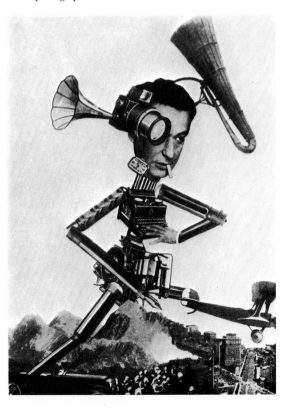

same time a whole new documentary tradition was started by Piscator's KPD pageant of 1925, *Trotz alledem!*, which absorbed factual material into its text and used slides and film projections to support it. The ensuing techniques determined Piscator's approach to theatre throughout his life, also influencing others around him such as Brecht who used them for rather different ends. As for the cinema Pabst's use of documentary shots and natural lighting in *The Love of Jeanne Ney* seems to be based on Eisenstein's example, while *Berlin* follows that of Dziga-Vertov. Here Ruttmann, with his background as a maker of abstract films, edited machine movements in such a way as to meet Dziga-Vertov's principle that

> We find the delights of the dancing parts of a mechanical saw more congenial and easier to understand than those of human beings dancing to entertain themselves.

The logical consequence of reportage or factography was montage. The Russian Formalist critics seem to have been the first to realize that such material, consisting as it did of so many diverse facets of reality, could not be confined within the 'Procrustes's bed', as Brik termed it, of a plot but had to be assembled in some other way. Montage then was the editing process by which the various facets became put together in a new and significant order. The term was used by Eisenstein in his earliest theoretical article, in the third issue of *LEF*, which was called 'Montage of Attractions' and derived from the circus-style Ostrovsky production for which he and Tretiakoff had been responsible at the Proletkult First Workers' Theatre. Here the elements which had to be pieced together were not film shots but a number of different theatrical attractions or turns, and the analogy which Eisenstein saw was with the photomontage practised by Heartfield and Grosz, who would draw on a 'pictorial storehouse' of images, then cut and combine them to make a well-constructed work.

This ultimately Cubist collage principle, which was already being applied in Germany, was at the root of the more elaborate theory of film montage which Eisenstein and other Soviet directors subsequently went on to work out. His first film, *Strike*, was conceived as a montage of shocks, of images which could be expected on scientific, Pavlovian grounds to produce shock feelings in the spectator; then in *Potemkin* and subsequent films the process became more consciously 'dialectical', picking on contrasting images so as to bring out the 'con-

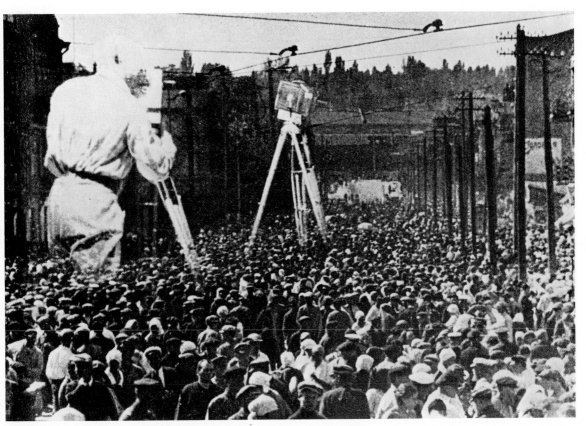

Trick montage by Dziga-Vertov from *The Man with the Movie Camera*

traditions' whose resolution each time moves history a step onwards. There was room, it seemed, for a variety of different approaches and methods; thus where Eisenstein summed montage up as 'collision' Pudovkin aimed rather at 'linkage', while Dziga-Vertov wrote still more generally that montage was 'the organizing of the visible world'. What remained clear was that it was a method of turning a mass of disparate items into an artistic whole, allowing the items themselves no longer to be planned from the outset but to be collected or devised almost at random. Here was a structural principle which was no more to be confined to the cinema than to pictorial collage. It could have the widest possible application.

Techniques akin to collage were already to be found in the novel, particularly in two of the great landmarks of 1922 which now arrived in German translations. Thus *Schweik*, with its interweaving of real-life incidents and characters, its anecdotes and

quotations and shifts of linguistic level, appeared in 1926; *Ulysses*, with its journalistic parodies and its alternation of styles, in 1927. Writing a year later, Victor Shklovsky could note that

> my idea of a literary work as being all of a piece has been superseded by a sense of the value of the individual item. The fusion of the various items interests me less than their contradictions.

But even to novelists the example of works like *Potemkin* was stronger than purely literary precedents, and it was this, as Feuchtwanger pointed out to Eisenstein's biographer, that led them to start experimenting with 'the film technique of rapid sequence of pictures, the simultaneity of different situations'. Aside from certain books written, like Babel's 'film-novel' *Benia Krik*, in deliberately cinematic style, we accordingly get montage entering the novel proper, as with Feuchtwanger's own *Success* where the thread is now and again broken by a

chapter giving 'An Excerpt from the History of Munich' or 'Four Bavarian Biographies' that have nothing to do with the story –

> Johann Maria Huber, Civil Servant in Munich, attended the board school for 4 years, and a secondary school for 10. 1 year he had to take twice over. His vocabulary consisted of 1,453 German words, 103 Latin, 22 French, 12 English, 1 Russian . . .

– or John Dos Passos's *U.S.A.* trilogy, with its intercut sections headed 'Newsreel' (with Joyce-like parodies of the popular papers) or 'The Camera Eye' (a plain allusion to Dziga-Vertov).

With Brecht the same montage technique spread to the drama, where the old Procrustean plot yielded to a more 'epic' form of narrative better able to cope with wide-ranging modern socio-economic themes. That, at least, was how Brecht theoretically justified his choice of form, and from about 1929 on he began to interpret its penchant for 'contradictions', much as had Eisenstein, in terms of the dialectic. It is fairly clear that in Brecht's case the practice came before the theory, for his actual composition of a play, with its switching around of scenes and characters, even the physical cutting up and sticking together of the typescript, shows that montage was the structural technique most natural to him. Like Hašek and Joyce he had not learnt this scissors-and-paste method from the Soviet cinema but picked it out of the air.

Finally, in the mixture of influences and methods helping to make up the mid-1920s culture, came the new appreciation of supposedly lowbrow forms of art. Though this had originated in France, with *Parade* and 'Les Six', the avant-garde in that country had subsequently rather lost interest; *L'Esprit Nouveau*'s view that the road to a new theatre led through the music hall remaining without echo. Only Léger still wrote of the virtues of popular forms, which also permeate the films of René Clair; otherwise they were no longer seen as models for serious artists. For the Russians and Germans however the impact of such ideas, making itself felt somewhat later, was reinforced by a politically grounded concern with the popular audience. If art was to have what the Russian Constructivists termed a 'social task', then intelligibility and accessibility were clearly important factors.

So Eisenstein could legitimately adopt circus techniques, just as Grosz and Mehring could appear in cabaret and Brecht before leaving Munich worked on the stage and film sketches of that great comic Karl Valentin. In 1925 a certain Walter von Hollander

proposed what he called 'education by revue', the recruiting of writers like Mehring, Tucholsky and Weinert to 'fill the marvellous revue form with the wit and vigour of our time'. This form was itself a kind of montage, and Reinhardt seems to have planned a 'Revue for the Ruhr' to which Brecht would contribute – 'A workers' revue' was the critic Herbert Ihering's description – while Piscator too hoped to open his first season with his own company in 1927 by a revue drawing on the mixed talents of his new 'dramaturgical collective'. This scheme came to nothing, though Piscator's earlier 'Red Revue' – the *Revue roter Rummel* of 1924 – became important for the travelling agit-prop groups which various communist bodies now began forming on the model of the Soviet 'Blue Blouses'. As for jazz, this is when it got taken up by such younger contrapuntalists as Ernst Křenek and Kurt Weill, who were less easily bored with it than Milhaud and saw a serious point in using its language and developing this further. For it was not the evolution of new formal conventions that mainly concerned these people, but the possibility of a shift in the social basis of the arts.

Such then was the climate of the time and the type of creative approach which it encouraged. The contrast with the Expressionism prevalent only a few years earlier scarcely needs underlining: objectivity in place of the previous intense subjectivity, self-discipline in lieu of passion, scepticism and dry humour instead of solemnity and faith. The fact that many of the men concerned had passed through an Expressionist phase, whether as students (Schwitters, Dix) or as fully formed artists (Becher, Goll, Gropius, Taut), makes the change all the more striking: their attitudes had altered while the urban, mechanized background to their work remained much the same.

If the earlier movement had been remarkable for its all-embracing nature (taking in everything from poetry to graphics to cinema), this was even more the case now, and in going on to trace the new movement in one art after another we must not forget how closely interwoven it all seemed. Open an issue of *Das Kunstblatt* for 1926, for instance, and you will find an article by the Swiss architectural critic Sigfried Giedion on Le Corbusier's La Roche house, along with a report on a one-man show by Otto Dix and stills from Chaplin's *The Gold Rush*. Or look at the 1930 double issue of *Das neue Frankfurt*, which reports on five years of municipal rehousing in that city; it also reviews the world premiere of

Schönberg's *Von heute auf morgen*, criticizes Piscator's *Das politische Theater* and reproduces a Baumeister recently bought by the Berlin National-Galerie. Or examine the whole Piscator nexus: Gropius designed him a 'Totaltheater'; Brecht, Mehring, Jung, Toller were among his writers; Grosz drew the animated film background for his *Schweik*, while his composer Edmund Meisel provided the score for *Potemkin* and also worked on Ruttmann's *Berlin*. Or note Schlemmer on a week-end visit to Berlin in 1928, when he saw Chaplin's *The Circus*, a Léger show at Flechtheim's gallery, and the Piscator *Schweik*. Clearly there was a lot else going on at the same time, and there were many works of art which harked back to Expressionism or beyond, or commercialized the new climate in a modish and superficial way. But at the centre of all the arts in Germany in the second half of the 1920s there was a remarkable consistency of outlook and method, and it is this which we shall now concentrate on, hard as it is to give it a precise name.

'Tangible reality'. Karl Hubbuch's big watercolour *The Cologne Lady Bather*, 1927, from the Mannheim Kunsthalle

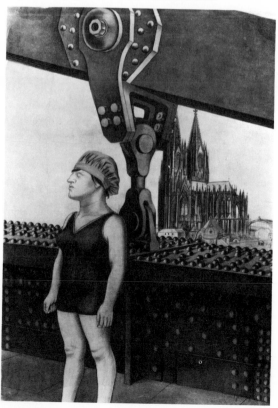

11 Neue Sachlichkeit, objectivity, Verism, the Magic Realists

The name, and its origin in the 1925 Mannheim exhibition. Division of this show between Verist social critics and Italianate Magic Realists, with Beckmann as an independent outsider. Relation of the new factual style to L'Effort Moderne and other non-German trends; ensuing decline in the work of Dix and Grosz. Aspects of 'Neue Sachlichkeit' in more abstract Art: Schlemmer, Baumeister etc.

Hartlaub's show of pictures of 'tangible reality' took place at the Mannheim Kunsthalle in the middle of 1925, and the title which he adopted for it, 'Die neue Sachlichkeit', quickly caught on as describing the new post-Expressionist trend. Here was a phrase which seemed to encapsulate the spirit of the time, recalling as it did both the 'Gegenständlichkeit' of the Berlin Dadaists and the 'Sachlichkeit' of the prewar Werkbund, that same 'Sachlichkeit' as had been specified as the hallmark of good journalism by Egon Erwin Kisch. Both these words can be translated by 'objectivity' in English, a term which at least covers something of what they mean. So the theme song of the Schiffer–Spoliansky revue called *Es liegt in der Luft* (or 'There's Something in the Air') of 1928, which took up Hartlaub's title and popularized it, may be rendered:

> There's something in the air called objectivity,
> there's something in the air like electricity.
> There's something in the air, and it's in the air, the
> air.
> There's something in the air that's pure silliness,
> there's something in the air that you can't resist.
> There's something in the air, and it's in the air,
> And you can't get it out of the air.
>
> What has come over the air these days?
> Oh, the air has fallen for a brand-new craze.
> Through the air are swiftly blown
> Pictures, radio, telephone.
> Through the air the whole lot flies,
> till the air simply can't believe its eyes.
> Planes and airships, think of that!
> There's the air, just hear it humming!
> Trunk calls, Trios in B flat
> In the gaps that are left a picture's coming.
>
> *Refrain*: There's something in the air called
> objectivity ... (and so on).

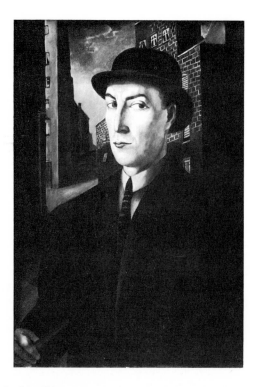

All the same, the idea is rather more complex than the popular notion of it, and the word 'objectivity' soon becomes an obstacle to understanding. For where the 'Gegenstand' was the object (or 'Veshch') as it concerned the Constructivists – i.e. the actual concrete thing – a 'Sache' is a fact, a matter, a 'thing' in a more abstract sense. Its quality of 'Sachlichkeit' then implies objectivity in the sense of a neutral, sober, matter-of-fact approach, thus coming to embrace functionalism, utility, absence of decorative frills. To render 'Die neue Sachlichkeit' therefore by 'The new objectivity', as is commonly done in English-speaking countries, is only partially right, and we have to be careful not to let the looseness of the term lead us to use it in contexts where the Germans would not have used it themselves. Like all such -ismic expressions it has to be treated historically, not as a handy descriptive label; and the first thing to do is to see how it was originally applied.

There were 124 pictures by thirty-two artists in the Mannheim exhibition, which travelled the same autumn to Dresden and other middle German cities including Dessau, the Bauhaus's new home. Other exhibitions under the same title followed, notably one at Karl Nierendorf's gallery in Berlin in the spring of 1927. The artists in question fall into two main groups: at Mannheim there were, first of all, the coolly uncomplimentary social commentators like Grosz, Dix, Schlichter, Georg Scholz of the former Novembergruppe 'opposition', along with Karl Rössing from Essen, Räderscheidt, H. M. Davringhausen and Karl Hubbuch. Tacked on to these and seemingly under the wing of the critic Franz Roh, who was one of Hartlaub's advisers in planning the show, were the more Italianate, mainly Munich-based artists like Schrimpf, Mense and Alexander Kanoldt, who fell under Roh's rival label of Magic Realism or 'Magischer Realismus': a term implying a certain debt to 'Metaphysical' painting and thereby a family connection with the pictorial ideas even then being promoted by the Surrealists in France.

Except that both groups painted figuratively they had little in common, while between them stood Max Beckmann, independent as always but at that point much closer to the first group, particularly in his graphic work. After 1925, as the allegorical element came to dominate in his painting, he no longer showed under the 'Neue Sachlichkeit' label, but the original exhibition nonetheless contained five of his paintings from the years 1917–23, to which Hartlaub subsequently added others. In that period, while

A hard-headed generation. *Above*, Carlo Mense's portrait of the painter H. M. Davringhausen, 1922, now in the Wallraf-Richartz Museum, Cologne. *Below*, *Man and Streetlamp*, a lost painting by Anton Räderscheidt, 1924

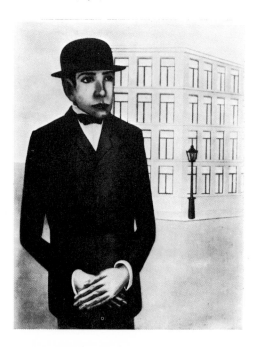

many of his fellow-Verists were still embroiled with Dada, Beckmann was painting Frankfurt street scenes, portraits, a bar in Baden-Baden, with a new firm relentlessness. This was when a critic described coming across him in an empty room of the Frankfurt station restaurant, sitting alone with a sweaty face, smoking a cigar with a champagne bottle before him: 'I've never met such a solitary man'.

In subsequent Neue Sachlichkeit shows further artists were included, most of them akin to the more socially-conscious of the two groups. Christian Schad, for instance, the former Dadaist who originated the photogram even before Man Ray, now resurfaced with Italianate paintings that were soon followed by hard Veristic portraits: of Kisch, of the twelve-tone composer Josef Matthias Hauer (both with Eiffel Tower girders in the background), of a Count Saint-Génois d'Anneaucourt with his hands in his dinner-jacket pockets and two smart, tough, transparently-clad ladies behind him. Carl Grossberg (said to have been one of the early Bauhaus students, though his name is not on the surviving lists) made careful drawings of industrial installations for different firms, then began painting increasingly fantastic factory pictures: great stylized machine-rooms populated by the odd bird or bat. Fritz Radziwill, a friend of Dix's from north Germany, painted like a mixture of Sunday painter and old master, often placing some disturbing minor incident in his shabby settings. Hans Grundig from Dresden joined the KPD in 1926 and concentrated on explicitly political and proletarian themes. Others again took no part in the group exhibitions but clearly belong in the same school: thus throughout the later 1920s Wunderwald was painting his views of Berlin, with its elevated railway, its iron bridges, its tramlines and peeling poster hoardings. Yet another Dadaist could be seen turning to Verism with the smooth still-lifes painted around 1927 by Hannah Höch, formerly an adept of photomontage.

To some extent these people were only doing what painters elsewhere had done slightly earlier without bothering to find a particular name for it. Part of the effect of the postwar 'rappel à l'ordre' at Rosenberg's Galerie de l'Effort Moderne, for instance, had been the emergence of former Cubists as new hard, smooth, Veristic painters: less ruthless than those in Germany, perhaps, but not all that unlike them. Thus around 1922–5 Auguste Herbin, a Cubist before and a non-figurative painter of some distinction again later, was painting buildings and landscapes in a flat,

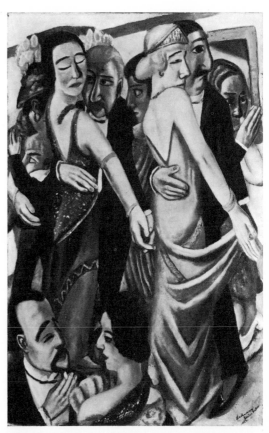

Beckmann, 1923 vintage. His painting of a 'Tanzbar' in Baden-Baden, now in the Munich state collections

poster-like realistic style, while another ex-Cubist Jean Metzinger was doing the same kind of thing in rather more ingratiating style. Léopold Survage too moved away from Cubism after 1919, as did Le Fauconnier, another realist convert.

To these can be added the American expatriates who had begun working under the impact of Léger and the Purists, starting with Gerald Murphy whose enormous painting of liner funnels at once echoed Le Corbusier's notions of 'les yeux qui ne voient pas' and had the clean literalness of Carl Grossberg's pictures. Charles Sheeler was a similar instance, a city-conscious artist and photographer whose ideas of composition had been learnt in the same school. The Constructivist-influenced Lozowick too reflected something of this spirit in his paintings. Back in the U.S. itself Edward Hopper was now beginning to paint those urban and architectural scenes which relate him too to Die Neue Sachlichkeit, though

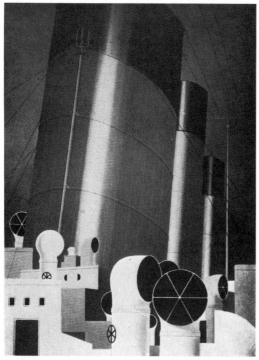

Gerald Murphy's *The Liner*, 1924. A huge painting now lost, but reproduced at the time in *L'Esprit Nouveau* and the *Bulletin de l'Effort Moderne*

coming nowhere near that school's harshness. Later there would be other artists in the same tradition: Ben Shahn and, on the Magic Realist side, the Englishman Edward Wadsworth with his calm, smooth mechanical compositions, deriving ultimately from a more Futurist or Vorticist view.

There was even for a time a parallel development in the USSR, traceable back to the First German Art Exhibition which was held in Moscow in October 1924 and visited Leningrad three months later. This huge show, involving 126 artists of all schools, was organized by Muenzenberg through the IAH and its Aid to Artists and supervised by Otto Nagel; and its impact can be compared with that of the Berlin Soviet exhibition of 1922. Though it included nine exhibitors from the Bauhaus and fifteen from the *Sturm* circle (among them Baumeister) far the strongest impression was made by the Verists of the Red Group: Grosz, Dix, Schlichter, Griebel, Davringhausen and seven others. It was these who led Lunacharsky to comment that the Germans had 'surpassed nearly all our artists in the degree of their

mental assimilation of the revolution and the creation of revolutionary art'.

Others were less enthusiastic, commenting on the element of sadism, of grimacing as evidence of a sick culture. 'When you come down to it', wrote the critic Fedorov-Davidov in *Pechat i revolutsia*, a little unfairly,

the social protest of the German artists is directed exclusively against prostitution. . . . Undoubtedly prostitution is among Germany's most flagrant problems but is it the most important, let alone the only one?

Nonetheless the new Association of Easel Painters or OST, which was formed just at that time with Shterenberg as its leading figure, parallels several aspects of Die Neue Sachlichkeit, not least its debt to Constructivism (for the group included a number of former Vkutemas pupils as well as the former Cubo-Futurist Lebedev, now visibly influenced by Grosz) and its revival of the portrait, as instanced in works like V. N. Perelman's 'Worker-correspondent' of 1925.

Much of the German work only originates after the Mannheim show, and indeed 1925 seems to mark a new turn in the art of many of the painters concerned. Thus Grosz now returned to oil painting, which he had neglected for some years; the memorable portrait of Max Herrmann-Neisse which he showed at Mannheim – the little hunched poet in his dark suit and spats – being followed by others: of Mehring, of Schmeling the boxer, of his mother, of Herzfelde, his patron Felix Weil and so on. These were literalist pictures, the work of a skilled draughtsman rather than a painter, and with them go some new literalist preparatory drawings. Yet, inconsistently enough, the same year saw Grosz and Herzfelde issuing their polemical pamphlet *Die Kunst in Gefahr*, which summed up the trend towards 'the dismantling of the artist in his present form' and viewed the laborious process of oil painting as being 'out of tune with the times' compared with the new collective art of the cinema. According to this essay the artist now had two logical choices: either he could merge in industry as a designer or advertising man, or else he must become a propagandist for the revolution.

Up to a point Grosz himself was still following the second course, since he continued to do cartoons for *Der Knüppel* till it ceased publication in 1927; moreover both in Russia and in Germany he was recognized as a major Communist artist, though *Die Rote Fahne* was already commenting on his loss of interest in politics by the end of that year. At the same

time he also had his contract with Flechtheim –
something that the pamphlet hardly allowed for – and
if his first trip to Paris in 1924 had been productive
enough his wife could complain in 1925 that he had
spent seven weeks there simply talking and drinking
and visiting ten different bars a night. It seems to have
been an impossible position to maintain with any
kind of integrity; the drinking increased (though it is
difficult to state at what point it became self-
destructive), the quality of the work went down. In
1927 Grosz told a friend that he meant to produce
'saleable landscapes' for Flechtheim so as to win time
for painting big satirical pictures; however, the
landscapes resulting from half a year's stay in France
were feeble and the ensuing big picture (*The Rabble
Rouser* of 1928) hardly up to standard. Not long
after that Flechtheim cancelled the contract. Good
drawings still appeared in Grosz's illustrated books,
but too often they were earlier drawings re-used, and
even so no new albums appeared between 1925 and
1930. Only when a worthwhile job came along, like
the illustrations to Brecht's 'children's poem' *Die drei
Soldaten* or the cartoon film and cut-out puppets for
Piscator's *Schweik* production of 1928 could he again
do justice to himself. Indeed the *Schweik* drawings (as
distinct from the resulting volume of lithographs)
contain some of his best work.

For Dix the year 1925 marks his return to Berlin
and the start, somewhat as with Grosz, of an intensive
concentration on portraits: among others those of
Hugo Erfurth the photographer, the specialist Dr
Mayer-Hermann with the great spherical X-ray
camera apparently sitting on top of his head, Alfred
Flechtheim with his hand resting lightly but poss-
essively on a painting, and the monocled Sylvia von
Harden with her cocktail, her horse teeth and her
cork-tipped cigarettes. Then in 1927 he returned to
Dresden as a professor at the Academy there. From
this point on there was a more domestic tendency in
his work (due to the birth of his two sons) as well as a
more academic one, though the latter was not
immediately important. For he was able now to carry
out three major projects which he seems already to
have planned: an apparently big (though no longer
extant) picture of street fighting, with helmeted
Reichswehr firing on civilians armed with pistols,
followed by the two great triptychs, first
Grosstadt, the Big City, with its jazzing central
group in evening dress flanked by streets full of
whores, dogs, a beggar, a crippled soldier; then,
started in 1929 and completed only three years later,

The new portraiture. *Above*, Grosz's portrait of the poet Max
Herrmann-Neisse, 1925. Shown in the Neue Sachlichkeit show, and
now back in the Mannheim Kunsthalle. *Below*, Otto Dix, *The Doctor*
(Dr Hans Koch), 1921; Wallraf-Richartz Museum, Cologne

the *Der Krieg* triptych deriving from his earlier literalistic painting of the trenches.

Otto Griebel too painted an excellent self-portrait in a café setting. Meanwhile Nierendorf, the dealer who had induced Dix to come back to Berlin, not only held a first Neue Sachlichkeit show in the capital but also devoted a further exhibition in 1927 entirely to modern portraits, which included work by a number of younger artists such as the Dresdener Karl von Appen. Here Schlichter showed his painting of Brecht in a leather jacket with a car appearing behind him. He was yet another who turned to portraiture around this time, painting Kisch, Arnolt Bronnen the playwright and Brecht's wife Helene Weigel with a combination of accurate insight and topical sense.

That, in outline, is the extent of Die Neue Sachlichkeit properly speaking: it was from the first a relatively small movement, even though there were many minor artists working in similar vein and its characteristics can also be found in the more explicitly political art that followed. The strange thing, in so close-knit a new culture, is that the Bauhaus should

apparently in no way have felt its effects, Beckmann and Grosz having seemingly had no connection with that school apart from providing prints for one of its early albums, while Dix is not known to have had any contact at all. Nevertheless the actual term, with its echo of the old Werkbund 'Sachlichkeit', came automatically to be extended to the new functional architecture and design, and in Oskar Schlemmer the Bauhaus had an artist whose metaphysically tinged work was like a graver and more detached version of Magic Realism. The apparent barrier may in part have been political, since social criticism à la Grosz would hardly have suited Gropius's policy of non-alignment. More probably it was due to the distaste of the Bauhaus painters for so deliberate a return to figurative art, since even where they were not themselves wholly non-representational they saw figuration as something to abstract from rather than to be pursued for its own sake.

Today however, when the moral superiority of figurative to non-figurative art is no longer quite the article of faith it once was, we can see that several of

Goodbye to Berlin. Central portion of Dix's *Big City* triptych of 1927/8, now on loan to the Stuttgart city gallery

In Dix's wake. *Self-portrait in the Pub* by Otto Griebel, a Dresden Dadaist and member of the Red Group. Shown in 1928; present whereabouts unknown

the qualities sought by the Neue Sachlichkeit artists are also to be found in those outside the movement: in particular the clarity, balance and mechanical hardness which had re-entered painting with Léger and the Purists after 1918. Nor is this just a subjective judgement, for after all Grosz had absorbed elements of Constructivism, while Schlemmer tried to teach his students objectivity, even if by that he meant something more philosophical than did the Verists. As he put it in his diary for April 1926:

> If today's arts love the machine, technology and organization, if they aspire to precision and reject anything vague and dreamy, this implies an instinctive repudiation of chaos and a longing to find the form appropriate to our times. . . .

It was even possible, at any rate in 1924, for convinced Communists to paint abstractly without having their heads bitten off by the Party; for that was the year when Oskar Nerlinger and other artists associated with *Der Sturm* formed a politically committed group called 'Die Abstrakten' which took part in propaganda work, held discussions with proletarians and did drawings for the KPD press.

As an expression of the climate of the time, then, it is arguable that Baumeister and Schlemmer and the pre-1927 Léger were more central than Dix or Beckmann, both of whom retained recognizably Expressionist features. The former were more sober, less emotionally involved, much better in tune with the new architecture, quite as sceptical about art's existing social role and every bit as exact in their

work. The only thing that they lacked by comparison with Die Neue Sachlichkeit proper was the latter's edge of topicality and its social commitment – something however that is not entirely easy to reconcile with the idea of objectivity. Such artists are to be distinguished from other Bauhaus painters like Feininger, who remained a Cubist–Expressionist of an earlier breed, or Kandinsky, who was essentially a symbolist even though at the Bauhaus he moved away from his old expressive freedom towards something altogether cooler and more geometrical. The sober, tidy approach characteristic of Die Neue Sachlichkeit is to be found rather among the Bauhaus's Constructivists, above all Moholy-Nagy, and indeed their attitude was also socially engaged, if in a much less vehement and ultimately self-destroying sense than Grosz's.

Furthermore, even if Arp had now gone to settle in France, where he came (however inappropriately) under the banner of the Surrealists, there was still a certain amount of related sculpture about – an aspect of art which 'Die Neue Sachlichkeit' as such seems to have neglected. Among this Schlemmer's noble figures, at once organic and machine-like, are outstanding, while Joost Schmidt's more abstract constructions have the same calm exactness: he being yet another who, like Moholy, was quite prepared to work for utilitarian ends. Some of the later sculptures of Rudolf Belling, though he is often thought of as an Expressionist, are likewise relevant, as are the stylized animal figures of Ewald Mataré, simple, precise and free from sentimentality.

12 The Dessau Bauhaus: a new concern with building and design

Gropius's Dessau buildings and a more practical curriculum, fitting the general climate of the new international culture. Staff changes and foundation of an architecture department under Hannes Meyer. Architecture as a matter of organization, whether of human needs or of technical building operations. Resignation of Gropius and appointment of Meyer as director; his innovations, notably photography, sport and practical involvement with industry. Emphasis on the quantifiable.

Turned out of Weimar on 1 April 1925, Gropius's Bauhaus reopened the same autumn in Dessau, an industrial city of 86,000 inhabitants half way between Weimar and Berlin. This choice was primarily due to the conservative mayor Fritz Hesse, who felt that the school would help Dessau's cultural prestige and could also well further his housing programme. He made contact with Gropius and the Kandinskys (whose diplomacy was evidently important throughout the school's Dessau period), got the backing of the SPD members of the city council, likewise of the Anhalt provincial government, and arranged not merely to take over the bulk of the staff but to finance a new group of school buildings which Gropius would design. Put up in the autumn of 1926, these eventually cost 902,500 Marks exclusive of furnishing (or 27.80 Marks per cubic metre, roughly one-third more than Hesse had originally allowed for); they included an 'Atelier-Haus' for the students and (over and above that) three single and three double houses for the teachers, Gropius renouncing his 5800 Mark fee for the benefit of the school's hitherto non-existent architectural department.

Schlemmer's theatre department had to be financed in part by the municipal theatre; there were salary cuts (opposed particularly by Kandinsky and Klee); the pottery department under Marcks had to be left behind. Starting with only 63 students, the school was at first in temporary quarters in the museum and the existing arts and crafts school, which for a time came under Gropius since its director had resigned. At the end of 1926 however the new buildings were formally opened before a gathering that included Martin Wagner of the Berlin GEHAG building society, the Frankfurt city architects Ernst May and Martin Elsaesser, Erwin Redslob the state art adviser (or 'Reichskunstwart'), G. F. Hartlaub from Mannheim, four guests from Paris and finally two extreme functionalists in the shape of Hannes Meyer and Mart Stam.

It was at Dessau in the second half of the 1920s that the Bauhaus concept of 'Art and Technology – a new unity' really came to fruition. A new curriculum was drawn up with two aims in view: work 'am Bau' – i.e. in connection with a building – and 'practical experimental work for the construction and equipment of houses: development of prototypes for industry and the crafts'. There was thus a shift of emphasis from ideal, almost metaphysical building (the 'cathedral of socialism') to the real thing, and away from handicraft and pure painting. One of the first steps was the setting up of a Bauhaus GmbH, or limited company, financed by the builder Adolf Sommerfeld and other well-wishers (including the trade unions) for the commercial handling of Bauhaus designs and products.

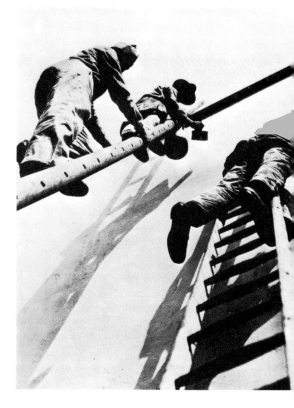

The Bauhaus shifts to Dessau. Students painting one of the new staff houses in 1926, an anonymous Bauhaus-style photograph

A statement was issued by Gropius explaining that the school wished to further the housing drive and would therefore treat its workshops as laboratories for the application of formal skills to new technologies. The principles must be

A decidedly positive attitude to the living environment of vehicles and machines.
The organic shaping of things in accordance with their own current laws, avoiding all romantic embellishment and whimsy.
Restriction of basic forms and colours to what is typical and universally intelligible.
Simplicity in complexity, economy in the use of space, materials, time and money.

The so-called 'Einheitsschrift', dispensing with capital letters, was adopted from the outset as a visible sign of the new up-to-the-minute attitude. Still more effective as a manifesto of the school's intentions were the buildings themselves: the elegant asymmetrical grouping of the main blocks, the uncompromising glass-curtained workshops, and the teachers' houses with their new domestic devices such as the washing machine at the Gropius's, the eye-level oven, the dirty-linen chute.

Ehrenburg, who came to stay with Kandinsky in 1926, reported to his Soviet readers that he was at once stunned and disturbed by what he saw. Disturbed, because so much domestic efficiency was too much for him and he felt that private life should be more of a muddle; stunned by the first sight of the buildings, with their

glass walls that form a transparent angle, merging in the air yet separated from it by a precise act of will. I was involuntarily brought up short. It was not just amazement at a clever invention, it was pure admiration.

For him it was 'the first time the world has seen a cult of unadorned reason, the same clear and sober principle that affects us so powerfully in the dome of Santa Sophia'. To this can be added Schlemmer's sense, even before work began on the buildings, that the move from Weimar was a move into the modern era:

The artistic climate here cannot support anything that is not the latest, the most modern, up-to-the-minute, Dadaism, circus, *variété*, jazz, hectic pace, movies, America, airplanes, the automobile. Those are the terms in which people here think.

Such feelings can only have been reinforced by Moholy-Nagy's policy in editing the Bauhaus books.

Gropius's new Bauhaus buildings. (1) The 43-year-old director outside his own house

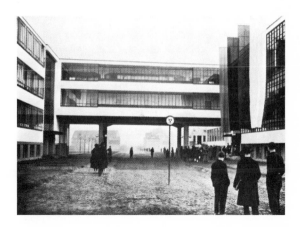

(2) *Above*, the main workshop block on opening day. (3) *Below*, the Gropius kitchen with its new gadgets

Started at Weimar as a series for publishing works emanating from the school, this scheme expanded to take in books first by Mondrian, Van Doesburg and Oud, then Malevitch's *Non-Objective World*, after which Moholy planned (as of 1927) to cover a whole cross-section of the modern movement, with the collaboration of outside avant-gardists like Antheil, Tzara, Kiesler, Lozowick, Stam, Burchartz, Karel Teige the Czech Constructivist and Jane Heap of the *Little Review*. Though none of these later titles ever appeared the very possibility gives some support to ideas like those of Max Bill, who arrived from Zurich that year as a nineteen-year-old student. Interviewed in the school magazine he said that he had come in the hope of studying architecture, since 'Corbusier had turned my head'. Disappointed in the school at first, he had gradually begun to find what he really came for: 'clarity'. 'I see the Bauhaus as something bigger than it really is', he said:

> Picasso, Jacobi, Chaplin, Eiffel, Freud, Stravinsky, Edison etc. all really belong to the Bauhaus. Bauhaus is a progressive intellectual direction, an attitude of mind that could well be termed religion.

With the new aims and the changed climate came changes in the staff. The painters became less central to the school's work, thanks both to the practical, functional emphasis and to Moholy-Nagy's militant feeling that art was dead and its job should now be done by the photographer. Feininger had been particularly shocked by an article of Moholy's about the future development of moving light shows and colour transparencies, while Klee, he wrote, was 'quite paralysed' by such views. Henceforward Feininger did no teaching at all, but became a kind of resident artist, continuing to be on the staff and living in one of the new houses. Muche, once close to Itten, left after the weaving students had objected to working under him. At the same time the first batch of ex-students was appointed as teachers: Josef Albers, Marcel Breuer, Herbert Bayer, also Joost Schmidt, Hinnerk Scheper and Gunta Stölzl.

There was now no wood workshop and no stained glass (formerly Klee's department); bookbinding having already been dropped earlier and pottery left behind. The division of studies in the year 1926–7 therefore was:

Basic course: Moholy-Nagy and Albers.
Cabinet making: Breuer.
Metal workshop: Moholy-Nagy.
Weaving: Muche, succeeded by Stölzl.

Sculpture: Schmidt.
Theatre: Schlemmer.
Wall painting: Scheper.
Advertising and typography: Bayer, Schmidt.

– this last having taken over from the old printing workshop. The distinction between technical instructors and 'teachers of form' could now more economically be ignored, since most of these people had undergone the double training, Muche being the last survivor of the old system. Klee and Kandinsky thereafter became somewhat isolated, and seem henceforward to have taught only in the Basic Course or in a Seminar for Free Plastic and Pictorial Creation (*Gestaltung*).

For the first term after the opening of the new buildings there was still no architecture department. Gropius had asked Mart Stam to come and set one up, but he refused on the ground that he was not a teacher. Around the same time however Gropius was discussing his plans also with Hannes Meyer, who had developed within the Swiss Cooperative movement, then been converted to the modern aesthetic by *L'Esprit Nouveau*. Meyer was not uncritical of the Bauhaus, using (according to Schlemmer, who instantly liked him) such terms as 'glorified arts and crafts' and even 'Dornach', an allusion to Rudolf Steiner's anthroposophical headquarters near Basel. It was he who now became Gropius's second choice, and he agreed to come in April to head the new department. His teaching policy there, so he told Gropius in a letter of 18 January, would 'be on

absolutely functional–collectivist–constructive lines in keeping with *ABC* and 'Die neue Welt'.

The first of these was the Swiss architectural magazine being run by Stam and Hans Wittwer, Meyer's architectural partner; the latter an article which Meyer had published in 1926 outlining his views. In it one finds familiar Corbusier-like allusions to aircraft and cars, to gramophones and mechanical pianos, to psychoanalysis and the Burroughs adding machine. According to this programme 'The artist's studio becomes a scientific–technical laboratory', the constructive principle runs through everything, art is dead, likewise the novel; 'our communal consciousness will not tolerate any individualistic excesses'. So poetry must yield to phonetic poems, novels to short stories, the drama to sketches, frescoes to posters, opera to revue and so forth.

> The stadium has carried the day against the art museum, and physical reality has taken the place of beautiful illusion. Sport merges the individual into the mass. Sport is becoming the university of collective feeling.

This last emphasis on collectivity is explicit: 'Cooperation rules the world. The community rules the individual' – 'cooperative', according to Schlemmer, who shared one of the double houses with him, being Meyer's favourite word.

Gropius himself was at this time engaged on two big jobs for the Dessau municipality. At Törten from 1926 to 1928 he built an estate of 316 two-storey houses together with a four-storey block for the local Coop, while during 1927 he designed a new mun-

icipal labour exchange which was finished by mid-1929. The first of these in particular, involving as it did the careful rationalization of the building process, with breezeblocks and concrete beams being prepared on the spot, seems to have brought him close to Meyer's conception of 'organization of needs' as well as to his own pre-1914 views about industrialized building. Thus Gropius's article for the school magazine, written on the basis of his Törten experience and called 'Systematic preparatory work for rational housing construction':

> The time is past for manifestos such as helped prepare the way intellectually for the new architecture. It is high time to enter the stage of sober calculation and precise analysis of practical experience. . . . A house is a technical–industrial organism, whose unity is composed organically from a number of separate functions. . . .
>
> Building means shaping the different processes of living. Most individuals have the same living requirements.

– so every house on an estate can be the same, and to decide otherwise would be 'wasteful and a misplaced emphasis on individuality'. Two issues later Meyer expressed much the same views, though more polemically:

> the new house, being prefabricated, is an industrial product and accordingly a job for specialists: economists, statisticians, hygiene experts, climatologists, industrial consultants, experts on standards, heating technicians . . . as for the architect? . . . from being an artist he becomes a specialist in organization! the new house is a social work . . .

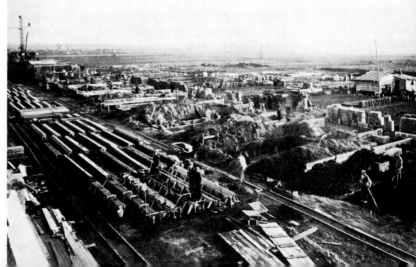

Left: appointed to get the architecture department started in 1927: Hannes Meyer

Architecture as organization. Gropius's Törten estate south of Dessau, 1927, showing on-site manufacture of breezeblocks and beams

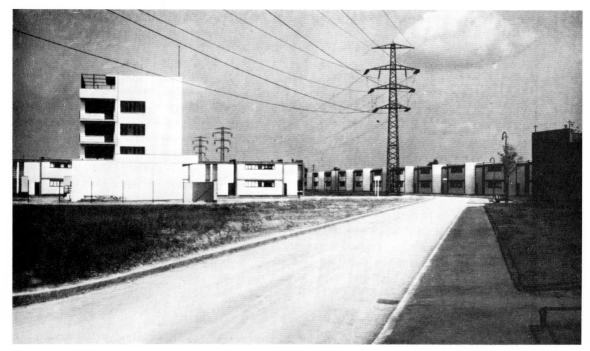

General view of the Törten estate soon after its completion

So building, according to his definition, meant 'the considered organization of the different processes of living'. This Corbusier-like phrase, which is almost word for word what Gropius said, was finally shortened down by Meyer to state (in bold type) that 'building is just organization: social, technical, economical, psychological organization'.

Only nine months after Meyer's arrival at the Bauhaus Gropius told his colleagues that he was going to resign. From the first, so Ise Gropius noted in her diary, he had thought of the Swiss as his successor; so on 4 February 1928 he wrote to Fritz Hesse proposing him on the grounds of his 'qualities both objective and personal'. Just why Gropius wished to leave at this point is still something of a mystery; it has been suggested that other people's attacks on the Bauhaus were a possible motive, but these were less acute than at Weimar and stronger reasons could well have been staleness combined with a wish to go on building while the boom lasted. He might for that matter have felt that if major changes were to be made in the school – there having been pressure from the student representatives to get rid of the less active teachers – they would better be made by someone else. Moholy-Nagy, who might

reasonably have expected the succession and could not stand Meyer, immediately resigned too, complaining to the teachers' council that the Bauhaus was being turned into a technical training school and that he refused to continue teaching 'on this specialized, purely objective and efficient basis'. Bayer followed; so did Breuer, though it seems that his leaving was coincidental. Schlemmer, while foreseeing that the budget for his theatre department would be cut in order to help establish architecture, stayed none the less on being given a full teaching appointment and the prospect of lecturing on 'man' in the Basic Course.

Theatre accordingly now became a spare-time subject and was no longer included in the curriculum. It had always been marginal to the main aims which Gropius had laid down, but the short plays and dances staged by Schlemmer, with their highly imaginative doll-like geometrical costumes, were so original and exploratory that it now seems one of the most brilliant aspects of the school. It was also Schlemmer and his students who had prepared the periodical fancy-dress parties and other formal celebrations at which the Bauhaus-Kapelle or student jazz band used to play. Though these were halted by

order of the municipality, Schlemmer seems to have accepted the change phlegmatically enough. Under the new regime he anyway expected there to be a slightly less 'aristocratic' atmosphere. But Meyer, he thought, 'will keep things going in his realistic, calm, sensible way'.

Meyer took over on 1 April 1928, and promptly abolished Saturday classes so as to leave the day free for sport. As well as his own Swiss partner Hans Wittwer, he now had Mart Stam teaching architecture for one week in each month; moreover he got the students working on actual commissions, notably a further group of houses at Törten where twelve of them were involved. Moholy was not replaced at the metal workshop, which was fused with cabinet making to make a new department of interior design, initially under Albers, who also took over the Basic Course. Early in 1929 a photography section was added under Walter Peterhans, this being Meyer's only major innovation; in addition guest lecturers were now brought in to cover philosophy and the previously neglected social sciences.

For reasons that will appear later it is difficult to get an unbiassed view of Meyer's activities, but among the achievements which he himself was most proud of were the school's engagement in exhibition design, its establishment of practical connections with industry – thus it was in 1928 that some of the best-known Bauhaus light fittings started to be made by the firm of Körting and Matthiessen and that an agreement was reached for wallpapers to be designed for the firm of Rasch – and the division of the ensuing royalties between school and students. It was Meyer's view that the whole institution had previously been too inbred, too remote from everyday life, too wrapped up in its own 'Bauhaus style' which the Hungarian critic Ernst Kállai shortly afterwards characterized thus:

Tubular steel chairs: Bauhaus style. Lamp with nickel body and white glass shade: Bauhaus style. Wallpaper covered in cubes: Bauhaus style. Wall without pictures: Bauhaus style. Wall with pictures, no idea what it means: Bauhaus style. Printing with sanserif letters and bold rules: Bauhaus style. doing without capitals: bauhaus style . . .

Instead the school was now to be directed (so Meyer claimed) towards popular necessities rather than luxuries, in such a way as to wean it away from idealism to 'the one reality we control: that which can be measured, seen, weighed'.

Of the student body of 170, according to a prospectus issued in 1929,

140 are of german origin	22 are between 24 and 29
8 from anhalt	11 are 30 or over
78 from prussia	1/3 need less than 50 Marks a month
26 from saxony	
28 from the rest of germany	1/3 need 50 to 100 Marks a month
30 are foreigners, to wit:	
8 swiss	1/3 need 100 to 200 Marks a month
4 poles	
3 czechs	33 pay less than full fees
3 russians	25 live in the *atelierhaus*
2 americans	39 came to the bauhaus as apprentices
2 latvians	
2 hungarians	22 came with a school leaving certificate
1 austrian	
1 dutchwoman	35 are doing the basic course
1 turk	
1 persian	7 are 'pure artists'
1 palestinian	19 work in the weaving department
1 stateless	
119 are male	54 are cabinet makers, painters, metalworkers
51 female	
14 are married	23 are building students
47 are between 16 and 19	27 are in the advertising and print workshop
90 are between 20 and 24	5 are in the bauhaus band

Such was the Bauhaus in Meyer's day: lodged in Gropius's fine buildings, selling its prototypes to industry, still boasting its distinguished painters but concentrating much more on its original aim, 'der Bau'. Perhaps this is the school's best-known image – apart from one notable exception, the director himself. For after 1930 Meyer's association with the Bauhaus was to be systematically played down.

Students on the roof at Dessau. *Left to right*: Loew, Albers, Weininger, Röseler, Jackson, Breuer, Koch, Schawinsky

13 Modern architecture: Berlin, Frankfurt, Stuttgart, OSA, CIAM

Functionalism and the housing drive of the mid-20s, particularly in Berlin and Frankfurt. The Socialist-inspired Berlin GEHAG with Taut as chief architect; the Britz, Zehlendorf and other Berlin estates. Appointment of Ernst May in Frankfurt to coordinate all planning down to furniture and fittings. The Stuttgart Weissenhofsiedlung as a collective architectural demonstration. Other new German buildings and ways of publicizing them. Parallel developments in Russia up to 1929. First meetings of the international movement in the CIAM.

Nothing did more to characterize the emphatically urban civilization of the later 1920s than the rapid development of this new architecture. In the six years prior to 1925 men like Gropius and Mies van der Rohe had built little; Swiss architecture still seemed conservative; Adolf Loos had left Vienna; so that about the only truly modern works in the whole of central Europe were certain buildings of Erich Mendelsohn's (notably his hat factory at Lucken-walde and the Sterneberg house in Berlin) and the first of Otto Haesler's Celle estates. Nonetheless the concept of functional building had emerged clearly enough for critics to be able to write of 'Zweck-mässigkeit und Sachlichkeit' – i.e. purposefulness and utility, sobriety etc. – while in 1925 Adolf Behne, the critic who had helped found the Novembergruppe, published his *Der moderne Zweckbau* effectively formulating the new creed.

Related in spirit to 'Die neue Sachlichkeit' – a term whose frontiers soon became blurred enough to embrace it – this new tradition of exact, rational architecture now spread with remarkable speed right across Weimar Germany, starting with the big cities and thereafter spilling over into other mid-European countries, particularly Switzerland and Czechoslovakia, the two most naturally accessible to its blend of precision and matter-of-factness. Of course its roots lay largely elsewhere: in the postwar work of such Dutchmen as Oud, Dudok and Van Loghem as well as in the still unrealized doctrines of Le Corbusier. But Germany became the new movement's effective centre and was for many years the one country where it made a real impact not only on the townscape but on the everyday life of ordinary people.

For all the deliberate unpretentiousness and impersonality of its aesthetic, this architecture embraced some outstanding individuals who could handle it with elegance and perfectionism, notably Gropius, in some of his buildings, and Mies van der Rohe. But what gave it its particular dominance was not so much the occasional building of genius (like the Dessau Bauhaus) as the more humdrum activities of countless lesser architects and, above all, its harnessing to a major social aim. This was the modern housing drive which began in Vienna in 1923, inspired Haesler's pioneering work at Celle the same year and was thereafter in Germany financed by the new rent tax on the Viennese model. Not all cities risked employing radically modern architects on such tasks, and some of the solutions were architecturally conservative; thus although the great Viennese schemes were themselves long regarded as exemplary on social grounds (and were indeed a specifically Socialist achievement) about the only modernists ever employed on them were Josef Frank and Peter Behrens, who was in his mid-fifties when he designed two of the lesser blocks; major undertakings like the kilometre-long Karl Marx Hof for instance, with its 1400 flats, being the work of a city architect called Ehn who, rather unjustly, barely figures in modern architectural history. But many of the movement's basic principles penetrated even where its outward hallmarks (such as the flat roof) did not, and in one German city after another – Celle, Breslau, Altona, Cologne, Dresden, Leipzig, Stuttgart, though *not* the more reactionary Munich – competent-looking flats and housing estates were built by such run-of-the-mill functionalists as Richard Döcker, Adolf Rading (both of Stuttgart), Karl Schneider (Hamburg), H. Richter (Dresden) and Wilhelm Riphahn (Cologne). At Magdeburg too Taut's former assistant Johannes Göderitz employed Konrad Rühl and Karl Krayl to complete some 2000 dwellings in two years.

Vienna apart, the great re-housing centres were Berlin and Frankfurt-am-Main. Here there were two outstanding figures who in their respective ways were every bit as important to modern architecture as were Gropius and Mies, though because they were organizers rather than artists their achievement has often been underrated. These were Ernst May the Frankfurt city planner and Martin Wagner who founded the GEHAG building society in 1924 and later became chief city architect of Berlin. Originally an engineer, Wagner was a member of the SPD who had devoted himself to forming cooperatives of

building craftsmen, and his GEHAG (or Gemein-nützige Heimstätten-Spar-und-Bau A.G.) was largely staffed by Socialists and financed by the trade unions. One of the two main Berlin building societies, its primary aim was to develop economical building techniques so as to offer low-rent housing. This Berlin housing drive did not at first follow an overall plan, since the different building societies varied in their attitude to the functional style; thus of 63,924 dwellings provided by the societies in the five years 1925–9 (as compared with 36,898 by private enterprise and none by the city) only about a fifth were designed by modern architects. After 1927 Wagner began planning new suburbs, likewise the reconstruction of the Alexanderplatz and the Potsdamerplatz, but much of this remained unrealized in the changed economic climate that followed.

In Frankfurt the picture was altogether more clearcut, with May in 1925 drawing up a ten-year programme which was largely to be executed by the city, and the building societies and similar foundations following its overall plans and standards. During the first half of this period, i.e. from 1926–30, 15,174 dwellings were completed in and around Frankfurt, mainly in the form of suburban estates with long blocks of terrace housing. Effectively rehousing about 9% of the population, this established modern architecture as a way of life even more decisively than did the roughly comparable number of modern dwellings executed in the larger area of the capital. Berlin, it is true, had the Avus motorway, while Tempelhof with its buildings by Heinrich Kosina was an inner-city airport that remains unique in Europe, if not the world. But it was Frankfurt which emerged as the first twentieth-century city.

Wagner himself seems to have done little designing in Berlin, and the chief architect for the GEHAG was Bruno Taut, who was appointed around the time of its foundation in 1924. That year Taut visited Holland for a conference on garden cities, and the Dutch influence is visible in his first GEHAG flats in the working-class district of Wedding; among the visitors to these was Lunacharsky. Around the same time Wagner went to the United States to study industrial building methods, which were then preoccupying many of the more socially-minded architects. The huge Britz estate with its 1480 GEHAG dwellings (plus 1329 put up by other societies) was accordingly the first to be built with the aid of lifting and earth-moving equipment and a rationalized division of labour, and Taut ingeniously used the standardized forms that resulted to create the spectacular horseshoe-shaped block by which the whole scheme is known. This scheme was begun in 1925, as also was the Karl Legien estate on the Prenzlauer Berg, a series of five-storey blocks of flats with inner gardens, called after the Socialist trade union leader and containing 1144 dwellings; both took several years to complete.

Several more Taut estates followed, notably the Friedrich Ebert flats in Reinickendorf, built for another society, and a big, pleasantly wooded estate in the south-western district of Zehlendorf which consisted of 1601 dwellings in a mixture of three- or four-storey blocks and individual terrace houses. Of other architects, Hugo Häring and Otto Salvisberg each had a small part in this scheme, while Gropius, Forbat, Otto Bartning and Häring built the so-called Siemensstadt estate for employees of the electrical firm, who had their own building society; the overall

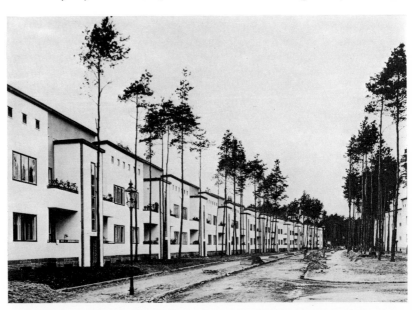

Rehousing Berlin. A GEHAG scheme at Zehlendorf, 1927, supervised by Bruno Taut

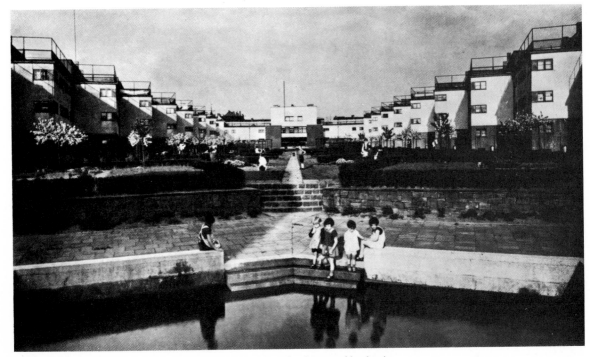

Rehousing Frankfurt. Ernst May's Bruchfeldstrasse estate, planned and executed by the city

planner here was Hans Scharoun. Mies van der Rohe too was responsible for a tenement block in the Afrikanerstrasse, of extremely utilitarian appearance. Nearly all these buildings had the flat roofs that in those days were considered (quite *un*functionally) as a necessary gesture against the more reactionary architects, but they were characterized above all by their social aspects. The first was low rents, entailing a continual concern with economy both of plan and of building methods. Light, air and open space came next, with big inner gardens and generous provision of balconies. Finally there were the communal washhouses and other shared services.

In Frankfurt the aims were very similar, but were much more logically pursued. May was appointed in 1925 by an SPD–Democrat–Centre Party municipal coalition under a Democrat mayor, Ludwig Landmann, which had come to power the previous year and was prepared to use compulsory land purchase to help its plans. Aided by Karl Rudloff and others, and understudied by Martin Elsaesser, May did much of the designing himself, whether for the city or for the building societies involved; thus the big estates around the periphery of the city were all his, though

there was also a small scheme with 198 flats by Gropius, and the Hellerhof estate of 800 flats out to the west of the main railway station was by Stam. For the majority of the new buildings, including some by other local architects, May's office could establish standards: not only for doors, windows etc. but also for ground plans for different-sized flats and for the space-saving fitted kitchen, designed by Grete Schütte-Lihotzky, known as the 'Frankfurt kitchen'.

Unit furniture designed by Franz Schuster and Ferdinand Kramer was sold to tenants through a non-profit-making municipally owned firm; well-designed beds and light fittings were included in a form of local design register. There were communal washhouses as in Berlin, but also in many cases centralized heating and hot-water systems, along with some instances of piped radio; kindergartens had been planned but not yet installed, while the provision of community centres, garages and even local radio stations remained hopes for the future. Particular attention was paid to gardens, two special estates being provided for market gardeners; a standard weekend house was also designed. There was a triple block of 43 flats for professional women,

and an old people's home designed by Stam and Werner Moser (for the Henry and Emma Budge Foundation). As in Berlin, new building techniques were developed to reduce costs, and by 1927 a factory had been set up to produce precast foamed concrete wall slabs which allowed the walls of a flat to be erected in 1.3 days.

Meantime the Stuttgart city authorities had decided early in 1926 to finance a model estate of some sixty dwellings which would be planned under the aegis of the Werkbund and viewed in the first place as part of a Werkbund exhibition the following year before passing to the city. This was the Weissenhofsiedlung, whose director was Mies van der Rohe. Arguing that 'the new dwelling' was much more than a purely technical or economic problem and accordingly

> only to be resolved by creative abilities, not by means of computation or organization,

he invited fifteen of the best-known modern architects to take part, including Oud and Stam from Holland, Le Corbusier and Jeanneret from Paris and Josef Frank from Vienna, as well as most of the leading Germans aside from Ernst May. Behrens and

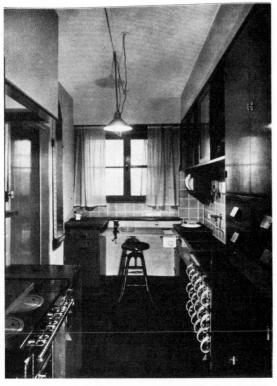

Comprehensiveness of the new planning. (1) The 'Frankfurt kitchen' designed for May's office by Grete Schütte-Lihotzky, 1926

(2) Modern light fittings and (3) The 'Frankfurt bed', from sheets of the Design Register established under May's auspices for recommendation to estate tenants

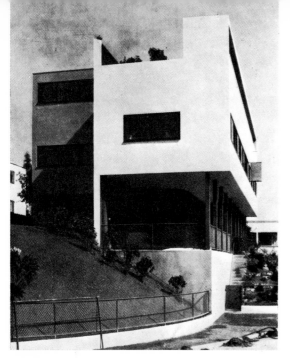

A masterpiece of the Stuttgart Weissenhof estate, 1927. The double house by Le Corbusier and Pierre Jeanneret

Gymnastic equipment in the new home. *Above*, house by Theo Essenberger on the Werkbund's Breslau estate, 1929. *Below*, Piscator's bedroom in the Berlin flat designed for him by Gropius and Breuer, 1927–8

Poelzig of the old generation were included, Hannes Meyer and Van Doesburg being among the other notable omissions. Loos, Häring and Mendelsohn were invited but unable to take part. The aim of the whole show, according to Werner Graeff, whom Mies put in charge of the accompanying publications, was to show how the leading spirits of the day envisaged the new architecture, which Mies himself insisted was based on 'the struggle for a new way of habitation, together with a rational use of new materials and new structures'.

Unlike the provision of more functional housing estates this was not something that could be done on the cheap, and a wide variety of often brilliant and sometimes beautiful buildings resulted. Some of the participants designed models for serial repetition, Oud's row of five houses being among the most compact while Stam's with their brutally sparse furnishing foresaw the elimination of much of the domestic work which was then still regarded as normal. Max Taut set out to use standard elements, his brother to produce a cheap detached house. Gropius conducted two highly original but visually rather wretched experiments in prefabrication, leading to new conclusions for the building industry; as in his work at Törten he saw the architect's 'main task today as that of an organizer, who must bring together all the biological, social, technical and creative problems' – exactly what Mies had denied. Mies himself in his block of twelve flats used a steel skeleton construction to allow considerable variability of floor plan within a uniform building scheme. Le Corbusier's two houses, one single and the other double, were a most elegant demonstration of his five principles – construction on *pilotis* or weight-carrying reinforced concrete stilts, the free plan which this permits, the roof terrace, the long windows and the untrammelled façade. Though they were the only houses still unlet a year later, they remain, to all outward appearances, among his finest and most convincingly logical achievements.

As a demonstration of new ways of building, looking and living this enterprise was enormously impressive, and it not only helped to unite the leading modern architects in a common front but also attracted the general public, of whom up to 20,000 a day are said to have visited the estate and the exhibition which complemented it. Here there were examples of furniture and fittings (including illustrations of the 'Frankfurt kitchen', and items by Kramer and Schuster) to supplement those in the

houses themselves. The approach of the architects to their interiors varied, depending no doubt on the time available, some designing their own, others calling in outsiders (Mies for instance got a group of Swiss Werkbund members to furnish some of his flats), while several stuck to furniture available in the shops, such as the standard Thonet bentwood chairs. There was considerable provision for gymnastics, for instance in the houses by Stam and by the Stuttgart architect Richard Döcker; indeed to judge from the surviving photographs the estate's inhabitants were to consist mainly of healthy-looking women in swimsuits. Some of the furnishing was extremely spartan, that of the Stam and Gropius houses in particular, Le Corbusier's being almost as austere but more subtly and satisfyingly proportioned. Only the Stuttgart and Breslau architects (Rading and Scharoun) seem to have set out to make their houses look comfortable, with large, flexible and attractive living rooms.

A smaller Werkbund scheme was carried out in Breslau in 1929, while there was also a plan to build a second large estate under Werkbund auspices in Vienna, though uncertainties about the site stopped this from being realized till 1932. Here the guiding hand seems to have been Josef Frank's, who came back from Stuttgart very critical of German developments, which he saw as too arbitrary and programmatic; so that the estate of seventy houses which eventually went up in the southern district of Lainz had nothing to match the more extreme experiments at Stuttgart. The only German architect represented here, in fact, aside from Schütte-Lihotzky of May's team (who was technically a Viennese), was Hugo Häring. Many of the outsiders however might well have been included at Stuttgart: Guévrékian and André Lurçat from Paris, for instance, Richard Neutra from Los Angeles (with a clumsy-looking one-storey house), and Rietveld from Holland with four terrace houses. This time Adolf Loos also took part.

Of the countless other modern buildings which went up in Germany from 1925 onwards it was naturally the more public structures that most affected people's lives. Among the outstanding examples prior to 1930 were Max Taut's Berlin printing union headquarters or Buchdruckerhaus, Poelzig's I. G. Farben offices in Frankfurt (well known to the Allied occupiers after 1945), Döcker's big modern hospital at Waiblingen, Osswald's skyscraper for the *Stuttgarter Tagblatt*,

Scharoun's home for single people built in conjunction with the Breslau 1929 Werkbund exhibition, Hannes Meyer's trade union (ADGB) school at Bernau near Berlin, and Mendelsohn's various buildings, notably the Universum cinema in Berlin. Mies built a remarkable brick monument to the revolutionary leaders in the Friedrichsfelde cemetery where Liebknecht, Luxemburg, Jogiches and twenty-nine others lay buried; this was commissioned by the KPD and unveiled by Wilhelm Pieck in June 1926. More influential for other architects, however, was his pavilion for the 1929 international exhibition at Barcelona, a pure exercise in perfectionist building; but this was for export only.

Similarly with the various private houses by Mies, Mendelsohn and others, whose aesthetic of discreetly underplayed extravagance could, for most people, only be appreciated via the architectural press. This was extremely active in the later 1920s, when a number of specialist publishers – Englert und Schlosser in Frankfurt, Klinckhardt und Biermann in Leipzig, Wedekind and Julius Hoffmann in Stuttgart, and Schroll in Vienna, not to mention the Bauhaus books and *Das neue Frankfurt* – were concerned to propagate the new architectural ideas. Here such buildings as Mies's houses for the Tugendhat family at Brno and for the Wolfs at Guben, Behrens's house in the Taunus mountains north of Frankfurt, and Mendelsohn's own house overlooking the Havel lake in south-west Berlin, could all bear out the principle formulated by Mendelsohn for the latter: 'New House – New World', even if the world in question was one which few could afford. Besides these there were the great paper projects, which became known through the same means, or through the various architectural and building exhibitions which were then held: not only Le Corbusier's marvellous schemes but also Stam's plan for the railway station at Geneva, Gropius's 'Totaltheater' project for Piscator, and all Mies's large-scale designs. It is worth noting, perhaps, that no truly modern theatre, or railway station, or university structure, or tower block was ever actually built.

More than in any of the other arts the rapid developments in architecture were part of an international movement. Once again there was a certain parallelism between Germany and the USSR, even though the state of the Russian building industry was a very very long way behind that of the German. Thus in June 1925 Lissitzky returned to

When 'formalism' was a clean word. *Above*, Mies van der Rohe's monument to the murdered revolutionary leaders of 1919, commissioned by the KPD, 1926. *Below*, the Moscow planetarium, 1929, by Barshch and Sinyavsky

Moscow, somewhat disillusioned with such Western colleagues as Arp, Van Doesburg and Moholy-Nagy, and expecting to take over the architectural department of the Vkhutemas, which he proposed to run on the Bauhaus principle of 'Art and Technology – A New Unity'. There he joined Ladovsky and Melnikov in the new society of architects called ASNOVA (or Association of New Architects). Actual building was just getting under way; the first postwar students were beginning to practise; and that November the director of the Moscow Housing Department, N. F. Popov, wrote an article in *Isvestia* rejecting passéist styles in favour of 'the new proletarian culture':

> Our architecture is the style of work, liberty and science, not that of luxury, oppression and superstition.

The following year the rather larger, self-proclaimedly Constructivist group called OSA (or Association of Contemporary Architects) was formed with Moses Ginzburg, the Vesnin brothers and the critic Gan among its leading members. Lissitzky remained only loosely attached to Vkhutemas and none of his building projects got off the ground; instead he was diverted into exhibition design, for which he was uniquely qualified. Ladovsky too seems to have remained a paper architect. Nonetheless a number of modern buildings now went up, many of them under the heading of what the OSA termed 'new social condensers' – a concept peculiar to Soviet society, meaning certain new institutions intended to absorb and transform the individual. Among these were the workers' clubs, of which Melnikov built six between 1927–9 and Golossov of OSA the important Zuyev Club in Moscow, and some quite novel housing schemes conditioned by the desperate overcrowding.

The latter took two main forms: the 'house-commune', or block of flats with no kitchens and entirely centralized services, for which the Moscow city Soviet held a competition in 1925, and the standardized living units devised by a team under Ginzburg for the Russian (as opposed to Soviet) Building Committee. Ginzburg himself incorporated such units in the flats which he built in 1928–9 for the Finance Commissariat on the Novinski Boulevard in Moscow, where the communal services included a library, a gymnasium and a crèche as well as a canteen and a central kitchen, the flats being provided with a cooking recess only. The trouble with all such ingenious designs however was that in the prevailing

conditions the units were liable to be occupied by more than one family, so that the more economically planned they were, the more intolerable they were to live in: a problem which the German city architects had not had to face.

At the same time several influential public buildings also went up, the most spectacular being in connection with the Dnieproges hydroelectric scheme (or Dnieprostroy) on which Victor Vesnin, Nicholas Kolly and others worked for some five years starting in 1927. Thus the *Pravda* and *Isvestia* buildings in Moscow (by Golossov and Barhmann respectively) were both in the modern idiom, as was the Moscow planetarium built by Sinyavsky and Barshch in 1929. Right at the beginning of this development a first sample had been shown to the outside world in Melnikov's Soviet pavilion for the Paris Exposition des Arts Décoratifs in 1925, where Rodchenko and Shterenberg helped with the display

and the former showed his designs for a workers' club. At the end of the same year Mendelsohn had come to design a dyestuffs factory in Leningrad, the forerunner of a number of foreign architects who were to work in the USSR. In 1929 Le Corbusier, who was already in touch with Ginzburg and OSA, began designing the headquarters of the cooperatives, or Centrosoyuz building in Moscow, in collaboration with Kolly. This was the true climax of what came to be known as the International Style.

Preliminary moves to form an international organization of modern architects appear to have been made at Stuttgart during the Werkbund exhibition. At that time the League of Nations was still unresolved how to settle the scandal of the competition for its Geneva headquarters (now the European headquarters of the United Nations) which would have been won by Le Corbusier and Pierre

Founding fathers of the 'International Style'. The meeting of European architects at La Sarraz, 1928, which set up the CIAM

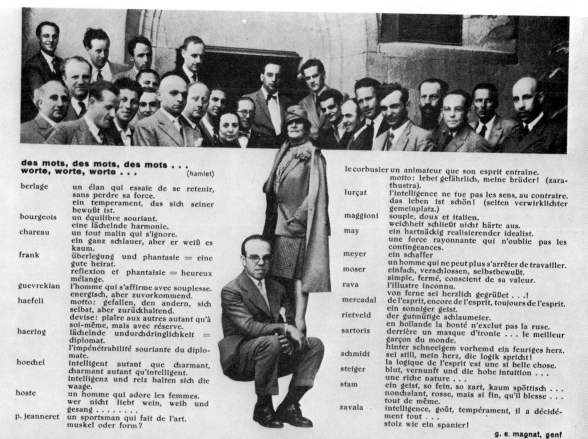

des mots, des mots, des mots . . .
worte, worte, worte . . . (hamlet)

berlage · un élan qui essaie de se retenir, sans perdre sa force.
ein temperament, das sich seiner bewußt ist.

bourgeois · un équilibre souriant.
eine lächelnde harmonie.

chareau · un tout malin qui s'ignore.
ein ganz schlauer, aber er weiß es kaum.

frank · überlegung und phantasie = eine gute heirat.
reflexion et phantaisie = heureux mélange.

guevrekian · l'homme qui s'affirme avec souplesse.
energisch, aber zuvorkommend.

haefeli · motto: gefallen, den andern, sich selbst, aber zurückhaltend.
devise: plaire aux autres autant qu'à soi-même, mais avec réserve.

haering · lächelnde undurchdringlichkeit = diplomat.
l'impénétrabilité souriante du diplomate.

hoechel · intelligent autant que charmant, charmant autant qu'intelligent.
intelligenz und reiz halten sich die waage.

hoste · un homme qui adore les femmes.
wer nicht liebt wein, weib und gesang

p. jeanneret · un sportsman qui fait de l'art.
muskel oder form?

le corbusier un animateur que son esprit entraîne.
motto: lebet gefährlich, meine brüder! (zarathustra).

lurçat · l'intelligence ne tue pas les sens, au contraire.
das leben ist schön! (selten verwirklichter gemeinplatz.)

maggioni · souple, doux et italien.
weichheit schließt nicht härte aus.

may · ein hartnäckig realisierender idealist.
une force rayonnante qui n'oublie pas les contingeances.

meyer · ein schaffer
un homme qui ne peut plus s'arrêter de travailler.

moser · einfach, verschlossen, selbstbewußt.
simple, fermé, conscient de sa valeur.

rava · l'illustre inconnu.
von ferne sei herzlich gegrüßt . . .!

mercadal · de l'esprit, encore de l'esprit, toujours de l'esprit.
ein sonniger geist.

rietveld · der gutmütige schlaumeier.
en hollande la bonté n'exclut pas la ruse.

sartoris · derrière un masque d'ironie . . . le meilleur garçon du monde.
hinter schneeigem vorhemd ein feuriges herz.

schmidt · sei still, mein herz, die logik spricht!
la logique de l'esprit est une si belle chose.

steiger · blut, vernunft und die hohe intuition . . .
une riche nature . . .

stam · ein geist, so fein, so zart, kaum spöttisch . . .
nonchalant, rosse, mais si fin, qu'il blesse . . .
tout de même.

zavala · intelligence, goût, tempérament, il a décidément tout . . .
stolz wie ein spanier!

g. e. magnat, genf

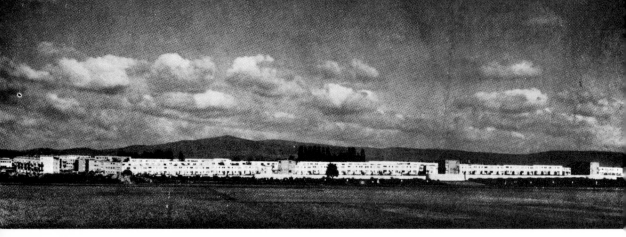

Weimar Germany's 'new sense of life'. One of Ernst May's Frankfurt estates seen from the Nidda valley around 1929–30

Jeanneret had the French representative not somewhat underhandedly objected to their project on a technicality. When in December the job was awarded instead to a French academic architect called Nénot it was over the protests of architectural groups in several countries, including the Werkbund and Taut's new 'Ring' of advanced German architects, as well as of such individuals as Loos, Berlage and Van de Velde. Thereafter it seemed all the more urgent, not least to Le Corbusier himself, that some such organization should be set up. With the Swiss art patron Hélène de Mandrot as hostess and Corbusier. Guévrékian, Karl Moser, Giedion and the Swiss Werkbund as moving spirits, invitations were accordingly sent out in March 1928 for a meeting at the château of La Sarraz in the Vaud that June.

In the course of three days papers were given there by Le Corbusier, May, Hans Schmidt, Lurçat and Berlage (Gropius and Oud being among those who failed to arrive). A joint declaration was agreed rejecting all dependence on 'the principles inspiring bygone societies', recognizing the need for architecture to conform with the social changes brought about by the machine age, and acknowledging that architecture belonged properly on 'the economic and sociological plane'. Among the further signatories were Josef Frank, Häring, Hannes Meyer, Stam and Rietveld. A permanent organization was then and there created, with Giedion as its secretary, under the name of Congrès Internationaux d'Architecture Moderne, or CIAM.

In 1929 a second meeting was held in Frankfurt on the subject of minimal dwellings, with May and Gropius as the main speakers, by which time a management committee had been set up including additional representatives from such countries as the US (Neutra), England (a certain C. J. Robertson), Finland (Alvar Aalto), Hungary (Farkas Molnár), Poland (Szymon Syrkus), Sweden (Sven Markelius),

and the USSR (Ginzburg, with Kolly as his deputy) And so it seemed that an international, socially orientated movement had finally got under way.

But if Le Corbusier in Paris was that movement' acknowledged pioneer, Germany was still the country where the new ideas had been most widely and thoroughly applied. Thus the much-travelled Count Kessler was right when he took one look at the new Savoy Theatre in London and wrote that 'where architecture is concerned London and also Paris are at least half a lifetime behind Berlin, Hamburg Frankfurt and Stuttgart'. This was at the end of May 1930, when Kessler was collecting the sculptor Maillol to work on the illustrations of a Horace for his Cranach Press in Weimar. On their way back to that city they stopped to look round Frankfurt. Since his guest seemed much struck with the beauty of the youths and girls whom they saw sunbathing there Kessler explained to him that in Germany there was now a widespread movement towards 'light, sun happiness and the enjoyment of one's own body' then took him out to Römerstadt, one of May's big northern estates overlooking the Nidda valley Maillol, he noted,

was almost speechless with amazement. 'Jamais je n'a vu cela. C'est la première fois que je vois de l'architecture moderne qui est parfaite. Oui, c'est parfait, il n'y a pas une tache. Si je savais écrire, j'écrirais un article.' We wandered round Römerstadt to continually increasing expressions of his admiration 'Jusqu'à présent, tout ce que j'ai vu d'architecture moderne était froid; mais ceci n'est pas froid, au contraire.' I again told him that this architecture only expressed the same new sense of life that was turning the young to sport and nakedness, and that it drew its warmth from this much as mediaeval buildings had drawn theirs from the Catholic attitude to the world. This new German architecture has to be seen as part of a comparable new attitude if one is to understand it.

14 Living design: furniture, printing, publicity, exhibitions

The propagation of new standards, particularly in Germany. Solutions for modern living; design at the Bauhaus and elsewhere. Lissitzky, Tschichold and the typographic revolution: abolition of capital letters; Heartfield's book-jackets and Schwitters's 'Systemschrift'. Extension of the modern movement into advertising and exhibition design. Instances of German industrial patronage.

The kind of impersonal utilitarian design aimed at by the Russian Constructivists was practised during these years not only at the Bauhaus but also in other art schools, studios and factories all over Germany. And along with the design and the manufacture of modern equipment (and exhibitions, advertising and printed matter) went a positive drive for its use, which was conducted in an almost missionary spirit. Where today the publicizing of good design is conducted largely in terms of fashion, or of keeping up with the Joneses, and ultimately of publicity for the manufacturers concerned, in Germany in the late 1920s there were writers and publishers whose object it was simply to make people live in a more up-to-date way.

'Sachlichkeit' indeed was not the cold affair that it might seem, but could inspire missionary devotion and even passion, with the result that the ordinary member of the public was under considerable moral pressure to move with the times. Giedion's booklet *Befreites Wohnen*, Adolf Behne's *Neues Wohnen – neues Bauen*, Ludwig Neuendorfer's *Wie wohnen* and *So wollen wir wohnen* were all injunctions to the public to throw away its old-fashioned furniture, fittings and other cumbersome possessions in favour-of the best modern designs; the last of these tracts, with its suggestions for making the best of the old objects, being put in notably practical terms. Even the Communist press joined in, though the basic principles were perhaps nowhere so well stated as in Le Corbusier's book of 1926, *L'Art décoratif moderne*, which was primarily a reaction to the Paris *Arts Déco* show of the previous year. For Le Corbusier founded his argument not on the work of any 'designer' but on such anonymous functional things as metal office furniture, garden chairs, high quality leather goods, hospital and laboratory equipment together with the

desks and typewriters of (for some reason) the City National Bank of Tuscaloosa. 'This is cold and brutal', says one of his captions in that book, 'but it is exact and true', thus taking us back to the basis of *L'Esprit Nouveau*'s original approach.

In Germany the situation was a special one, since there were now many able modern designers and much of their work was beginning to appear in the shops. Here the new machine aesthetic spread so rapidly after about 1925 that it could be applied not merely to such quasi-symbolic exercises as the tubular steel chair (which was, like the flat roof, a programmatic gesture rather than a true functional design) but to some much more ingenious solutions for modern living: the compact kitchen with its sink unit, the folding bed, nesting chairs and stools, double-decker beds for children, unit furniture and built-in cupboards. Designed by men like Schuster, Kramer and Adolf Schneck of Stuttgart (architect of one of the Weissenhof houses), the new types of furniture and other equipment which now came on to the market were much more radical, and in the long run more influential, than any redesigning of traditional articles in terms of new forms and new materials such as Marcel Breuer and others practised at the Bauhaus before Hannes Meyer took over.

True enough, the steel furniture of Mies van der Rohe, Breuer and Stam caught on and became fashionable; indeed Mies's Barcelona chair remains an expensive status symbol to this day. Yet if tubular chairs were the sensation of the Weissenhofsiedlung and the 1927 Werkbund show, the same occasion provided plenty of evidence that the anonymous Thonet designs, both old and new, could do the job quite as comfortably, simply and elegantly while at the same time being a lot cheaper. Against that the glass and metal lamps associated with the Bauhaus – Marianne Brandt's for the Leipzig firm of Körting

Rise of the tubular steel chair. An advertisement for the 'German Steel Furniture Co. Ltd.' of Berlin, 1930

DEUTSCHE STAHLMÖBEL G.M.B.H.
BERLIN SW 61
TELTOWERSTR. 47·48

DIE NEUEN FEDERNDEN STAHLMÖBEL haben durch ihre Formschönheit, Zweckdienlichkeit u. unerreichte Bequemlichkeit größte Erfolge erzielt.

warum 4 alphabete, wenn sie alle gleich ausgesprochen werden (großes latei-
nisches, kleines lateinisches, großes deutsches, kleines deutsches)? warum 4
verschiedene klaviaturen einbauen, wenn jede genau dieselben töne hervorbringt?
welche verschwendung an energie, geduld, zeit, geld! welche verkomplizie-
rung in schreibmaschinen, schriftguß, setzerkästen, setzmaschinen, korrekturen
usw.! warum hauptwörter groß schreiben, wenn es in england, amerika, frank-
reich ohne das geht? warum satzanfänge zweimal signalisieren (punkt und großer
anfang), statt die punkte fetter zu nehmen? warum überhaupt groß schreiben,
wenn man nicht groß sprechen kann? warum die überlasteten kinder mit 4 alpha-
beten quälen, während für lebenswichtige stoffe in den schulen die zeit fehlt?

die kleine schrift ist „schwerer lesbar" nur, solange sie noch ungewohnt. „ästhe-
tischer" ist sie nur für die verflossene zeit, die in der architektur das auf und
ab von dächern und türmchen wollte.

unser vorschlag wäre puristisch? im gegenteil: wir sind für bereicherung aller
wirklichen lebensregungen. aber alle 4 klaviaturen drücken ja dieselben lebens-
regungen aus.

und das „deutsche lebensgefühl"? hatte unser eigenstes gut, die deutsche
musik etwa nötig, eine deutsche (und vierfache) notation hervorzubringen?

franz roh

The German typographic revolution. *Above,* leaflet by Franz Roh
calling for a sanserif alphabet without capitals, 1929. *Below,* Jan
Tschichold's title for his 1928 textbook for the book printers'
union

and Matthiessen, Adolf Meyer's for Zeiss Ikon and
Christian Dell's for Bünte and Remmler of Frankfurt
(Dell having been joint head of the metal workshop
until the move to Dessau) – were all excellent, as was
the glassware of Wilhelm Wagenfeld and the wood
furniture of Erich Dieckmann, a student who had
remained at Weimar under Bartning. But even this
has to be seen in context. Plain, rational design in
solid materials was not confined to any single group
or school; contemporary publications show, not least
by their advertising pages, that there were also
various other firms manufacturing modern electric
fittings, while good-looking chinaware was available
from such sources as the State Porcelain factory in
Berlin, the Kästner stoneware firm at Elsterwerda
and the State Majolica factory at Karlsruhe. More
than in any other country ornament in Germany had
been discarded.

The ideas of Lissitzky and (in lesser measure) Van
Doesburg, which had already been influential at the
Weimar Bauhaus, now led to a typographical
revolution in which artists rather than printers played
the leading part. Starting with a predilection for
heavy black rules (which recalled Mondrian's rect-
angular outlines) and a square-cut layout, such as
can be seen in the early issues of Schwitters's *Merz* or
the first Bauhaus books designed by Moholy-Nagy,
the new designers, many of them like Lissitzky
himself not specially grounded in printing, created a
quite distinctive typographic look. This was partly a
matter of asymmetrical layout, as preached (in
Elementare Typographie, 1925, and other publications)
by the young Munich typographer Jan Tschichold,
who now submitted type to the same compositional
principles as shaped a Constructivist painting. But
quite as decisive was the urge to reject all traditional
forms of decoration, leading to a reaction not only
against the German Gothic alphabet, or black-letter
Fraktur, but also against seriffed Roman letters. This
practice was yet another utterly unfunctional gesture,
since sanserif (or Grotesque) typefaces, except for
display purposes, make much less easy reading than
letters with thick and thin strokes and feet to them,
but it became a point of principle; at the same time an
unfortunate mannerism grew up of starting para-
graphs without indenting them, a doctrinaire sacrifice
of legibility which accompanied the asymmetrical
ranging of everything to the left. One other
unfunctional convention which made rather less
headway was that of the 'Einheitsschrift' already

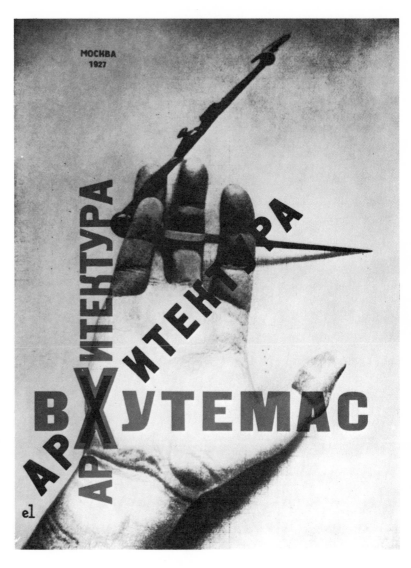

A Constructivist classic. Lissitzky's cover for *Architecture at the Vkhutemas*, 1927

referred to, which abolished capitals partly in order to economize on types and partly for the ostensibly democratic reason that nouns should not, as is the traditional German rule, be elevated above other words by being given a grander initial letter. Gropius himself henceforward always wrote like this, so did Hannes Meyer, while Brecht adopted the practice for typing in 1925 and retained it for the rest of his life, though he sensibly returned to normal conventions when it came to publishing his works.

Between them such developments affected the whole printing world sufficiently to make the books of this period instantly recognizable, with their good plain bindings, their use of roman letters for novels and poems, and sanserif for books on architecture and the like, and their brilliant use of photographs closely related to the text. There were also the new-style photomontage jackets, with Rodchenko as the chief Russian practitioner and Heartfield the German; 'if I weren't Tucholsky', wrote that writer, 'I'd like to be a book-jacket for the Malik-Verlag'. All this went with a certain radical curiosity about the very form of the book and of the letters of the alphabet. Thus Lissitzky could write in the *Gutenberg-Jahrbuch* in 1926, arguing that the traditional book was as cramping to printed matter as was the proscenium

Two of Lissitzky's Hanover jobs. (1) Advertisement for Messrs. Günther Wagner's Pelikan carbon paper

(2) The abstract rooms for the Hanover Landesmuseum, 1928, showing works by Mondrian, Picabia and Moholy-Nagy

stage to the drama, while Schwitters used printers' display letters and symbols as graphic elements in his children's book *Die Scheuche* (1925), and in 1927 designed his 'Systemschrift', an alphabet which made no distinction between upper and lower case and tried to convey the phonetic equivalents of the various letters as suggested by his own sound poems.

Both these two artists were engaged in advertising, and in 1929 Schwitters was put in charge of the publicity for the Dämmerstock estate at Karlsruhe, yet another collective housing scheme, directed this time by Gropius. For neither in Russia nor in Germany was advertising design considered in any way inconsistent with the aims of the modern movement. Rodchenko and Mayakovsky for instance had already devised advertisements for the main Moscow stores, while throughout the second half of the 1920s a whole series of Soviet artists produced posters of considerable merit, often using photomontage, as well as magazine covers and book jackets. Before leaving Germany Lissitzky too did a number of jobs for Günther Wagner, the Pelikan ink firm, including a Bauhaus-like letter heading with thick rules and asymmetrical composition. Schwitters, who likewise worked for Pelikan, founded his own agency in Hanover and in 1927 formed a 'Ring neuer Werbegestalter' or circle of new publicity designers, including Tschichold, Vordemberge-Gildewart, Domela and Baumeister; one of his tasks being some slogans for the Hanover trams.

The same year Hans Bellmer dropped out of political cartooning to become an advertising designer, before resurfacing later as a Surrealist. The Constructivist Werner Graeff, after being press and publicity officer for the Werkbund exhibition (producing for it two beautifully designed books quite free of obtrusive mannerisms), helped plan the Stuttgart 'Film und Foto' exhibition of 1929, then in 1931–2 taught at the Reimann graphic design school in Berlin. At the Bauhaus Joost Schmidt's department, under Meyer's directorship primarily concerned with advertising and exhibition design, worked for various outside clients including the Dessau municipality and the Rasch wallpaper firm. In the Ruhr the former Dadaist Max Burchartz, another Ring member, set up an agency called the 'Werbebau Studio'; like the Russians and Heartfield he made use of photomontage, while in *Gestaltung der Reklame* he wrote what must have been one of the earliest books on modern advertising design: 'Max is at last on the right track' wrote Lissitzky from Moscow in 1925.

This whole development was summed up by Hartlaub in the *Kunstblatt* of June 1928, using terms that have since become familiar. Illustrating his thesis with (*inter alia*) Heartfield's jackets for a novel by Upton Sinclair and a travel book by Huelsenbeck (who had been working as a ship's doctor), plus two semi-abstract film posters by Tschichold, Hartlaub argued that in the modern world of 'football grounds, boxing matches and six-day cycle races' the art of advertising was a

> truly social, collective, real mass art: the only one we now have. It shapes the visual habits of that anonymous collectivity the public. Little by little an artistic attitude is hammered into the mass soul by the poster hoardings. . . .

Other critics were sceptical, being rather more concerned with what the advertisements actually said. Thus Iwan Goll wrote ironically of advertising as 'educating mankind' by annulling our obligation to think, and concluded that the appropriate kind of poetry to match it would be one that

> landed a straight uppercut to the reader's left temple or a lightning blow somewhere round the heart. Rapid image. Convincing expression. And a long echo in the soul it has touched.

– no bad description, incidentally, of Mayakovsky's verse. There is also a batch of all-too-perceptive parodies of drivelling advertising copy written by Tucholsky in 1927, finishing up with a powerful recommendation for a stimulant called Kokmès, a name suggestive of cocaine.

> 'Kokmès' has no harmful side effects, since it has no effects at all. We are only manufacturing it in order to cover the high advertising costs, and we advertise it in order to be able to manufacture it. In this way we symbolize what lies closest to our heart: the German economy.

Many of the artists and architects concerned were also involved in exhibition design, whose development was one of the features of the period. For the exhibitions in question, many of them devoted to architecture and other everyday arts, often combined missionary-style instruction and exhortation with new spatial and technical solutions by the designers. Thus Moholy-Nagy included a view of his and Gropius's AHAG exhibition in Zehlendorf among the examples of spatial interpenetration in his Bauhaus book *Vom Material zur Architektur*, while Lissitzky, besides designing the Moscow Polygraphic Exhibition of 1927, returned three times to Germany

A Bauhaus extravaganza. Project for an advertising kiosk by Herbert Bayer (1924)

the hygiene exhibition in Dresden and, more commercially, the international fur show in Leipzig.

Meanwhile the Bauhaus's department under Schmidt was contributing to various architectural or building shows, designing a stand for the Junkers firm's gas appliances in Berlin in 1929 and showing a 'people's flat' (under Meyer's regime) at the Grassi Museum in Leipzig the same year. Two such exhibitions were of particular importance, first the Stuttgart exhibition of chair design in 1928, called simply 'Der Stuhl', which was in effect a sequel to the Werkbund show of the previous year. The second was the Werkbund section of the exhibition mounted by the Parisian Société des Artistes Décorateurs in the Grand Palais in 1930, where Gropius was in overall charge and Breuer, Moholy-Nagy and Herbert Bayer all designed rooms. This was France's first glimpse of the new German interior design, since it had been excluded from the 1925 Arts Déco show.

This whole drive for good everyday design, with architects joining with constructively-disposed artists, was unique in Europe and indeed in the world, and it had a remarkable consistency. To a great extent it was stimulated and ultimately paid for by public authorities and other non-profit-making bodies, such as the various branches of the Werkbund. At the same time there were a number of far-sighted industrial firms involved. Thus the Dessau Bauhaus was supported by the local firm of Junkers (who were primarily aircraft manufacturers, producing among other things the Ju 87 and 88 dive-bombers of the Second World War), by Emil Rasch, who first commissioned Meyer to produce wallpaper designs and whose sister had been a painting student in the Weimar days, by Adolf Sommerfeld the Berlin builder, by the various manufacturers who made the Bauhaus light fittings, textiles (the Deutsche Werkstätte in Hellerau, Pausa of Stuttgart, Polytextil of Berlin) and furniture (such as Standard-Möbel of Berlin). Similarly Schwitters and Lissitzky were employed not only by the Hanover municipality, the Land gallery and the private Kestner-Gesellschaft of local art-lovers, but also by Pelikan inks and the Bahlsen biscuit firm. In Paris too Le Corbusier was aided by the motor manufacturer André Voisin, who contributed to the expenses of the *Esprit Nouveau* pavilion at the Arts Déco show and lent his name to the great town-planning scheme exhibited there; though the attitude of the public authorities in France was very different.

to contribute with typical brilliance to a number of such shows. The first of these had no publicity aspect, being the 1926 Dresden art exhibition where he was given a 6 × 6 metre space which he turned into an abstract art room: a small masterpiece which stimulated Alexander Dorner of the Hanover Landesmuseum to commission two abstract rooms for that institution in 1928. Now destroyed, these have a great perfection in the surviving photographs, though the care and subtlety of the proportions and the variations of wall surface must have made it almost impossible ever to change the pictures shown. Then in 1928 Lissitzky brought a team of Russian helpers to create a masterpiece of display in the Soviet pavilion at the 'Pressa' exhibition in Cologne, gearing photomontage and Constructivist symbolism to a forceful exposition of the role of the Soviet press; among the visitors to this were Maxim Gorki and Kisch. The following year he designed the Soviet contribution to yet further exhibitions: the Stuttgart film and photo show (for which Dziga-Vertov came),

So far, the interest of such industrialists in modern designers scarcely extended beyond the commissioning of publicity work of various kinds and the design of household objects, one oustanding exception being Gropius's designs of 1930 for car bodies for the Adler firm. But the influence of the new design ideas, and even more of the principles behind them, could hardly fail to penetrate a long way beyond the circle of avant-garde architects and artists whom we have been considering. Generally the standard of design in Germany at this time was being raised, with results that could be seen in all kinds of manufactured objects and affected every aspect of day to day life.

Industrial design in the Bauhaus's orbit. (1) Passenger cabin of a Ju 38 aircraft, designer unknown, for the Dessau firm of Junkers

(2) Gropius's prototype limousine on an Adler Standard 6 chassis. His collaborators included Rachlis (Berlin engineer), Professor Lisker (Frankfurt) and Paulon (a sculptor)

15 The camera eye: new photography, Russian and avant-garde films

Photography by avant-garde artists: Lissitzky, Moholy-Nagy, Rodchenko and others. New angles, scales and perspectives. Photo-journalism and its political implications: a subversive medium, e.g. as realized in Muenzenberg's weekly *AIZ*. His International Workers' Aid and the cinema: its Moscow studios and German distribution. A golden age of Soviet film making, almost despite Soviet film policy. French and German experimental films and their reception; secondary role of the German commercial film and its abuses of the new reality; critical view of Hans Richter. Artists, the cinema and the question of 'social command'.

It was also a time of rapid progress in photography, without which the development of exhibition display and modern typographic layout would have been very different. This was due above all to those Dadaist and Constructivist artists whose disillusionment with painting had led them to try the new medium; as Franz Roh pointed out, it was not the established professionals but the 'outsiders' (he used the English word) who dominated the Stuttgart 'Film und Foto' exhibition of 1929. For instance Lissitzky, after his early experiments with photomontage, had only begun taking photographs in 1924, using his future father-in-law's enormous (13 × 18 cm) plate camera; the self-portrait which he incorporated in the montage 'The Constructor' and his portraits of Arp and Schwitters date from this time. Rodchenko in Moscow also seems to have started serious photography during the same year, when he took his fine portraits of Mayakovsky; again this came after his first photomontages. Moholy-Nagy was yet another artist who came to the medium through photomontage, for he only began seriously concentrating on photography once he had gone to the Bauhaus and his wife Lucia had studied with a professional photographer in Weimar in order to be able to help him; they had no proper laboratory before the move to Dessau. In 1925 Moholy published his book *Malerei, Fotografie, Film*, of which a copy was sent to the Vkhutemas where Lissitzky that year was asked to set up a photomechanical laboratory.

Others who mastered the technique included Burchartz, Vordemberge-Gildewart, Herbert Bayer, Graeff and Feininger's sons Andreas and Lux, while

The photographic eye of the 1920s. *Lotte*, by the former Dadaist – Constructivist Max Burchartz

Baumeister produced some very original photo-montages. This quite widespread artistic concern with the new medium was almost exclusive to Germany and Russia – Man Ray and Florence Henri in Paris were exceptions – and it was based on two things. First there was the productivist ethic of self-subordination to the 'social command' of a new industrial world, now strengthened by the awareness that photography was an essentially democratic medium which all classes were beginning to use. Secondly there was the rapid advance of photographic technology, as seen in such German inventions as the Leica miniature camera and the photoflash bulb.

You only have to study the old illustrated magazines to see that the standard of professional and press photography was already higher in Germany than in other European countries. Erich Salomon, indeed, who was among the first to take advantage of the Leica's portability, was one of the greatest of all photojournalists, catching politicians and others at their most natural in a way that is now hardly possible; there are also some memorable portraits by him, including those of Schlemmer and Gropius. But by 1929 (which was when photography was first formally taught at the Bauhaus) men like Moholy, Graeff, Roh and Tschichold had started expounding the new possibilities of the art in terms that were revealing to photographers and painters alike and even today seem astonishingly up to date.

Thus it was Moholy who, in *Von Material zur Architektur* that year, showed how micro-photography, X-rays and astrophotography could provide entirely new images of reality, at the same

time using straight, precisely-focussed pictures to reveal materiality and texture as in his Bauhaus Basic Course. The Roh-Tschichold album *foto-auge – oeil et photo – photo-eye* did much the same by means of images only, while extending these to cover such other aspects as photomontage, photographic publicity, the photogram and photo-reporting; here the Russian influence is made plain from the outset by Lissitzky's 'The Constructor' on the cover and the echo of Dziga-Vertov in the title. Finally Graeff, in a lively and well-designed primer (again of 1929) called *Es kommt der neue Fotograf!*, used shrewdly-chosen examples from many sources to demolish every recognized rule of photography and prove that there is no reason on earth for the camera to obey the same laws of perspective and balance as the human eye. It can twist, foreshorten, superimpose, blur and cut; all that matters is that the photographer should remain in control.

This interest in the instrument's new possibilities quickly spread to the popular illustrated press; among Graeff's examples for instance being a page from the *Kölner Illustrierte* proclaiming 'Das Bild liegt auf der Strasse' – the picture's lying in the road – and showing textural photographs of different street surfaces: 'asphalt' in fact. 'In order to teach men to gaze unconventionally', wrote Rodchenko in *LEF* in 1928, in terms that seem to anticipate Brecht's 'alienation' theories,

The constructive camera. Photographs by Lissitzky of two poet–artists in 1924: *above*, Hans Arp; *below*, Kurt Schwitters

> it is necessary to photograph ordinary, familiar objects from totally unexpected vantage points and in unexpected combinations; new objects on the other hand are to be photographed from various perspectives, giving a full impression of their appearance.

It was now that one of the best-known Soviet journalists, Mikhail Koltsov, became the first editor of a journal called *Sov'etskoe Foto* devoted especially to the encouragement of 'worker-photographers' both in Russia and in Germany. A similar awareness of the essential subversiveness of this medium had already encouraged Muenzenberg to use the growing funds of the IAH to found a 'Union of Worker Photographers' with its journal *Der Arbeiterphotograph*.

At the root of this new development lay perhaps an article by Tucholsky in the *Weltbühne* in 1925 which complained of the old-style satirical papers like *Simplicissimus* and contrasted the feebleness of their drawings with the power of unembellished photography of such subjects as 'arrested Communists before and after interrogation; comparative physiog-

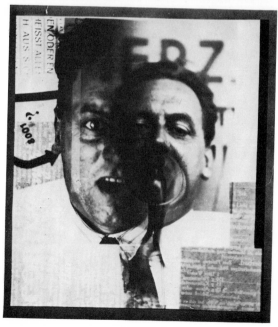

nomies of Lenin and Hindenburg; a parade under Wilhelm and one under Seeckt'. The workers might have been denied control of the cinema, Tucholsky said, but 'the photographs are there, dynamite and detonators in the psychological struggle'. So there ought to be a polemical journal illustrated with tendentious photos. Just that indeed was provided by the IAH the same year when Muenzenberg started the weekly *Arbeiter-Illustrierte Zeitung* (or *AIZ*), edited at first by a friend of Kisch's called Frank Hoellering, then by Lily Corpus, the Communist granddaughter of Albert Ballin the shipping magnate. Thereafter the IAH's publishing empire was founded on the success of Tucholsky's recipe, the *AIZ* at one point reaching a circulation of 450,000.

If the German cinema was in wholly capitalist hands, and shaky ones at that, it should be remembered that the silent film was among the most international of media, nor was any country more receptive to foreign products than Germany at this time. This was partly

A page from Werner Graeff's *Es kommt der neue Fotograf*, published for the Stuttgart 'Film und Foto' exhibition of 1929. *Top*: how to twist the rules. *Bottom*: the use of panorama

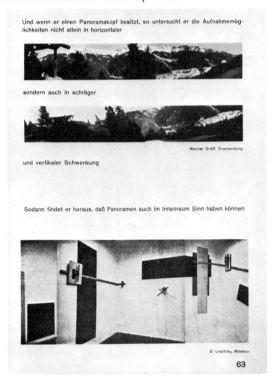

due to UFA's deal with the Americans, giving the Hollywood firms fresh outlets throughout the country, together with a way of getting round the quota system; thus while the number of German cinemas increased between 1920 and 1929 from 3700 to 5000 the number of films actually produced there fell from 646 in 1920 to 175 in 1929. At the same time Muenzenberg's IAH played an extremely influential part here too, and one which related much less to its original objective of charitable aid than to its incidental aim of promoting close relations between Germany and the USSR, particularly in the cultural field. The story began when the Russ cooperative studio in Moscow got into financial difficulties as a result of the New Economic Policy; the IAH, under its Russian title of Mezhrabpom, then came to its aid and reorganized the studio under the new name of Mezhrabpom-Russ. This outfit, which also owned some cinemas and later acquired its own raw film factory, was responsible for such early Soviet films as the science-fiction *Aelita* (with sets by Exter and others) and *Cigarette-Girl from Mosselprom*, and it accumulated a strong team of directors, including Protazanov, Otzep and above all (from 1925) Vsevolod Pudovkin and Boris Barnet.

A year later Muenzenberg also took over a German production firm called Prometheus, which he turned into a distributor of Soviet films in Germany. The first film which this handled was a German–Soviet co-production called *Superfluous People*, in which Werner Krauss and other leading German actors were directed by the Russian Alexander Razumny; later, in 1929, Prometheus joined Mezhrabpomfilm (as the Russian firm became called after a further reorganization) to co-produce Tolstoy's *A Living Corpse* in Berlin with Otzep as director and Pudovkin in the leading part. It was Prometheus which gave the majority of exported Soviet films the titles by which they became known abroad (*Storm over Asia*, *Bed and Sofa* and the like), and doubtless the same firm was in part responsible for the fact that (according to a table in Jay Leyda's *Kino*) more Soviet films were being exported to Germany than to any other country: twelve in the period up to 15 February 1927, as against three each to Britain and France. Further to stimulate such traffic, Muenzenberg in 1928 set up another organization, called Weltfilm, for the distribution of 16 mm copies to working-class organizations. The same year the Soviet Trade Delegation brought Asja Lacis back from Moscow to supervise film distribution from Berlin.

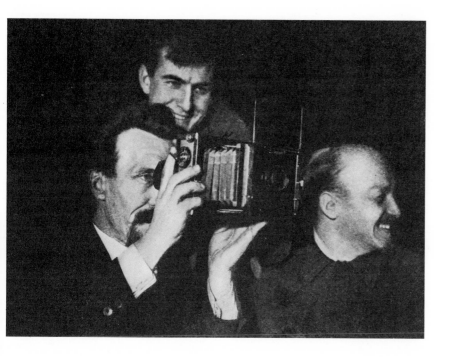

Soviet leaders take up the camera. Rykov, *left*, and Bukharin, *right*. Photo by N. Vladimirov in *Sov'etskoe Foto*, 1928

In this period of 1925–9 the great films in Germany, for critics and public alike, were those of Chaplin, Eisenstein and Pudovkin, the crucial year being 1926, when *The Gold Rush* and *Battleship Potemkin* were shown for the first time in the capital. With Chaplin by now a known quantity – though still an astonishing one – it was *Potemkin* which had the greatest impact, so that the Berlin premiere of Eisenstein's masterpiece on 29 April was an historic occasion as well as being something of a miracle in itself. For the Soviet Trade Delegation, who had received the film just a month after its first showing in Moscow, felt sure that the German censors would forbid it, which was perhaps why they offered it to Prometheus rather than to a capitalist distributing firm.

Prometheus got Piel Jutzi to edit a German version and commissioned a musical score from Edmund Meisel, the young composer who had worked with Piscator on his political shows *Revue Roter Rummel* and *Trotz Alledem*; Eisenstein himself came to Berlin to discuss the music with him, and the result was a powerful score which was of course not recorded but sent out to all cinemas showing the film. The censors by then had seen the film and banned it; Prometheus, with Paul Levi as their counsel, promptly appealed to the top censorship authority, who quashed the ban

thanks largely to the reactions of one of their expert advisers, the theatre critic Alfred Kerr. At the last moment before the premiere General Seeckt made representations to the Prussian government that so revolutionary a film was dangerously subversive, so the state SPD premier Otto Braun and the head of the Berlin police had to have a special showing before it could go on. With that, despite further censorship troubles in the provinces, *Potemkin*'s fortunes were finally made; the film is said to have run for a year at one Berlin cinema alone. So, oddly enough, was Eisenstein's reputation in his own country, which had remained uncertain after the first Moscow showing. For as Lunacharsky wrote in a short German-language introduction to *Der russische Revolutionsfilm* in 1929,

> The full revolutionary force of this brilliant piece of film and its new technique were not immediately understood in Russia. It was only the German reaction to it that made us realize how far our cinema had progressed.

The great upsurge of film making in Russia at this time, though still dependent on imported materials (cameras, raw film and the like) was the real climax of what may be called the Lunacharsky period in the Soviet arts; nor can it be dissociated from the whole 'left' art of the time. Eisenstein, as we have seen,

Painters and the 'absolute film'. (1) Chaplin sequence from the
Léger/Dudley Murphy *Ballet mécanique*, 1923–4

started as a designer for Meyerhold's theatre, thoug
his actual drawings are hardly to be compared wit
those of more serious artists. Dziga-Vertov, Pudov
kin and Sergei Yutkevitch had been painters
Kozintsev was Mrs Ehrenburg's brother, whil
Dovzhenko, to whose Berlin experiences Georg
Grosz doubtless owed the serialization of h
autobiography in the Kharkhov magazine *Kino* i
1925–6, said in effect that it was the arguments c
LEF that made him give up newspaper cartoonin
and go into the cinema instead. Rodchenko, again
designed titling for Dziga-Vertov and did the sets fc
Barnet's *Moscow in October*, one of Mezhrabpom
Russ's two productions for the tenth anniversary yea
(*The End of St Petersburg* being the other). Altman wa
responsible for the sets when Granovsky of th
Moscow Jewish Theatre made his first film with th
actor Mikhoels.

As for the writers, it was one of *LEF*'s editor
Nikolai Aseyev, who wrote *Potemkin*'s titles. Shklov
sky became the principal scriptwriter of the perioc
working with many of the leading directors fror
1925 onwards, and notably on *By the Law*, *Turksib* an
Bed and Sofa; Brik wrote the script for Pudovkin
Storm over Asia; while Tretiakoff, after trying vainl
to get Eisenstein to make a film about the Chines
revolution, contributed a number of scripts to th
Georgian branch of the new industry, including *Sa
for Svanetia* in 1930. Mayakovsky, it seems, woul
dearly have loved to take part too; however, he ca
hardly have endeared himself to the semi-philistir
administrators in the background by the fierceness c
his attacks on them, whether in private or in publi
so that his various scripts and projects remaine
virtually unused.

For obvious reasons the cinema was the art abou
which the Communist Party minded the most:
affected more people than any other, its documentar
and propaganda importance had been more stresse
by the late Lenin, it figured more largely (both way
in the foreign trade balance, and now with the succe
of *Potemkin* it suddenly became extremely significa
for Soviet propaganda abroad. Sovkino, which ha
been set up in 1924 as the chief administration of th
newly nationalized industry (with Mezhrabpom as a
'organization of the international proletariat' bein
left outside this), was headed by a worthy ol
Bolshevik called Shvedchikov, and such men
judgement, just like that of the Hollywood tycoon
seems to have been guided primarily by accountant
figures. *Strike*, Eisenstein's first film, fell flat at th

box-office, though Koltsov in *Pravda* at once recognized its importance; *Mother* was nearly cancelled when Pudovkin overran his budget; in Lunacharsky's words it 'had a very bleak reception in Moscow'. *Potemkin*, though made under Sovkino's management, had actually been commissioned on the strength of *Strike* by Lunacharsky's commissariat, so it took considerable persuasion by Mayakovsky *et al.* to get Shvedchikov to send the film to Berlin.

In fact the new Soviet cinema had to battle for its existence, and this was one reason for the growing complaints about Sovkino which led in March 1928 to the first All-Union Party Conference on Film Questions and the ensuing reorganization of the industry. As a result of the conference Mezhrabpom-Russ, where there had been a financial scandal, became Mezhrabpomfilm, and Shvedchikov was replaced by Boris Shumyatzky together with his assistant Pletnev, the Bukharinite president of Proletkult and producer of *Strike*. Hopeful as such changes might look, the conference did little to support the leading directors (of whom neither Eisenstein nor Pudovkin were party members) and in the course of its criticism of Sovkino's foreign imports it made a somewhat ill-omened use of terms like 'decadent'. True enough, the feature films imported at that time were largely trashy, though Jay Leyda (a subsequent pupil and assistant of Eisenstein) thinks that without their box-office takings the Soviet industry could never have financed its own films. But unhappily it seems that the same criticism was applied to the avant-garde film clips which Ehrenburg had brought back from Paris in 1926 and shown to an invited audience in Moscow. These included René Clair's *Paris qui dort* (1923) and very probably the Léger–Murphy *Ballet mécanique* (1924), as well as fragments given him by Renoir, Epstein and others.

Whereas in the USSR the general openness of the cinema situation had allowed the 'left' artists and writers to make full-length films, elsewhere their opposite numbers from the Dada and Constructivist movements remained confined within a kind of avant-garde ghetto, where the films and the money were alike short. The French Communist critic Léon Moussinac, in his book of 1928 on *Le Cinéma soviétique*, accordingly dismissed such works with a certain contempt as a mere laboratory exercise. And true enough, if it was a pity that the Soviet directors, who were curious to learn about such things, had so little chance to see them, this paled into relative

(2) *Vormittagsspuk (Ghosts Before Breakfast)*, 1928, by the ex-Dadaist Hans Richter. Script by Werner Graeff

insignificance compared with the fact that when Moussinac wrote, neither *Shoulder Arms, The Kid* nor *The Gold Rush* had yet been imported at all. Yet such men as the writer René Clair (Chomette) and the painters Richter, Ruttmann, Picabia, Léger and Man Ray did indeed produce a body of extremely original experimental work in the silent era, and in Germany it came to form a significant part of the cultural scene.

The process began in May 1925, when Richter prepared a programme under the title 'Der absolute Film' to be shown by the Novembergruppe in conjunction with the UFA documentary department; this brought together *Entr'acte, Ballet mécanique,* Eggeling's *Diagonal-Symphonie* and abstract films by Ruttmann, Hirschfeld-Mack of the Bauhaus and Richter himself. Eggeling, who died just at that time, had only slowly begun to animate the film-like scrolls which he and Richter had been making for some years; Richter however for his part worked these into three short films, called *Rhythm 21, 23* and *25* according to their year of origin, the last of the three being hand-coloured. After the success of this first show he was asked to make commercials, as well as one or two special effects for feature films. With his earnings from such jobs he was able to make further experimental works, this time using the camera, for which he devised a number of optical tricks. Thus *Filmstudie* with the cameraman Endrejat was an imaginative exercise in abstract photography, while *Vormittagsspuk* (or *Spuk der Gegenstände,* or *Ghosts Before Breakfast*) was made at Hindemith's request for the Baden-Baden music festival of 1927; based on a script by Graeff, it involves a memorable episode with a group of levitating bowler hats. Other similar works followed, then in 1929 Ivor Montagu invited Richter to an avant-garde workshop in London. Quite unexpectedly he decided to make 'a social film with a social content' which he called *Everyday*. He took this away to edit, lost heart and left it in a laboratory in Switzerland, where it came to light in 1966. Among other things it shows Eisenstein acting a London policeman: allegedly a splendid performance.

Sandwiched between the new ideas of the Western avant-garde and the revolutionary impact of the great Russians, the German commercial cinema in this period played a somewhat subdued role. To its chief interpreter, Siegfried Kracauer, who at the time was film critic for the *Frankfurter Zeitung* and is inclined to see the Expressionist film as its high point, the reason lies in the schizophrenia of the mid-1920s: outward democracy conflicting with a basic urge to autho[r]tarianism. At the same time one contributory cau[se] was surely the first serious impact of the box-office[:] the Hollywood imports started to compete and t[he] film makers themselves became more influenced [by] American practice. Nonetheless the commerc[ial] productions attributable to the Neue Sachlichk[eit] spirit were by no means all disastrous. Admitte[dly] some of them, like the succession of 'street' film[s] retain more of the mannerisms of Expressionism th[an] is generally acknowledged, while a film like Murna[u's] *Der letzte Mann* of 1924 (so wrongly called *The L[ast] Laugh* by the cachinnomane English) with its mob[ile] camera and smoothly title-less story, has more of t[he] new realistic approach. But even before the gre[at] Russian films arrived Béla Balázs's *The Adventures o[f a] Ten-Mark Note* for Fox Europe set out to provi[de] what its author termed a 'cross-section' of Ber[lin] society somewhat in the tradition of Kaiser's pl[ay] *Nebeneinander.* And not only Ruttmann's *Berlin* b[ut] also Joe May's (Mandel's) *Asphalt* subsequent[ly] shared the new urban vision.

The chief realist director of the time however w[as] G. W. Pabst, a former theatre producer from Vienn[a] who made his name in 1925 with *The Joyless Street* fo[r a] firm called Sofar. With Asta Nielsen and the you[ng] Garbo as its stars, this film was still made in a stud[io] using so stagey an actor as Werner Krauss, where[as] Pabst's UFA film *The Love of Jeanne Ney* in 1927 seem[s] to have been made deliberately in the new Russia[n] idiom. Ehrenburg, arriving to watch the filming [of] his novel, felt understandably 'ill at ease' when re[al] White ex-officers (who had kept their uniforms) we[re] given vodka and told to carouse; it was too like h[is] own experiences. The lighting was as natural [as] possible; the camera peered around, other scen[es] being shot in the Paris streets, where the story [is] partly set. Much has been made of Pabst's use [of] significant real-life detail – a broken mirror, an iro[n] basin – but against this must be set his (or h[is] scriptwriter Rudolf Leonhard's) perversion of t[he] end of the story, where instead of being guillotin[ed] the Soviet hero is taken by Jeanne into a church to [be] converted and saved, after which they live on [as] happy Catholics. According to Ehrenburg, who d[id] what he could to protest at this travesty, it was th[e] result of Hugenberg's takeover of the UFA compan[y] which occurred while the film was being made: th[e] new management insisted on a happy endin[g.] Brilliant as it was, then, this picture was an early lesso[n] in the use of realistic means for an unreal effect.

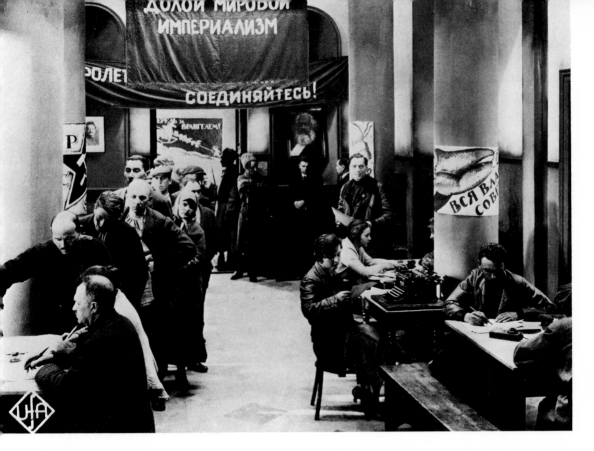

Lessons of the movie medium. *Above*: the deceptive realism of Pabst's *Love of Jeanne Ney*, made for UFA in 1927 on Ehrenburg's revolutionary story. *Below*: two pages from Richter's *Filmgegner von heute – Filmfreunde von morgen*, 1929, expressing his criticisms of false prettification and the treatment of people as dolls

Sie fotografieren scharf, um die
Glyzerintränen deutlicher zu bekommen

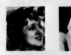

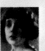

sie fotografieren weich, um
Süßes zuckersüß zu machen

 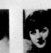 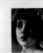

sie verwenden Optik, Licht und Schminke, um jeden menschlichen Ausdruck
aus dem Gesicht zu verbannen.

Umbo

Sie fotografieren den Prunk an Stelle des Menschen

sie fotografieren Männer wie Mädchen

. . . kann es das Publikum wirklich nicht ertragen, echte Menschen zu sehen?
Navarro —

Foto Lersky Metro-Goldwyn

aber so zeigt man ihn nicht. Man präsentiert ihn als Puppe.

In 1929 Richter, in consultation with Graeff, wrote a book for the Stuttgart 'Film und Foto' exhibition, where he too was one of the 'outsiders'. Like Graeff's companion photography book his *Filmgegner von heute – Filmfreunde von morgen* is very amusingly written and tellingly illustrated by stills and film strips taken from a wide range of the period's best movies – *Mother, The General Line, The Man with the Movie Camera, The Last Days of St Petersburg, Storm over Asia*, Dreyer's *Le Passion de Jeanne d'Arc, Ballet mécanique* and similar experimental films by Chomette, Man Ray, himself and others – all of which hang together far better than critics of the avant-garde could have conceived. Such evidence is used by Richter to show the possibilities of camera movement, of cutting and montage, of overprinting and trick lenses, of rhythm and contrast and the authenticity of untrained acting, as well as the same purely photographic lessons as are more fully developed by Graeff.

Then he goes on to take to pieces the German and American commercial cinema of the same time: the exaggerated gestures of the actors, the overuse of stars like Jannings, the artificial sweetening of pretty or handsome faces, the stagey costume pieces like Fritz Lang's two studio-made Nibelungen films, the too dominant sets as in *Metropolis*: it is this phoneyness, he argues, imposed ultimately by 'the artistic judgement and conscience of the businessmen' which alienates many people from the cinema. The latter become the 'Filmgegner', the anti-film people of the title, whom Richter saw as starting to band together everywhere in film societies in order to get away from the common commercial abuses of the medium. The first such societies were at that time just being formed, including one led by Richter himself under the name of German League for Independent Film. It was here that he saw the 'Filmfreunde', the cinema's friends of tomorrow,

The Congress of Independent Film at La Sarraz, 1929. Balázs, Eisenstein and Isaacs are seen on the left of the middle row; Ivor Montagu (who lent this photo) *bottom right*, with Richter in a white shirt behind him next Moussinac (moustached)

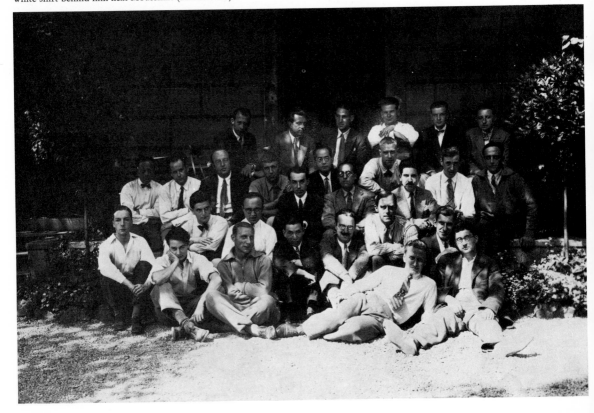

who would have to be won back by a change of policy on the distributors' part.

'Dramatists', wrote that excellent English critic Robert Herring when introducing *Films of the Year* for 1927–8,

> were too obsessed by the story-telling properties of the screen to see that it had any others. These the poets, sculptors, painters and musicians were conscious of . . .

In September 1929 a group of such experimentalists met at the Château de La Sarraz, just as the architects had done after the previous Werkbund show at Stuttgart two years earlier. Their theme was 'The Art of Cinema, its Social and Aesthetic Purposes' and among those attending were Richter, Ruttmann, Balázs, Moussinac, Robert Aron and two representatives of the London Film Society in the shape of Ivor Montagu and Jack Isaacs. Then along came Eisenstein, Tissé and Alexandrov to turn it all into a memorable charade. For in order to demonstrate his method of directing crowd scenes (particularly with untrained actors) Eisenstein with Richter as his partner got the congress to make a short film, since lost, in which The Art of Cinema (played by Aron's friend Janine Bouissounousse) was liberated by the avant-garde from the demon Commerce (Isaacs clad in some of the château armour). Not unnaturally, no serious professional organization like the CIAM emerged. But a few photographs still survive to remind us that for the leaders of the art the film at that time was not only socially and aesthetically significant but also fun.

If the representatives of the Soviet avant-garde differed from their opposite numbers in the West it was not so much a matter of originality or even commitment. The fact was rather that the former had found the 'social command' (and with it the financial backing) that was now stimulating advanced German designers and architects but not yet the corresponding film makers, who still remained a fringe. To that extent Sophie Lissitzky was right when, reporting to *Das Kunstblatt* from Moscow, she linked Eisenstein's work with that of the Dadaists and with the Grosz–Herzfelde obituary for art in *Die Kunst in Gefahr*. It was to this last, she said, that *October* had given the answer: 'Art has been saved'.

> Following the universal crisis of artistic creation in the past ten years, that same country which had the courage to break with every tradition after the world catastrophe has brought us the fruits of a shared idea and collective work: the film.

16 Theatre for the machine age: Piscator, Brecht, the Bauhaus, agitprop

Middlebrow entertainment and the revaluation of the classics. The challenge of cinema. Piscator's first political productions and his development of documentary theatre; splitting of the Volksbühne and formation of his own company; his historic productions of 1927–8 with their use of machinery and film. The new dramaturgy and the problem of suitable plays. Brecht's reflection of technology, notably in *Mann ist Mann*; his collaboration with Kurt Weill and the success of *The Threepenny Opera*; epic theatre and the collective approach. Boom of the 'theatre of the times' in 1928–9. Experiments at the Bauhaus: Schlemmer, Moholy-Nagy, Gropius's 'Totaltheater' etc. The Communist agitprop movement. Parallel developments in Russia: Meyerhold, TRAM, Tretiakoff.

Where the living theatre was concerned the Germans started, as Goll had suggested in his *L'Esprit Nouveau* article, with enormous advantages, and nowhere is it less true to suggest that the Weimar Republic created nothing new. The origins of this situation lay in the cultural–political development of the country prior to its unification, for right up to the First World War the local courts at centres like Darmstadt and Weimar had pursued independent cultural policies even though their political significance had gone. Alongside the mixture of aristocratic patronage and local pride which had nurtured the smaller opera houses and provincial theatres the prewar SPD had built up its own rival cultural tradition of workers' theatre groups and choral societies, culminating in the Berlin Volksbühne or People's Stage, whose great theatre on the Bülowplatz bore the inscription 'Art to the People'.

Between them these two rival factors bred a large and alert theatre-going public, as well as a group of dramatic critics who have perhaps never been equalled; moreover the demands of so much large-scale opera (in particular of Richard Wagner, with his vast scenic conceptions) had created a technical standard, even in quite obscure provincial houses, which the greatest theatres elsewhere could not yet match. In 1905 the Austrian Max Reinhardt had arrived to start applying the new technical possibilities to more loosely and episodically-constructed plays: Shakespeare, Strindberg, Büchner, the second

part of Goethe's *Faust*, leading up to the Ex-
pressionists who dominated the Berlin theatre
between 1917 and the end of 1923. Besides all this,
and serving as a 'fringe' to the theatre proper, there
was the cabaret tradition originated by Wedekind in
Munich, which now provided a channel for such
socially critical poets (and in some cases performers)
as Tucholsky, Mehring, Ringelnatz and Brecht.

If Kaiser's *Nebeneinander* in November 1923 had
marked the end of Expressionism it was Zuckmayer's
immensely successful *Der fröhliche Weinberg* at the end
of 1925 which established a new vein of realistic
comedy, well rooted in German rural life. Though
this work effectively eliminated its author from the
literary avant-garde – the critic Herbert Ihering (a
notable supporter of Brecht's) writing severely that it
'drew him into the sphere of mediocrity' – it was a
pioneering effort. Indeed the high standard of
middlebrow entertainment was one of the theatrical
features of the later 1920s, when the gifted Marcellus
Schiffer could write a revue sketch later used as an
opera libretto by Hindemith ('Hin und Zurück' from
the Berlin revue *Hetärengespräche* of 1926), as well as
the topical song already quoted on p. 111, which
helped popularize the very notion of 'Die neue
Sachlichkeit'. Another new trend was the recon-
sideration of the classics in the light of current social
and political thinking; thus one of Erich Engel's first
important productions in Berlin was an anti-heroic
interpretation of *Coriolanus* in February 1926, with a
proletarianized plebs and a near-timeless setting by
Neher. By the end of that year Jessner had staged
Hamlet rather similarly as a critique of the monarchy,
while Piscator's *Die Räuber* at the Staatstheater stood
Schiller's text on its head so as to reflect the IAH's
current campaign for the expropriation of the
German princes.

Dominating everything then were the two out-
standing figures of the cinema, Eisenstein and
Chaplin, whose example was at once a challenge and
an inspiration. 'After viewing *Potemkin*', Max Rein-
hardt is supposed to have said, 'I am willing to admit
that the stage will have to give way to the cinema',
while Brecht wrote that he only went to see *The Gold
Rush* because of the utter discouragement of other
Berlin theatre people, who thought that their own
medium would never be able to match it. The real
problem of the theatre in these years was whether it
could come to terms with its new rival and find the
fresh resources of language, staging and dramaturgy
which would enable it effectively to compete.

This was where Piscator's contribution was crucial. It
was determined by three factors which distinguished
him from all the other leading directors of the period.
First of all he had been one of the socially-conscious
Berlin Dada group who entered the KPD, and his
deep faith in the Russian revolution had made him an
early supporter of the IAH. Secondly he identified
himself with the ideals of the Volksbühne movement
in a way that far outlasted his actual period of direct
involvement with it; and thirdly he had an intense
interest in, and a considerable imaginative gift for,
the application of new technological devices to the
theatre. The first of these characteristics had been
evident in his early agitational productions for the
Proletarian Theatre, the second in his more con-
ventional work at the Central-Theater thereafter; but
it was only now, after his first Volksbühne pro-
duction at the end of the 1923/4 season, that all three
began to come together. For the KPD's election
campaign in the winter of 1924 he staged an
agitational revue called *RRR* or *Revue Roter Rummel*,
then the following summer he was asked by the Party
to direct an episodic pageant covering the history of
the German Left from 1914 to 1919 for performance
to the Tenth Party Congress. Politically speaking, the
election campaign was followed by the loss of about a
million votes, while the Tenth Congress saw the fall
of the Maslow/Ruth Fischer leadership and the
election of Thälmann. But on the theatrical level the
one work introduced Piscator to two of his chief
collaborators, Edmund Meisel the composer and
Felix Gasbarra the dramaturg; while the other, the
pageant *Trotz alledem* (or 'in spite of everything', a
phrase of Liebknecht's), depended for its visual
impact on the projection of film sequences from the
war.

With this the documentary theatre was born, and
in February 1926 Piscator for the first time applied its
techniques to one of his now regular productions for
the Volksbühne, spurred on (almost certainly) by a
pre-release viewing of *Potemkin*, with whose Berlin
censorship problems he had been asked to help. The
play in question was Alfons Paquet's *Sturmflut*, a
somewhat unmemorable successor to his *Fahnen*
which centred on a ridiculous intrigue set in the
Russian revolution, where Paquet had been a
reporter. Piscator made the main feature of his set a
big cinema screen on which a naval battle and crowd
scenes were projected. 'The photographic image', he
wrote, 'conducts the story, becomes its motive force
a piece of living scenery.' Three months later he

staged Paul Zech's episodic Rimbaud play *Das trunkene Schiff* against a triple screen showing projected watercolours by George Grosz, and again used film to show the moving sea behind Rimbaud's ship. Finally in March 1927 he took a play by Ehm Welk about the middle ages (called *Gewitter über Gottland* and since quite forgotten) and updated it by a politically-slanted film prologue and background, thus causing a major furore.

This production split the Volksbühne movement whose employee Piscator had been for nearly three years, and doubtless he had known that it would. For despite its high social aims and its long SPD tradition the organization had stagnated ever since 1918, becoming in effect a cheap ticket subscription agency for all classes, centred on a theatre management of incongruously conservative views. Even during those three years there had been many complaints by the critics and by others, Toller for one having threatened to sue the board after his release from gaol when they broke an agreement to stage his war play *Die Wandlung* on the grounds (in their manager Heinrich Neft's words) that 'the play is too radical' and might alienate their members. So now when the board told their outstanding director to make changes in his production to accord with their principle of 'political neutrality' a strong pressure group was quickly organized with the help of Toller, Feuchtwanger, Tucholsky and others who were by no means always aligned with the KPD. Thus supported, Piscator was able not merely to break away and form his own (already planned) company but also to take a section of the Volksbühne membership with him as a guaranteed audience for its productions. Financed by a loan from a *nouveau riche* industrialist called Katzenellenbogen whose wife-to-be wished to act for him, he rented the Theater am Nollendorfplatz, booked Gropius to design him a 'Totaltheater' for some 2000 spectators, and recruited a politically committed 'dramaturgical collective' under Gasbarra which included Brecht, Mehring, Jung, the Austrian journalist Leo Lania and others who could be trusted to rewrite his chosen texts and add the right documentary framework.

Such was the background to the First Piscator-bühne, for whose 1927–8 season Piscator himself directed four productions that have remained influential to the present day. The first was Toller's *Hoppla, wir leben!* (or Hoppla, Such is Life!), an underestimated play reflecting, in relatively sober terms for this author, his disillusionment with the

SPD as a result of his prison experiences, and conceived from the first in terms of a multiple stage and some use of film. Piscator encouraged his dramaturgs to cut back any romanticism in Toller's language and in the character of his hero (who was turned into a quasi-proletarian) and made the result into something of a technological masterpiece: the episodes taking place in different sections of a three-tier scaffolding of gas piping designed by Traugott Müller with a high central niche for projections. *Rasputin*, which followed, was seen in rehearsal by Lunacharsky, and consisted of an adaptation of a play about the last days of Tsarism by Alexei Tolstoy and the historian Shchegolev; again it was spectacularly staged, with a rotating hemispherical set that opened in segments, and the projection of up to three films at a time as well as statistics and documentary material.

In January 1928 came the dramaturgs' adaptation of the official stage version of Hašek's *Schweik*, five years after the author's death from drink and disillusionment in Czechoslovakia. For this Piscator adopted an even more fluid and original approach, staging much of the action on two treadmill stages which carried actors and items of scenery across the stage opening or allowed the former to walk against their motion. The designer here was George Grosz, who after making some 300 preliminary drawings (so he said) provided cut-out figures and objects to be brought on by the treadmills, and an animated cartoon film for projection in the background. By the time of the fourth production, a play about the international oil business called *Konjunktur*, the company's financial situation was getting desperate and the staging had to be kept much simpler; but this now forgotten work by Lania remains interesting because it was by one of Piscator's chosen writers, and also for the political vicissitudes through which it went – the Russians taking great exception to the self-interested role originally given them – and its music by Kurt Weill. Part of the trouble was that *Schweik*'s unexpected success at the box-office could not be exploited, because the principal actor Max Pallenberg had another engagement. The money ran out, there was back entertainment tax due, and the First Piscatorbühne went broke.

Piscator's aim was to make the theatre into a mixture of lecture hall and debating chamber, where the audience would see a socially relevant play supported by a wealth of documentary material and so be inspired to argue the issues out. Though more than one of his productions ended with the singing of

New techniques and the 'epic theatre'. Piscator's *Schweik*, 1928, with cut-out drawings by Grosz on a treadmill stage. (Max Pallenberg as Schweik)

'Engineers of the feelings', *below*, with their victim. Brecht's *Mann ist Mann* at Darmstadt, 1926, with set by his friend Caspar Neher showing their use of a flimsy half-curtain and visible lights

the Internationale by the cast (and sometimes by the audience too), he claimed not to be aiming at a simple revolutionary impact, and indeed criticized *Potemkin* for achieving this at the cost of any factual picture of the main events of 1905. Brecht, in his paradoxical way, later pretended that Piscator was above all a playwright, meaning by this that as a director he had discovered a new way of putting plays together, making use of the new mechanical resources and media, and thus evolving a form of dramatic montage which was tantamount to play-writing even if he himself scarcely wrote a scene.

Unfortunately Piscator's undoubted gifts in this direction were not enough to make texts of the calibre which he needed, even with a whole collective of dramaturgs to carry out his instructions. The odd thing was that Brecht himself, while being one of the collective's more active members (working on *Rasputin* and *Konjunktur* and bearing, by his own account, the major responsibility for the adaptation of *Schweik*, though this may well be an overstatement), never completed a play of his own which would suit Piscator's requirements. He had various unfinished projects on the stocks which Piscator announced as part of his future repertoire, and with Fritz Sternberg the sociologist the two men discussed revising Brecht's earlier *Drums in the Night* to make an historically more relevant account of the German revolution. But for some reason Brecht found it impossible in this period to complete any play dealing with contemporary social–economic problems, and so although it was Brecht who saw the point of Piscator's 'epic theatre' as making it possible for such plays to be written, it was other dramatists who actually managed to write them.

Brecht at this time was already fascinated by the workings of society, and had indeed been curious enough about their economic aspect (as seen in the Chicago wheat market depicted in Frank Norris's novel *The Pit*) to study the ideas of Marx. These gave him a schema of political and economic conflict that could be effectively carried over into dramatic terms. Despite this 'dialectical' approach he was not yet the committed communist he later became, but spent the years between 1924 and 1929 poised between avant-garde and established theatre, trying to write for the latter, continually impressing and intriguing it by the power of his language and the originality of his ideas, and yet unable except in one almost accidental case to write plays of a sort that would succeed there. Always a compulsive rewriter, he began by revising his early

plays *Baal* and *In the Jungle* in the spirit of the time, shortening and urbanizing the former for a Sunday production by the 'Junge Bühne' in February 1926 (so that the poet's garret became a garage and the bard himself a mechanic); while the latter became *In the Jungle of Cities* with pseudo-precise dates and times for each episode and an introduction presenting the story in sporting terms as 'an incomprehensible wrestling match between two men'.

His one major new play was *Mann ist Mann* (or Man = Man), which in the two years between Brecht's move to Berlin and its Darmstadt premiere in September 1926 developed from an utterly Bavarian project to a near-caricature of the prevailing myths. For he recast it as a British Indian montage derived from Kipling, with a sequence of music hall 'numbers' and frequent references to whisky, boxing, beer, cigars and the like. In this rich and largely farcical work the original Bavarian concept of the malleable human personality remained, but it was now presented discontinuously, in quasi-mechanical terms: thus Brecht's answer in 1926 to an interviewer who inquired about the theme of the play:

A. It's about a man being taken to pieces and rebuilt as someone else for a particular purpose.
Q. And who does the rebuilding?
A. Three engineers of the feelings.

'Tonight', said the prologue to the Darmstadt production, 'a man is reassembled like a car' (the word for 'reassembled' being 'ummontiert').

Pruned down, and with its implicit anti-militarism brought more to the fore, *Mann ist Mann* was broadcast by Berlin Radio early in 1927 and staged by Engel for the Volksbühne the following year. Ihering saw in its author a link between Chaplin, Piscator and 'the objectivizing trend in music', calling him 'the first German playwright who neither acclaims nor attacks the mechanisms of the machine age but takes them for granted and thereby overcomes them'; while Kurt Weill in two articles for the radio magazine *Der Deutsche Rundfunk* adjudged it 'the most original and powerful play of our time'. As a result of this Weill met Brecht the same spring, and almost immediately the two men decided to collaborate on an opera. The libretto which Brecht now devised was pieced together from a number of different elements: his private myth of a great grasping city called Mahagonny, on which he had already based half-a-dozen songs with tunes of his own making; a play project updating the biblical Cities of the Plain and

known as *The Flood* or *Untergang der Paradiesstadt Miami*, for which his aide Elisabeth Hauptmann had been collecting documentary material about hurricanes; finally some eight more assorted poems, two or three of them from his student days and others from his more austere current production. Out of this process of montage came two related works: first a 'Songspiel' or suite of six numbers now known as *The Little Mahagonny* which was staged in a boxing-ring set at the Baden-Baden music festival that summer; then the main libretto which was ready for the composer to work on early in 1928.

The full-length *Rise and Fall of the City of Mahagonny* was envisaged as a somewhat different type of opera from those which Weill had previously written to texts by the rather older Georg Kaiser, for it was to be an 'epic opera' made up of a succession of self-contained musical forms, performed in no elaborate grand opera setting but against inscriptions and projected drawings by Caspar Neher, whose collaboration became integral to the work. However, before Weill could seriously get down to its composition, something happened which not only put the whole project back by nearly a year but also served to divert Brecht both from his involvement with Piscator and from his efforts to write a major social–critical play. This was the arrival of Ernst-Josef Aufricht, a former actor with Viertel's *Die Truppe*, who was about to take over the Theater am Schiffbauerdamm and wanted a work with which to open his season at the end of that August. For, failing to interest the would-be impresario in his own projects, Brecht suggested that he read a translation of *The Beggar's Opera* on which Elisabeth Hauptmann had been working. Aufricht liked it; Brecht began overhauling it and inserting new songs; then he brought in Weill to set them, along with Neher and Engel for the staging. And so, hardly ten weeks after the First Piscatorbühne had collapsed, Brecht and Weill had scored the great German hit of the decade with *The Threepenny Opera*, which ran for a year in Berlin and was thereafter taken up throughout Germany and indeed all round the world.

What Brecht brought to the theatre of the 1920s was a good deal more than his talent as a dramatist, or even his sense of humour (though certainly this made him something of an exception). For he also acted as a catalyst for many other gifted people, while his restless dissatisfaction with his own dramaturgical technique (and of course with much of the existing German theatre) led him throughout the period to work out the theoretical implications of his preferences and opinions, whether as articles for Ihering's paper or as comments on his own plays. More than most dramatists (let alone poets) he wanted to direct, and had the knowledge and ability to do so; and even if he was not diplomatic enough for managements to permit this, in Engel and Neher he had two like-minded friends whom he trusted. Like Piscator, then, he developed the ability to run a collective; indeed his critical attitude towards 'personality' and individual genius led him in Berlin to erect collective work almost into a principle.

From about 1926 on, then, Brecht was a recognized factor in the Berlin theatre, often speaking in the name of 'the younger generation' in a quite aggressive manner and taking up, in his essays and statements, many of the new ideas of the time: sociology, Americanism, sport, the detective story, the scientific attitude, the behaviouristic acting or Chaplin and other great clowns which, like the very tone of voice of Hašek's Good Soldier, had its influence on *Mann ist Mann*. His ideal was, he claimed that year, 'a quick-witted audience that knows how to observe, and gets its enjoyment from setting its reason to work' like the crowd at a boxing match; so the kind of production he most admired was one that expounded a story 'in a perfectly sober and matter-of-fact [*sachlich*] manner'. If Piscator, then, had used the term 'epic theatre' to describe his own type of semi-documentary production, with its new technical aids, for Brecht it meant something rather different: the clear unreeling of a sequence of episodes so as to tell a complicated story, complete with its social implications, by means of a linear montage in which all the joins should be visible. Moreover he already saw the need to emphasize the strangeness of much that the ordinary audience took for granted. Concerned as he hitherto had been almost exclusively with the established theatre, he already felt the need for 'a *different* audience', such as neither man had reached.

Piscator with *Konjunktur*, Brecht with his 'epic' theories and his unfinished plays, had made a first, only partly effective attack on contemporary social themes, but now the idea caught on. 'Zeittheater' or 'theatre of the times' in the course of 1928 became a fashionable concept and a new theatrical mode. Two of the plays which brought this about were ones which should have been done by the Piscatorbühne but now had to be produced elsewhere: Günther Weisenborn's realistic submarine drama *U-Boot S4*,

which was staged at the Volksbühne in October as a concession to Piscator's section of the membership, and P. M. Lampel's *Revolte im Erziehungshaus* about the abuses in a Prussian reformatory, which in December became the first production of the Gruppe Junger Schauspieler, a new collective formed from actors whom Piscator's collapse had left without jobs. Both plays were based on fact, the former on a collision which had occurred the previous year between a rum-runner and an American submarine, while the latter came from a book of reportage by the author, who had himself worked in such an establishment; it is one of the few German plays of this period beside Brecht's which have stood up to revival.

There were also two comparable productions at the Deutsches Theater and the Staatstheater; for the more established theatres seem to have felt the need to catch up with the new trend. The first of these was Feuchtwanger's *Die Petroleuminseln*, dealing somewhat more superficially with the theme tackled by *Konjunktur*, while the second was Ferdinand Bruckner's *Die Verbrecher*, which dealt with the abuses of criminal justice and was conceived in terms of a multiple set not unlike that for *Hoppla, wir leben!* In the new year came Erich Mühsam's topical Sacco and Vanzetti play performed by another collective of ex-Piscator actors under Alexander Granach, along with the first of a crop of World War I plays, Maxwell Anderson's *What Price Glory?* which Piscator directed for another management. Though Piscator himself had little use for the term 'Zeittheater', all these productions were to a greater or lesser extent his legacy, and the idea continued to grip the German theatre, later extending to the cinema as well.

Outside the established theatre in this period there were two other important examples. The first of these was the experimental stage work conducted at the Bauhaus even after the dissolution of Schlemmer's theatre department in 1928. Though this was essentially the work of painters and sculptors and none of the students concerned was to contribute (so far as we know) to the professional theatre, Piscator for one was clearly aware of its interest, for at the end of 1927 he was toying with the idea of making Schlemmer his principal scene designer, while Moholy-Nagy was soon to be working with him once again in the Second Piscatorbühne of 1929. Once or twice the department's work could be seen briefly in Berlin – the *Triadic Ballet* was danced by Harald Kreutzberg at the Metropol Theatre in 1926, for

Gropius's 'Totaltheater' project for Piscator. Plans, showing three positions of the stage (in black) according to how the circular portion of the auditorium is rotated. The starry pattern around it consists of triangles plotting back-projections from the fourteen boxes round the outer walls, with front-projection from the roof.

instance – but generally speaking its activities were even more experimental than Schlemmer's characteristic dances and sketches, and some of them seem to have remained entirely conjectural. So Ludwig Hirschfeld-Mack devised an apparatus for projecting coloured light shows in accordance with a quasi-musical score; a number of other students planned shows for mechanical puppets; Joost Schmidt sketched a highly adaptable mechanized theatre; while Farkas Molnár's design for a 'U-theatre', seating nearly 1600 spectators round three sides of an arena stage, may well have had some influence on the Piscator 'Totaltheater' project.

This plan by Gropius, which would have seemed advanced even today, was for a single oval am-

phitheatre whose central section could be rotated so as to give an arena or a thrust stage, or could alternatively be filled up with more seats facing a wide proscenium stage. Right round the walls were screens for the back-projection of film from twelve different projectors, presumably in accordance with Piscator's demands. Another scheme of this sort was Moholy-Nagy's graphic 'score' for a 'mechanical–eccentric' show on a triple stage with cinema screen, which anticipates the scores of some modern composers. Likewise his essay of 1924 'Theater, Zirkus, Variété' outlines an Eisenstein-like 'theatre of surprises' which would achieve total theatre effects by the use of noises mixed with music, of optically blown-up images and the sudden contrasts associated with the externalized acting of Chaplin, the Fratellinis and other great clowns. Here he foresaw the stage use of 'complex apparatus' like films, cars and lifts, as well as rising and falling platforms or suspended bridges to give variations of level.

If the greater part of these experiments were mechanical–aesthetic, apart from a few benevolent social considerations like the democratic equalizing of all seating categories in the 'Totaltheater', the other new area of development at this time was overwhelmingly social–political. This was due to the rapid spread of agitprop groups on the model of Piscator's revue RRR which followed the visit of the Soviet Institute of Journalists' 'Blue Blouse' group in the autumn of 1927. Prior to that, the workers' theatre movement in Germany, like the worker choirs and the Volksbühne itself, had been traditionalist, dimly reflecting the taste of the enlightened middle class of some decades earlier. Following Piscator's early example, the Young Communists had developed a more militant form of entertainment, with Maxim Vallentin of the Deutsches Theater as their artistic director, and this was followed up by Muenzenberg's IAH, who not only invited and publicized the Soviet group – whose first performance took place in Piscator's theatre – but also later sponsored their own group Kolonne Links. Meanwhile the Young Communist group became Das Rote Sprachrohr (The Red Megaphone), and soon there was a whole network of such propagandist performers: the Hamburg Nieter, the Proletkult Cassel (with Teo Otto as their gifted designer), the Roter Wedding from the Berlin district of that name, and many others.

Having at first kept aloof from the old federation of workers' theatres, in 1926 these overwhelmingly Communist groups joined it under KPD in-structions, and within two years had secured the election of a new leadership under Arthur Pieck, son of the KPD deputy and Politbüro member Wilhelm Pieck, with Béla Balázs and later Gustav von Wangenheim as artistic directors; at the beginning of 1929 they also started issuing the Arbeiterbühne as their journal. Admittedly such songs and other texts of theirs as have survived are not very impressive, but as an example of street theatre and dramatized political meeting the movement set a precedent of world-wide importance, and various other significant figures were drawn into its orbit. Above all it related not only to Piscator himself, who remained a well-wisher and helper even though his own work took a different direction, but also to the left-wing cabarets like the Kabarett der Komiker founded in Berlin in 1924, to which Kästner and Erich Weinert and other acute versifiers of the later 1920s came to contribute. On all these different levels – of major theatrical development, of aesthetic experiment and of political commitment – the German theatre of the later 1920s pursued its own course, paying relatively little attention to what was happening elsewhere. Meanwhile in Russia the outstanding younger talents seemed to have become diverted into the cinema, leaving the theatre no longer in quite the leading position which it had occupied up to about 1924. All the same there was a certain parallelism with the German situation, for with Ostrovsky's The Forest that year and, most famously, Gogol's The Government Inspector in December 1926, Meyerhold too began reinterpreting the national classics, causing some unease among his critics. Late in 1925 moreover the Leningrad Young Communists set up an agitational theatre group called TRAM, or the Theatre of Working-class Youth, which grew into an organization controlling a number of agitprop groups and formed a working alliance with Vallentin's Das Rote Sprachrohr. As for the special place occupied by Brecht, this has some analogy with the role of Tretiakoff both as playwright and as theoretician, and it is not surprising that the two men later became allies and friends.

During 1926 Tretiakoff's play Roar, China! about a real-life incident involving a British gunboat was staged at Meyerhold's theatre – Lania later made a German version – after which his next major work was a remarkably subtle comedy called I Want a Child – adapted in German by Brecht – which was ostensibly about eugenics and the liberated Soviet woman while also providing a sharp critical picture

German agitprop. (1) The Breslau group 'Die Trommler' (The Drummers) strike a militant stance.

(2) The 'Proletkult Cassel' directed by Ilse Berend-Groa in their 1926 show *Yesterday and Tomorrow*. Designer Teo Otto

of Moscow society. This was in effect a 'Zeitstück', and when Tretiakoff offered it to Meyerhold it looked like being just what the latter needed. For the Meyerhold Theatre's audiences had started falling off, a government commission was appointed to examine its affairs, and the need for contemporary plays was pressing. Accordingly Meyerhold got Lissitzky, who had apparently never worked for the theatre before, to design Tretiakoff's play a setting that would make the auditorium into a public meeting-hall (that old objective of Piscator's), and this in turn led to a scheme for a wholesale rebuilding of the theatre which, however, like Gropius's project, remained on paper.

Still hoping that the production would materialize, despite censorship difficulties, Meyerhold at the same time pursued Mayakovsky for a contemporary work, telegraphing him in the spring of 1928 to say 'Theatre in agonies. No plays . . .'. That autumn Mayakovsky was able to send him *The Bedbug* just as the official commission were threatening to cut off funds, with the result that in the following February this play was staged with sets partly by Rodchenko and incidental music by the theatre's twenty-two-year-old pianist, D. D. Shostakovitch. Successful as it was, it was not a great work. But read Piscator for Meyerhold, Brecht (with his *St Joan of the Stockyards*) for Tretiakoff, Moholy-Nagy for Lissitzky and Rodchenko, and Weill or Eisler for Shostakovitch, and the similarity to the advanced German theatre was now close, for all the reluctance of either Piscator or Meyerhold to admit it.

Avant-gardists in the Soviet theatre. *Left to right*, Shostakovitch, Mayakovsky, Meyerhold, Rodchenko, preparing *The Bedbug*, winter 1928/9

17 Music for the times: jazz, applied music, Kroll- and Zeitoper

Expressive and anti-expressive composers; the 'metric strictness' of Neue Sachlichkeit music and its relevance to jazz. Germany as the new centre: role of the music publishers and the arts administration. Hindemith and other typical composers; ideas of Gebrauchsmusik and Gemeinschaftsmusik indicating their interest in music's social and functional basis and its new mechanical aids. Hanns Eisler and the first distinctively Communist compositions. The Berlin Kroll-Oper and the modern opera boom; 'opera of the times' and the undermining of traditional forms by Brecht and Weill.

By the mid-1920s the Neue Musik associated with the ISCM (or Internationale Gesellschaft für Neue Musik) had become a recognized movement, with Schönberg and Stravinsky as its rival heads. Looking back ten years later Ernst Křenek saw his 'New Music' as embracing not only Schönberg's immediate followers but also Hindemith, Bartók, Weill, Milhaud, Honegger and the Czech microtone composer Alois Hába. To this list he might well have added Prokofieff, Janáček and the later Ravel, the Spaniard de Falla, the Italians Casella and Malipiero – even the emerging Anglo-American composers headed by figures like Copland and the young Walton. For there was in that decade a remarkably vital yet still largely homogeneous outpouring of new music quite distinct from most of what had been current twenty or even ten years earlier, its points of reference (as included in its concerts) being not so much the prewar giants, like Richard Strauss or even Debussy, as *Pierrot lunaire* and *L'Histoire du soldat*, together with the more unromantic work of Reger, Busoni and Satie.

To Křenek, who saw the movement as linked by a common love of shock effects, its members could be divided between Expressionism on the one hand, as furthered by the Schönberg school, and on the other an 'anti-Espressivo' trend which might take the form of neo-classicism, Surrealism (by which Křenek seems to have meant the setting of Dada-like texts) or the 'Neue Sachlichkeit' of Hindemith and his followers. 'Instinct' told him that there was a connection even between Schönberg's op. 25 Piano Suite and the cabaret-style 'Songs' which Weill wrote

Central to the rhythmic revolut-
ion of the 1920s: the jazz band. A
painting of 1927 by Carl Hofer

to Brecht's texts, however irreconcilable such works
might seem. And indeed there was a certain area
common to both pro- and anti-expressive composers,
even though the former were largely out of sympathy
with the spirit now prevailing in the other arts. For
both parties were interested in new instrumental
combinations, in formal counterpoint and the kind of
vocal experiments suggested by Schönberg's *Sprech-
stimme*, with its implications for the kind of 'music
theatre' that was then emerging. Where they prim-
arily differed was in the relative importance attached
to the problem of tonality on the one hand and
rhythmic momentum on the other: that 'metric
strictness' which Adolf Weissmann saw as typical of
'Neue Sachlichkeit' in music. There was also a total
contrast in attitudes to melody, though this aspect
was somewhat overlooked by the theoreticians, who
had come to see tunes as so much structural fodder: at
best 'themes', if not mere tone-rows. More radically,
there was the question of music's purpose, audience
and social basis, about which a new curiosity was now
developing among the younger musicians.

The neo-classical influence was still strong in 1925,
and it continued to affect many composers even after
direct pastiche à la *Pulcinella* had been abandoned.
This was not mere imitation of French fashions

(though it is worth noting that Stravinsky took
Cocteau to be his librettist for *Oedipus Rex* in 1926)
but corresponded to a persistent need for chamber-
scale orchestration and rhythmic drive, such as can be
found fulfilled in the early Hindemith with his 'atonal
jazzing-up of Bach's sewing-machine counterpoint',
as Constant Lambert dismissively called it. Jazz itself
at this time reflected very similar qualities, with its
strong yet elastic rhythms and concertante soloists,
and its appeal to some of the same composers was by
no means coincidental. Admittedly Milhaud, who
had been among the first to appreciate the genre, was
somewhat put off on finding, during his second trip
to the United States in 1926, how far jazz had become
popular and even 'official'. None the less he re-
cognized the high skill of the instrumentalists, their
ability to improvise on almost polytonal lines and
their power to get new effects out of the traditional
instruments: the dry percussiveness of the piano, the
shrill clarinet, the bleating and snarling brass.

There is indeed something of the updated *Branden-
burg Concerto* about the best jazz of the period, such as
the recordings made by Duke Ellington with his
Cotton Club orchestra from 1927 on, by Miff Mole's
Molers and the various Chicago groups of the mid-
1920s, while unforgettable solo performances came
from Louis Armstrong, Bessie Smith and Earl Hines,

Jazz, Berlin fashion. Weintraub's Syncopators in the revue *Das bist du*

to mention only three great names of that time. It is a strange fact, however, that neither Stravinsky and Milhaud, the pioneers in this field, nor Hindemith and Weill in Germany are known to have heard jazz music of this calibre; so that it seems to have been the more commercial bands, with their greater remoteness from the original spontaneity of such music, who provided their models: Weintraub's Syncopators, for instance, and the Lewis Ruth Band. Prescient as the 'new music's' appreciation of jazz might be, both musically and in Weill's case socially, it accordingly never had quite the impact it should and only a small minority of those touched by it wrote in the jazz idiom for long.

To pro- and anti-expressives alike Germany now seemed to be the centre. Thus Milhaud found the Donaueschingen festivals more congenial than those of the ISCM, while Stravinsky, after his estrangement from Diaghileff and the departure of Koussevitzky for Boston in 1924, began visiting Germany every year: 'Stravinsky in Permanenz?' said a headline to Weissmann's review of the Berlin *Oedipus*. This appeal was partly the result of the traditional cultural decentralization of the country, with its many opera houses and excellent provincial orchestras, but partly also of the new prosperity. 'Berlin was in the chips', wrote Antheil of his return there in 1928 (with an opera to place).

Everywhere you looked there were new, expensive
 night clubs.
The electric lights were back in their sockets.
The red carpets, new ones, were down on the
 floors of the expensive hotels.
People had their brass doorknobs out again –
 whereas in 1923 you couldn't find a brass
 doorknob in all Berlin: people would just steal
 it in the night.

Two publishing firms dominated the modern musical scene: Schott of Mainz, publishers of Hindemith and of the review *Melos*, and Universal-Edition of Vienna and Leipzig, publishers of the rival *Anbruch* and of such composers as Milhaud, Weill, Křenek, Wilhelm Grosz and the whole Schönbergian school. Emil Hertzka of Universal indeed now emerged as a more powerful force behind the scenes than even the great Parisian salons or the American musical hostesses, and he was energetically seconded by Dr Hans Heinsheimer, the young chief editor and organizer of his opera department.

At the same time this German musical renaissance was a belated reflection of the socialist cultural policies that followed the November Revolution. Becker and Kestenberg at the Prussian Ministry of Education and Culture had long been dissatisfied with the traditionalist policy of von Schillings at the State Opera, and in 1923 had tried to get him to accept Otto Klemperer, then at Cologne, as his principal conductor. Though Schillings rejected Klemperer he did however appoint Erich Kleiber, who in December 1925 established a formidable milestone by directing the premiere of Alban Berg's *Wozzeck*, a great Expressionist masterpiece which had been completed in Vienna four years earlier but never staged. By then Schillings had himself been relieved of his post; Schönberg had been designated as Busoni's successor at the Academy; while the appointments of Hindemith (for composition), Schnabel and Egon Petri (for piano) and Carl Flesch (for violin) to Franz Schreker's Hochschule für Musik were about to follow.

This policy of attracting outstanding innovators was not dissimilar to that of Gropius at the Bauhaus, and it too had its new institution in the shape of the Kroll-Oper, or second State Opera on the Platz der Republik. This theatre of 2200 seats had earlier been

planned by the Volksbühne as a popular opera house, but they had run out of money and transferred it to the Prussian State as a second opera where their members would have priority subscription rights. Since the Berlin city council meantime had taken over the privately-run Deutsches Opernhaus, which had likewise gone bankrupt, there were now to be three subsidized operas in Berlin – too many, certainly, for the potential demand, but not too many for the supply of new works. In 1926 this led to a general reorganization which gave the city for a few short years the richest, if also the most top-heavy musical life in the world. Heinz Tietjen, the Intendant at the new municipal opera (where Bruno Walter was musical director), was made Intendant also of all four Prussian state operas, those in Berlin together with the two in Kassel and Wiesbaden. A major rebuilding programme was undertaken at the old State Opera, which temporarily closed. And Klemperer, at once the most radical and the most objective of conductors, was made musical director of the Kroll-Oper with dictatorial powers over staging and a designer of his own choice in the person of Edward Dülberg.

Such, in brief outline, was the background to the astonishing musical open-mindedness of Germany in the later 1920s; and it depended more on a change of patronage than on any very rapid development in public taste. Of the composers thus encouraged far the most traditionalist in many ways was Schönberg, who had no wish to react against Expressionism or even the Symbolism of his own generation, retained an old-fashioned sense of his own genius and dignity (terming it 'welcome evidence of his proper attitude to his elders' when Hindemith organized a fiftieth birthday concert of his music in 1924), saw his new twelve-note method of composition as above all ensuring the future supremacy of German music, and used it to express ideas, moods and even texts of an essentially pre-1914 kind. Schönberg's reputation when he came to Berlin was above all that of a great teacher and an incomparable master of his material, but this did not mean that there was universal admiration for the material itself or the uses to which it was put.

Stravinsky for one seemed more in tune with the European *Zeitgeist*, and was correspondingly more disliked by musical conservatives, while the ebullient Hindemith combined great skill and versatility as a player with remarkable creative fluency and a lively curiosity about the world around him. The characteristic German style of the time therefore is not dodecaphonic but rather dissonant, contrapuntal,

Berlin's demand for modern music. *Left*: Stravinsky with Klemperer (bow tie) and Dülberg in 1928 for the production of *Oedipus Rex*. *Right*: Schönberg with his pupil Rufer following his move there in 1927

New jobs for music.
Richter's *Vormittagsspuk*
set to pianola
accompaniment by
Hindemith in 1928

Originating in his contacts with the youth movements, the former led him first to the composition of pieces and choruses for musical amateurs, even for beginners, and culminated in 1932 in a complete programme of music, both ceremonial and incidental, for a youth music festival at Plön in north Germany, including a typical piece of Hindemithian ingenuity in the shape of three choruses for separate choirs to be sung either successively or simultaneously.

Sneered at in retrospect by Křenek as 'Blockflötenkultur' – recorder culture – and derided at the time by Brecht as a means of saving the traditional structure of music from social change, Gemeinschaftsmusik served at once as a check to the increasing technical difficulty of the new music, which often only the most skilled professionals could perform, and as a method of familiarizing the naive ear with its conventions. By extension moreover it led on to the notion of the 'Lehrstück' or 'learning play' as a form of cantata or music theatre which besides teaching the pleasures of performance would serve as an exercise in social philosophy, the secular equivalent of a Bach Passion. The more religious preoccupations of Hindemith's later music had so far only surfaced in one work, the *Marienleben* cycle for soprano and piano to Rilke's texts, which was performed in 1923.

Gebrauchsmusik, a word coined on the analogy of Gebrauchsgrafik (or commercial art), involved the exploration of every available new practical function or outlet for music. One obvious channel lay in the mechanical instruments which had already fascinated Stravinsky in Paris, notably the pianola and the mechanical organ. The 1926 Donaueschingen festival was accordingly devoted to works for such machines by Hindemith (music for Schlemmer's *Triadic Ballet*) and the slightly older Ernst Toch, relieved by some military band music by the same composers. Toch even foresaw the possibility of cutting master gramophone discs as it were from zero, without depending on a previously rehearsed performance, so as to achieve

> a degree of precision which human executants could never reach: a complete objectification, a depersonalization of performance ... all traces of spontaneity, sentiment, impulse will be eliminated.

A year later the festival shifted to Baden-Baden, where the first medium to be tested was the miniature opera employing extremely economical forces. This resulted in the Mahagonny 'songspiel' (or 'Little Mahagonny') by Weill, Hindemith's own ingenious

rhythmically forceful and melodically somewhat perfunctory except where it uses the idiom of modern dance music; much of it is on the chamber music scale adopted by the Donaueschingen festivals and retained by Hindemith until the Concerto for Orchestra of 1925. Often too it is touched by jazz, as in the compositions of such composers as Erwin Schulhoff, Wilhelm Grosz and the early Křenek, while others like Weill and Edmund Nick went on from 'serious' beginnings to specialize very largely in the music of popular entertainment. This was possible because of the prevalent self-abnegation and unpretentiousness which accompanied the new downplaying of the emotions. With Hindemith setting the example of outward impersonality and matter-of-factness in his working methods there was little danger of such men finding the popular medium unworthy of them.

The essence of this approach, as against the more narrowly formal concerns of the Schönbergians, was that from about 1926 on it was applied in a search not so much for new internal rules for music as for new external tasks. As guided by Hindemith at the Baden-Baden festivals which now succeeded those at Donaueschingen (the municipality taking over from the prince as patron) this took two main directions, defined by him as Gemeinschaftsmusik and Gebrauchsmusik, or communal music and utility music.

'Sketch mit Musik' *Hin und Zurück* – both of which works will be considered presently in the larger operatic context – a fairy story by Ernst Toch and Milhaud's miniature *L'Enlèvement d'Europe*, which Hertzka subsequently persuaded the composer to supplement with similar treatments of the Theseus and Ariadne legends, so as to make a half-hour triple bill issued by Columbia on three 80 rpm records.

Thereafter the task was film music, where Edmund Meisel's *Potemkin* score had already shown how effectively even a (in Weill's and other opinions) mediocre composer could transform a film if he went about it seriously; Antheil's *Ballet mécanique* music too had been played with the Léger film at the previous festival. In 1928 experiments were made in synchronization, some of them using a contrivance by Robert Blum which projected the relevant bars of the score on the conductor's desk as the film unreeled. Hans Richter's *Vormittagsspuk* (commissioned specially, with Hindemith himself and Werner Graeff among the performers) was geared to a Hindemith pianola roll, while a Felix cartoon was accompanied by the mechanical organ. Subsequently other composers joined in – Milhaud again, Schönberg's Berlin pupils Walter Goehr and Walter Gronostay, likewise Paul Dessau, a disillusioned opera conductor who had worked under Klemperer in Cologne. The following year the composition of works specially for radio was also explored.

The importance of these researches has long been underrated. For this was a time when not only new instruments (like the Pleyela and, in 1923, Messrs Förster's quarter-tone piano) were being evolved, but radio and the gramophone were undergoing the most rapid technical and social development and the sound film was just round the corner. Even magnetic recording on iron oxide was being tried out by the AEG electrical company in Germany as early as 1928, though the modern tape recorder was still a long way away. In such a changing context much would have been lost without the alertness and adaptability of the more sophisticated musicians. At the same time some, like Weill and Hanns Eisler, were prepared to go still further in their querying of music's existing social structure and purpose. In the spring of 1925 Weill began a four-year stint as chief critic of the weekly journal *Der Deutsche Rundfunk*, for whom he not only reviewed musical and other programmes at a juncture when the relations between serious music and broadcasting were still uncertain, but also wrote the odd article about the wider problems of the radio medium, seeing it at once as a likely substitute for the vanishing patronage of a concert-going élite and as a formative factor in the development of a new (and presumably better) society.

As for Eisler, that Viennese pupil of Schönberg's who like Webern had concerned himself with the training of worker–musicians, he arrived in Berlin at the end of 1924 and within eighteen months had been crushingly disowned by his teacher for a few sceptical remarks about the twelve-note system. Convinced that musical originality was a matter of attitude and ability rather than of new formal systems, he became critic to the Communist *Die Rote Fahne* early in 1927 and taught at the party's Marxist Workers' School (or MASch) where he met Brecht. As a writer and lecturer he combined ideological prejudice (such as led him to dismiss Stravinsky after *Oedipus Rex*) with a refreshing if highly indiscreet common sense (as applied to the economic facts, for instance, of Berlin musical life). On the creative side his experience as composer to Maxim Vallentin's Young Communist agitprop group caused him to evolve a quite new type of political song to replace the traditional socialist hymns. Like Weill, who formulated the idea even before Brecht, he adopted the notion of a 'gestic' music which would underline the attitudes of an action or a text, using the strong rhythms and novel orchestration of the 'new music' to make these absolutely plain.

New instruments and tonalities. Quarter-tone piano by the Czech firm of Förster, as used by Alois Hába

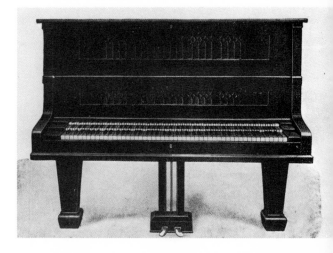

Differing in the final direction of their social commitment but linked through their association with Brecht, these two composers stand at the extreme point of a musical-theatrical evolution which remains the most remarkable feature of the whole modern German school. It too can be said to have begun in 1925 with the premiere of *Wozzeck*, for though there were significant productions before that (for instance of Křenek's and Hindemith's early works to Expressionist texts) at Frankfurt and other provincial houses they were rare exceptions, nor could the German scene as a whole yet compete in novelty with Paris and its staging of chamber operas by Satie and Stravinsky. Thereafter however a modern opera boom began which not only involved virtually every leading German and Austrian composer apart from Webern but also attracted some of the chief figures from outside.

Stravinsky's *Oedipus Rex* was given its first stage (as opposed to oratorio) production under Klemperer at the Kroll-Oper, much to its composer's satisfaction. Likewise Milhaud's *Christophe Colomb* had its premiere, and for many years its sole stage performances, not in Paris but at the State Opera in Berlin. Antheil too describes Stuckenschmidt calling on him in Paris in 1927 and advising him 'to write an opera in popular American rhythms' for this new market, with the result that he composed *Transatlantic* and moved hopefully to Berlin, where Kurt Weill got him a job writing incidental music for Jessner's Staatstheater production of the Aeschylus *Oedipus*. As he wrote later,

> Whatever else had been new and amazing in old Paris now migrated to Germany.

At the centre of this renaissance was Klemperer's activity at the Kroll-Oper. Though his regime there opened austerely enough on 19 November of that year with *Fidelio* in its original version and a geometrical set, within two years he had performed not only *Oedipus Rex* (in a triple bill with *Mavra* and *Petrouchka*) but also Hindemith's *Cardillac* and *Neues vom Tage*, three Křenek one-acters and a French triple bill centring on *Le Pauvre Matelot*, one of Milhaud's simplest and most powerful works.

The influence of Klemperer's Kroll-Oper stemmed less from its repertoire however than from its fresh approach to the medium. It was not an opera of great voices or famous guest artists but above all an ensemble, whose best-known member, Jarmila Novotna, stood out primarily for not looking like an opera singer. Klemperer sought for authenticity, if necessary at the cost of tradition – he was criticized, for instance, for using Wagner's unfamiliar early version of *The Flying Dutchman* – and he tried to inspire an objective attitude in his performers at a time when more emotive conductors like Furtwängler and Bruno Walter were still very much in the ascendant; this is said to have led him to discourage certain vibrati and crescendi and generally to warn against sentimentality. 'Unthinkable without the dogmatism of the "Neue Sachlichkeit" trend', so Weissmann termed him.

At the same time exceptional pains were taken about the setting and the stage production, particularly after the first year. For this was when Klemperer and Dülberg abandoned their dictatorial rights, allowing such outstanding talents as the stage directors Fehling and Gründgens and the designers Neher and Moholy-Nagy to be called in. This development seems to have been due to the new director of productions, Ernst Legal, who had played Galy Gay in the original Darmstadt production of *Mann ist Mann*, and his dramaturg Hans Curjel, who had been both a theatre conductor and assistant director of the Karlsruhe city gallery. Nothing more visually radical was indeed seen in any theatre of the time than Legal's production of *The Tales of Hoffmann* in February 1929 with its sets by Moholy-Nagy, though the provincial operas thereafter began to show such startlingly modern settings as those by Heckroth at Essen and Schenck von Trapp at Darmstadt, with their use of montage and their pop-art anticipations. Outwardly at least, these people were bringing opera up to date in a way that looks remarkable even today.

Meanwhile Klemperer was introducing more and more modern works into the symphony concerts which the Kroll-Oper also gave: a programme that same month for instance was made up of *Pulcinella*, Weill's wind suite from *The Threepenny Opera*, Hindemith's Violin Concerto with chamber orchestra (op. 36) and the *Sixth Brandenburg Concerto* with Hindemith himself as one of the players. To Heinrich Strobel, the *Berliner Börsen-Courier*'s critic, this was the very embodiment of the contemporary approach to music, the opposite of

> a society concert where the audience is forced to listen to some composer or interpreter of no special interest to it.

And so he could report an exceptional directness and spontaneity of response on the listeners' part.

New settings for opera. Ernst Legal's Kroll-Oper production of *The Tales of Hoffmann*, 1929, designed by Moholy-Nagy. Photographed by Lucia Moholy during a performance

From 1928 on the modern opera tended to become specifically the 'Zeitoper', or opera of the times, on the analogy of the simultaneously fashionable 'Zeittheater'. This process began perhaps with the widespread success of Křenek's 'jazz opera' *Jonny spielt auf* (first performed in Leipzig in February 1927), whose trivial libretto about a black dance band violinist, with its polyglot phrases like

> Oh, ma bell', nicht so schnell,
> Gib mir einen kiss!
> Oh, my dear, so ist gut,
> Oh, you know, I love you!

is offset by some memorable tunes. *The Little Mahagonny* followed, including some not dissimilar English words –

> Oh, moon of Alabama
> We now must say good-bye

> We've lost our good old mamma
> And must have dollars
> Oh, you know why.

– though without the chic St Moritz-cum-railway-station setting of Křenek's more ambitious and ephemeral work.

Thereafter contemporary settings abounded. So the otherwise unknown Max Brand wrote the opera *Maschinist Hopkins*, first staged in Duisburg in April 1929, where an old-fashioned plot of jealousy, murder, foiled ambition and fallen woman is decked out with modern industrial trappings (including machines that talk) and jazz interludes, such as a Black Bottom on a pseudo-American text by Antheil; much of the music being heavily chromatic. Wilhelm Grosz, with Balázs as his librettist, wrote the short film-studio satire *Achtung, Aufnahme!!* with its bitter conclusion (this time in German) that 'real suffering can earn you a lot of money', followed by *Baby in der*

'Opera of the times' in the provincial houses. (1) Finale of Křenek's *Jonny spielt auf* at Darmstadt, 1928. Jazz tunes and a black musician hero

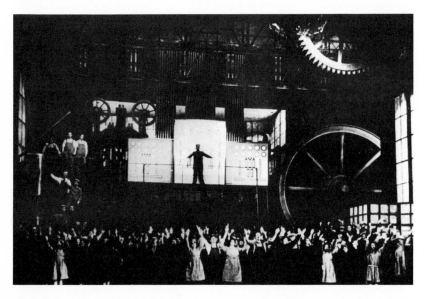

(2) Max Brand's *Maschinist Hopkins* at Frankfurt. The romantic hero in a factory setting

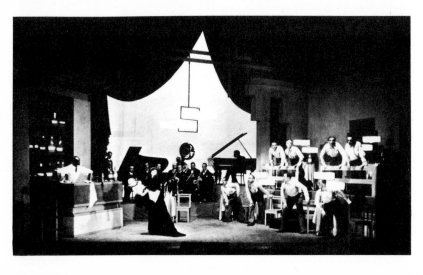

(3) Wilhelm Grosz's *Baby in der Bar* at Hanover, 1928. Farcical bar-room ballet, with jazz band on stage

Bar, an admirable comic ballet where a Tragic Mother's abandoned infant learns to walk, then to dance (I Shimmy-Blues, II Tango, III Shimmy, IV Blues, V Charleston), till the Mother reappears with a second bundled infant and the Mixer throws all three out. The Kroll-Oper contributed its bit with a restaging of Hindemith's *Hin und Zurück*, based on a Berlin revue sketch where a contemporary *crime passionnel* is arbitrarily thrown into reverse; also the first production of his *Neues vom Tage*, featuring a professional divorce co-respondent and an aria by the heroine in her bath. Eisler in 1929 wrote the cantata *Tempo der Zeit*, Edmund Nick a 'lyric suite' for radio on texts by Kästner called *Leben in dieser Zeit*.

Outwardly all these works were up to the minute, to a point where they threatened to split the seams of so normally conservative a medium. The fact that they did not do so may seem to have proved Eisler's contention in the case of *Jonny spielt auf* that its 'superficial modishness doesn't stop this work from being just as stodgy and petty-bourgeois as most operas by modern composers'. None the less there was already a handful of people prepared to modernize the medium itself, which Stravinsky had by then (in Weissmann's view) rendered no longer viable. This was the real contribution of Weill's works with Brecht, starting with the unpretentious song sequence of *The Little Mahagonny* on its boxing-ring stage. For the full-scale *Mahagonny* of which this version was a by-product represented a considerable rethinking of operatic principles. The new 'epic' opera was to narrate and report, so Weill wrote in 1928; therefore its music should be autonomous, interrupting the narrative at slack points rather than trying to inflate it with great gusts of extra wind; the aim should be to get away from the culture of a social élite and write for a new audience brought up on 'work, sport and technology'.

As it turned out, *Mahagonny* was not quite so radical as that, and if the Kroll-Oper eventually refused it this was due probably less to the novelty of its form than to the force of its apocalyptic social message. But *The Threepenny Opera*, which the two men wrote in such a hurry that summer, was a much less orthodox claimant to the title of 'opera', and its use of haunting, yet intelligible songs as interruption, parody and comment proved even more subversive of existing convention than its strong but essentially palatable social satire. Thereafter Brecht's idea of music theatre, and for a time Weill's too, became pushed in a different direction thanks to their involvement with Hindemith's 'Lehrstück' experiments, a process which led shortly to Brecht's rejection of the opera form, even as rejuvenated by *Mahagonny*, and to his ensuing collaboration with Eisler. With this the comparative flippancy of his original assault on the medium was soon to disappear.

An odd point about the socially-conditioned musical developments of these five years was that nothing comparable seems to have been experienced in Russia. This was a period when Soviet musicians, thanks above all to the two Leningrad contemporary music societies and in particular to the critic Igor Glebov, were comparatively well informed about the new music elsewhere; thus Klemperer and Fritz Stiedry both came from Germany to conduct, while Milhaud and Wiéner were interested guests in the spring of 1926, attending the first Soviet production of Prokofieff's *Love of Three Oranges* as well as the Meyerhold Theatre's *Roar, China!* and a rehearsal of *The Inspector General*. A year later *Wozzeck* was given in the Leningrad Opera, to be followed (according to Eisler) by productions in Kharkov and Odessa.

In 1927, too, Prokofieff made his first visit since leaving the country nine years before; and tentative arrangements seem to have been made for the performance of his industrial ballet *Le Pas d'acier* which had originally been commissioned by Diaghileff in Paris. Shortly afterwards his *Chout* was given its only Soviet production in Kiev, while Stravinsky too heard that there had been concert performances of *Oedipus Rex* and *Les Noces* in Leningrad. Even in those hopeful times however there was nothing comparable to the socio-musical experiments of Hindemith and his friends, nor did anything like the 'Zeitoper' flourish. This was partly due perhaps to the shortage of original modern composers, aside from Shostakovitch, who was just beginning to become known. In 1928–9 he did indeed write a score to accompany Trauberg's film *The New Babylon*, one of the first of its kind since Meisel's music for *Potemkin*. Generally speaking, however, the social and utilitarian approach to music was unique to Germany, and every bit as unfamiliar to the Russians as jazz or the twelve-note system. As for Eisler's political songs, if they were new to the Berlin workers' choirs they were even more so to the USSR. Whatever its internal differences, in respects like these the German 'new music' had gone a long way ahead of the Russian not only technically but also in social terms.

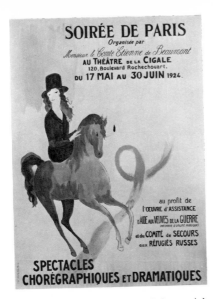

18 Retrograde symptoms: modishness in France, German polarizations

Capitulation and compromise in the French avant-garde; end of *L'Esprit Nouveau* and the Swedish Ballet; vulgarization of the modern idiom in the Arts Déco exhibition of 1925. Unchanged social basis of French patronage; Diaghileff's pursuit of fashion. Dwindling relevance of the Paris avant-garde to the Germans; their preference for Barbusse and Zola. Shifts in Soviet literary politics and polarization of German Left groupings after the 1928 Comintern congress; splitting of Socialist-led bodies; foundation of Communist writers' and artists' organizations. Symptoms of right-wing cultural reaction. Mixed Communist attitudes to the new sobriety.

For all the importance attaching to Milhaud and Le Corbusier it is difficult not to be struck by the lack of French influence in Germany after the stabilization and since Dada came to an end. That this was not due to any change in the German attitude to foreign ideas in general can be seen from the persistent interest shown there in both America and Russia; nor was it at all uncommon in the later 1920s for people like Grosz and Beckmann, Mehring and Tucholsky, Brecht, Piscator and their various collaborators to stay in France in order to work. What their French opposite numbers were doing at this time however seems to have had little to offer them, and the reason lay surely in a general decline of the Parisian avant-garde after its last fling in the shape of *Relâche*. For 1925 was a year of retreat all along the line. Satie died, Cocteau was converted to Catholicism, *L'Esprit Nouveau* closed down, Ozenfant and Le Corbusier split (none too painlessly, it seems), the Swedish Ballet was dissolved, Hébertot had just given up the Théâtre des Champs-Elysées which now went downhill and soon became a cinema, the Pitoëffs had to make do without a regular theatre, Tzara withdrew into private life as did Rolf de Maré, Picabia moved to the Côte d'Azur to produce tedious decorative art.

All these events were symptomatic of something that could already have been foreseen when the Congrès de Paris collapsed and that was to provoke a number of comments over the next few years. Thus Goll, reviewing Etienne de Beaumont's 'Soirées de Paris', decided that the first quarter of the twentieth century had come to nothing:

Avant-garde Paris and its social context. *Above*, Marie Laurencin's poster for the Soirées de Paris, 1924. *Below*, their sponsor Count Etienne de Beaumont, photographed by Baron de Meyer

The whole structure of a self-supposedly modern, new and youthful art is crumbling; . . . there is a *fin de siècle* atmosphere all round us, a complete 1890s decadence.

L'Esprit Nouveau too, in one of its last issues, could complain editorially of the number of recent 'capitulations and ingenious compromises by people who once had a future', while in 1928 Mayakovsky found that the only art he could bear in Paris was the cinema:

the poets and painters are more repulsive than slimy oysters. Rotten. That trade has become totally degenerate.

Such views may have been overstated, but they certainly suggest a new level of disillusionment. It was not just Dada that was over but a good deal more.

Nothing resumed the change so conspicuously as the 1925 Exposition des Arts Décoratifs, the first great international exhibition of the postwar era, which occupied the Grand Palais and extended to the Invalides, taking in both banks of the Seine. This was the product of a plan first launched by Charles Couyba in the Chamber in 1904, which had been gradually building up until in the postwar context it grew into a major national effort to confirm Paris as the centre of contemporary fashion and good taste. There was thus (for example) a Pavillon de l'Elégance and a Pavillon Fémina, with next it a chapel, followed by the Compagnie Royale Asturienne des Mines and the Société de Gaz de Paris; top dressmakers sat on the selecting committees alongside obscure establishment architects and rubbishy artists like Jean-Gabriel Domergue.

The avant-garde was not exactly excluded from this great patriotic operation, since there was also an official Soviet pavilion designed by Melnikov with Rodchenko in charge of display, while thanks to the support of the minister De Monzie the remarkable *Esprit Nouveau* pavilion by Le Corbusier could be put up despite some opposition. But Germany, as a defeated enemy, was not asked to take part at all, nor, to Van Doesburg's great indignation, was *De Stijl* put in charge of the Dutch exhibit. The emphasis was placed from the outset on a clearly identifiable

Cubist chic, style Arts Déco 1925. A model in a Sonia Delaunay coat and hat, with matching roadster

La Réception à la Préfecture Maritime. Hanging by Dufy, now in the Musée d'Art Moderne, Paris
(Centre Pompidou)

modernism, and this led to the successful commercialization of certain Fauve and Cubist conventions along the lines later termed 'jazz-modern'. Among the more reputable artists whose work lent itself to such a process were Dufy, Derain and Sonia Delaunay, while the architect of the moment proved to be Robert Mallet-Stevens, adept of a flat-roofed modernism whose hallmarks (such as the horizontal window-bar) were only façade-deep. It took a quarter of a century and more for French architecture and interior design to recover, and certain branches (luxury bookbinding, for instance) have continued to show the effects to this day.

What took place here was a diffusing of the modern movement for the benefit not of the less well-off but of the luxury consumer. And this refined vulgarization dovetailed only too well with the evolution of French cultural patronage since the time of *Parade* in 1917. For whereas German society had in many ways changed since then, leading the modern artists to look out for new patrons and new types of commission, in France the public and private power structures remained much as they had been before 1914, so that what had changed rather was the individual patron's attitude to the language of the modern movement. At the heart of that movement in 1924 could stand a Man of Distinction like the Count de Beaumont, whose house was the old Spanish Embassy and whose article on the modern cinema for *The Little Review* in 1926 was illustrated for no very clear reason with pictures of Lady Abdy, Mrs Daisy Fellows, the Comtesse de Noailles and other hostesses of the time. Madame de Noailles in turn commissioned Van Dongen and Léger to decorate her new villa by Guévrékian at Hyères and later underwrote the Bunuel–Dali film *L'Age d'or*. Its Paris showing is said to have caused her husband's expulsion from the Jockey Club.

Milhaud's *Les Malheurs d'Orphée* and other new works were commissioned by the American-born Princesse Edmond de Polignac, one of the Singer sewing-machine family, who also subsidized various important first performances such as that of *Oedipus Rex*. Others again were given in Natalie Barney's salon in the Faubourg Saint-Germain. 'A 1926 salon performance in Paris', wrote Antheil with typical

irreverence of one of these distinguished occasions,

> was a very interesting happening, usually taking place in an antique room, among priceless antique furniture and still more antique French millionaires and bearers of ancient titles.

These were the sort of people to whom Diaghileff and Cocteau had made the modern idiom in the arts acceptable and even exciting and whose standards were now reflected in what we have come to term Art Déco. Intelligent and benevolent as they might be, in the French context their good opinion had become too important, and it was only the odd man out (like Léger, Le Corbusier or René Clair) who could ignore it in favour of his own ideals or lesser people's needs.

The effect can be seen in the decline of Diaghileff's repertoire after *Les Noces*. Roughly speaking his Russian Ballet, spurred no doubt by the success of de Maré's company from 1922–4, was then doing for ballet what the Germans thereafter did for opera: that is, gearing it to contemporary themes and the latest pictorial and musical conventions. But there was a basic difference in the cultural climate of the two countries in the mid-1920s which led Stravinsky for one to comment on the alertness of the young German audiences (who at the Kroll-Oper were often on free tickets) and the limitations of Diaghileff's 'famous "subscribers"'. So Poulenc, the most unaggressive of modern composers, wrote *Les Biches* (The Does) for a cast of young girls in a set by Marie Laurencin; Milhaud's *Le Train bleu*, so called after the PLM's luxury express to the Côte d'Azur, was thought up by Cocteau to show off the athletic talents of the young dancer Patrick Kay (henceforward Anton Dolin) and costumed by Coco Chanel the dressmaker; while Auric's *Les Matelots* for Serge Lifar, designed by another modish painter, Pedro Pruna, capitalized on that slightly ambiguous vogue for maritime life of which other aspects can be seen in some of Masereel's French woodcuts or in Pierre Mac Orlan's stories *Port d'Eaux-Mortes* which Au Sans Pareil published in 1926 with lithographs by Grosz.

In this wishy-washy, extremely *mondain* setting, to which gifted English hedonists like Lord Berners, Constant Lambert and the painter Christopher Wood thereafter added their bit, the occasional echo of the Soviet avant-garde, as in Pevsner's and Gabo's Constructivist perspex set for *La Chatte* in 1927, seemed dislocated and incongruous. Not surprisingly, the Russian Ballet seldom came to Germany even in the period of economic boom, nor did their

visits there leave quite the same mark as in other countries. The cosmopolitan Count Kessler, for instance, who was perhaps the nearest German equivalent to the French type of patron, records seeing that company perform *Les Biches*, *Les Matelots* and their earlier masterpiece *The Three-Cornered Hat* in Berlin at the end of 1925, to great applause. Three years later however Diaghileff told him that Berlin was the only city he had been unable to conquer: each attempt ending 'disastrously from the material point of view, with a deficit of between a hundred and a hundred and fifty thousand francs'.

It was much the same with the Surrealist movement which had emerged from the wreckage of Paris Dada: seen from England or America it might appear comparable to the great French-based innovating -Isms of the past, but already in the case of Cubism and Futurism the German artists had shown themselves

Comment by *Das Kunstblatt* on a Dufy wallpaper, 1929. Note the word 'modern' in contemptuous quotes.

Kunst und Sport. Ertüchtigung an der Wand. Stofftapete von Raoul Dufy, ausgeführt von einer „modernen" Tapetenfabrik in Paris.

able to take from such movements only what served their own aims; and when Surrealism came along it proved to be of much less relevance to their concerns. This was in the first place due to the fact that the new movement was the product of the *Littérature* group, who had now more or less shrugged off Zurich Dada, retaining only Tzara's techniques of provocation and Marinettiesque self-advertisement. At the time of the Surrealist Manifesto of 1924 it was indeed doubtful whether there could be such a thing as Surrealism at all in the non-literary arts, and this uncertainty seemed justified when it turned out that Chirico, whom Breton had identified as the great Surrealist painter, had already in fact abandoned his earlier Metaphysical concerns in favour of Böcklinesque figures, horse-scapes and society portraits.

Nor, from the German point of view in 1925, was there anything all that unfamiliar in the supposedly Surrealist aspects of the work of Max Ernst and Arp, who now showed under that label, any more than in that of the Bauhaus-based Klee, whom Breton would have liked to recruit for his movement, but could not. There was in fact something slightly factitious about the very idea of Surrealist painting right up to the point when Dali arrived with his distinctively creepy academicism in 1928: not so much about the pictures themselves – which could have hung in other contexts and shone there; Magritte's in the Neue Sachlichkeit shows, for a start – as about their ascription to the new dogmas which Breton proclaimed. Moreover these dogmas and the manner of their preaching were alike incompatible with the wider German movement. Breton's romantic irrationalism, his belief in mysterious forces and the quasi-mediumistic use of the imagination could scarcely have been opposed to the open-eyed utilitarianism of the younger Germans, with their respect for objective facts. As for his group's aggressive public gestures, like Georges Sadoul's insulting postcard to a Saint-Cyr colonel or the wanton breaking-up of a nightclub that dared to call itself after *Les Chants de Maldoror*, one of their cult books, these were bound to seem trivial to anyone who had experienced serious political violence.

If anything it was pre-1919 Expressionism that the Surrealists' attitudes recalled for the Germans, though the bilingual Goll, whose admiration for Apollinaire had briefly led him to speak up for 'Überrealismus', soon turned against them and accused them of falsifying the Surrealist idea. Attracted like the wartime Activists by the concept of revolution, which they incorporated in the title of their new magazine *La Révolution surréaliste*, Breton, Aragon and Eluard remained none the less bourgeois in their life-styles and their concern with *bella figura*; hence their flirtations with the Communist Party were less easy to take seriously than those of the Berlin Dadaists. Except in its packaging, their work was not politically subversive, and even if it had been the obscurity of its language would have prevented it from having subversive effects. Once Dada was over the art of the Surrealists remained unknown and undiscussed in Germany even by so devoted a Parisian as Tucholsky; nor was there any intrinsic reason why it should be less acceptable to the Paris salons than the work of Cocteau or 'Les Six'. For whatever else surrealism might be, it was not linked to modern society and modern technology but rather a revolt against it, or at best a corrective. Where it did influence more advanced artists, as briefly in the case of Picasso and even Léger, its effect was to weaken rather than to intensify their relationship with their time.

For German writers in these years the great French exemplar was Zola, whose Rougon-Macquart novels began appearing from the Kurt Wolff Verlag in 1923 and thereafter served, together with current American and Russian fiction, as the standard by which those of German society could be measured. Otherwise however, so Feuchtwanger wrote in 1927, the modern French novel came to seem unimportant to them, being too concerned with psychology rather than outward events. As a result the French writers best known in Germany in those days remained those associated with the anti-war sentiments that had led to the establishment of *Clarté*: Barbusse above all, but also Jules Romains and Romain Rolland. These people were however among the *bêtes noires* of the Surrealists, who came increasingly to resent Barbusse's status as the principal representative of French communist literature in the eyes of the USSR. Due in the first place no doubt to the attitude of Lunacharsky, who had been directly linked in Switzerland with the anti-war movement and thereafter had a special esteem for those, like Masereel too and the much younger Toller, who had contributed to it, the international attention paid to Barbusse and his subsequent journal *Monde* became of some cultural–political importance after the foundation of the International Bureau for Revolutionary Literature (or IBRL) in October 1927. This Moscow-based secretariat, headed by the exiled Hungarian Béla Illés

and responsible to the Comintern, was set up on the initiative of RAPP, the militantly 'proletarian' writers' organization that dominated the Russian literary scene towards the end of the 1920s. However, far from standing for the old internationalist humanism, the IBRL took its role from the first as being that of an organ in the Soviet party's two-pronged campaign against Social-Democracy and Trotskyism. This was of particular relevance in France, where there was a good deal of support for Trotsky, while the attacks on Social-Democracy had a decisive effect on the German intellectual Left.

Already at the Fifth Comintern Congress in 1924 Zinovieff, smarting from the flop of the expected German revolution, described the SPD as 'a wing of Fascism'. At the next Congress in the summer of 1928, when the talk was of an imminent capitalist war against the USSR, led by England, it was decided not to form any united front with the Socialists, since their leaders were 'social-imperialists' determined to help in the assault. In all non-party organizations Communist 'fractions' must now be set up. Never very good at compromise at the best of times, the KPD and its followers were thus encouraged to cut their links with the SPD, splitting or seizing those organizations in which both had members. Already Piscator had been helped to secede from the Volksbühne in 1927; on the same principles the KPD formed a fraction within the workers' theatre movement, tried to get it affiliated to the IAH, then captured control in 1928. In 1927 too the KPD's Eleventh Conference for the first time passed a resolution on cultural matters (no doubt under the influence of the assertively 'proletarian' groupings now coming to dominate the arts in Russia) calling on all 'proletarian–revolutionary' elements in the arts to form a 'Red cultural front'.

Thus inspired, Becher, Andor Gábor and the Young Communist functionary Alfred Kurella, who that autumn were part of a delegation to the tenth anniversary celebrations in Moscow, also attended the IBRL's foundation meeting and undertook to form a German section of that body. Simultaneously some of the surviving adherents of the earlier Red Group decided to set up a sister organization which would correspond to the Association of Artists of the Russian Revolution, an essentially academic body now posing as Proletarian. Both plans materialized in the following year, when the new German Revolutionary Artists Association (or ARBKD) was founded in

Germany's militant 'proletarian' poet.
J. R. Becher and his faithful steed

March and the Proletarian–Revolutionary Writers' League (BPRS) in October. The second of these coincided with the creation of a cultural secretariat within the KPD and the official commencement of Stalin's First Five-Year Plan.

Up to this point there had been no real polarization of the modern movement in Germany. From Beckmann to Schlichter, from Tucholsky to Brecht, from Hindemith to Eisler its members somehow cohered despite harsh mutual criticism and differences of political outlook. Nor was the opposition which they faced anything like as ruthless and bloody as it had been before the stabilization. None the less the apparent freedom on which so many foreign visitors to Berlin now commented – the brothels, the openly acknowledged lesbianism, the homosexual nightclubs and all the other vividly recalled attractions – was largely confined to the moral sphere, and there was evidence to show that the platform of tolerance on which the cultural renaissance rested was not very thick.

Art was still apt to be regarded as dangerous, both for political and for moral reasons; thus Erich

Kästner's arrival in Berlin in 1927 as a satirist in the Tucholsky vein was due to his having been dismissed from the *Neue Leipziger Zeitung* for a musical poem – it was the centenary of Beethoven's death – illustrated as below by his friend Erich Ohser. Roughly:

> The virtuoso's lullaby
>
> O thou, the last of my nine symphonies!
> That pink and white chemise is so becoming . . .
> Come like a cello in between my knees
> And let me give thy strings a gentle strumming.
>
> I'll leaf through thy full score if I may do so
> (All filled with pauses, shakes and tremolo),
> Cause thee to sing as loudly as Caruso,
> My mutely longed-for double-dotted Oh!
>
> Let's roam those octave passages together
> (Just take the Furioso once again) –
> My left-hand technique's lighter than a feather
> But that crescendo's one we must sustain!
>
> Thy figured bass, how shapely and euphonious!
> Thy syncopations on a rhythmic ground!
> Never was an impromptu more harmonious . . .
> Speak then, if thou canst still give out a sound!

Scandal in Saxony, 1927. Erich Kästner's Beethoven centenary poem (English version above), with drawing by Erich Ohser

Brecht was forced to leave his publisher Kiepenheuer when one of the latter's new backers (following the stabilization) wanted the Ballad of the Dead Soldier removed from his first collection of verse; in 1926 he had to explain himself to the State Prosecutor, who disliked his Christmas poem, 'Maria'. The ex-communist dramaturg Oskar Kanehl was tried in 1924 for endangering the public peace by his revolutionary poems. And throughout the second half of the decade the law seems to have conducted a positive vendetta against the provocative figure of Becher, who was himself the son of a judge.

Becher from 1924 on was writing some extraordinarily nasty rubbish, but the crime of 'literary high treason' of which he was accused in October 1927 was hardly borne out by the various works which the police seized over a period of two years, if indeed that concept makes sense at all. So far as the evidence of his verse went, this had the same hectic, hectoring quality of his earlier Expressionist work, but with the Masses now taking the place of Humanity, 'der Mensch'. Thus his 'Maschinen-Zeit' of 1926:

No longer do I hymn angel squadrons, on stilted legs
Sphere-clambering, nor with noble Godsounds
The bleating chorus of saints – – – –
Proletariat: mass-cry, fire-toothed!
Iron-beaked slashbird! . . .

Vorwärts, du Rote Front!, the first of the confiscated books, starts with a hymn to 'Kampf' or 'struggle', that concept more often associated in our minds with Adolf Hitler:

This book is born of struggle
It is struggle.
It wants more struggle.
Pure works of art are for after the victory.
We however are in the midst of the battle.
O that all artists, writers and
Thinkers might realize this!
Start seeing!
The day of decision is nigh.
Forward!
Struggle!!

Elsewhere, as for instance in an article of 1925 called 'Bourgeois mess, revolutionary struggle', Becher went even further, looking forward to the clumping, metallic march of 'the KPD-troops' not so much against the rulers as against 'good people', chamber music and the unfortunate Ernst Toller (who had just left gaol and a few months later was a guest of the Soviet government). The main item in his indictment however seems to have been the anti-war novel *Levisite* which he published at the beginning of 1926, a highly imaginative work whose story switches from Germany to America, from dream to reality, and from the factory to the front line; its communist ego-hero is the son of a judge who is shamed into committing suicide. It was absurd to suggest that this book represented any kind of threat to the state, and in the event the case against Becher was called off when an amnesty was declared following the SPD success in the May 1928 Reichstag elections. All that had been achieved was that the left-wing intellectuals had been mobilized in a series of protests, and an apparent justification provided for Becher's brand of aggressive intransigence, which became more and more prevalent from now on.

The same amnesty led to the release of Max Hölz, whose life sentence following the fighting of March 1921 had become the subject of similar protests (partly organized by Muenzenberg's IAH) and was one of the *causes célèbres* of the time. At Leipzig however three booksellers had by then been prosecuted for selling Becher's writings and condemned to one or two years' detention in a fortress. Nor were the other arts all that much more immune. In November 1926 Bartók's *The Miraculous Mandarin* was taken off after a single performance at the Cologne Opera, apparently on moral grounds and at the insistence of Dr Adenauer, the then mayor. In 1927 some murals by the utopian–communist Heinrich Vogeler, who had emigrated to Russia and given his house to be a home for political detainees' children, were ordered to be removed by the state, then, after protests by the Manns and others, covered over. The following year George Grosz was prosecuted yet again, along with Herzfelde as publisher, for alleged blasphemy in the *Hintergrund* album of drawings issued in connection with the Piscator *Schweik* production that spring. This case, centring on Grosz's drawing of Christ in a gasmask (with the caption, taken from *Schweik*, 'Shut your trap and soldier on'), went up to the Supreme Court and back, eventually ending around Christmas 1930 with an acquittal, but also with the destruction of the blocks and the originals. The defence lawyer in this case, Alfred Apfel, had also represented Hölz and Becher; subsequently he defended Friedrich Wolf. He seems to have been recommended in the first place by Kisch.

Such incidents had a double importance. They remind us today that the German reaction had not

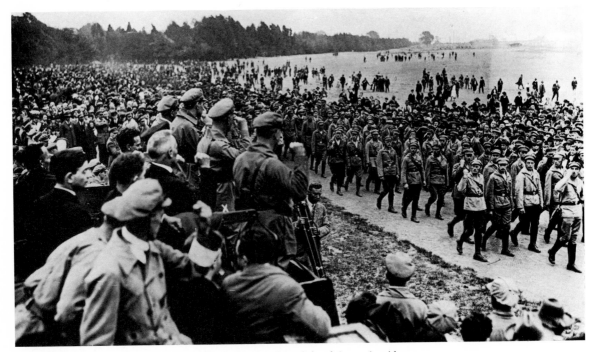

Heading for a confrontation. The Communist Roter Frontkämpferbund in 1926, with Thälmann taking the salute

just disappeared with the arrival of Stresemann in 1923, but had gone into a temporary hibernation whence it could at any moment re-emerge. At the time however their lesson seemed to be that compromise was impossible. So it was not only Becher who wanted to dump large sections of the modern movement in order to impose the views of his own party; Kemény too can be found after 1924, when he took over as *Die Rote Fahne*'s principal critic, rounding on his friend Moholy-Nagy in *Das Kunstblatt* and accusing him of incompetence, sterility and failure to give the new age 'a visual expression commensurate with its technological and economic urgencies'. By the beginning of 1928 indeed both Kemény and Hanns Eisler had gone on to chafe against the new sobriety in general, dismissing it as 'short-sighted realism', while Brecht too, in welcoming Neue Sachlichkeit (in Lenin's name) as a corrective to the traditional theatre, wrote that

> this quite necessary and inevitable step forward will be a reactionary affair . . . *neue sachlichkeit* is reactionary.

At the end of 1928 the Kleist Prize, previously won by Brecht, Barlach and Zuckmayer, was given to a new writer, Anna Seghers, for her novella *The Revolt of the Fishermen of Santa Barbara*. The success of this vividly imagined yet restrainedly told story of a defeated strike in an unidentifiable community was taken by the magazine *Die literarische Welt* as a sign that Neue Sachlichkeit was now over: in five years (they said) it had been 'driven to death'. True enough, Seghers was at bottom a romantic, and her short first book harks back in some respects to Kafka's *In the Penal Colony*. But in her subsequent novels she was soon to display many of the characteristics of the new sobriety, for all her communist ideology. At this stage the former movement was far from dead, and the majority of politically aware writers and artists, apart from the rhapsodic Becher, had adopted its impersonality as well as its social concern. What was happening was that the Communists were preparing to go it alone, and in the process were burdening themselves with the problem of defining the new 'proletarian–revolutionary' label which they had adopted. This would lead to complications as soon as the climate changed.

THE CRUNCH

19

1929–30

The political, economic and aesthetic changes of the period around 1929, which put a stop to Weimar Germany's interlude of democracy. Another moment of crisis, seen once more in several areas: the economic collapse; the changes in Soviet cultural policy at home and abroad; economic and other pressures on the arts in Germany; polarization and decline in the visual arts; radicalization of the Berlin theatre; emergence of committed novelists of a new kind. Dealt with area by area.

Economic collapse, death of Stresemann

The Wall Street crash and its disastrous effects on the German economy; Stresemann's death and the revival of nationalism; re-emergence of the Nazis, Communist hopes of a revolutionary situation.

'Let's hope 1929 brings us plenty of struggle, friction and sparks.' So wrote the playwright Friedrich Wolf in the last days of 1928. The KPD which he had recently joined may have been disastrously wrong in its predictions in 1923, but this time it was to prove only too right: he got what he wanted, with a

vengeance. For it was during the next eighteen months that the first real cracks began to appear in the none too solid cement holding the stabilized Republic together. Once again there was a complex upheaval whose effects could be seen in many countries, only this time it was not in any sense a 'return to order' but rather the opposite. Once again its origins were largely economic, first a decline in German industrial production and a corresponding drop in tax revenue, then a falling-off in foreign investment to half that of the previous year, finally in October the Wall Street crash, which led to a calling-in of American loans and thereby to a credit crisis in Germany itself.

Coinciding fatally with this process (which was of course to snowball as the unemployment figures rose and the state had to find more and more cash for unemployment benefit) were the new international negotiations for the revision of the Dawes Plan. The Young Plan which superseded this may have somewhat lightened the reparations burden, while the removal of the main allied control measures was

vital for the country's independence. But even the revised sum was more than Germany could pay from its own resources, and once the negotiations were over the non-Socialist parties in the government coalition saw no common interest in maintaining their alliance, or even perhaps the parliamentary system itself. Within a fortnight of Hindenburg's putting his presidential signature to the acceptance of the Young Plan the Socialist-led government had fallen. With his support the new chancellor, Heinrich Brüning, thereafter began governing by decree, the first time this had happened since 1923.

Stresemann's death on 3 October 1929 was thus more than symbolic: for he had committed his party to the Republic and his country to Europe, and without him neither commitment was to be honoured for long. Already the nationalists and the Stahlhelm, their licensed private army, had set up a committee to campaign against the Young Plan, and by enlisting the support of Hitler they had in effect promoted this Bavarian fringe leader to be for the first time a serious political factor. New recruits for

Symbol of a crucial year. Stresemann's funeral in October 1929. View from the Reichstag, with (successively) the hearse, the police, the Bismarck statue, the Victory Column and the Kroll-Oper in the distance

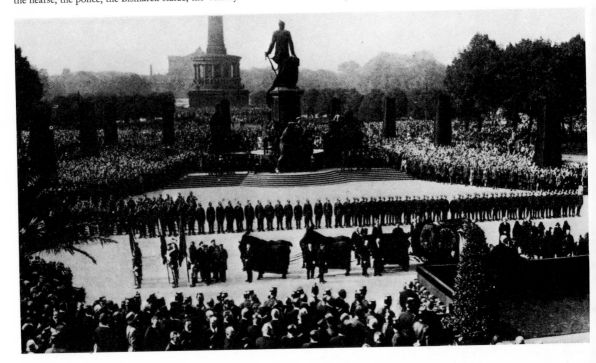

the National Socialist party and its uniformed SA began rolling in; suddenly it gained seats in local elections, and by the end of the year had won command of the student bodies in nine universities. Meanwhile the SA's opposite number, the Communist Roter Frontkämpferbund, had been banned following the riots of May Day in Berlin. Here the already nervous SPD administration had forbidden the traditional workers' marches, and when these took place none the less had allowed the police under their command to fire, with the result that some forty unarmed demonstrators were killed.

According to the sociologist Fritz Sternberg, who watched it with him, this incident was conclusive in turning Brecht into an active KPD supporter. More generally it had the effect of making the Socialist police chief Zörrgiebel appear as a second Noske, thereby prompting an anti-German demonstration in Leningrad, exacerbating Soviet–German relations and still further discouraging any reconciliation between the two left-wing parties. It was now too that Kurt Tucholsky, though much less of a Marxist

May Day in Berlin, 1929. Mounted police chasing demonstrators at Neukölln

than Brecht, first started collaborating with Muenzenberg's *AIZ*, having told his employers at the Ullstein papers that if they didn't like this dual allegiance he would leave them. The result appeared during 1929 in the form of the book *Deutschland, Deutschland über Alles*, a brilliant montage-like indictment of countless aspects of German life, both private and public, in which poems, sketches and brief polemical reports are linked to photographs selected, laid out and once or twice wittily improved by Heartfield. This now classic work sold around 50,000 copies.

With the Russians applying themselves relentlessly to Stalin's industrialization policy and the forcible elimination of his critics at whatever level, the arts everywhere were shaken up under the influence at once of sharpening political antagonisms and of economic restrictions. 'Lost: A Renaissance' was the pessimistic heading on the *Little Review*'s final editorial when the magazine folded that year. In August too Diaghileff died in Venice, another landmark gone, even if the previous six years had seen no more masterpieces from him. Yet artists in Germany, with their highly developed social awareness, were better equipped than most to face such changes, and once again the pressures under which they worked were at first far from unstimulating.

In many ways the effects on the arts there were fundamentally different from those of the 1921–3 turning-point, with its consolidation of the whole modern movement on a new sober, objective plane. Admittedly the artistic language and conventions remained formally close to those which had been established at that time. But the political engagement now became intenser, while the dangerously shifting ground once again gave an element of excitement to the economical, still outwardly impersonal style. It was, in many eyes, the beginning of a run-up to a new revolutionary situation, and one which neither the right-wing Socialists nor the old nationalist forces seemed likely to be able to control as successfully as in 1919 and 1923. Part of the ensuing debate therefore was concerned not so much with aesthetics as with the 'apparatus' of the arts, the eventual control of the media and the cultural establishment in a changed society.

Yet if a Communist revolution seemed more imminent, the Soviet example had come to appear a good deal more ambiguous than earlier in the decade; for Stalin's influence on the arts was just beginning to make itself felt. While the USSR regained something

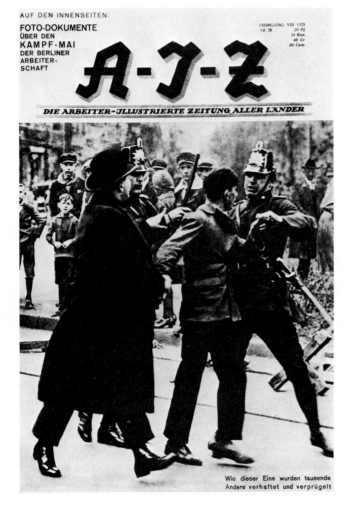

AUF DEN INNENSEITEN:

FOTO-DOKUMENTE
ÜBER DEN
KAMPF-MAI
DER BERLINER
ARBEITER-
SCHAFT

JAHRGANG VIII 1929
NR. 20 20 Pf.
15 Kon.
40 Gr.
30 Cent.

A·J·Z

DIE ARBEITER-JLLUSTRIERTE ZEITUNG ALLER LÄNDER

Wie dieser Eine wurden tausende
Andere verhaftet und verprügelt

The changing climate. *Left*: an arrest after the Berlin May Day demonstrations, photographed by an *AIZ* 'worker-photographer'. *Right*: back in Moscow, a jovial show of unanimity by Stalin (*right*) and supporters at the Fifteenth Party Congress. Photo by V. Samsonov from *Sov'etskoe Foto*

of its old prestige by comparison with that of America (whose tarnished image is marvellously expressed in Brecht's poem of 1929 on 'The late lamented glory of the giant city of New York'), as more evidence arrived of the growing cultural reaction in Russia many German artists and writers became somewhat disorientated. For this reaction bore too many points of resemblance to the new conservatism in Germany, which now saw the need for economy as an excellent pretext for interfering in the arts and took its own previously stifled prejudices – part traditionalist, part chauvinist, part racial – as guidance. Though the Weimar renaissance was still far from dead, henceforward it was caught between two fires.

'Proletarian' art organizations and the Five-Year Plan

Stalin's Five-Year Plan and the banishment of Trotsky. The new aggressively 'proletarian' movement in the arts; its attacks on modern music, architecture and cinema. End of *LEF* and suicide of Mayakovsky.

During 1929 Lunacharsky resigned when Stalin took higher education away from his commissariat and put it under the national economic council. Then aged fifty-four, he was to die four years later when about to take up an appointment as ambassador to Spain. In January Trotsky was exiled to Turkey; in November Bukharin, who with Rykov and others had been guilty of opposing the harsher aspects of the Five-

Year Plan, was removed from the Politburo; meanwhile Radek returned from two years' exile in Siberia and was allowed to work his way back into favour as a foreign affairs expert. In April the Sixteenth Party Congress approved the Plan, and in the autumn the process of forcible collectivization of agriculture began in bloody earnest.

This, very briefly, was the background to the rise in fortunes of RAPP and the 'proletarian' movement in the arts in general, whose leaders may have started by merely arrogating to themselves the right to stand for Communist Party policy but by the end of the year had been confirmed in this role by an article in *Pravda*. These new 'proletarian' associations were a very different proposition from the old Proletkult from

whose ashes they had originated, since their ambition was not to operate parallel to the party but to be in effect its executive arm in cultural matters. Where the old movement moreover had been able to accommodate men like Eisenstein and Tretiakoff, the energetic Averbakh and his friends now saw one of their main tasks as the discrediting of all such bourgeois-influenced artists and their formal experiments, in favour of a more utilitarian commitment to the politicians' aims, above all to the Five-Year Plan.

With the Leninist policy of official disengagement now superseded by a Central Committee resolution of December 1928 telling publishing houses to bring out more socially relevant authors, RAPP felt freer than ever to assault precisely those people and groups

whom foreign well-wishers, and above all the Germans, had seen as embodying the new revolutionary culture. Full of dogmatism they snapped at *LEF* and *New LEF*, the Formalist critics, the Constructivists, Meyerhold, the satirical school associated with NEP (Ilf and Petrov, Zoshchenko, Kataev), and the theoreticians of the cinema. Nor did they attack their victims on socio-artistic grounds alone, for the political campaign against Trotskyism and other forms of opposition provided fresh weapons of denunciation which they did not hesitate to use.

In January one of their targets, the critic Voronsky, was arrested as an alleged Trotskyist and exiled to Siberia for a year. The same month the Association of Proletarian Musicians issued the first

Targets for the new 'proletarian' criticism. (1) Ivan Leonidov, whose daring architectural projects included this model for a Lenin Institute

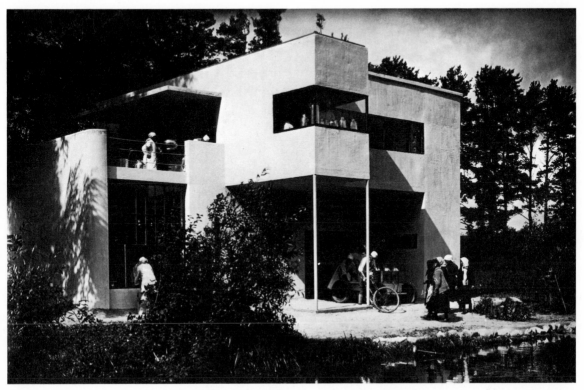

(2) Eisenstein, whose *The General Line* was altered at Stalin's request. Note the very modern rural building in this film about collectivization.

number of a magazine *Proletarian Musician* dedicated primarily to fighting 'the influence of decadent bourgeois music among young musicians', a phrase aimed at Shostakovitch as well as at the Leningrad cult of contemporary Western music. This Association's 1929 manifesto indeed specifies not only 'mysticism' and 'decadent' moods as evils to be combated, but also primitivism (by which the bourgeoisie was thought to be trying to slow up its own degeneration) and 'Reproduction in a musical work of the movement of the contemporary capitalist city with its milling humanity and industry'. The same body took exception that year to the Bolshoi ballet's proposed production of *Le Pas d'acier*, and managed to get it shelved.

In architecture too a similar association formed under the initials VOPRA devoted itself to demolishing the most brilliant of the young Soviet architects, Ivan Leonidov, a student of the Vesnin brothers at the Vkhutemas whose projects – and he was never allowed to get beyond projects – were publicized by his colleagues of OSA between 1927 and 1930. In *Iskusstvo v Masse* he was accused of sabotage, another topical offence, and from then on his career was wrecked. Stalin's own role in such developments is by no means clear, since he can be found assuring the playwright Bill-Belotserkovsky that 'to raise the question of "Rights" and "Lefts" in literature' would be wrong. At the same time Averbakh in a fiftieth birthday tribute that December could praise Stalin's unpublished 'utterances upon questions of literary politics', while it was Stalin personally who made Eisenstein change the ending of *The General Line* a few months before. Not that Eisenstein himself can have been all that surprised at this, since he was always insistent on his propaganda role, and in taking collectivization as the theme of the film had anticipated the Party's concerns of 1929 all too well.

The renewed attraction of Germany for the Soviet avant-garde at this time was perhaps a tribute to the

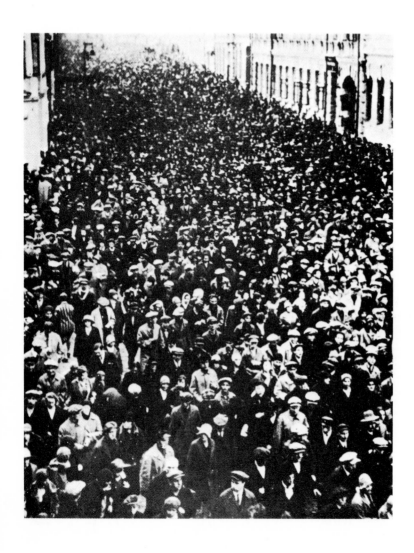

End of an era. Moscow turns out for Mayakovsky's funeral after his suicide in spring 1930.

energies of the IAH and the Society of Friends of the New Russia; however it was also in part a reflection of the problems at home. Lissitzky had to come there anyway in connection with the Stuttgart 'Film und Foto' exhibition and other shows; Dziga-Vertov undertook a lecture tour and gave the first showing of *The Man with the Movie Camera*, his last silent film; Eisenstein, at the beginning of a year's sabbatical (enlivened by the La Sarraz jaunt), spent some three months in Berlin and introduced the German version of *The General Line*, for which Meisel had again been asked to write a score, this time for synchronization. A little later Meyerhold's theatre did a six weeks' German tour with *Roar, China!*, *The Government*

Inspector, *Le Cocu magnifique* and Ostrovsky's *The Forest*; after which Tretiakoff came on a five months' visit.

Ignorant as always of the Soviet cultural scene, the more rabid anti-Communists in Germany clearly had no idea that such figures were anything but living exemplars of what they had learned to call 'Kunst-bolschewismus', 'art bolshevism': a concept based on the assumption that artistic and political subversion must necessarily be linked. In fact however it was just these artists who (along with Ehrenburg in Paris) were now subjects of attack in the USSR, and none more persistently so than Mayakovsky, hitherto the loudest and reddest of Soviet poets, who tried to

interest Piscator in one of his plays (presumably *The Bedbug*) and in February 1929 arrived in Berlin to sign a contract with the Malik-Verlag. *New LEF* by then had ceased publication; Mayakovsky tried to refound the group as REF or Revolutionary Front, but *Pravda*'s article of December led them to capitulate, and early in 1930 he too joined RAPP.

This was too late to disarm his enemies, for his new play *The Bath House*, staged once again by Meyerhold, who thought it a better work than the very successful *Bedbug*, was torn to pieces in *Pravda* a week before the premiere by a RAPP critic called Ermilov, in an article devoted to 'Some manifestations of petty-bourgeois "leftism" in literature'. Meyerhold consequently was forced to withdraw it after only a few performances. The poet's closest friends the Briks at that time were in Berlin; and to add to his depression his latest love affair had foundered on the woman's refusal to leave Paris, where she was an émigrée. In April the journal *Pechat i revolutsia*, edited by Lunacharsky and V. Polonsky, proposed to publish Mayakovsky's photograph with an editorial greeting, but was ordered to omit it by the head of the State Publishing House. On 14 April he shot himself. At his funeral Mikhail Koltsov drove the hearse.

Economy and reaction in Germany, Die Linkskurve

Impact of the German economic crisis on the arts; reactionary campaigns and acts of censorship. The 'proletarian' *Die Linkskurve* and its criticisms of the avant-garde.

In Germany an early sign of the new economic pressure could be seen in July 1929 when the Prussian Oberrechnungskammer (or public accounts committee) proposed that the Kroll-Oper and the Schiller Theater should be shut down. The latter had been taken over as a second theatre by Jessner in 1923, and had never established a distinctive character of its own, so an objective argument could be made out for shedding it. But in the case of the Kroll-Oper the patent absurdity of having three opera houses also served as a pretext for attacking its modernist policy. Already the Berlin actors had protested against their own worsening economic conditions, and in the autumn both Brecht and Piscator suffered spectacular failures; later in the 1929–30 season a serious falling-off in audiences seems to have been felt, provoking a spate of revues and musicals and leading Reinhardt

(who had just lost his manager brother Edmund) to make an alliance with the two principal commercial managements. Ironically, but logically, this was the time of *The Land of Smiles* and the Erik Charell production of *White Horse Inn*.

The financing of the building cooperatives by the 'Hauszinssteuer' was brought to an end. Among the town-planning projects to be cancelled were a proposed satellite town at Spandau outside Berlin, and the Goldstein garden city at Frankfurt, which included a do-it-yourself venture where would-be tenants were to build the houses cooperatively, then draw lots for who should occupy them. Gropius too had been working on a vast 'cooperative city' to be built in the southern part of Berlin: a rigidly uniform and rectilinear scheme which was now abandoned thanks largely to the objections of the cooperatives' members.

Painters clearly had difficulty in selling their pictures, to judge from the institution by the SPD in 1929 of a 'Künstlerselbsthilfe' or artists' self-aid organization headed by Pechstein and Belling and designed to make art less dependent on bourgeois patrons. From the world of publishing too there were some hair-raising stories, though it is hard to say whether they had any practical influence on what appeared. Plievier, for instance, whose *Des Kaisers Kulis* was published early in 1930, thought it prudent to have his royalties collected every day from the Malik-Verlag offices, while at Rowohlt's the subsequent collapse of the Darmstadt National Bank meant a moratorium in payments to authors (apart from Emil Ludwig, who would not accept this) and shareholders alike. Kurt Wolff gave up publishing altogether and lived privately till the foundation of Pantheon Books in New York in the Second World War.

Unofficial conservatism and official censorship alike took a new lease of life. In February 1929 the Nazi Alfred Rosenberg, who had for some years been attacking the culture of the time on largely racialist grounds, founded a nationwide 'Kampfbund für Deutsche Kultur' or Militant League for German Culture whose first targets included the music of Křenek and Weill. Nationalist campaigns that year led to the cancelling of two of Barlach's commissions for war memorials and the hampering of others. In March the Reichswehr, via the Prussian SPD Minister of the Interior, succeeded in banning P. M. Lampel's second play *Giftgas über Berlin*, an anti-militarist work featuring generals Seeckt and Schlei-

'Proletarian' criticism in Germany. *Die Linkskurve* or 'The Left Turn', published by the BPRS in 1929 with Becher as chief editor

In May efforts were made unobtrusively to stifle the *Berlin Requiem* by Weill, a work of seriousness and power whose Brecht text is neither improper nor noticeably political: Frankfurt Radio, who had commissioned it, finally gave it a performance, but the promised broadcasts from other transmitters did not take place. Similarly with the Leipzig premiere of the opera version of *Mahagonny* early the next year, which was interrupted by demonstrations in the stalls, leading one witness to comment by citing Goethe's 'an age is ending here and now, and you can say you were present'. Even more symptomatic was the resignation from the Staatstheater in January of Leopold Jessner, who as a Jew and a Socialist at the head of his profession had been a *bête noire* to the extreme Right long before either Weill or Brecht. He was succeeded by a modernist in the shape of Ernst Legal from the Kroll-Oper, though with reduced powers.

As the extreme Left likewise became more militant, it also became more indifferent to the effect on non-Communists of its own changing aesthetic line. Based on the policies of the RAPP in Russia, this was uncompromisingly hammered out first in *Die neue Bücherschau*, a magazine whose editorial board included Becher and Kisch as well as the independent Max Herrmann-Neisse, and later in the newly-formed BPRS's organ *Die Linkskurve*. The former began by asking various writers whether there was any literature and art that expressed the aspirations of the workers, getting a variety of answers which the editors interpreted as a vote primarily for the books of Zola and Gorki (Kollwitz, Masereel and Grosz being the most widely-named artists). Only a few issues later, however, Herrmann-Neisse, who had already struck an individual note by naming Leonhard Frank and Franz Jung as his only German candidates, wrote that the erratic nationalist Gottfried Benn was a better prose writer than 'the suppliers of propaganda material', at which Kisch and Becher resigned.

By then *Die Linkskurve* had been planned, and finance had been promised by the parent IBRL in Moscow; its first number came out in August 1929. Becher, Gábor and the newly converted Weinert were its editors, along with Kurt Kläber of the Internationaler Arbeiter-Verlag, the KPD publishing house, and the former Guards officer Vieth von Golssenau who, as 'responsible editor', wrote under the name Ludwig Renn. With the second number Hans Marchwitza also joined, to act as sole repre-

cher which the Gruppe Junger Schauspieler wanted to put on at the Theater am Schiffbauerdamm; it was seen by Zörrgiebel at a closed performance, also unfortunately by an invited group of Young Communists whose shouted insults to the police chief can hardly have stimulated his indulgence. The police likewise tried to stop Marieluise Fleisser's *Die Pioniere von Ingolstadt*, the Brecht-influenced satire which followed, the pretext once again being its picture of the military as seen at work, this time in a small Bavarian town. In the event the authorities were contented with a few modifications at some of the more outrageous moments: e.g. the love-making in the churchyard was in future to take place behind a tomb.

sentative of the 'worker-correspondent' movement which had been part of party journalism for the previous five years. Most of the meat of the early issues however was concerned with nothing so logical as actual working-class writers, but rather with criticizing the shortcomings of rival left-wingers, mainly of bourgeois origin like the editors' own. So Piscator, Barbusse, Döblin, Toller, Plievier and Tucholsky were all attacked, sometimes in sneering terms and with none too much regard for accuracy; even though Piscator was a member of the Association and Barbusse the parent Bureau's French representative. 'We have to keep at arm's length from those "sympathetic" to us', wrote Becher in the first issue of 1930. Even within the Communist movement itself there were a remarkable number of people in the arts, both Russian and German, to whom this good resolution was to apply.

Sacking of Hannes Meyer, the ARBKD

Removal of Hannes Meyer from the Dessau Bauhaus. Nazis capture the Thuringian Ministry of Education and appoint Schultze-Naumburg to the former Bauhaus at Weimar. The Communist artists' organization as heirs to Neue Sachlichkeit; demise of *Der Sturm* and *De Stijl* and further stagnation of Dix and Grosz.

In May 1929 the next budget for the Bauhaus only narrowly scraped through the Dessau city council. Up to that point the new director Hannes Meyer had never publicly spelt out his political views, although the uncompromising and humourless nature of his written statements from 1926 on should have shown that they were likely to be on the extreme Left. Despite the fact that in March 1930, in line with his undertaking to Gropius to keep the school unpolitical, he had dissolved a student KPD cell, his decision to contribute to an IAH collection organized by some students that summer inspired a local press report that the KPD had formed a Bauhaus branch. Informed, according to his own account, by the museum director Ludwig Grote, a busybody who thought Meyer should have forbidden the collection, Hesse the mayor took Grote to see him and the following exchange allegedly took place:

> Grote: Hannes Meyer, I think you are trying to pull the wool over our eyes.
> Meyer: You know perfectly well, Dr Grote, that I am a scientific Marxist.

Whether or not Meyer also said that he had never belonged to any party, as his subsequent statement claims, this mild enough admission outraged Hesse, who commented to Grote that it 'virtually disqualified him as head of the Bauhaus'. Quite to his surprise he was thereupon sent for and told to resign, which he refused to do. Supported by a few students and only one member of the staff, the weaver Gunta Stölzl, he insisted on a legal settlement and wrote a somewhat clumsy open letter to Hesse which was published in the Berlin *Das Tagebuch* in August. Then in the autumn he went off, followed by twelve of the students, to teach at the Moscow Vkhutemas, now renamed WASI and devoted solely to architecture under the Heavy Industry Commissariat.

In December 1929 the state elections in the Bauhaus's former province of Thuringia saw the Nazi vote more than doubled, reaching 11.3% of the total, and accordingly Wilhelm Frick became Minister for Education, the first Nazi minister to enter any German state government. His short period in office has become famous because he appointed H. F. K. Günther the racial theorist to a newly instituted chair of Race Research at Jena university, a step which had quickly to be annulled when it emerged that the teachers' organizations had not given their agreement. While it lasted however he successfully issued an 'Ordinance against Negro Culture' and had pictures by Bauhaus and other masters removed from the Weimar museum. He also appointed the conservative architect Paul Schultze-Naumburg, author of an unpleasant anti-modernist tract called *Kunst und Rasse*, to succeed Otto Bartning at the architectural school in the old Bauhaus buildings. One of the new director's acts was to have Oskar Schlemmer's murals obliterated with white paint. This was done without reference to the artist, who since October of the previous year had been teaching at the Breslau Academy. The school's building superintendent, who wrote privately to tell Schlemmer of this piece of vandalism, commented 'But who can block the march of history?'

The new ARBKD failed to attract the better-known German artists, though few at this juncture were so totally non-committal as Schlemmer, who not only refused to take sides over the sacking of Meyer but abstained in the crucial Reichstag elections of the same year. Differing markedly from the BPRS of the writers in that its outstanding members were indeed of working-class origin, the ARBKD's policies encouraged artists not so much to modify

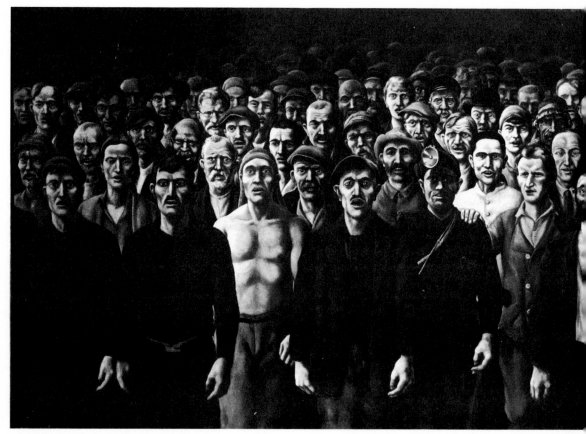

Communist art of the ARBKD. Otto Griebel's big painting *Die Internationale*, now in the East
Berlin Museum for German History

their predominantly 'Neue Sachlichkeit' style as to
apply it to outspokenly proletarian and political
subjects. Nor was the main weight of the movement
so much in Berlin, where Otto Nagel was its leading
spirit, as in Saxony among the pupils and followers of
Dix: the Grundigs, for instance, the gifted Griebel,
who had passed through Dada and the Red Group,
and the somewhat younger Wilhelm Dodel and Curt
Querner. Dix himself, however, though his new
great triptych of trench warfare *Der Krieg* was the
centre of a 'War and Peace' exhibition at the Leipzig
Grassi-Museum in 1929, had by now become
relatively conservative, and aped the German old
masters in the bulk of his work, which had lost all its
former sting and conscious satirical intention. Even
Der Krieg was essentially an echo of the Isenheim Altar,
painted with a creepy literalism akin to Dali.

The satirical *Der Knüppel* had ceased publication
after August 1927, to be followed by a paper called
Eulenspiegel under Nagel's editorship to which neither
Schlichter nor Grosz contributed. Henceforward
Grosz drew only for the bourgeois (and Bavarian)
Simplicissimus; he drank too much, he was totally
despondent about the future of the country, and his
art was deteriorating. Meanwhile the *Sturm* gallery
closed, the magazine by now being dead on its feet,
with Walden obsessed by his enthusiasm for the
Soviet Union. Though *De Stijl* too had declined into
a skimpy and intermittent one-man review of
practically no moment, after Van Doesburg's move
to Paris in 1929 the core of the whole international
abstract movement began to shift to that city, where
it henceforward became the main alternative to the
new surrealist art.

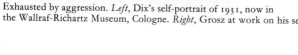

Exhausted by aggression. *Left*, Dix's self-portrait of 1931, now in the Wallraf-Richartz Museum, Cologne. *Right*, Grosz at work on his self-portrait

Transformation in the theatre, Brecht, Piscator, the collectives,

The 'Lehrstück' and Brecht's isolation from the established theatre. Failure of Piscator's second company and creation of the Piscator collective. Further development of the 'play of the times'; formation in Moscow of international workers' theatre league. Birth of the talking film.

At this critical juncture one of the most suggestive new developments was the didactic theatre devised by Brecht. Sparked off in the first place by Hindemith's notion of 'Gemeinschaftsmusik' and intended to be staged outside the conventional theatre, this applied the sparse language of Brecht's city poems to a semi-Japanese dramatic form as Europeanized by Claudel and Arthur Waley on the

one hand and by Meyerhold and Tretiakoff on the other. It was first realized at the Baden-Baden festival of July 1929, two and a half months after the May Day shootings, when two works were performed on a concert platform with no scenery other than projections and inscriptions. Both dealing alike with the implications of the first transatlantic flights, these were the *Lehrstück* or *Badener Lehrstück* to a fine score by Hindemith, and the *Flug der Lindberghs* or *Lindberghflug* which was intended to be one of a number of experimental works for radio and was composed in collaboration by Hindemith and Weill. The first of these formally quite radical dramas brought about the scandalizing of the audience, the alienation of the Baden-Baden patrons and the ending of Brecht's promising new association with Hindemith. The second led a year later to the

A new musical–dramatic form. Brecht's radio 'Lehrstück' *Lindberghflug* performed at the 1929 Baden-Baden Festival with music by Hindemith and Weill. Brecht is standing, *right*.

Brecht–Weill 'school opera' *Der Jasager* on a text taken over virtually unchanged from one of Arthur Waley's translations of the Japanese Noh plays.

Fruitful as it was to prove in other ways, the writing of these didactic pieces made it impossible for Brecht to concentrate properly on the planned successor to *The Threepenny Opera*, his (or rather his collective's) new comedy with Weill, *Happy End*, to which he himself now paid far too little attention apart from providing the songs. For Aufricht's regime at the Theater am Schiffbauerdamm the result was a disaster, blamed by him partly on an un-expected political harangue inserted in the play's last scene, partly on the interventions of Reich and the young Bulgarian Slatan Dudow, both of whom had come from Moscow. Whether or not either of these factors in fact aggravated the comedy's intrinsic weaknesses may be doubtful, but certainly Aufricht dropped his most successful author like a hot potato,

and from now on the commercial theatre was largely closed to Brecht's work.

A week after *Happy End* Piscator at the Theater am Nollendorfplatz put on *Der Kaufmann von Berlin*, a spectacularly advanced production and an even greater disaster. This was Piscator's come-back after his first company's collapse, a year and a half earlier, and if Mehring's text for the new play was no masterpiece its theme – a poor East European Jew arriving during the inflation and becoming a Berlin millionaire – was topical from many points of view; moreover the sets by Moholy-Nagy were brilliant and the stage machinery more complex than ever. The songs this time were composed by Hanns Eisler, who was thereby brought into contact with the actor Ernst Busch, henceforward to be closely identified with his music. One of the high points of the play indeed was the 'Song of the Three Street-Sweepers' with which it concluded: the three figures philo-

sophically sweeping away the rubbish of the pre-stabilization era – a pile of paper money, a steel helmet, last of all the body of the man who had once worn it – to the refrain 'Crap: chuck it out!'. But it was just this finale, with its implied affront to the army, which angered the well-to-do first-night audience, and after four weeks' controversial run, with soaring costs, the theatre's nominal director banned the use of the red flag, took Piscator's name off the theatre and forbade him to enter the house.

Some of Piscator's actors then formed a touring collective under his name, engaging him as a rank-and-file member at a much reduced salary, and had a considerable success with a modest 'Zeitstück' about the abortion law by Carl Credé: a naturalistic play which the group used to introduce a general audience discussion of this topical problem. Piscator's 'proletarian-revolutionary' colleagues approved, since such a production was less dependent on a wealthy snob audience; moreover it was a further sign of grace in their eyes that, after previously not bothering to keep up to date with the Soviet theatre, he now agreed to stage two modern Soviet plays by Bill-Belotserkovsky and Anatol Glebov. This development however came too late to figure in Piscator's montage-style book *Das politische Theater* at the end of 1929, which was mainly put together during his year and a half of inactivity and accordingly bases its concept of political theatre largely on his more extravagant productions. Even these, it should be remembered, were voluntarily submitted to the political guidance of the KPD – a somewhat different matter from the RAPP cultural–political line as echoed in *Die Linkskurve*.

In the new context the Berlin theatre could only continue moving leftwards by becoming increasingly uncommercial. This did not prevent the emergence of a number of new dramatists, such as Ödön von Horváth with *Die Bergbahn*, or Julius Hay, who heard the *Threepenny Opera* songs in Hungary in 1929, dropped everything and moved to Berlin with four plays ready roughed out in his head. But it did mean that the more radical plays, including most of the new 'Zeitstücke', could for the time being only be done by the subsidized theatres or by struggling collectives. Luckily the changes of command at the former were helpful, Karl Heinz Martin taking over the stagnant Volksbühne only a few months before Jessner was succeeded by Legal. The Gruppe Junger Schauspieler staged Wolf's abortion play *Cyankali* and took it on a tour of the USSR; the Junge Volksbühne was formed from Piscator's Volksbühne supporters; while the Volksbühne itself performed the Herzog–Rehfisch *Die Affäre Dreyfus* which Piscator had hoped to produce.

In the autumn of 1929 the IAH sent the 'Das rote Sprachrohr' agitprop group on a Soviet tour, while in December the German workers' theatre federation under Arthur Pieck was the prime mover in setting up an international league of workers' theatres, with its headquarters in Moscow, somewhat on the lines of the IBRL. Where previously the impact of the Russian theatre in Germany had been delayed and indirect, a number of the left groups, both amateur and professional, from now on came more and more to look to the East.

A still more important development at this point was the introduction of the talking film, which now brought theatre and cinema much closer together. Reinhardt might oppose it – which was why he abandoned his Hollywood ambitions at this juncture and returned to Berlin – but Piscator was already in touch with Mezhrabpom and in 1930 visited Pudovkin in Russia, where he discussed his own possible involvement in that field. Meantime the last German silent pictures reflected the cinema's growing interest in social themes and the 'Zeittheater', prompted perhaps by the formation of left-wing film societies under Richter and Heinrich Mann, and the expansion of the *Arbeiterbühne* magazine to cover film.

During 1929 Muenzenberg's Prometheus made its first three full-length films, starting with the working-class documentary *Hunger in Waldenburg* directed by Piel Jutzi, who was also the cameraman, and scripted by Piscator's aide Leo Lania. Two feature films followed: *Mutter Krausens Fahrt ins Glück*, directed by Jutzi on a script due partly to the painter Otto Nagel and intended as a memorial to Heinrich Zille; and the Hamburg film *Jenseits der Strasse* which Leo Mittler directed. Under the name of Studio-Film an independent group including Robert Siodmak, Billy Wilder, Fred Zinnemann and Moritz Seeler (the former organizer of the Berlin Junge Bühne) made *Menschen am Sonntag* about the leisure activities of small Berlin employees, a film which the renamed *Arbeiterbühne und Film* criticized as dangerously un-class-conscious and Balázs found too factual. Finally commercial film versions were also made of the two Łampel plays and *Cyankali*, though the censorship of the former and the 'kitschy' unreality of the latter (this being Wolf's own verdict) rather deadened their effect.

Persistence of the social theatre.
Wolf's anti-abortion law play
Cyanide staged naturalistically by
a Berlin actors' collective in 1929

A non-communist film of
everyday life. *People on Sunday*,
1929, by a group of young Berlin
cineasts including Robert
Siodmak, Edgar G. Ulmer, Billy
Wilder and Fred Zinnemann

Book clubs and war novels

Growth of new German prose writing following *All Quiet on the Western Front*. Other war books and their sequels: Renn and Plievier.

It was only at this late stage that a truly distinctive new German prose literature began to appear, one with its roots in the modern era rather than in the Berlin or Munich of before 1914. Stylistically the way had been prepared by the evolution of the former Expressionist Franz Werfel, whose novel *Der Abiturententag* of 1926 has a measured coolness quite unlike his earlier poems and plays, and still more by the revelation of the amazingly even and exact prose in which Kafka recorded the flights of his imagination: the most ambitious of which were not published until after his death in June 1924. To this can be added the impact of the Russian and American novelists whose work began appearing in German around the same time – Sinclair Lewis, Dreiser and Dos Passos, for instance; of the great reporters from John Reed to Kisch, with their vivid patchwork of facts; and also perhaps of the logically constructed detective stories which in the hands of Agatha Christie and Dorothy Sayers constituted the decade's outstanding new literary genre.

So far however there had been nothing in the prose fiction of the younger Germans to match the dry, concentrated toughness of Brecht's irregular verse, or the unobtrusive precision of such socially aware satirists as Tucholsky and Kästner; this was a tone as yet scarcely audible even in the stories which these poets also wrote. But with the year 1929 came a marked change, consisting of a further simplification and compression of style, a modernization of themes and attitudes, a greater awareness of major social issues not unlike that of the 'Zeittheater', and a more 'epic' approach to the handling of widely varied material. There was something of a social transformation here, in that the writer no longer treated himself as a member of a superior caste, and also because a number of genuinely working-class writers emerged. And certainly this reflected the political contexts of the time: not just the issues themselves but the type of sociological analysis, the encouragement of 'worker-correspondents' on the Russian model, the sceptical treatment of heroes.

Another factor, specific to Germany, was the influence of the two left-wing book clubs, the Bücherkreis and the Büchergilde Gutenberg, whose great discovery, the mysterious Mexican writer B.

Traven, was a best seller from the publication of *The Death Ship* in 1926 on. Thought in fact to be an obscure anarchist actor-writer called Ret Marut who had left Germany after the fall of the Munich Soviet, Traven provided a more sceptical and less Europe-centred version of the social novel popularized by Zola, Gorki, Jack London and the Dane Martin Andersen-Nexö; and right up to the Second World War he dominated the reading of the German Left.

Late in 1928 both book clubs became more frankly political with the appointment of Karl Schröder and Erich Knauf as their respective chief editors, and thereafter the Büchergilde's list in particular moved closer and closer in character to that of the Malik-Verlag. It would seem that the ensuing transformation of the indigenous German novel owes a good deal more to them than to the writing of such KPD pundits as Becher and Kurt Kläber, whose literary judgement and style had been formed at an earlier stage. Nor was it effected by the hitherto recognized 'progressive' writers but by people who had previously been unknown, or had dropped out of literature and only returned to it after some years of non-literary experience. It came, in other words, as something fresh.

The decisive theme in this evolution was the First World War, and the decisive book – more so even than was *A Farewell to Arms* for the English-speaking world – was written by a dissatisfied advertising man who neither then nor later wished to cut a literary figure. This was Erich Maria Remarque's *All Quiet on the Western Front*, whose enormous success in 1929 was surely due to his ability to give a direct, sober insight into those extreme experiences which after the calm of the mid-1920s were once again becoming all too relevant. Written with many short sentences, sometimes of only three to five words, using the full stop as its principal instrument of punctuation, Remarque's novel was unsentimental without being insensitive. It aimed simply to be objective: 'neither an indictment nor a confession' in the words of the preliminary note, but a report on a generation 'destroyed by the war – even when they escaped its shells'. This standpoint, maintained throughout the novel, is clearly not quite as neutral as the author claims, and those with a purely heroic view of 1914–18 were offended by it; but it was exactly right for a public still quick to protest against slights on the German army as such.

A wave of war books, plays and films followed, not so much anti-war as vivid, realistic and lacking in

So in *Krieg* and its immediate sequel *Nachkrieg*, which takes Sergeant Renn into the security forces of the Republic, the crazily disjointed happenings of military life are set down with something of the same deadpan jerkiness as Dashiell Hammett's *The Glass Key*: a mad world recorded in the sparse phraseology of a trained observer's notes.

We can apply the revealing test of the opening few lines, where the quality of a novel so often asserts itself for better or for worse. Here is Remarque:

> We are lying nine kilometres behind the front line. Yesterday they relieved us; now our stomachs are full of beef and baked beans and we feel well fed and content.

Renn:

> They promoted me corporal on the day we mobilized. I could not go out to my mother's and I wrote to say good-bye to her. Her answer came the day we moved off.

Zweig:

> This earth of ours, the little planet Tellus, was whirling busily through pitch-black airless icy space that is for ever swept by myriad waves . . . (etc.)

Barbusse:

> The great pale sky fills with thunderclaps: each explosion simultaneously reveals, falling away from a red flash, a column of fire in what is left of the night and a column of smoke in such daylight as has already appeared.

Theodor Plievier, again, whose naval book *Des Kaiser Kulis* appeared in the winter of 1929–30, was an ex-sailor, an adventurer whose father (so he claimed) had had the gents' lavatory concession in the Busch Circus. His story of the High Seas Fleet accordingly starts with a chapter headed 'Shanghaied!':

> 'Dierck!' And again:
> 'Dierck! Come aloft, quick!'
> The sleeping man shook the hand away from his shoulder, ponderously he rolled over to face the bulkhead. Why couldn't they leave him alone . . . (etc.)

In his biography Harry Wilde, then an actor in an agitprop group, describes how Plievier had first started writing sea stories (collected in *12 Mann und 1 Kapitän*, 1930) around 1928 and been paid a monthly salary by Gustav Kiepenheuer to produce a sea novel. Partly under the influence of the pre-serialization of Remarque's book, partly because

enthusiasm; differing accordingly both from Arnold Zweig's *The Case of Sergeant Grischa* of 1927 (which described no fighting and owed its success partly at least to its humane attitude to a captured Russian) and from the handful of earlier works such as Barbusse's *Le Feu* with its heightened shock effects.

Ludwig Renn's *Krieg*, another widely read book though a less internationally famous one, belonged to the same stable despite obvious differences. Renn, while a Communist and a leading BPRS figure, was at the same time a Saxon aristocrat with an inside knowledge of the German army's standards and traditions, which in a curious way his extreme left-wing uprightness and decency still exemplified. The product of a cramped and difficult upbringing, movingly described in his more personal later books, he here demoted himself to non-commissioned rank and wrote his linked vignettes of an infantry unit's experience not just in short sentences but in short paragraphs and short chapters, adopting the wholly impersonal tone of a field notebook filled under intense pressure and with no concern for smooth transitions or stylistic refinement. There was nothing preconceived in this method, so he told the *Moskauer Rundschau* in 1930:

> I don't work by following a previously established formal plan but concentrate my thoughts on the content as I write. Once the work is complete in draft I try to see what form it has taken and go on to purge that form of foreign elements.

Unpretentiousness in prose writing. *Above*: spread from the catalogue of the Soviet exhibit at the Cologne Pressa Exhibition, 1928, designed by Lissitzky and advocating the encouragement of 'worker-correspondents'. *Left*: the dispassionate novel of action: Erich Maria Remarque's *All Quiet on the Western Front*, 1929

Wilde argued that Zola rather than 'Jack London plus Upton Sinclair' should be his model, he then changed plans, scrapped the dockside bars and whores which the public was thought to want, and told Wilde (who had just come from seeing *October* with Béla Balázs) 'I'm writing the novel of the German navy at war.' Once again sentences and paragraphs are often short, the structure episodic, though a more conscious excitement is created by the use of many exclamations, as the vivid horrors of the Dogger Bank action, the futilities of Kiel, the tragic sentencing of the mutineers of 1917 (to whom the book is dedicated) and the bloody outcome of Jutland are all described from the lower-deck point of view. As with Renn there was no linking thread to this novel; instead Plievier sent Wilde searching for material and told him that the structure would emerge from that. 'He had no intention of writing a précis or establishing a plan of work,' says Wilde; indeed the original heading to the last chapter is said to have been 'Balls to artistic form!' until altered on the proof.

Plievier was too much the old anarchist ever to join the KPD, but the political message of his novel nonetheless led Kiepenheuer to turn it down, leaving Herzfelde's Malik-Verlag to publish it instead; it was also serialized in the Communist daily *Die Rote Fahne*. A sequel followed, much as with Renn, but this time with a greater documentary element and more authentic historical figures: Plievier's aim, he wrote

in a publicity leaflet, being to write a series of social novels which would make him 'the German Zola'. Also published by Malik, this second book bore the lapidary title *Der Kaiser ging, die Generäle blieben* (The Emperor went, the generals remained). The third was to be called *Demokratie*, but only one chapter has survived.

Epic structures and light prose

Novels of revolution, social upheaval and urban pressures. The epic and satirical approaches of Seghers, Kästner, Fallada, Tucholsky and Döblin.

One model for the Communist political novel of this period may have come from the secretary of the IBRL himself, for Béla Illés's *Die Generalprobe* appeared in German in 1929 from the KPD publishing house Internationaler Arbeiter-Verlag. 'Peter Kovacs, a mechanic', says the introductory résumé,

> subsequently a private in the Austro-Hungarian army, goes over to the Reds in 1918. He fights against the Czechs. He fights against the Rumanians. The Red Army is beaten and he flees to Vienna. The whole thing is told simply and without undue emotion. The story of a Hungarian worker. The story of the Hungarian Revolution.

With its two sequels, which likewise oscillate between Hungary, Vienna and Czechoslovakia, this unembellished book with its open, far from happy ending gives a remarkably rich and credible impression of Hungarian revolutionary life in success and failure, never concealing the uncertainties of underground work or the differences inside the party.

Anna Seghers, whose husband László Radványi was one of the Hungarian Communists working in Berlin, seems to have been influenced by it in writing her second novel *Gefährten* (1932), which relates to her later books much more closely than does *Aufstand der Fischer*. Here, in a long procession of sub-chapters whose brevity contrasts with the calm leisureliness of her writing, she switches the story between Hungary, Berlin, Italy, Bulgaria, Ruthenia, Moscow, China, Heidelberg and other places to build up a cumulative picture of the intangible union of so many scattered revolutionaries – workers, academics, an ex-officer, no peasants – in a time of successful and brutal counter-revolution. Much the same epic technique can also be found, handled rather differently, in Ehrenburg's documentary novel *10 HP* about the

French motor industry which Malik published in 1930, though here the alternation of scenes, interspersed with expository sections, satire and real events, was essentially subordinated to reportage. What Seghers could add to this was the imaginative power shown in her first prizewinning book, the ability to bring a whole countryside to life and to create credible people on both sides of the political front. It was only a pity that in *Gefährten* she did not allow herself enough elbow-room to deploy her special gifts.

In August 1929 Ernst Rowohlt the publisher ran into one of his former authors on the isle of Sylt, gave him a job and in effect dragged him back into the literary world. This was Hans Fallada, a man whose disastrous adolescence, in several ways resembling Johannes Becher's, had left him precariously balanced and with a recurring morphine addiction. Working as an administrator on various north German country estates, he had repeatedly swindled the owners and gone to gaol, his last discharge being in 1928. His book *Der junge Goedeschal* which Rowohlt had published nine years earlier was a study of adolescence written in sometimes hectic Expressionist prose. Now however he sat down to write perhaps the most remarkable German novel of the time, a broadly-conceived story of a farmers' revolt in Holstein not far from the Danish border, based on what he had himself witnessed as a reporter for a local paper. The theme is one that has not often been handled but is politically important (in the light both of the Nazi successes and of Soviet collectivization); the knowledge of people and settings (from the aristocratic Schloss to the police barracks) is first hand; the ear for dialogue is brilliant, the narration sober, sometimes comic and always well organized. *Bauern, Bonzen und Bomben* was the publishers' title: farmers, functionaries (SPD functionaries, for the area was part of Prussia) and fireworks, the bombs of right-wing violence. 'The best imaginable political guide to the *fauna Germanica*', wrote Tucholsky in a long review, and he appended a personal appeal to George Grosz: 'Read this. It's your book.'

Perhaps because its author was hardly known, perhaps because in addition to showing up the nationalists and mocking the SPD he remained remote from the Communists, this book was not a tremendous success. What made Fallada's reputation rather was the novel *Kleiner Mann – was nun?* (Little Man – What Now?) which immediately followed – this time actually with a cover drawing by Grosz –

'Best political guide to the *fauna Germanica*'. Gulbrannson's cover to *Farmers, Functionaries and Fireworks*, 1931

and reflected the experience of his first months back in Berlin with a beloved wife and a newborn child. This much lighter, ultimately desperate book describes the cares of a young shop assistant and his proletarian wife in the Germany of 1931. Its strength lies in its simplicity and the acuteness of its social observation (somewhat anticipating that of Christopher Isherwood, who was also a Berlin resident since 1929 if a more disengaged one); its charm in the character of the girl; its weakness in the very notion of the 'little man' and the question-begging that this entailed, together with a tendency to cuteness exemplified (in the original German) in the use of the historic present throughout. It all adds up to an unconscious mixture of realism with a touch of self-

pity, and if this proved to be the perfect recipe for a best-seller the fact says a good deal for the middlebrow standards then prevalent in Germany.

Tucholsky's novel of 1931 *Schloss Gripsholm* was the result of his emigration to Sweden in 1929. It was lighter still, starting like a slightly arch travel article, then moving into two serious themes which twine round each other: his delicately described love for two women at once, and the not unsymbolic suspense story of how they rescue an unhappy child from the rigid German-run children's home near by. Tucholsky would like to have written another *Babbitt*, he once said, but what emerged was something much more individual; it remained his only novel. Nine years younger than he, but similar in style and outlook, Erich Kästner had picked up Tucholsky's term 'Gebrauchslyrik' (on the analogy of Hindemith's Gebrauchsmusik) to describe the neat satirical verses by which he had become known. Then, says his companion Luiselotte Enderle, he was invited by Edith Jacobson, the widow of the former *Weltbühne* editor, to write a children's story for Williams & Co., a Berlin publishing firm with which she was connected. The result was *Emil und die Detektive* which appeared (according to the first edition's imprint) in 1930 and established Kästner as one of the world's chief modern children's authors, and the first such to come from Germany since the alarming *Struwwelpeter* eighty-six years earlier.

Kästner's uniqueness lay in his ability to write extremely simply, in short, enticing sentences; to describe the life of poor families in convincing terms; to address himself always to the children rather than the book-buying parent, yet never to talk down to his young readers, whom he treats as if they are as capable as himself of dealing with real life and complicated moral issues. This power, used with a beautifully-judged mixture of seriousness and humour, seems to have originated in his own happy childhood and the artisan-class circumstances in which he grew up. Much the same virtues are used more sophisticatedly but with comparable freshness in his first novel for adults, *Fabian*, subtitled 'The Story of a Moralist', which appeared the following year. Ethical in a thoroughly unethical Berlin setting, combining cynicism with hope, this subtly-balanced book is full of memorable episodes and juxtapositions – the appalling cabaret of crazed performers, the Nazi and the Communist who have shot one another, the reading of Schopenhauer in a big store where the unemployed Fabian has to fill in time –

Zweitens: Frau Friseuse Tischbein, Emils Mutter

Als Emil fünf Jahre alt war, starb sein Vater, der Herr Klempnermeister
Tischbein. Und seitdem frisiert Emils Mutter. Und onduliert. Und wäscht
Ladenfräuleins und Frauen aus der Nachbarschaft die Köpfe. Außerdem muß
sie kochen, die Wohnung in Ordnung halten, und auch die große Wäsche
besorgt sie ganz allein. Sie hat den Emil sehr lieb und ist froh, daß sie
arbeiten kann und Geld verdienen. Manchmal singt sie lustige Lieder. Manch-
mal ist sie krank, und Emil brät für sie und sich Spiegeleier. Das kann er
nämlich. Beefsteak braten kann er auch. Mit aufgeweichter Semmel und
Zwiebeln.

21

Children's books without condescension. The hero's mother as presented by Kästner and Walter Trier in *Emil and the
Detectives*, the former's matter-of-fact classic of 1930

contributing to a tragedy that is all the more effective for being so contained. This novel seems at once detached and personal, the result perhaps of the device of calling the central figure by his surname throughout; indeed the reader never learns what Fabian's first name is, or if he has one at all.

Again we can apply the test of the opening lines, working backwards and ignoring introductions: first *Fabian*:

> Fabian sat in a café called Spalteholz and read the headlines in the evening paper: British airship explodes above Beauvais, Strychnine stored alongside lentils, Girl of nine jumps from window, Quest for new premier fails again . . . (et seq.)

Tucholsky:

> She had a contralto voice and was called Lydia. The fact was that Charlie and Jake christened any woman involved with one of the three of us 'The Princess', this being a mark of respect to the prince consort in question . . .

Little Man:

> Five minutes past four. Pinneberg has just verified the time. He stands, a neatly dressed, fair-haired young man, in front of No. 24 Rothenbaum-strasse, and waits.

Bauern, Bonzen und Bomben:

> A young man is rushing down Burstah Street. As he goes he directs furious sidelong glances at the windows of the shops that lie crammed together in this, the main street of Altholm.

Seghers (1):

> The revolt of the fishermen of Santa Barbara ended with the fleet's delayed departure on the same terms as for the previous four years. Really the revolt was already finished by the time Hull had been handed over at Port Sebastian and Andreas had died trying to escape between the cliffs.

Seghers (2):

> It was all over.
> The village was surrounded, the exits had been blocked, the air was bitter, hearts hammered.
> It was an August day, the midday heat pressed on the brown and golden plain, the low huts, unseeing and streaked with earth.
> Soviet Hungary was finished.

Illés:

> Peter Kovacs, a Red soldier, was discharged as fit from the Karolyi Hospital where he had been treated for the last five weeks. It was a few minutes after noon when the hospital gate closed behind him.

There were also many other new novelists at this time: Ernst Glaeser with a version of his own war experiences, Erik Reger with his novel of Ruhr industry *Union der festen Hand*, Ernst Ottwalt with *Ruhe und Ordnung* based on his own repudiated past as a nationalist student and industrial trainee. Such authors were now almost typical: middle-class, would-be professional writers with insights into particular aspects of postwar German society, conveying them by means of naturalistic narrative and a fragmented structure. What was original here, and in the work of the worker-correspondents whose first full-length novels now began appearing – Erich Grünberg's *Brennende Ruhr*, Willi Bredel's *Maschinen-*

The Nazi contribution to German literature. Otto Kirchner's *Old Newspaper Reader* studies the party's *Völkischer Beobachter* in the autumn of 1932.

fabrik K & V – was the way the naturalistic camera was used, not so much the technique of naturalism itself. It was an angled, faceted realism, as in photomontage; an edited, rearranged realism, as in the cinema; a selective realism, as in Caspar Neher's stage sets, with their sparse use of authentic materials and solid objects.

This unobtrusive originality of vision, so much a part of the 1920s even though only now extended to the novel, was not entirely appreciated by critics at the time and was largely buried by later events. Perhaps it never caused so much stir as when it was more laboriously applied, with more theoretical palaver and on a more ambitious scale by a recognized older writer who was not only a Socialist but also a member of the Prussian Academy of Arts; for this raised it off the earth to the level on which criticism more commonly moves. The book in question was Alfred Döblin's *Berlin Alexanderplatz,* a panoramic view of that city with its East End underworld, seen vividly but always from above. Appearing in 1929 it was consciously conceived as an 'epic work', and often it has been compared with Joyce, though in fact Döblin only read *Ulysses* when he was already a quarter of the way through the book; thereafter, he said, Joyce was 'wind in my sails'.

Many years later Walter Mehring was to link Döblin's approach with the simultaneity of the Futurists and of Delaunay's prewar paintings; and indeed Döblin as a young contributor to *Der Sturm* before 1914 had been among those who felt the first impact of Futurism in Germany most strongly. So, belatedly, the hands on the clock now coincided, as the direct influence met up with the indirect development of those principles through Dada and montage and the Soviet cinema.

Then they were put back.

'KAMPF' AND ITS ILLUSIONS

20 Weimar crumples: rule by decree, Nazi rise, optimism on the Left

Nazi electoral successes. Government by decree and dissolution of the Socialist-led Prussian government. Failure of the Left parties to combine; their over-confidence and simplification of the conflict; German Communism as a closed world. Vitality of the theatre in face of the new reaction: Piscator, Brecht, the collectives and the newcomers. Talkies and the Left film. Nazi moves against 'cultural Bolshevism' in the Bauhaus and elsewhere; punitive measures against Left writers. Economies in the arts: the campaign against the Kroll-Oper and the demolition of the Prussian arts administration.

'Germany Puts the Clock Back': such was the title chosen by the American journalist Edgar Ansell Mowrer for his account of the steady slide into Nazism that followed Brüning's decision to rely on government by decree. Retrospectively, the collapse of the Weimar democracy seemed inevitable: the credit crisis leading to a record rise in unemployment, the ending of the French occupation of the Rhineland to increased nationalist agitation, the abandonment of parliamentary methods to political irresponsibility,

Gesichter des neuen deutschen Reichstags

Political physiognomy of 1932. A montage by Flachslander (ex-Bauhaus) showing Heinz Neumann, KPD (*top centre*), Goebbels (*two to the right*), Hugenberg (*top right corner*), with the Nazi general von Epp below him, Goering (bemedalled, *centre*), Pieck (*next left*) and Thälmann (*bottom left corner*)

Below, Hitler addresses a Berlin crowd in April. Goebbels is just visible behind him.

and these three factors in turn to a strengthening of the extremist parties against the middle, and so to a further withdrawal of the foreign investor's confidence and an intensification of the original crisis.

The steps taken along this gloomy path were well marked. The Reichstag which Brüning dissolved in the summer of 1930 had been elected in 1928; the new elections in September gave the Socialists 143 seats (a loss of 10), the KPD 77 (a gain of 23) and the Nazis 105 (a gain of 92, representing $5\frac{1}{2}$ million new votes won in two years). Eighteen months later, at the end of April 1932, a new Landtag was elected for the state of Prussia, giving the ruling SPD there 94 seats (a loss of 43), the KPD 57 (a gain of 9) and the Nazis 162 (a gain of 153); thus for the first time the SPD lost its position as the dominant party in the most important province. On 20 July Brüning's Nationalist successor Von Papen forcibly deposed the Socialist Prussian government, thereby destroying the SPD's control of the Berlin police: a crucial point. Another Reichstag election followed at which the SPD lost a further 3 seats, while the KPD gained a further 11 and the Nazis no less than 68, giving them 230 deputies in all as against the 232 of SPD and KPD combined. Finally in November of that year, less than three months before Hitler became chancellor, came the first apparent setback, when the Nazis dropped 2 million votes and were reduced to 196 seats, while the KPD went on gaining and reached 100. The SPD however lost more than the KPD gained, and although the combined Left parties overtook the Nazis this was made up for by the gains of the non-Nazi Right.

During the last two and a half years of the Republic's life, in other words, not only were its liberal institutions largely cleared out of Hitler's way for him, but also something like a third of the electorate decided (quite democratically) to support him, until his was overwhelmingly the strongest single party. Given this situation, plus the fact that nobody – not the trade unions, nor the Prussian police, nor the Socialist Reichsbanner, nor even the KPD and its semi-underground Roter Frontkämpferbund – was prepared to use organized force to resist him, everything else that happened was incidental; the uniforms, the street skirmishes, the brutish behaviour of the new Nazi deputies, and all the rest. The middle-of-the-road parties were squeezed into ineffectiveness while the extreme Right and the extreme Left gathered strength, and of these two it was quite clear which was gathering it quicker.

The only hope of checking this process would have lain in an alliance of the two 'Marxist' parties, that is the SPD and the KPD. But, alas, the enmities of the Noske–Ebert era, confirmed since 1928 by Comintern policy, were stronger than any sense either of common loyalties or of immediate danger. The SPD remained willing to combine with the Nationalists and the Reichswehr against the possibility of a Communist coup, while knuckling under to every threat of force from the Right. The KPD was not sorry to see the Republic's institutions demolished and the SPD's established positions undermined. Hence in the Berlin street demonstrations and beerhouse brawls of 1932 Communists and Nazis were by no means always on opposite sides; to Theodor Plievier indeed, who knew the murdered Nazi hero Horst Wessel and his group, it seemed that at street level the membership and the 'social' slogans of the two parties were largely interchangeable. This is borne out by the left-wing lawyer Alfred Apfel,

who in his recollections quoted Wessel's murderer Ali Höhler – the issue was actually a sordid quarrel over prostitutes' territories, and Höhler got off with a six-year sentence – as saying that

> In our district we didn't take all that political stuff too seriously. One week you're Nazi, the next you're Communist, just as it comes . . .

While as for the reasoning of the Communist leaders, Wilde cites a devastating passage from the KPD theoretical journal *Die Internationale* around the time of Von Papen's Prussian coup:

> A social democratic coalition confronting a confused, divided and far from battle-worthy proletariat would be a thousand times greater evil than a straightforward Fascist dictatorship opposed by a united, class conscious mass proletariat determined to fight.

The only real explanation of the KPD's intransigence towards the Socialists in this increasingly desperate situation is that the former were convinced

Confrontation in the streets. Curt Querner's *Demonstration*, 1930. Part now in East Berlin National Gallery

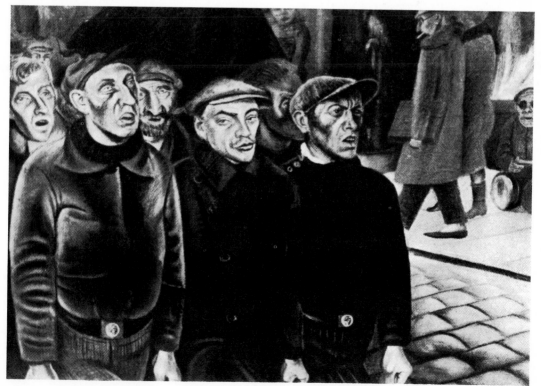

that when such a fight came they would win. In the light of later events their historians have tended to stress those occasions when they tried to collaborate with the SPD and got rebuffed, but the prevalent feeling at the time was certainly one of wholly unjustified optimism. Bourgeois society was crumbling, along with its political institutions and its social, ethical and artistic values, and the crunch was about to come: that *Kampf* to which both extremist parties were so looking forward. Stimulated by their electoral gains at the SPD's expense, prompt to make too much of the Nazis' losses in November 1932, even the most intelligent Communists welcomed the apparent simplification of all issues. Everything was now satisfactorily black-and-white, or rather brown-and-red; everyone had to choose which side he was on; the time for compromise was over. 'Counter-revolutionary forces rallying round the Fascists', was Eugen Varga's prediction for 1931,

> revolutionary forces rallying round the Communists. Every day makes it clearer that a revolutionary situation is developing.

So the polarization of German life, cultural as well as political, had to continue, and all broadly democratic organizations (such as the Volksbühne or the SDS, the Writers' Defence Association) must be penetrated or split, even at the cost of demolishing them.

To some extent the extreme unreality of this attitude, with its deceptive aura of do-or-die militancy, sprang from the old left-wing tendency to underrate the non-urban population, which was where the Nazis had so much of their strength. At the same time it reflects a certain social and cultural isolation which sprang from the KPD's own successes. For the German Communists lived in a world of their own, where the party catered for every interest. Once committed to the movement you not only read the *AIZ* and the party political press: your literary tastes were catered for by the Büchergilde Gutenberg and the Malik-Verlag and corrected by *Die Linkskurve*; your entertainment was provided by Piscator's and other collectives, by the agitprop groups, the Soviet cinema, the Lehrstück and the music of Eisler and Weill; your ideology was formed in Radványi's MASch or Marxist Workers' School (which at the start of 1931 claimed 2400 students); your visual standards by Grosz and Kollwitz and the CIAM; your view of Russia by the IAH. If you were a photographer, you joined a Worker-Photographers' group; if a sportsman, some kind of Workers' Sports Association; whatever your special interests Muenzenberg had a journal for them. You followed the same issues, you lobbied for the same causes. And so all records and recollections of the German Left in this period move the reader at once into a quasi-autonomous sphere, where the notion of a successful battle to take over the vacant political, economic and cultural establishment seems entirely natural.

Pending the arrival of this (as it proved) imaginary Armageddon there was a cultural tug-of-war in which gains were made on both sides. While in many respects the reaction stiffened, further radical progress was made in the cinema and in the Berlin theatre, where some of the most interesting innovations only now took place. With the 'Zeit-theater' (so Piscator suggested at the beginning of 1931) no longer able to keep up with events, a certain return to private, mystical and atmospheric subjects began to make itself felt. That spring, agitprop groups were banned from performing at Berlin political meetings and the police persecution was such that their central leadership dissolved early in 1932; also in 1932 Wolf's publishers rejected his play *Bauer Baetz* on the grounds that there was no chance of its being staged, while the Volksbühne and other theatres turned down Brecht's *St Joan of the Stockyards*, which as a result was never staged in Germany during the author's lifetime.

None the less the Volksbühne could now put on Communist works like Wolf's *Sailors of Cattaro* and Julius Hay's *Haben* which it would scarcely have touched under Neft's regime, while Piscator's old supporters now split off altogether as the Junge Volksbühne, presenting such productions of their own as the revue *Wir sind ja sooo zufrieden* for which Brecht, Eisler, Weill, Ottwalt and others wrote songs and sketches in the autumn of 1931. The Deutsches Theater too, hitherto hardly a politically involved body, produced Zuckmayer's *The Captain of Köpenick* and Horváth's *Tales from the Vienna Woods* that year, and at the end of 1932 helped to establish Hay as the last major left-wing playwright of the period when Karl Heinz Martin staged his *Gott, Kaiser und Bauer* with Kortner, Erwin Kalser and other committed actors. Even the Staatstheater, under Legal's direction, presented Brecht's own production of *Mann ist Mann*, which played for only a few days at the beginning of 1931 but struck Tretiakoff (then on his lecture tour of Germany) as the most remarkable thing he had seen since Meyerhold's *Cocu magnifique*.

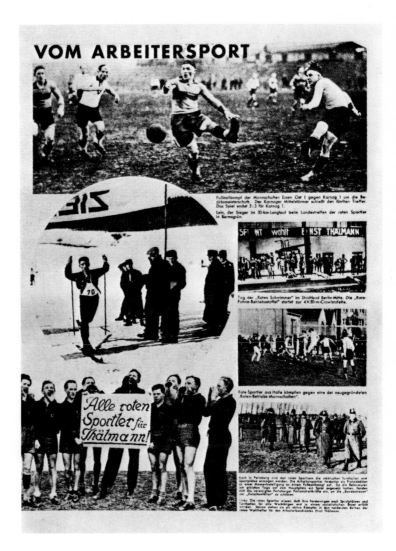

The self-sufficient world of German Communism. A page on 'workers' sport' from the *AIZ* 1932, no.11. Note the vociferous sportsmen at the bottom with placard saying 'All Red Sportsmen for Thälmann!', the KPD presidential candidate.

The swansong of Piscator's theatre was *Tai Yang erwacht*, Wolf's 'counter-play' to *The Chalk Circle*, set in a near-revolutionary modern China and designed by Heartfield, which Piscator's collective presented at the Wallner-Theater in Berlin's East End just before the Staatstheater *Mann ist Mann*. This beautiful-looking production fell between the collective's two productions of modern Soviet plays, at a moment when the KPD critics had at last begun to make approving noises, not least because of Piscator's own relatively subordinate role in the running of the company. In the spring of 1931 he left for the USSR,

leaving his collective to wind itself up as best it could; for the next twenty years he was absent from the German stage. Other collectives still flourished, however, notably the Gruppe Junger Schauspieler under Fritz Genschow, whose various productions of 1931-2 included Kataev's *Squaring the Circle*, another contemporary Soviet play, and Brecht's *The Mother* with Hanns Eisler: that extraordinarily powerful didactic exercise in revolutionary behaviour, framed in a Russian setting but designed to apply to contemporary Germany and to be stageable in halls or political meetings.

Piscator's farewell to Berlin.
Wolf's Chinese revolutionary
play *Tai-yang Wakes Up*,
staged with the Piscator
Collective in a setting by
Heartfield, January 1931

According to Brecht's impresario Aufricht he initially supported this production (which opened at his Theater am Schiffbauerdamm in January 1932) as a way of distracting the playwright from the almost simultaneous Berlin premiere of *Mahagonny*, which had been in some danger of foundering on the disagreements between Brecht and Weill. The fact was that Brecht had developed very rapidly indeed since the summer of 1929, having become concerned primarily with the political–didactic theatre then evolving from the Lehrstück, as well as with the prospective (post-revolutionary) capture of the whole cultural 'apparatus' or Establishment; in late 1932 he was also attending the MASch where Eisler and Heartfield both taught. Most of his work of this time was outside the conventional theatre: first the Communist Lehrstück *Die Massnahme* with Eisler at the end of 1930, which split the workers' choral movement; then songs for Eisler and Ernst Busch to perform at meetings or in a new political cabaret called Die Brücke (with Genschow and others); finally an adaptation of *Measure for Measure* for the Gruppe Junger Schauspieler which was never performed.

Independently of both Brecht and Piscator, moreover, yet another Communist group now came on the scene in the shape of the Truppe 1931, a collective distinct from the now semi-underground agitprop movement and led by the former Reinhardt actor Gustav von Wangenheim. Like Hay's plays and the new revolutionary works by Wolf and Brecht, Wangenheim's *Die Mäusefalle* was a last-minute indication of how the theatre of a Communist Germany might have evolved if these people's optimism had only had solider grounds.

With the establishment of the sound film (sound-on-film, 1930; commercial agreement between Tobis and Western Electric the same year) a comparable left-wing trend briefly affected the cinema. Three films, to start with, reflected the vogue for war plays and novels: the Hollywood *All Quiet on the Western Front*, memorably directed by Lewis Milestone; Pabst's *Westfront 1918*, and the expressly anti-war *Niemandsland* (or *War is Hell*) made by Victor Trivas, with music by Eisler. UFA contributed a film of *Emil and the Detectives* directed by Billy Wilder on a script by Emmerich Pressburger. Pabst's *Kameradschaft*, about the solidarity of French and German mineworkers,

had Lampel as one of its scriptwriters and used actors from Brecht's and Piscator's productions: Alexander Granach, Ernst Busch, Friedrich Gnass. No film of this time however was quite so original, whether structurally or organizationally, as the one authentic Brecht film *Kuhle Wampe*, in which the same team as staged *The Mother* and *Die Massnahme* set out to deal with an even more immediately topical subject, the Berlin unemployed.

This was in more than one way a reaction against Pabst's film of *The Threepenny Opera*, which was shown in February 1931 and for all its merits was not quite the political satire which Brecht had hoped to extract from his stage hit. Partly in order to ensure himself a more effective right of veto, partly because the intended producers Prometheus had been bankrupted by the crisis and their successors Praesens were short of money, he and his colleagues – Dudow as director, Eisler as composer, Ottwalt as joint scriptwriter, George Hoellering as producer etc. – formed themselves into a production collective. They had come more and more, said Brecht, 'to treat

The ultimate political film. *Kuhle Wampe*, 1932, by Brecht, Dudow, Eisler and Ottwalt, here showing a performance by the 'Red Megaphone' agitprop group before a Berlin crowd

organization as a major element of our artistic work. This was only possible because the work as a whole was political.'

It is indeed a key film, since it not only reflects Brecht's thinking about the 'apparatus' of the arts but also, thanks to the political like-mindedness of all the participants (including the workers' sports organizations, the actors from the Gruppe Junger Schauspieler and Vallentin's 'Das rote Sprachrohr' agitprop group), issues unmistakably from within the inbred world of German Communism. Add to this Eisler's music – so unlike the glutinous scores of commercial cinema – the episodic, deliberately chopped-up construction, the unconventional placing of the moments of intensity, finally the new function of the songs; and you get a form of work that was never to be followed up but remains suggestive even today.

It was taken for granted that such films would fall foul of the censorship, and *Kuhle Wampe* was no exception. None the less it was finally released in the spring of 1932, whereas *All Quiet on the Western Front* eighteen months earlier had been banned after its Berlin premiere on the grounds that it was injurious to German prestige. There were three threads in this increasing cultural reaction: fear of Communist propaganda, economic retrenchment and (as in the latter film's case) specific cases of agitation or pressurizing by the Nazis. This last was what helped to block Milestone's film, whose Berlin premiere at the end of 1930 was disrupted by Goebbels' followers unleashing a number of white mice in the auditorium. Nazis also broke up the Frankfurt production of *Mahagonny*, using stink-bombs, and secured the dismissal of the Zwickau museum director Hildebrand Gurlitt whom they accused of 'furthering the dissolution of our *Volkstum*' – a characteristically club-footed term for national identity – by exhibiting Kollwitz, Barlach, Klee, Grosz, Chagall and other 'bolshevist' artists, an offence no doubt aggravated by the fact that Zwickau was near the Czech frontier.

Another particular target of the Nazis was as always the Bauhaus, where Meyer was replaced that summer by the stricter and politically more neutral Mies van der Rohe. So far as Nazi hostility was concerned this altered nothing, for Mies was still aesthetically beyond the pale, for all his élitism, and although the party's gains in the Dessau local election of November 1931 were not yet enough to get the school closed this could be done as soon as they had captured the Anhalt provincial government the

following spring. The crucial vote at Dessau took place in August 1932, when only the four KPD councillors and the mayor voted for the Bauhaus's continuation, the SPD for some reason abstaining. Rather than close down altogether, the school, which under Mies had become still further orientated towards architecture, then moved to a former factory building in Berlin, where it reopened briefly as an unsubsidized private establishment before being finally shut down for good and all by the Nazis in 1933.

Though Mies and even Gropius seem to have hoped that some kind of last-minute compromise might still be possible the reputation of the Bauhaus as a stronghold of 'art bolshevism' had been decided at least ten years earlier, so that in retrospect it is doubtful whether the increased social and political commitment of the Meyer era did anything to shorten its life. The mistake was, and sometimes still is, to treat the Nazis' attitude to such matters as in any sense rational. To them, on the contrary, any form of association with the SPD or the November Revolution was 'Marxist', just as any innovatory ideas in the arts fell under the heading of Art- or Cultural-'Bolshevism', quite irrespective of the real cultural–political alignments suggested by such terms.

As before, the bias of the judiciary was partly to blame for the repressive measures now taken against individual writers and artists. True enough, the long drawn-out *Hintergrund* blasphemy case brought against Grosz and Wieland Herzfelde finished at the end of 1930 with both men's acquittal, while *Kuhle Wampe* finally got past the censorship after its initial rejection. But generally there was a new wave of arrests in support not merely of political stability but of every kind of established value. Wolf, for instance, was gaoled for a week in February 1931 for offences against the abortion law, then released with the possibility of a ten-year sentence hanging over him. Renn was arrested in November 1932 when teaching at the MASch, charged with 'literary high treason' like Becher before him, and kept in prison for some two months. Piscator, who might never have been bankrupted if he had been granted the same entertainment tax exemption as was allowed to other 'quality' theatres, was gaoled briefly as a debtor at the beginning of 1931 – an experience that surely helped to influence him to leave the country.

At the end of the same year Carl von Ossietzky, an independent-minded liberal pacifist of considerable

Haussuchung im „Bauhaus Steglitz"

Kommunistisches Material gefunden.

Auf Veranlassung der Dessauer Staatsanwalt-
schaft wurde gestern nachmittag eine größere Ak-
tion im „Bauhaus Steglitz", dem früheren
Dessauer Bauhaus, in der Birkbuschstraße in Steg-
litz durchgeführt. Von einem Aufgebot Schutz-

war jedoch verschwunden, und man vermutete,
daß sie von der Bauhausleitung mit nach Ber-
lin genommen worden waren. Die Dessauer
Staatsanwaltschaft setzte sich jetzt mit der Berliner
Polizei in Verbindung und bat um Durch-

Alle Anwesenden, die sich nicht ausweisen konnten, wurden zur Feststellung ihrer Personalien ins
Polizeipräsidium gebracht.

polizei und Hilfspolizisten wurde das Grundstück
besetzt und systematisch durchsucht. Mehrere
Kisten mit illegalen Druckschriften wurden be-
schlagnahmt. Die Aktion stand unter Leitung von
Polizeimajor Schmahel.

Das „Bauhaus Dessau" war vor etwa Jahres-
frist nach Berlin übergesiedelt. Damals waren
bereits von der Dessauer Polizei zahlreiche ver-
botene Schriften beschlagnahmt worden.
Ein Teil der von der Polizei versiegelten Kisten

suchung des Gebäudes. Das Bauhaus, das
früher unter Leitung von Professor Gropius
stand, der sich jetzt in Rußland aufhält, hat in
einer leerstehenden Fabrikbaracke in der Birkbusch-
straße in Steglitz Quartier genommen. Der augen-
blickliche Leiter hat es aber vor wenigen Tagen
vorgezogen, nach Paris überzusiedeln. Bei
der gestrigen Haussuchung wurde zahlreiches
illegales Propagandamaterial der
KPD. gefunden und beschlagnahmt.

Last days of the Bauhaus. Report of a police raid on its makeshift Berlin premises alleging that 'a lot of illegal KPD propaganda material was found and confiscated'

toughness and obstinacy who had become editor of the *Weltbühne* five years earlier (seemingly on Tucholsky's renouncing the job), was given an eighteen months' gaol sentence for revealing secret Reichswehr subsidies to the Lufthansa, which was supposed to be a civilian concern. His friend Gumbel, the generally reliable cataloguer of political murders prior to 1924, was forbidden to teach; Erich Weinert the poet was repeatedly prevented from reading his political satires in the autumn of 1931, when he was also unsuccessfully prosecuted for the subversiveness of his gramophone records; Willi Bredel the Hamburg 'worker-correspondent' was gaoled for two

years in 1930, emerging in early 1932. Starting in the autumn of 1929 a wave of such arrests led to the gaoling of some fifty Communist journalists in the ensuing twelve months, while by 1932 both Bredel and Becher were complaining of difficulty in getting their books published.

Against that, a new cheap series called the Rote Eine-Mark Roman – Red novels for one mark apiece – was started in 1931 with Hans Marchwitza's Ruhr novels *Sturm auf Essen* and *Schlacht vor Kohle*, but the former was already banned by that August, and if the series managed to get at all established before 1933 it was only within the enclosed Communist world.

Repression before Hitler. Spread from the *AIZ* 1931, no.1, showing the sixty-five 'worker-journalists' sentenced during 1929–30. Among these are Willi Bredel (*five from left in the second row*) and Fritz Hampel, or 'Slang' (*two from left in the bottom row*).

The economy measures continued. Thus the Folkwang art school at Essen was closed in 1931, when its teachers were dismissed; and thereafter, of the various Prussian state academies, only those in Düsseldorf (where Klee taught) and Berlin were kept going, the ones at Breslau (with Oskar Moll and Schlemmer), Königsberg and Cassel being shut down. Max Burchartz at Essen lost his job; Schlemmer had to take a salary cut before becoming likewise unemployed. The Kroll-Oper's fate too was already effectively decided in the autumn of 1930, when the Prussian budget made no provision for it; it came to an end accordingly in July 1931. This occurred well before the Nazi contingent in the Prussian Landtag had become at all significant, and at first the arguments used were relatively rational ones.

It was calculated that the total receipts of all the state theatres had gone down by 679,556 Marks while their expenditure rose by 504,900 Marks. This added up to an unexpected deficit of 1.2 million Marks, which could be neatly enough covered by saving the 1.8 million Marks paid as subsidy to the Kroll. Though it may well be true that the Land finance minister Höpker-Aschoff found Klemperer personally antipathetic, the crucial factor here was the attitude of the Volksbühne, which had a right to insist on the Kroll's continuation if it wished, thanks to its contractual claim to a large number of guaranteed seats. This right was not exercised, and instead the organization chose to be paid off at the rate of 100,000 Marks a year. One motive for the Volksbühne was clearly its own financial problems,

Worker–writers find a last outlet. The 'Red One-Mark Novel' series inaugurated in 1931

given by the Kroll to modern music – actually all the Hindemith, Stravinsky and Schönberg performances rolled together amounted to less than those of one single popular opera such as *Freischütz* or *Carmen* – and in so doing played into the hands of the real cultural reaction. The effect could be seen in the views of a Nationalist Landtag member called Koch, who (to applause from the Nazis) complained of the Kroll's 'moderner Sachlichkeit' and the 'Nigger culture' of Křenek's *Jonny spielt auf* – which the Kroll had never performed, but no matter – as symptomatic of the growing 'substitution of Jewish pessimism for Christian–German culture'.

Such people could only have been delighted when the Volksbühne succeeded in having Hindemith's *Neues vom Tage* removed from the repertoire, or when in the winter of 1930–31 the Foreign Ministry had the premiere of Janáček's *From the House of the Dead* postponed in retaliation for some Czech demonstrations against German films. For there was a campaign against Klemperer and the Kroll, just as there were campaigns against Piscator and the Bauhaus, and it was unfortunate that Socialists should have supported it, whatever their motive. During the autumn of 1930 many eminent figures including Stravinsky and Thomas Mann spoke up on the other side, calling for the Kroll's continuation, but even by the most optimistic count its position was precarious, and a production of *Mahagonny* might well have proved the last straw. Not surprisingly this opera was rejected, despite Klemperer's advocacy of Weill's music: to be done eventually by Aufricht's commercial management under Alexander Zemlinsky, now the Kroll's number two conductor. By then the Kroll had anyway been shut, leaving Klemperer himself in the position of a reluctant and unwanted recruit to the staff of the State Opera.

And yet the Kroll's final season, when Hans Curjel had taken over from Legal as director of productions, was quite outstanding. The works themselves were not all that radical, Hindemith's short 'film sketch' *Hin und Zurück*, with its reversing of music and action alike after a farcical–dramatic climax, being the principal innovation apart from the Janáček; but both visually and in terms of direction there was evidence of a lively fresh approach. The young directing–designing team of A. M. Rabenalt and Wilhelm Reinking updated the *Barber*; Gustav Gründgens, previously known only as a highly promising actor, staged *Figaro*; Moholy-Nagy set *Madam Butterfly* in a mixture of constructivism and

due not least to its declining membership, which according to Hans Curjel had fallen to little more than one-third of its 1923 figure of 140–150,000. At the same time however there was a clear lack of sympathy with the Kroll's innovatory policies.

For there had never been much liaison between the two bodies, and as a result the Volksbühne felt that its role as provider of nearly half the audience was badly neglected. The members, said its secretary Siegfried Nestriepke, suspected that they were being fobbed off with inferior performances and resented the new works; thus there had been 102 letters of complaint about Stravinsky's *Oedipus Rex*, all of which he had passed on to the Kroll. Careful as Nestriepke was however to say that he was merely representing the tastes of his members, he much exaggerated the place

A masterpiece of the Kroll-Oper's final season. Moholy-Nagy's set for *Madam Butterfly*, with the Czech soprano Jarmila Novotna, photographed by Lucia Moholy

photo-naturalism; Karl Kraus adapted Offenbach's *Périchole*, whose cast included such Piscator actors as Leo Reuss and Friedrich Gnass as well as Irene Eisinger, Else Ruziczka and other well-known singers. Natalia Satz of the Moscow Children's Theatre was brought in to direct *Falstaff*, while Caspar Neher designed some of his finest sets for *From the House of the Dead*, directed by Curjel himself. All the surviving evidence suggests that in such ways the Kroll at the end of its career was generating opera productions which would appear modern even by today's standards.

But the battle had already been lost, and with Von Papen's accession to the chancellorship it could be seen that it was much more than a merely economic one. For as Rudolf Olden subsequently pointed out, the real death-blow to German democracy was neither Hitler's rise to power nor even the Reichstag Fire of March 1933, but the dissolution of the Prussian government the previous July; and this was true on the artistic as well as the political plane. Not only the police were taken over; following his announced programme of combating cultural bolshevism, Papen also abolished the cultural department of the Prussian Education Ministry, sacking both Seelig (in charge of theatre) and Kestenberg (music), and thus effectively neutralizing the whole structure of arts administration set up by the November Revolution. So the way was prepared for Hitler as the SPD tamely gave up.

For the Communists of course this merely proved their 'either–or' point of view: no compromise was possible, and like Mies's apolitical regime at the Bauhaus the concessions made by people like Kestenberg himself (who conspicuously failed to intervene in favour of the Kroll-Oper in 1930) and the Kroll management (who rejected *Mahagonny*) did nothing to save the day. At the same time the Kroll's late blooming might perhaps have warned them how deceptively stimulating even the most desperate conflict can be. In the excitement of the struggle the real balance of forces too easily got overlooked.

Changes in German–Russian relations. The Moscow international organizations and the role of Muenzenberg's Mezhrabpom-Film; its relevance to the growing exodus of German writers, actors and directors. The Kharkhov writers' congress and its foreign repercussions. Establishment of MORT; liaison roles of Wolf, Tretiakoff and Koltsov. Arrival in Russia of May, Taut and other architects; Russia as a hopeful alternative home. New Stalinist policy for a uniform culture based on Socialist Realism and the discouragement of formalism. Adoption of this line by *Die Linkskurve* with its campaign against reportage, montage and epic narrative forms. Triumph of the Nazis and total suppression of the modern movement.

Seen from outside the state of the Republic from 1929 on was worrying. Egged on by the Stahlhelm and other Nationalist groupings, the Brüning government largely abandoned Stresemann's conciliatory approach to both West and East in favour of a scheme of customs union with Austria (as first step to an *Anschluss*) and a greater concern with the situation of German minorities abroad. From this point onwards the Russians seem to have lost their old instinct to align themselves with Germany, ceasing to view her any longer as a fellow-outcast from the European community, instead growing suspicious of her 'imperialist' motives (as seen for instance in her support of those German-speaking peasants who resisted Stalin's collectivization measures). If Briand's loss of the French premiership in the spring of 1931 reflected in some degree the failure of that country's conciliation policy, Litvinoff's appointment as Soviet Foreign Minister expressed the USSR's mistrust of Germany and consequent need to improve relations with Britain and France.

It is true that the military links between the Reichswehr and the Red Army continued, so that while both Brüning and Papen were seen in Russia as incorrigibly anti-Soviet the latter's war minister and short-lived successor General Schleicher offered some hope of a change. The German industrialists, moreover, gained confidence in the Five-Year Plan and found they could alleviate their own crisis by selling more to Russia, thereby doubling their exports to that country between 1929 and 1931, and

in 1932 providing just under half of all Soviet imports. None the less there was certainly a marked change in the Russian attitude to relations with Germany, which while in some ways becoming intensified were now much more exclusively concentrated on the KPD and its supporters. And this was above all true in the cultural–political field.

The picture which emerges from the still fragmentary evidence about this period – memoirs, periodicals from within the closed communist world – is of a great increase in German–Soviet exchanges and a sharing of artistic ideas, works and resources such as had not been seen since 1922. Partly this was due to the growing power of Muenzenberg's IAH, with its film companies, its agitprop group Kolonne Links and its stable of German publications: the weekly *AIZ* (with a circulation at one time of around half a million), *Welt am Abend* and *Berlin am Mittag* (both daily), the satirical *Eulenspiegel*, *Der Rote Aufbau*, *Der Weg der Frau* and so on; there were even two makes of cigarette with progressive names and cards portraying international communist leaders. This unique body, enjoying a semi-independent status under the Comintern, operated in both Germany and the USSR and certainly saw its overriding aim as the furthering of good relations particularly among artists and intellectuals sympathetic to communism; unlike the more orthodox Society of Friends of the New Russia

Socialism walks to the cemetery. SPD leaders following the hearse of Hermann Müller, their last national premier, in March 1931

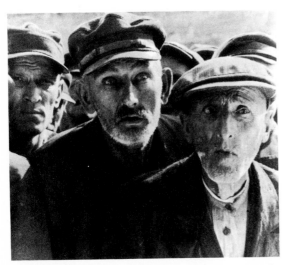

Cultural traffic on the Left. Still from Pudovkin's *The Deserter* for Mezhrabpom-Film

or that society's parent body VOKS in Moscow it could offer them jobs in the USSR as well as mere trips.

At the same time the growth of the Soviet 'proletarian' cultural groupings, whatever its effect within Russia itself, helped to strengthen Soviet internationalism, if only within the somewhat narrow confines of the politico-cultural requirements for which they stood. For it was they who gave birth not only to the IBRL administered by Illés but also to the corresponding International Bureau of Revolutionary Artists (in which Alfred Kurella and the Hungarian Béla Uitz were prominent) and the IATB or International Association of Workers' Theatres run initially by Heinrich Diamant and later by Piscator and Arthur Pieck; this in turn spawned an International Music Bureau in which Hanns Eisler was active. Based in Moscow and outlasting the 'proletarian' movement itself, these new secretariats were important both in the immediate context of Soviet–German interchange and in that of the international 'anti-fascist' culture that followed. Fortuitously or not, they seem to have operated in much the same sense as the IAH, broadening out notably once they had substituted 'revolutionary' for 'proletarian' in their titles: a significant symbolic gesture.

In the spring of 1931 Pudovkin was in Hamburg for Mezhrabpom-Film, making *The Deserter* on the theme of the 1923 rising in that city. But most of the Mezhrabpom (IAH) traffic was the other way, and this makes it look as if Muenzenberg had the twofold aim of helping to tide the Left German cinema over the reaction and at the same time sheltering the more vulnerable individuals by giving them temporary work in the USSR. Piscator for instance arrived in Moscow that April to direct a film which initially looked like being either Plievier's *Des Kaisers Kulis* or his own dramatization of *An American Tragedy* but finally materialized as *The Revolt of the Fishermen of Santa Barbara*, based on Anna Seghers's book; with him came his former business manager Otto Katz, who was even more threatened by the tax authorities, and who was now given a job at the IAH's Moscow headquarters. Hanns Eisler came to write the music for Joris Ivens's film *Song about Heroes*, about the building of the new city of Magnitogorsk, on a script by Tretiakoff. Jutzi and Balázs came as directors of *Tisza Burns*, a film about the Hungarian Revolution, on a story by Illés. Hans Richter too was invited as an 'experimenter', and arrived the following year to work on a film for Prometheus called *Metall* with Pera Attasheva as co-author of the script. He was well viewed at that time by the KPD thanks to his chairmanship of the League for Independent Film, and was living with the communist actress Margaret Melzer.

With such people came a number of actors, Paul Wegener, Leo Reuss, Lotte Lenya, in addition to the Kolonne Links members and Carola Neher, the poet Klabund's widow, who had married a Soviet engineer called Becker. This was at a time when other foreigners were working in Soviet films or studying at the Film Academy (like Jay Leyda and Herbert Marshall); thus Mezhrabpom itself had brought Langston Hughes and some forty black actors from the US to make a film which was never realized. But the German contingent were far and away the most numerous, and with Hitler's advent to power it seemed natural enough that they should accommodate a further wave of political refugees.

Though two of the Moscow international secretariats – that for theatre and that for writers – had already been established, it was only with the arrival of the 1930s that such organizations became at all effective. The main event here was the IBRL's second conference at Kharkov in November 1930, with Leopold Averbakh of the RAPP as the chief speaker. This was attended by 100 delegates from 23 different

countries, with the German BPRS team led by
Becher, Renn, Seghers, Marchwitza and the Moscow-
based Alfred Kurella as the strongest single group.
The meeting's chief practical achievement was to re-
form itself as the MORP or International Organi-
zation of Revolutionary Writers, Becher being the
only committee member appointed from outside the
USSR. At the same time it set up the journal
International Literature (in a number of different
editions of which the German was much the most
important), and arranged for the invitation of further
writers to visit Russia, including Wolf and the young
Arthur Koestler, historically a not unimportant step.
Among its theoretical conclusions was a certain
amount of criticism of the 'Left' element in the BPRS.

But what was much less predictable, or indeed
logical, was its implications for the arts in France.
For, faced apparently with a shortage of French
delegates, the secretariat had invited two surrealists,

Aragon and Sadoul, who happened to be in Russia
visiting Lili Brik, sister of the former's life compan-
ion Elsa Triolet. In a kind of euphoria this pair
somehow got the conference to condemn Barbusse's
Monde as anti-proletarian, to extend a qualified
welcome to Surrealism as 'une réaction des jeunes
générations d'intellectuels de l'élite petit-bourgeoise,
provoquée par les contradictions du capitalisme', and
even to approve Breton's dismissal of Artaud,
Desnos and other sinners. More seriously it approved
the scheme for a broad Association des Artistes et
Ecrivains Révolutionnaires or AEAR which Breton
and André Thirion (perhaps the one practical
communist in the surrealist group) had proposed and
which was eventually to turn out very different from
the Russian and German 'proletarian' organizations.

Unfortunately Aragon made something worse
than a fool of himself by publicly applauding
'l'oeuvre admirable de salubrité publique faite par la

German 'proletarian' writers at the Kharkov
conference, 1930. *Left*, in uniform, Ludwig
Renn. *Right of him*, Anna Seghers. *Behind her*,
Ernst Glaeser and F. C. Weiskopf

Guépéou', and calling for the shooting of 'saboteurs', then writing the atrocious poem 'Front Rouge' (which he later disowned) with its bloodthirsty threats against social-democracy. The result of this somewhat manic episode was still further to complicate the Surrealists' relations with the French Communist Party, who thereafter accepted Aragon as a comrade while reprimanding Thirion for having recruited him in the first place. For Breton could hardly in decency expel Aragon so long as he was threatened with prosecution for 'Front Rouge' – something that had grown into a slightly factitious public issue. Only when this had blown over could Breton cut him off as an 'opportunist', thus allowing Surrealism in future to identify itself with Trotsky's views in opposition to the official party line. Once the new AEAR was finally set up in March 1932 the Surrealists were accordingly left outside it.

The International Association of Workers' Theatres blossomed into MORT, a grouping of Revolutionary Theatres to match the Revolutionary Writers, at its second conference in November 1932, when Piscator, Wolf, Wangenheim and the French delegate Léon Moussinac were elected to the presidium. A year later it held an 'Olympiad' in Moscow at which groups from nine countries performed, including Kolonne Links. Two German playwrights developed particularly close relationships with their Soviet opposite numbers at this time. To start with, in 1931 Wolf was invited for a first visit, apparently on the initiative of the Soviet doctors (though he also had an invitation from Illés and a commission to write a script for Mezhrabpom). Not long after, he made contact with the Russian playwright Vsevolod Vishnevsky, an ex-sailor who wished to translate *The Sailors of Cattaro* for the Proletkult Theatre; Wolf thereafter translated Vishnevsky's own naval revolutionary play *The Optimistic Tragedy*, and a lifelong friendship ensued (Wolf being almost unique among German Communist visitors in that he made a real effort to understand Russians and to master their language).

Welcome in Moscow. Dudow (*left*) and Brecht (*right centre*) arriving for the world premiere of *Kuhle Wampe* in 1932, to be greeted by, among others, Piscator and Reich (*left* and *right* behind Brecht) and Tretiakoff (the tall bald man)

Then in 1932 Brecht too came to Moscow for the world premiere of *Kuhle Wampe*, and renewed his alliance with Tretiakoff, whose *Roar, China!* he had admired not least because of his own interest in Far Eastern writing and thought, and whom he had met personally during the Russian's lecture tour the previous year. This too had important effects, Brecht helping to adapt *I Want a Child*, while Tretiakoff edited the first Russian translation of Brecht's political plays (*Epic Dramas*, 1934): a very different proposition from *The Threepenny Opera* which was then running in Moscow at Tairoff's theatre. From then on Tretiakoff was among the handful of people whom Brecht acknowledged as his teachers, and his familiarity with the ideas of the *LEF* group played a crucial part in the evolution of Brecht's theories.

Not that this was Tretiakoff's only contribution to German–Soviet relations at this time, for in the book which he wrote after his German lecture tour he also discussed such figures as Heartfield, Piscator, Eisler and Wolf, whom he presented along with Brecht as *People of the Same Bonfire* and did his best to help promote in the USSR. For a while he was in a position to do this as international secretary of the new Writers' Union, where doubtless he furthered the visits of Heartfield (who came in 1931 on the invitation of *USSR in Construction*, held an exhibition of his work and stayed a year) and the singer Ernst Busch. Mikhail Koltsov was another who became something of a nodal figure, thanks to his association with Herzfelde's aide Maria Gresshöhner, otherwise known as Maria Osten. He was then a leading writer for *Pravda*, later to become internationally known as that paper's representative in republican Spain.

Though there were many other German visitors around this time, ranging from Herbert Ihering (who reported on the Moscow theatres) to Herwarth Walden and Heinrich Vogeler (who settled for good), the most influential were perhaps the architects. These were invited in effect as technicians with a definite job under the Five-Year Plan, though it is still not clear what Soviet agency was responsible.

The Soviet avant-garde hangs on. Lissitzky photographing the Dneproges hydroelectric scheme for *USSR in Construction*, the Five-Year-Plan magazine for foreigners

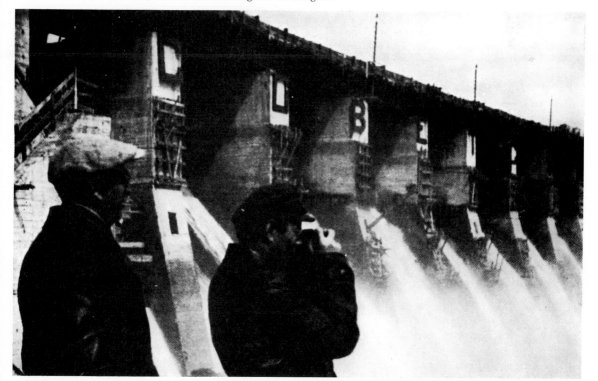

Return of the prodigal. Eisenstein arrives back from Mexico and the US in May 1932.

The first to come appears to have been Ernst May, who arrived in 1930 with a team of twenty-two for the planning of Magnitogorsk, a brand new industrial city in the Urals; his group included Mart Stam, Grete Schütte-Lihotzky, Hans Schmidt from Switzerland and the former Bauhaus pupil Gustav Hassenpflug; and some of its members stayed the full three years. Hinnerk Scheper of the Bauhaus staff similarly took a prolonged sabbatical in the USSR, where he headed a board advising on the use of colour in buildings. The Hungarian Fred Forbat was on another town-planning team.

Hannes Meyer too, besides his teaching job at WASI, was involved in planning, and with about half a dozen former Bauhaus students constituted a 'Bauhaus Brigade' which was considerably less well paid than May's team. Gropius himself designed a scheme for the theatre at Kharkov, though this was never accepted, while Bruno Taut, as one of the most politically committed of the German modernists, shifted his whole practice to Moscow during 1931. All this can be seen on the one hand as a reflection of the Soviet concern with the new architecture which had already led to the commissioning of Le Corbusier's Centrosoyuz building, and on the other as the result of a particular shortage of planning skills,

a field in which the Germans had shown themselves pre-eminent. A further factor was of course the shortage of jobs for architects since 1929 in Germany itself; according to May no less than 1400 had applied to join him.

The picture, then, in these last three years of the dying Republic is of a big socially-engaged section of the modern movement finding an alternative footing in Russia to help it through what was expected to be one last interval of reaction. This, perhaps, is what gave such people some of their confidence in the coming revolution, for their Nazi opponents had no such moral and practical support from beyond the border. Admittedly this support was only available to artists who were prepared to apply their ideas and talents to wider purposes, whether as a contribution to the social conflict then raging or as part of the general process of improving the conditions of the workers; but then a great many of the most advanced German creative artists wished anyway to do this and were keen to find new social–artistic methods. To men like Piscator, Brecht, May and Eisler, all of whom were in their ways important innovators still apparently at the height of their powers, the Soviet context, despite its foreignness, its unfamiliar language and its material drawbacks, was one in which their kind of work could be carried on; and the same feeling surely held good for many others who never personally experienced it but merely read the laudatory accounts in the Communist press.

Despite the misgivings of architects like Gropius, who saw a reaction coming, and whatever the disquieting aspects of the RAPP leaders' attacks on artists who stood outside its own orbit, there were still outstanding avant-gardists at work in the USSR: not only Meyerhold and the great film makers but Lissitzky, Tatlin (then obsessed with his glider, but teaching at WASI and designing stage sets), Malevich (one-man exhibition at the Tretiakoff Gallery in 1929), Ginzburg (then chief planner for the Crimea), Shklovsky (developing into a prolific writer of film scripts) and Tretiakoff. Prokofieff was on the point of returning there, while Shostakovitch's opera *Lady Macbeth of Mtensk* and other works seemed symptomatic of a new wave of talents among whom the excellent humorists Ilf and Petrov made a strong impression on the German Left.

Though it was not immediately clear quite how misleading this reading of the situation was, a number of decisive steps against all avant-garde art, however politically committed, were being taken

during 1932. Stimulated by Gorki, who was evidently struck on his return to Russia by the harm done to older writers by the militant 'proletarians', the Central Committee in April dissolved all existing art organizations in order to set up new all-embracing Unions, of which the Union of Soviet Writers was the most important. The preparatory committee of this body first met at the end of October, only three months before Hitler became German chancellor, and proclaimed a new guiding doctrine, that of Socialist Realism, which was soon to dominate all the Soviet arts. Behind this harmlessly vague-sounding principle lay the views of Stalin himself, who wanted an art that would be 'national in form and socialist in content' and at an informal preliminary meeting in Gorki's flat told the assembled writers that they were 'engineers of souls'. Exactly what Socialist Realism was really intended to mean only emerged by implication, but already it was clear that the dissolution of RAPP and its stablemates was not going to lead to any abandonment of the new practice of arbitrary intervention in aesthetic matters.

As for the direction in which such intervention would now go, it could be inferred from such measures as the subordination of TRAM that year to the Moscow Art Theatre, the charges of 'formalism' brought against Meyerhold by the Repertory Commission, the more critical labelling of exhibits in the Museum of Modern Western Art, and above all by the results of the architectural competition for a new Palace of the Soviets, in which Le Corbusier's and other international entries were spurned in favour of an unbelievably retrograde piece of wedding-cake design, topped by a vast figure of Lenin. Fortunately this monstrosity was never built, but it remained an unmistakable statement of aesthetic intention, comparable in its way with the Palais des Nations scandal. The Western architectural world took it as such; the CIAM abandoned its intention to hold its 1932 congress in Moscow; and for the next quarter of a century Russian architecture went its own ornament-encrusted way.

This change of line had been to some extent more generally anticipated in German communist circles by the editors of *Die Linkskurve*, who had been backing away from the 'proletarian–revolutionary' position ever since the middle of 1930. The crucial event here was the arrival a year later of Georg Lukács from Moscow, where he had been working in the Marx–Engels institute and contributing occasional criticisms to the German-language *Moskauer*

Rundschau. From November 1931 up to the *Linkskurve*'s death at the end of 1932 this immensely erudite and assured former commissar put forward the ideal of a return to the 'bourgeois cultural heritage' of conventional literary forms as demonstrated by Balzac, Tolstoy and the other great nineteenth-century realists. Following the same magazine's earlier criticisms of Piscator and agitprop, Lukács now launched an assault with Becher and Gábor against 'open', epic forms and the unintegrated use of real-life material. His main target here was ostensibly Ernst Ottwalt, whose second novel *Denn sie wissen was sie tun* about the German judiciary was largely reportage. But it was clear that he was also criticizing the more important figures of Tretiakoff (whose influence on German writers was described by Becher as pernicious) and Brecht.

Nor was Bredel spared, though the sharp reaction by his fellow-proletarian Otto Gotsche seems to have decided Lukács to concentrate thereafter on those of more bourgeois origin. What Lukács categorically rejected, without making too much attempt to understand it or hesitating to use such pejorative terms as 'decadence', 'Machism' and even 'Trotskyism', was any form of montage or 'factography' or deliberate revealing of the structure of a work. Strictly speaking the practices to which he so objected were not so much a departure from convention as such – since the Far Eastern models favoured by Tretiakoff and Brecht positively encouraged them – as a breakaway from the main Western heritage, that 'great tradition' which led from Aristotle through the Renaissance to the orthodox bourgeois novel and drama. But all non-European influences were anathema to Lukács, and he took the new Soviet Realist line as an additional reason to condemn them.

At the end of each year Muenzenberg's *Welt am Abend* used to ask its friends to name their outstanding experience during the previous twelve months. Looking back over 1930 Ihering picked Brecht's *Die Massnahme* and the closing scenes of *Des Kaisers Kulis* (in Piscator's adaptation) as likely one day to be seen as 'precursors of a new kind of classical writing'. Similarly a year later his old rival Alfred Kerr saw the main characteristic of 1931 as the German Republic's passive attitude to the mortally dangerous *kitsch* movement represented by Hitlerism. Far better than the professed cultural politicians of the Left these two theatre critics saw the real parameters of this last period. New forms were still being created, but *kitsch*

was on its way in, and the changing attitude of the Soviet establishment, by undermining the former, made the latter just that much harder to block.

Admittedly there was a two months' respite at the end of 1932, following the Nazis' electoral setback, when Papen could no longer hold his cabinet together and Schleicher took charge. Although Schleicher had helped Papen to overthrow the Prussian government he was a far more serious character, an opponent of Hitler who at this late juncture not only proposed a measure of agrarian reform but also tried to win SPD support. An amnesty law was even passed under which both Renn and Ossietzky were released. But Schleicher always underrated Papen's slipperiness, as well as his mysterious hold over the 85-year-old Hindenburg, and unfortunately he was not empowered to call the new elections which might have cut the Nazis down to size.

With Hitler's brown-shirted SA running riot in the provinces much as the Freikorps had once done, and a Reichstag already presided over by Hermann Goering, Papen and Hugenberg were soon able to swing the Nationalists against Schleicher and per-

suade Hindenburg to bring them back to power with Hitler as Chancellor. Formed on 30 January 1933, their new government installed further Nazis in the key posts: Frick at the Ministry of the Interior and Goering at the Prussian Ministry of the Interior controlling the police. A month later the Reichstag burned down for reasons that are still unclear. The terror began in earnest, racialism became a policy and a creed, and the Third Reich was born.

From that point the entire modern movement in Germany was not merely doomed but damned. For the Nazis were *not rational*; they believed in 'thinking with one's blood', and the result of that mysterious process was a threefold hatred of all advanced art. First of all, this was because it was associated with the ideas and institutions of the November Revolution, an episode which Hitler and his followers wished to see expunged from the calendar. Secondly, it was thought to be largely sustained by Jews, though in fact Jewish patrons and impresarios were if anything rather more involved in the dissemination of the classics. Thirdly, its formal originality, its element of shock and its avoidance of prettification were seen as destructive of German self-esteem and national

The quick descent into hell. (1) Nazi SA men in Chemnitz cutting a swastika in a young Jewish man's hair, while a proletarian looks on. A photo from Muenzenberg's *Brown Book*, 1933

morale; nor did it much matter whether this was supposed to be in aid of a Jewish conspiracy or of Bolshevik revolution since in such muddled minds Judaeo-Bolshevism appeared as a single horrible evil. No doubt it is difficult for anybody without some personal experience of such people to grasp the total illogicality of the ideas in which so many otherwise healthy Germans fanatically believed, but for the vast majority of those working in the arts the situation was already clear enough: whatever personal strings the individual might hope to pull, however impeccable his genetic background and his political affiliations, there could be no accommodation where aesthetics were concerned.

The bulk of the advanced artists left the country or, if already abroad, refrained from returning; some optimists (notably among the artists and musicians) held out for a while; some stayed on in Germany at the cost of remaining inactive or compromising their artistic integrity; some were forbidden to work or sent to gaol. So Piscator, Mart Stam and several of the architects remained in Russia as did the members of Kolonne Links; Lukács and Wolf went there, followed by Plievier, Weinert and Becher. Weill drove to France; Richter stayed there; Anna Seghers was arrested, then went there too. Brecht, Eisler and the Herzfelde brothers were among those who promptly left for Prague, Brecht subsequently establishing himself in Denmark. Schwitters at first hoped to go on working – Sibyl Moholy-Nagy describes him attending a Nazi banquet in honour of Marinetti late in 1933 – but moved to Norway after the Degenerate Art Exhibition of 1937; when Beckmann too emigrated to Amsterdam. Toller first went to England. Grosz had already left to teach in the United States, as later did Hindemith, Gropius and others; likewise Moholy-Nagy after a spell in Holland and England. Dix, Schlichter, Fallada and Kästner stayed and managed to work for a time, along with Engel, Neher and Herbert Ihering. Schlemmer found work increasingly difficult; Baumeister and Hubbuch were forbidden to paint; Griebel was put in gaol, Grundig and Nagel in concentration camps; Renn and Ossietzky were rearrested. And so the break-up of the modern movement began. What survived of it in exile was dispersed and deprived of nearly all its outlets. A great proportion never came back.

(2) Arthur Kampf's painting *Der 30. Januar 1933*, depicting the Nazis' celebratory procession through the Brandenburg Gate on the day they came to power

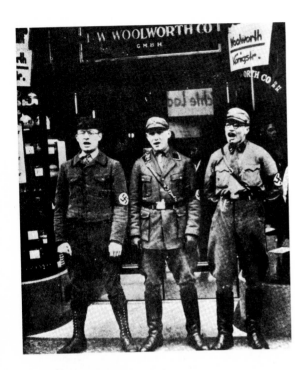

(3) SA men in Berlin proclaiming a boycott of Woolworths' as a 'non-Aryan' firm

(4) Gateway of the Oranienburg concentration camp, 1933, with a young worker leaving

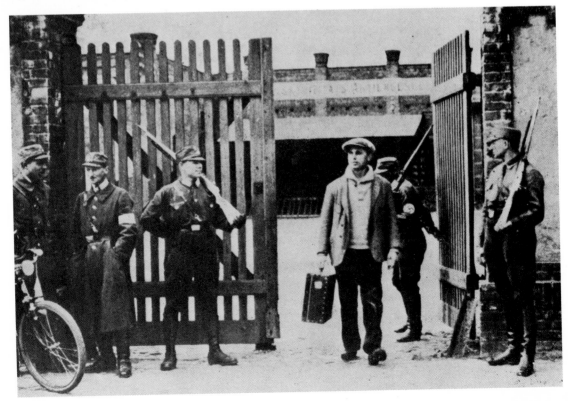

LOOKING BACK

22 Looking back today: what are the lessons from the wind tunnel?

Extinction of a new civilization. Its persisting relevance: e.g. documentary now, significance of Auden–Isherwood, modern photo-realism, music theatre; unresolved problem of the opera. The missing social dimension in today's culture; its hostility to 'political' art. This tradition's fluctuations in East Germany; its disastrous suppression in Russia after 1936. What went wrong? Inbuilt causes of the collapse: German nationalist and Russian Stalinist reactions, and the synchronization of the two. Importance since then of studying the political implications of political art: conflict as a stimulus *and* a killer. A word from Karl Marx.

Twice in the Weimar Republic's closing months Kessler in his diary records discussions with André Gide about its amazingly advanced civilization. Both times it was the architecture that sparked them off: Taut's buildings for the GEHAG at Zehlendorf, Erich Mendelsohn's austerely luxurious villa overlooking the Havel – chief of Berlin's many lakes – with its music room decorated by Ozenfant. 'It has to be understood as a new way of living, a new assessment of what life is for and how it is lived', said Kessler; while Gide pointed to this and to the Berlin theatre as

evidence that 'Germany is thirty years ahead of France'. It would be difficult to find two more highly cultured witnesses, and their opinion is on the face of it an impressive argument for those – mainly themselves architects – who see architecture as the all-embracing art. Yet, as we have seen, there was more to it than that, and the unique feature of the period was not so much the new buildings (which after all housed only about a tenth of the population even in Frankfurt) as the consistency of attitude and vision which underlay so many of its different aspects.

To go back to our starting-point, Mart Stam's houses and Kurt Weill's music did indeed hang together, and this was ultimately because they reflected the same assumptions: an openness to new technologies and media, an economy of resources, a sense that art should have a function, and a reluctance to work only for a social–cultural élite. These were attitudes which tacitly determined many more instant judgements of the eye and ear, and were themselves prompted not by 'pure' aesthetic considerations (if there can be such things) but by the tremendously rapid social and technical changes in the world around. Such changes were then occurring everywhere, but they had a far less muffled impact in those countries which, like Germany and Russia, had to make a fresh political and industrial start after the 1914–18 war.

Of the ideas and works which we have singled out from the much larger complex of the culture of that time an amazing number still seem to accord with our own preoccupations today, while some appear positively new and suggestive even now. Where architecture and some aspects of design are concerned their absorption by today's established figures has been so complete that a reaction has set in; indeed, faced with a choice between Hilberseimer's chilly-looking urban projects and the domestic architecture of Schultze-Naumburg so many architectural critics now would choose the latter that perhaps they should examine the implications. None the less Bauhaus design and typography, if they have become a commonplace, still rank as 'modern' – there have indeed been strikingly few original typographic ideas since then – while Mies's Barcelona chair can be found in the latest office buildings.

In the stage and screen arts too the documentary movement imported into England via John Grierson and the government film units is immensely strong, though not everyone remembers where it originated;

similarly Truman Capote's *In Cold Blood* and the German documentary plays associated with Piscator's return to the Volksbühne in the 1960s were often seen as something new, thoroughly though the ground had been explored forty years earlier. As for Brecht, he may now be a classic in his own country, but elsewhere he remains stimulating and controversial: in particular the didactic Lehrstücke offer a model for today's political theatre groups, as of course does the whole agitprop movement with its anticipations of modern street theatre. Nor has the pre-1933 Piscator yet been surpassed as a master of theatre techniques, even if the techniques themselves have advanced. A more radical theatre structure than the Gropius 'Totaltheater' has still to be built.

The two English-language writers most directly touched by this whole movement naturally exert more influence on us than do their German forerunners (who remain relatively little known abroad). They are W. H. Auden and Christopher Isherwood, neither of whom has so far been sterilized by too much academic approval. If in the end *Goodbye to Berlin* gave rise to *Cabaret*, and so helped to popularize the superficial aspects of the Weimar myth, Isherwood's frustrated masterpiece starts out from Dziga-Vertov, with the cool precision of 'I am a camera with its shutter open, quite passive, recording, not thinking', and the marvellous closing description of the cold city in the winter of 1932–3. It seems only natural, then, that Auden too should early have been involved in the English documentary film, while Isherwood himself (in *Prater Violet*) wrote an unforgettable portrait of Berthold Viertel, on one of whose films he later worked. Both men were known to Brecht, who wanted to recruit them for his proposed 'Diderot Society' in the mid-1930s. More oddly, readers of *Mr Norris Changes Trains* can find Mr Norris addressing an IAH meeting on the subject of the exploitation of Chinese peasants; and in fact Isherwood's real-life model Gerald Hamilton did have some doubtless ambiguous link with Muenzenberg's organization.

Similarly in painting the influence of the German Neue Sachlichkeit has so far been largely indirect, this time via America, so that although contemporary realistic work like that of David Hockney visibly relates to it, the connecting up, in our consciousness, of artists like George Grosz (whose first proper show in England only occurred in 1963) and the early Beckmann with Hopper, Sheeler, Shahn and other American urban or socially-critical artists has been

only a gradual process. Aside from the obvious fact that many of the best Neue Sachlichkeit artists have till recently remained forgotten even in Germany, a certain critical bigotry has been at work here. Because of the common view that modern art was a glorious progression towards complete independence of the real world it was assumed that any resumption of figurative painting could be only a retrograde step. The understanding of other modern movements which went into much Neue Sachlichkeit work, the thinking of Grosz and others about art's changing relevance in a changing world, the close parallels to Léger and Baumeister and other formal artists: all these aspects of Neue Sachlichkeit were alike ignored, as was the Nazis' hatred of it. Instead the whole trend became glibly dismissed as a prelude to Nazi art – which in fact was rooted in the Munich academicism of the late nineteenth century – or to the equally backward-looking Socialist Realism of Stalin's Russia. In this way the whole point was missed: that here was a first effort to adjust figurative painting to our own age.

Where music is concerned there has been even less success in following the real preoccupations of that time. Like the abstract symbolism of Kandinsky, the serialism of Schönberg and Webern was seen throughout the 1950s and 60s as the only path for the serious creative artist, and it is only lately that there has been any wide awareness of Kurt Weill as more than just a theatre composer. Eisler is at last beginning to arouse some interest, but a man like Antheil still appears completely forgotten: at the time of writing not one recording of his music is to be found. Likewise the distinction in Hindemith's work between his (for better or worse) purposeful compositions of the 1920s, with their social and technological preoccupations, and the more aimless and orthodox pieces that followed has still to be understood; the sense of the festivals which he inspired is known to comparatively few.

How much more so, then, does this blank patch in our awareness mean in the field of opera, where a really radical re-evaluation seemed for a moment to be under way. True enough, there has over the last decade or so been a revival of interest in what is termed 'music theatre', in the course of which stage or semi-stage works like *L'Histoire du soldat*, *The Little Mahagonny* and *Pierrot Lunaire* (with its faded text) have been brought under a common denominator. But by contrast with the 1920s, when one major object was to reconsider the use of music in the

ordinary theatre and cinema and bring the operatic medium up to date, the revival seems inbred and self-indulgent: an attempt by the composer to express himself in a further dimension. Except where children's opera is concerned, it has grown up apart from the world of opera proper, where the concern since 1945 has been with finding fresh resources for an older operatic tradition, and extending that. Throughout Europe, America and Australia the opera has been sent back to where Weill and his contemporaries came in: that is, to Richard Strauss and beyond. However new their purely musical conventions, where size of forces and nature of the operatic audience are concerned today's opera composers start from there.

So what is missing in the arts today by comparison with the time before Hitler? Above all, a sense of direction such as the moving spirits of the Baden-Baden music festivals so distinctively had. Ultimately this sense was political, in the widest meaning of the word; it was based on the creative artist's conscious involvement with a new society – new both in its structures and in its material resources – that had arisen out of the horrors of the First World War; it was strong in community feeling. This sense is what caused so many of the people concerned to rise above their selves and carry the modern renaissance on to a new plane where the arts in turn would penetrate the life around. Nothing emerges more clearly from a study of their achievement than that it was founded on a broadly socialist, and in many cases communist ideology and a generally sympathetic alertness to what was going on in the new Soviet Russia. The very name Constructivism suggests a wish to tackle the problems of rebuilding a shattered world, and this is what the early Constructivist vision became increasingly geared to not only in Russia itself but also at the Bauhaus and elsewhere in the German context, where it met up with Corbusier's and other new ideas from France. The internationalism that prevailed for a time after the war allowed such a mixture to take place. Wherever the old nationalist feelings began to re-emerge, whether in Germany or in the French cultural chauvinism of the mid-1920s, it was choked.

Nowhere was this more interestingly shown than in Russia's case, for what carried the influence of the new Soviet art, theatre and cinema so powerfully outwards was the sense of a common revolutionary future; as soon as the Russian cultural outlook once again became parochial the process of interchange

was constricted, even if for a short while it was also intensified as it became confined to artists (and even audiences) of the extreme Left. The whole movement, then, was one that depended on a conscious awareness of political factors, even though it was at once too varied, too widespread and too uneven to reflect any kind of systematic direction by the politicians; this was something that began only towards the end of the period. The great difference from today lies not in the surface aspect of the various artistic innovations but in the framework within which they were applied and judged. Many of the same ideas still seem suggestive to today's artists; but now the reason lies mainly in their formal aspects. Before 1933 it lay in their coherence with a fresh and hopeful view of the world.

The change is due partly to a general decline of optimism, but far more to a widespread conviction that art and politics do not, or should not mix. This now deeply engrained view – engrained not only in the Western countries but also in the 'unofficial' art movements of Communist countries – originated in the feelings of abhorrence created by the art policies of the Nazis, then snowballed after 1945 when even formerly 'progressive' leaders in the arts revolted against the Socialist Realism enforced by Stalin's lieutenant A. A. Zhdanov: something that Soviet culture has still not entirely overcome. If anything the conviction has subsequently been strengthened by closer study of the period of the Soviet purges in the mid-1930s, leading to the realization that the suppression of artistic heresies and the elimination of political opponents, even within the Communist movement, at that point went hand in hand.

The anti-communist propaganda of the Cold War period of course seized on this, and used many of Muenzenberg's own techniques to indoctrinate Western intellectuals with such views. At the same time the international policies of the Soviet Union after 1945 were hardly calculated to win over public opinion in the West, not even among the new student Left of the past ten years or so. And finally the association of the German movement of the later 1920s with the Russian-imposed Communist regime in East Germany has helped to make Western critics mistrust it. For all these reasons, whereas the German avant-garde prior to 1919 could be seen as part of the general progress of cultural innovation, after that point it was acceptable only as reflection of capitalist prosperity (the 'golden twenties'), not of new socio-aesthetic ideas.

The relations between the movement discussed in this book and the culture of the German Democratic Republic since its formation in the autumn of 1949 (with Arthur Pieck's father as its first president) have nonetheless not been all that straightforward. Of course those artists, writers, musicians and theatre people who came back to this part of Germany from exile or otherwise chose to associate themselves with it (as did men like Erich Engel and Herbert Ihering) were made welcome by the Communist authorities; thus Brecht was enabled to set up the Berliner Ensemble, Friedrich Wolf became ambassador to Poland, Wieland Herzfelde got a professorship and so on, while Becher, as the country's chief cultural official both before and after its constitution, rescued Hans Fallada again much as Rowohlt had once done, and inspired him to write a last remarkable book. Piscator too, before leaving America in 1951, had been encouraged by Wolf and Brecht to return to the revived East Berlin Volksbühne, though in the event this plan for some reason broke down.

At the same time anybody who was considered guilty of 'formalism' – i.e. who had not followed the guidelines of Socialist Realism – was likely to be criticized and to a greater or lesser extent hampered in his work. This limitation, which hit more of the major figures than might be thought (including even Eisler and Heartfield), at first seemed to follow the pre-1933 discriminations of *Die Linkskurve*: i.e. against agitprop, against Brecht and Piscator, against Tretiakoff and so on. Lukács's critical judgements were seen as mandatory, and in the process the most original Left artists of the 1920s became overshadowed by an earlier generation of 'bourgeois realists' such as Feuchtwanger and the brothers Mann.

However Lukács too was unmasked as a 'revisionist' in 1956, and his authority largely undermined; thereupon the agitprop veterans (like Vallentin) and former worker–correspondents (like Bredel or Otto Gotsche) somewhat reasserted themselves; and with this the accepted interpretation of Socialist Realism began more and more to diverge from the Soviet model. This change was very visible in the accounts given of painting, where the art historian Wolfgang Hütt convincingly singled out a tradition starting with the European Realism of the mid-nineteenth century and developing through Expressionism and the socially-critical Verists to the modified Neue Sachlichkeit of Griebel, Nagel and other Communist artists of the ARBKD.

The attitude to the Bauhaus altered: where once that school had been treated as a centre of bourgeois formalism it was now seen, thanks to some excellent research in Weimar, as socially motivated from quite early in its career. Important books appeared on Taut and Lissitzky; while the Russians' 'rehabilitation' of Tretiakoff encouraged reconsideration of his work. Moreover the younger generation began learning from 1920s' examples: thus poets owe much to Brecht; Piscator is a name to conjure with in the theatre; the outstanding novelist Christa Wolf is a follower of Anna Seghers; while Friedrich Wolf's son Konrad (unrelated to the former) is the country's leading film director. In short, the movement which interests us is now a recognized force in the GDR, but it was not automatically so; and the process which led to its recognition was, on all fronts, a development away from Stalinism, not towards it.

I would be glad if this book persuaded readers of two things: first that the arts are very closely interwoven with socio-political influences and ideas, and secondly that this is not to be regretted but can at times so stimulate the artists concerned as to produce results that from any point of view are highly original. The connections between the artistic and the political area are surely quite clear, and they cannot retrospectively be altered by our views for or against the Russian Revolution, or by our greater insight into its abuses and tragedies, or by any other conclusions on the purely political side. We have to recognize that they are not avoidable, and even more that they are not disreputable: our understanding of the arts becomes hopelessly narrowed as soon as 'politics' is treated as a dirty word.

Once we admit this, then what matters is to see where the relationship was a useful and productive one, and where it was not; something that is not always as simple as it may appear on the surface. Only three months after the second of Kessler's and Gide's impressively optimistic talks about the Weimar climate, the civilization they so admired was finished, and from then on Germany's pre-eminence was to be measured more in terms of tanks, aeroplanes, motorways, racing cars and quantities of uniformed blond men. Meantime in Russia the advanced culture of the 1920s, with its mutually inspiring exchanges with its Western counterpart, was giving way, if in a less abrupt and less publicized fashion, to something almost equally remote from it: a 'monolithic' (i.e. conformist) aesthetic rooted not so much in Marxism

or Communism as in earlier Russian traditions.

Both were clearly disastrous developments not just for the arts of the two countries but even more so for those sections of society which rejected the accompanying political change, and still more for the greater part of the outside world. Together they paved the way for what Brecht from 1937 on termed 'the dark times': relevant points in the blackness being the pillorying of 'Degenerate' art and music in Germany and the Soviet anti-'Formalist' campaign of the same time; the closing-down of Mezhrabpom and MORT in Moscow; the arrests and subsequent deaths of Tretiakoff, Koltsov, Meyerhold, Ernst Ottwalt and Carola Neher in Russia, of Mühsam, Hans Otto (of the workers' theatre federation), Erich Ohser and Erich Knauf in Germany; the internment in one kind of Nazi institution or another of Renn, Fallada and Ernst Busch; Willi Muenzenberg's mysterious death and the suicides of Toller, Tucholsky and Walter Benjamin. Ten years after the Weissenhofsiedlung and Le Corbusier's Centrosoyuz the civilization these architectural landmarks stood for had, sometimes literally, been killed.

So there is a threefold problem here: what went wrong in each of the two countries, and how did their cultural declines relate to one another? Clearly the sudden strangulation of the Weimar culture in question was not due to blind fate or Hitler's craziness or the emergence from nowhere of mysterious evil forces. The cultural–political reaction which killed it was built into the new Republic from the start, asserting itself unmistakably in the years up to 1924, and thereafter merely dormant but in no sense eradicated. Indeed its latent presence was part of the peculiar excitement of the whole Weimar atmosphere, much of what was best in the culture of the time coming from the challenge which it continually represented.

Could it have gone on being contained? It seems self-evident now that if only the SPD and the KPD had joined forces to keep the Nazis out instead of wasting their energies fighting one another the course not just of German culture but of all human history would have been very different. 'Warum versagten die Marxisten?' – Why did the Marxists crumple? – was the question put by Rudolf Olden the liberal journalist in a pamphlet published by Muenzenberg in Paris in 1934. His answers must have made painful reading for both parties, yet even he perhaps underrated the logic of those mutual suspicions and

resentments which prevented their leaders from concentrating on the real enemy. What is far less excusable is the tameness with which Socialists and Communists alike yielded to any threat of force; the defeatism of the one and the self-confidence of the other were suicidal.

In Russia too the traditionalist and academic pressures in the arts were artificially lifted for a time by the Revolution, but already by 1922 they were beginning to make themselves felt, and from then on the small size of the avant-garde and its relative independence of popular needs and demands meant that it was in a much more vulnerable position than its German opposite number with its growing basis of public appreciation and real social requirements. Here again more was involved in its demolition than the personal ambitions of Stalin, for the economic backwardness of the country, the need to clear up administrative chaos and to assimilate its non-European peoples were together quite urgent enough to call for authoritarian measures.

But if there was thus a certain political inevitability about Stalin's rule it is still unclear what it was that around 1929 turned his attention to the arts. This was when Gorki returned to the scene and helped him to communicate with the writers; it was also when Lunacharsky resigned, when the Kremlin leaders began personally vetting the new films, when Meyerhold's theatre was in difficulties and Stanislavsky's (after years of uncertainty) staged its first contemporary Soviet play. Whether this combination of circumstances would have proved quite so fatal if the leading cultural innovators in Russia had been less inclined to confess themselves wrong is difficult to say; but as it was they seem to have abandoned the field – once again – without a fight, Meyerhold being the one outstanding exception.

The effect, then, of the tightening of cultural links, just at this point, with the German Left was an ambiguous one. On the one hand relations had never been so close or in many ways fruitful; moreover the extreme political wing of Weimar culture suddenly seemed to have got itself a secure base. On the other, to all but its most disciplined members this appearance of security was deceptive, not just because the Nazis nevertheless won power and retained it but also because the new monolithic aesthetic was already being asserted and would soon be forcibly imposed. Similarly from the Russian point of view it was a tricky moment to choose, since the revolutionary internationalism on which the earlier relationship had

been based seemed to have outlived its usefulness (from a foreign policy point of view), while the Rapallo spirit was largely dead and the whole direction of Soviet diplomacy already changing. In one sense the new ties were justified by the sudden rise of the Nazis, first as helping German extreme Left culture to resist them, and then, when this proved to be a vain hope, as a necessary lifeline for many of the most dangerously threatened comrades.

In another, much simpler and more 'realistic' sense they represented a dangerous luxury for a country that was coming to be surrounded by enemies. War with the Nazis seemed sooner or later extremely likely, and the encouraging of large, comparatively uncontrolled and unassimilable German or German-dominated cultural enclaves in the USSR entailed obvious risks. The result could be seen during the paranoia that followed the murder of Stalin's colleague S. M. Kirov on 1 December 1934. From then on those German creative artists who continued to place their hopes in the Soviet connection were in an almost untenable position. For spy mania and xenophobia now conflicted with the outward 'anti-fascist solidarity', and meantime the close cultural parallels on which the old relationship had been built had somehow become parallels with Nazi rather than progressive Weimar art.

None the less there are today growing numbers of people who are drawn to the intensely committed art of the Weimar period: it was purposeful, respectful of the urgent issues of the time and productive of original forms and methods which remain in many ways exemplary for societies like our own. Never in our century has the gale of history blown so strongly as it did down the wind-tunnel of those fifteen years, and to those sensitive to it, the artists whom it so buffeted and tested are more rewarding to encounter than others who lived in more sheltered areas: Grosz than Picasso, Brecht than Aragon, Tucholsky than the Bloomsbury Group. True, they might be fatally battered in the process, as occurred with Tucholsky's depression, Piscator's grandiose schemes, Grosz's long decline and Hanns Eisler's losses of confidence: there were not many like Brecht who had the psychological and intellectual toughness to go on obstinately producing in the darkness without doubting their sense of direction. But more than any others such men have come to look like artists of our age, and it is self-deceptive if we simply admire them without trying to see the dilemmas in

which their commitment involved them.

Take away the romance and the myths, and they may have devised new forms, they may have taken the modern movement into previously unknown areas to give it new meanings and new tasks, but they failed on just that level which so intrigues many of those now looking at them for the first time: the political one. In so far as any country can be said to choose its rulers Germany chose Hitler, and bitterly as these artists had opposed him it is doubtful if they really persuaded anyone who did not already share their own views. Perhaps this is why such of them as survived without renouncing those views altogether chose not to return to the old militant methods: Piscator to the 'political theatre', Brecht and Eisler to 'Kampflieder' – fighting songs like the Solidarity Song from *Kuhle Wampe*, Grosz to cruel and exact delineation, Dix to anything remotely grotesque, and so on. For the clearest picture is not always the most accurate one; and while the black and white, either–or approach to political art may have been artistically compelling, it proved ineffective and even dangerous with regard to politics itself.

No Greek art without Greek slavery, said Karl Marx. And similarly no Weimar culture without Hitler's rise to power. For this culture was the product of a society which from the start rejected all idea of compromise, and by so doing made it ultimately impossible for National Socialism to be defeated except by war. Such intensification of conflict, the emphasizing of differences rather than their reconciliation, is for better or worse a very German way of looking at things, part of a traditional schematized view which prefers the sharp blacks and whites of wood-engraving to the French subtleties of oil paint or the thin English gradations of water-colour. The world is thereby seen as a clash of warring opposites: Hegel's thesis/antithesis, Nietzsche's polarity. Artistically this approach provides contrast; ideologically it offers certainty. Politically it leads to disaster. For if the Left parties of the Weimar Republic had been prepared to gloss over their differences instead of exacerbating them (by the use of invective like 'social–fascist') they would have kept Hitler out. This is something that should not be forgotten when we admire the effects of polarized political tensions on the creative artist at that time: true enough, they were urgent, exciting, forcing the artist to rise above himself; but only the inverted aesthete can blindly admire political art without also checking the political results.

Today, when modern Western societies have disquietingly good reasons for feeling in tune with the Weimar period, it is important that our interest in the artistic products of crisis should not lead us to hanker after crisis as such. The close involvement of the Republic's advanced culture with the social and political background may be exemplary; the work of the artists, writers, musicians and others who made it so, revealing and instructive. But if there is a lesson for our own time it is not just that art can benefit from a greater integration with hopeful socio-political causes. Above all it is that those causes had better not be lost.

Chronological table

Political events	The arts as a whole	Art and architecture

1917

		Jan. First Dada show, Galerie Corray, Zurich.
		Carrà meets Chirico in hospital, Ferrara.
31 Jan. Germany declares unrestricted naval warfare.	Feb. Huelsenbeck returns to Germany from Zurich.	5 Jan. Grosz recalled to army.
8 March. 'February Revolution' in Russia starts.	12 March. Artists' Union formed in Petrograd includes Mayakovsky and Brik.	c.20 Feb. Grosz in psychiatric hospital at Görden.
6 April. US declares war on Germany.		
11 April. USPD founded at Gotha.		
16 April. Lenin arrives Petrograd.	May. Ozenfant meets Le Corbusier.	c.26 April, Grosz discharged from army.
16 June. First Congress of Soviets.	June. Ball leaves Zurich. Dada gallery and events suspended.	July. Picabia returns from New York.
5 Sep. Sailors Köbis and Reichpietsch executed following German fleet mutinies.	15 Sep. Aragon and Breton meet in Val-de-Grâce hospital.	

> Also during 1917:
>
> Beckmann is discharged from the army.

7 Nov. 'October Revolution'. Lunacharsky Education Commissar. 20 Nov. Tanks first used at Cambrai.	16–19 Oct. Proletkult set up in Petrograd by first conference of proletarian cultural–educational bodies under Lunacharsky. 26 Nov. Apollinaire's lecture 'L'Esprit Nouveau et les poètes'.	
5 Dec. Russo-German armistice at Brest-Litovsk allows fraternization.		Dec. Léger finishes *La Partie de cartes*.

1918

28 Jan.–3 Feb. Strike in Berlin.	Feb. Moscow Proletkult conference.	29 Jan. Education Commissariat forms IZO. Punin and Altman on committee.
1 Feb. Austro-Hungarian navy mutinies at Cattaro.	18 Feb. First Dada evening at I. B. Neumann gallery, Berlin, includes lecture by Huelsenbeck.	Feb. Picabia to Switzerland to see a neurologist.
18 Feb. Brest-Litovsk negotiations break down. Germans resume advance.		
3 March. Brest-Litovsk treaty signed.	March. On move of government to Moscow IZO and TEO remain in Petrograd.	March. Shterenberg head of IZO, Tatlin head of its Moscow branch.
21 March. Start of German offensive in the West (till 29 April).		Spring. Heinrich Vogeler discharged on psychiatric grounds for letter to Kaiser re Brest-Litovsk.
25 March. Radek heads Western division of Commissariat for Foreign Affairs.	12 April. Second Dada evening at I. B. Neumann's. Huelsenbeck Dada Manifesto.	April. Academy of Arts, Petrograd, replaced by Free Art Studio (Svomas).
April. National sections formed in Soviet CP. Kun heads the Hungarian section.	May. Gorki starts cooperating with the government.	May. 'Propaganda by Monuments' launched in Moscow.
27 May–5 June. Further German offensive in West.	6 June. Dada evening at Café Austria, Berlin, includes Hausmann phonetic poems.	
June. British land at Murmansk.		
18 July. Start of final Allied offensive in West. German withdrawal to Siegfried position.	23 July. Tzara evening at the Meisensaal, Zurich, featuring his Dada Manifesto 1918.	Aug. Beckmann in Frankfurt starts *Die Nacht*.
Aug. British and French land at Archangel.	25 Sep. First All-Russian congress of Proletkult. Lebedev-Polansky becomes president, V. Ignatev secretary.	Autumn. Mayakovsky and Brik join IZO.
23 Oct. Liebknecht released from prison.		

Theatre and film	Music, ballet, opera	Writing and publication

26 Jan. Original Dixieland Jazz Band opens in New York.

1 Feb. Milhaud and Claudel arrive in Rio.

March. First issue of *Nord-Sud*.

Spring. Piscator meets Herzfelde in Flanders.

March. Victor issue first jazz record (by Original Dixieland Band).

Spring. Foundation of Malik-Verlag. First Grosz portfolio.

April. German army film unit set up.

April. *Neue Jugend* banned.

18 May. *Parade* at Théâtre du Châtelet, Paris.

11 May. Busoni *Arlecchino* and *Turandot*, Zurich Stadttheater.

20 April. Aragon called up.

End May–June. *Neue Jugend* weekly, two issues.

24 June. *Les Mamelles de Tirésias*, Paris.

July. First issue of *Dada*, Zurich.

Sep. UFA founded by Hugenberg with Deutsche Bank backing.

October. First issue of *De Stijl*.

> Also during 1917:
>
> Loew founds what is to become Metro-Goldwyn-Mayer.

> Also during 1917:
>
> Barbusse publishes *Le Feu*.
> Lukács returns from Heidelberg to Budapest.

23 Dec. Sorge's *Der Bettler* at Deutsches Theater, Berlin.

Dec. *Dada 2*, Zurich.

15 Jan. Concert at Théâtre du Vieux-Colombier by Groupe des Jeunes (nucleus of 'Les Six').

Jan. Oud's article 'Art and Machine' in *De Stijl 4*.

30 Jan. Cocteau asks Gleizes to send ragtimes from New York.

10 Feb. R. Goering's *Seeschlacht* at Royal Theatre, Dresden.

26 March. Debussy dies, aged 56.

March. Hašek joins Soviet CP.

April. Kurt Weill begins studying at Berlin Hochschule für Musik.

9 April. Aragon qualifies as a medical officer and goes to the front.

21 April. Prokofieff First ('Classical') Symphony performed, Petrograd.

April. Huelsenbeck edits 'Club Dada' issue of *Freie Strasse*. Picabia *Poèmes et dessins* published, Lausanne.

4 May. Karl Marx issue of *Die Aktion* includes *Communist Manifesto*.

1 June. *Kinonedelja* newsreel starts, with Tissé and Dziga-Vertov.

End May. Hašek joins 5th Red Army.
Summer. Herzfelde discharged from army and joins Grosz and Heartfield to work on puppet film.

July. Lourié head of MUZO, music dept. of Education Commissariat.

July. Tzara *25 Poèmes* published Zurich.

28 Sep. *L'Histoire du soldat* staged by Pitoëff, Lausanne.

Mid-Aug. Etienne de Beaumont gives party featuring a US jazz band.

6 Aug. Aragon wins Croix de Guerre.

18 Sep. Prokofieff arrives New York.

Political events	The arts as a whole	Art and architecture
29 Oct. German fleet mutinies.		Oct. Altman and other artists contribute to First Anniversary celebrations, Petrograd.
3 Nov. Austrian armistice, following independence of Jugoslavia (17 Oct.) and Czechoslovakia (28 Oct.). Michael Karolyi premier of independent Hungary.	11–13 Nov. First meetings of Hiller's 'Council of Intellectual Workers'.	1 Nov. Lenin inaugurates first 'agit-train'.
9 Nov. 'November Revolution' in Germany. Wilhelm II abdicates; Friedrich Ebert becomes president.	16 Nov. *Vorwärts* publishes declaration of support for new government by Kollwitz, Kellerman and other intellectuals.	24 Nov. *Pravda* protests against modern art purchases by IZO.
11 Nov. Armistice in the West.	17 Nov. Johannes Baader causes Dada disturbance in Berlin cathedral.	30 Nov. Shterenberg manifesto to progressive German artists.
12 Nov. Austrian emperor abdicates.		
21 Nov. Hungarian CP founded.		Dec. Second Svomas formed in Moscow from existing art and applied art schools. Malevitch, Kandinsky and Pevsner allotted studios. Memorial show for Olga Rosanova.
16–21 Dec. Rätekongress (Congress of Soviets) in Berlin. Russian delegation is turned back apart from Radek.	3 Dec. First meeting of the Novembergruppe.	
27 Dec. USPD ministers leave the government.		15–28 Dec. First Purist show, Galerie Thomas, Paris. Ozenfant and Jeanneret *Après le Cubisme*.

1919

1 Jan. KPD founded.	Jan. Novembergruppe Manifesto.	Start of year. Fifth State Exhibition, Moscow, includes Kandinsky, Pevsner, Rodchenko, Stepanova, Popova.
5–11 Jan. Spartacist revolt, Berlin.		
10 Jan.–4 Feb. Bremen Soviet.	Jan. or Feb. Ludwig and Frida Rubiner return to Berlin from Zurich.	
15 Jan. Murder of Liebknecht and Rosa Luxemburg.		
19 Jan. German Constituent Assembly elected: 44 nationalists, 22 KPD and USPD, 163 SPD. Meets Weimar 6 Feb.	22 Jan.–8 Feb. Picabia in Zurich, sees Tzara.	
12 Feb. Radek arrested Berlin.	31 Jan. Gropius applies for post as head of Weimar combined art schools.	Feb. Heinrich Vogeler arrested. His Worpswede house ransacked by Reichswehr.
21 Feb. Kurt Eisner murdered. 2–6 March. Communist International founded in Moscow. 10 March. Leo Jogiches murdered.	Feb. Gropius chairman of Arbeitsrat für Kunst.	Dix returns to Dresden and joins Dresden Sezession 'Gruppe 1919'.
21 March. Hungarian Soviet with Béla Kun Premier, Lukács Deputy Commissar for Education.	End March. Thuringian state government approves name 'Bauhaus'.	March. Beckmann finishes *Die Nacht*.
7 April–1 May. Munich Soviet Republic.	9 April. Dada event at Kaufleuten Saal, Zurich.	April. Arbeitsrat show of Unknown Architects at I. B. Neumann gallery.
	30 April. Dada event at I. B. Neumann gallery with Hausmann and Huelsenbeck (Proklamation Dada 1919). Spring. Bund für proletarische Kultur formed, Berlin.	27 April. Tenth State Exhibition, Moscow, devoted to Suprematism and Non-objective art, includes Malevitch *White on White* and Rodchenko *Black on Black*.
14. May. Gosizdat, Soviet state publishing house, set up.	24 May. Dada evening at Meistersaal, Berlin, with Grosz, Mehring, Huelsenbeck, Hausmann, Baader.	19 May. Feininger joins the Bauhaus.
5 June. Bavarian Freikorps shoot Eugen Léviné.		
June. Lukács, promoted Commissar, nationalizes publishing and theatres.	July. Arbeitsrat appeal 'To all artists of all countries' appears in *De Stijl 9*.	July. Duchamp in Paris (till Feb. 1920).
31 July. Weimar constitution adopted by Assembly.		
1 Aug. Fall of Hungarian Soviet. Rumanian army outside Budapest.		Aug.–Sep. Mayakovsky, Lebedev, etc. work on ROSTA windows.
Autumn. West European Bureau of Comintern set up in Berlin under 'Thomas'. Tucholsky, Gumbel etc. form peace group later called 'Nie wieder Krieg'.	Also in 1919: Radio Corporation of America is founded.	

Theatre and film	Music, ballet, opera	Writing and publication
7 Nov. Meyerhold directs Mayakovsky's *Mystery-Bouffe* at Petrograd Conservatoire.	11 Nov. Stravinsky at Morges completes *Ragtime*. 17 Nov. Harry Pilcer's jazz band at Casino de Paris.	15 Nov. First issue of *Valori Plastici*, Rome.

Also in 1918:

Zdanievitch in Tiflis evolves Zaoum.
Cocteau *Le Coq et l'arlequin*
De Stijl manifesto

Also in 1918:

Shoulder Arms and *A Dog's Life* (both with Charlie Chaplin)

23 Nov. Schönberg and friends form 'Verein für neue musikalische Aufführungen' in Vienna.

Dec. *Dada 3*, Zurich. IZO starts *Iskusstvo Komuny*, Petrograd, with Punin, Altman and Brik as editors.

Also in 1918:

Original Dixieland Band tours Europe. King Oliver goes to Chicago.

25 Dec. Hašek appointed deputy town commandant of Bugulma.

1919

During 1919:

Reed: *Ten Days that Shook the World*
Schwitters: *Anna Blume*

Feb. *391* no. 8 published from Zurich. Hašek collaborates on *Krassnaja Evropa*, new weekly for foreign communists in Russia.

15 Feb. Herzfelde *Jedermann sein eigener Fussball*, Berlin.

During 1919:

United Artists is formed by Chaplin, Fairbanks and Mary Pickford.

March. First issue of *Die Pleite*, Berlin.

19 March. First issue of *Littérature*, Paris.

Spring. Mayakovsky moves to Moscow.

May. Meyerhold to Yalta with TB.

May. *Dada 4–5* appears in two different editions from Zurich and Paris.

Also in 1919:

Ansermet hears the Southern Syncopated Orchestra in London.
Paul Dessau becomes Klemperer's assistant conductor at Cologne Opera (till 1923).

June. *Proletkult*, Berlin, one issue only.

Malik-Verlag publish *Der Dada 1*.

NRF reappears under Jacques Rivière's editorship.

July. Kameneva leaves TEO.

6 July–18 Oct. Agit-ship *Krasnaya Svesda* sails down the Volga.

Aug. Meyerhold arrested by Whites, Novorossisk, and held prisoner for 4 months.

July. Last issue of *Ma* to appear from Budapest.

9 Sep. Tsentrotheater established to centralize Russian theatrical affairs.

Autumn. Hanns Eisler becomes Schönberg's pupil in Vienna.

15 Oct. Cendrars/Léger *La Fin du monde* published.

Political events	The arts as a whole	Art and architecture
Oct. Lukács flees to Vienna. KAPD secedes from KPD, roughly halving it.	Nov. Fusion of Arbeitsrat and Novembergruppe.	4–30 Nov. First Novembergruppe exhibition, Berlin. Winter. Arbeitsrat show for Proletarians in E. Berlin.
13 Dec. Reds recapture Kharkov.	7 Dec. Dada event at Die Tribüne involving Piscator. 13 Dec. Dada event at Die Tribüne.	

Also in 1919:

 Richter heads Association of Revolutionary Artists, Zurich.
 IZO commissions Tatlin's monument to the Third International.

1920

Jan. Radek returns to Russia. Allies end blockade.	During 1920: A. K. Gastev founds TSIT in Moscow.	During 1920: Mendelsohn building Einstein Tower and Luckenwalde hat factory. Moscow Svomas is renamed Vkhutemas. Moholy-Nagy moves to Berlin.
8 Jan. Defeat of Kolchak (executed on 7 Feb.).	8 Jan. All-day meeting, Breton–Picabia. 17 Jan. Tzara arrives Paris.	
	23 Jan. Littérature 'matinée poétique', Palais des Fêtes, Paris, with music by 'Les Six'.	
8 Feb. Reds take Odessa.	5 Feb. Dada manifestation at Salon des Indépendants.	Feb. Duchamp returns to New York.
24 Feb. Nazi party founded in Munich.		
13–17 March. Kapp Putsch defeated by general strike after government fled to Dresden. Red Army formed in the Ruhr.	23 Feb–2 March. Marconi make two broadcasts a day from Chelmsford. 27 March. Dada evening Salle Berlioz (Théâtre de l'Oeuvre).	March. Société Anonyme founded in New York. 5 March. First Schadographs shown at Geneva Dada event.
28 March. Reds take Novorossisk. Denikin defeated.	29 March. Cocteau writes to Picabia breaking with Dada.	April. Cologne Dada exhibition.
25 April. Polish invasion of Russia. Kiev falls 8 May.	May. Start of broadcasting of Saturday concerts from The Hague.	30 April. Picabia and Ribemont-Dessaignes show at Société Anonyme.
	Inkhuk set up Moscow as part of IZO. Kandinsky chairman.	16–30 April. Picabia show Au Sans Pareil.
10 May. Czech CP asks for return of Czech communists from Russia.	22 May. Festival Dada at Salle Gaveau, Paris.	May. Obmokhu show at Vkhutemas. Lasts into 1921.
		28 May–3 June. Ribemont-Dessaignes shows 8 pictures Au Sans Pareil.
6 June. German elections. 71 nationalists, 88 KPD and USPD, 102 SPD.	15 June. Melba broadcasts from Chelmsford.	
Summer. Vienna expels Hungarian communists.		5 June. Erste Dada-Messe, Berlin.
Mid-July–Aug. Second Comintern Congress. Zinovieff chairman, Radek secretary.	Summer. Tzara to Bucharest via Zurich, returning to Paris in Oct.	
Oct. Halle Congress of USPD votes 237–156 to join Comintern.	Oct. Reopening of Théâtre des Champs-Elysées complex under Hébertot. First issue of L'Esprit Nouveau, Paris.	5 Aug. Gabo and Pevsner Realistic Manifesto. Pevsner show Tverskoe Boulevard, Moscow.
	8 Oct. Central Committee subordinates Proletkult to Education Commissariat; rebuff to Lunacharsky.	
12 Oct. Polish-Soviet armistice.		
16 Nov. With defeat of Wrangel Russian civil war ends.		Dec. Schlemmer joins the Bauhaus. Tatlin tower shown during Third Congress of Soviets.

Theatre and film	Music, ballet, opera	Writing and publication
30 Sep. Toller *Die Wandlung*, dir. Karl Heinz Martin at Die Tribüne, new Berlin political theatre, with Fritz Kortner.		
Oct. Leopold Jessner becomes Intendant of Prussian State Theatre in Berlin.		Oct.–Dec. *Littérature* includes Breton and Soupault *Les Champs magnétiques*.
28 Nov. Reinhardt opens his Grosses Schauspielhaus, with (from 26 Dec.) 'Schall und Rauch' cabaret in cellars.		Nov. *Ultra* founded, Oviedo. *391* no. 9 published from Paris.
2 Dec. Pitoëff's first Paris production, Lenormand's *Le Temps et un songe*.		11 Dec. LITO set up in Education Commissariat.
		Breton asks Picabia to collaborate on *Littérature*.

1920

Theatre and film	Music, ballet, opera	Writing and publication
20 Jan. Lenormand *Les Ratés* dir. Pitoëff, Geneva.	Jan. Princesse de Polignac presents Satie's *Socrate* in Paris.	*Jan. Die Pleite* suppressed. 10 Jan. René Hilsum opens Au Sans Pareil at 37 Avenue Kléber, Paris.
	16 Jan. *Comoedia* publishes Henri Collet's article 'Les Six Francais et Erik Satie'	
Feb. D. Leshchenko made head of Fotokino section of Education Commissariat.		Feb. *Dada 6*. Only issue of *Die Schammade*, Cologne.
21 Feb. Milhaud's *Le Boeuf sur le toit* at Comédie des Champs-Elysées, cond. Golschmann.	1 Feb. First issue of *Melos*, Mainz, ed. by Scherchen.	1 Feb. Eluard publishes first issue of *Proverbe*.
	23 Feb. Golschmann conducts Auric *Adieu à New-York*, Poulenc *Cocardes* and Satie *Trois Petites Pièces*.	27 Feb. Death of Rubiner.
Feb.–May. Pitoëff in Geneva directs Futurist plays for Art et Action.		
	8 March. Satie 'Musique d'ameublement' at Galerie Barbazanges, Paris.	March. *Dada 7*, final issue.
27 March. Tzara *Antipyrine 1, Le Serin Muet, L'Empereur de Chine, Vous m'oublierez*.	27 March. Satie and Ribemont-Dessaignes *Le Pas de la chicorée frisée*.	April. Literary manifesto no. 2 in *De Stijl* 6, 'Het woord is dood'.
		15 April. *Ma* no. 9 appears from Vienna with Kassák's appeal 'To the artists of all countries'.

Also in 1920:

Paul Whiteman's band tours Europe.

Theatre and film	Music, ballet, opera	Writing and publication
	15 May. Stravinsky *Pulcinella* Paris Opera, chor. Massine, des. Picasso, for Diaghileff.	1 May. Franz Jung arrives Murmansk as KAPD delegate to Comintern, having hijacked a ship, and stays a year.
22 May. *Les Ratés* at Théâtre des Arts, Paris, dir. Pitoëff.		
26 May. Tzara *Antipyrine 2*.		

Also in 1920:

Kafka *Ein Landarzt*
Lewis *Main Street*
Goll *Die Chaplinade*
Cendrars completes *Anthologie nègre*.

Theatre and film	Music, ballet, opera	Writing and publication
	7 June. Festival Erik Satie at Salle Erard, Paris.	
	June. Stravinsky leaves Morges to settle in France.	
July. Cendrars working on Abel Gance's *La Roue*.		July. First issue of Italian Dada review *Bleu*, Mantua.
Aug. Meyerhold head of TEO for RSFSR.		1 Aug. *NRF* includes Breton 'Pour Dada'.
Oct. Théâtre du Vieux-Colombier reopens.	Oct. Ravel visits Alma Mahler in Vienna.	
Meyerhold proclaims 'October in the Theatre'.	24 Oct. Swedish Ballet opens at Théâtre des Champs-Elysées with Debussy's *Jeux*.	
14 Oct. Piscator's Proletarian Theatre opens in Berlin with triple bill, des. Heartfield.		Oct. *Der Gegner* issue devoted to Proletarian Theatre.
7 Nov. Verhaeren *Les Aubes* dir. Meyerhold at RSFSR Theatre no. 1		20 Nov. *Pravda* publishes attack on Lunacharsky's plays by P. Kerzhentsev.

Political events	The arts as a whole	Art and architecture

8 Dec. Litkens becomes deputy to Lunacharsky. Overhaul of Commissariat begins.

1 Dec. Central Committee letter 'On the Proletkults' published in *Pravda*. Pletnev succeeds Lebedev-Polansky. End of Bogdanov's influence.

9 Dec. Picabia show at Galerie de la Cible opens with 'Parisian jazz' arranged by Cocteau.

1921

Jan.–Feb. Second Purist Show at Galerie Druet, Paris.

Jan. *De Stijl* appears from Weimar in new format.

Jan. Ozenfant becomes editor of *L'Esprit Nouveau*.

12 Jan. *Dada soulève tout*, anti-Futurist pamphlet; signatories include Tzara, Huelsenbeck, Evola.

> During 1921:
>
> Puni show at Sturm Gallery, Berlin.
> Lissitzky at architecture faculty of Vkhutemas.
> Oud leaves *De Stijl*.
> Picasso *The Three Musicians*

15 Jan. Marinetti launches 'Tactilism' in lecture at L'Oeuvre.

11 Feb. Reorganization of Education Commissariat.

8 March. Tenth Party Congress. Lenin announces NEP.

16 March. Anglo-Soviet trade agreement and *de facto* recognition.

March. 'March Action' in Mansfeld area led by Max Hölz. Kun, Pogany, Guralski and Franz Jung from Moscow to help. Riots in Hamburg.

> During 1921:
>
> Kandinsky, Pevsner and Gabo leave Inkhuk.
> Rodchenko becomes chairman, joined by Brik and Arvatov.
> Zdanievitch to Paris.
> Ribemont-Dessaignes leaves Paris for the country.

March–April. Russian show at Von Garvens gallery, Hanover, includes Puni, Kandinsky, Chagall, Archipenko.

15 April. Hölz captured.

14 April. Dada event at Saint-Julien-le-Pauvre.

15 April. Dada show at Bragaglia Gallery, Rome.

May. Return of first Russian firms to private enterprise under NEP.

11 May. Picabia article in *Comoedia* breaking with Dada.

3 May–3 June. Ernst show Au Sans Pareil. Ernst held up by visa problems.

14 May. Italian elections. Fascists get 29 seats.

13 May. Breton stages 'Procès Barrès'.

22 May. Third Obmokhu show at 11 Bvd. Dmitrovka, Moscow, with Rodchenko, Medunetzky and brothers Stenberg.

1 June. Evola show at Sturm Gallery, Berlin.

Summer. Drought in Volga Basin leads to severe famine.

10 June. Dada evening Galerie Montaigne includes Tzara *Coeur à gaz*.

17 June. Dadaists boo concert of 'Les Bruiteurs Futuristes' at Théâtre des Champs-Elysées.

6–20 June. Salon Dada at Galerie Montaigne. Includes Ernst, Baargeld, Mehring, Ray, Stella. Closed by Hébertot.

22 June. Third Comintern Congress starts.

July. Man Ray arrives Paris.

13–14 June. First Kahnweiler sale, Paris, includes 22 Braques and 26 Picassos.

12 Aug. Muenzenberg founds IAH (Mezhrabpom) in Berlin. Jung becomes its representative with Comintern. KPD Jena Congress (22–26 Aug.) approves it.

26 Aug. Murder of Erzberger. State of emergency in Germany till 16 Dec.

July–Aug. Tzara, Arp, Ernst, Bretons, Eluards meet in Tyrol. Arp statement on paternity of Dada (6 Aug.).

Aug. Radio KDKA starts broadcasting sport. Wave of new US stations follows.

20 Aug. Tarabukhin lecture at Inkhuk, 'The Last Picture has been Painted', inaugurates crucial discussions.

Sep. Lissitzky Inkhuk lecture on 'Prouns'.

Sep. Krasin talks in Berlin on setting up arms factories in USSR.

1 Oct. Piscator and Nagel become secretaries of IAH Artists' Aid for Russian Famine. Committee includes Grosz, Kollwitz, Paquet, Holitscher.

'5 × 5 = 25' show, Moscow. End of 'laboratory art'.

16 Oct. USPD votes to fuse with KPD. Minority join SPD.

Early Oct. Breton meets Freud in Vienna. Returns via Ernst in Cologne.

12 Oct. Brik lecture at Inkhuk.

1 Nov. Otto Braun becomes Prussian premier.

16 Nov. Gosbank opens in Moscow.

Mid-Nov. Fall of the Mark starts.

Oct. No more free distribution of printed matter in USSR.
Gorki emigrates.

1–30 Nov. Novembergruppe show at Josef Altman gallery, Berlin.

17–18 Nov. Second Kahnweiler sale includes 35 Braques and 46 Picassos.

24 Nov. Brik coins term 'Productivism' in Inkhuk lecture.

Theatre and film	Music, ballet, opera	Writing and publication

Theatre and film	Music, ballet, opera	Writing and publication
Also in 1920: Chaplin *The Kid*	21 Dec. *Parade* revived at Théâtre des Champs-Elysées. Dec. Busoni accepts Weill as pupil at Berlin Academy.	19 Dec. Hašek returns to Prague from Siberia.
	Jan. Lourié dismissed from MUZO and later emigrates. 5 Jan. *Walküre* at Paris Opéra is first Wagner production since 1914.	3 Jan.–1 Feb. Hašek's account of his Russian experiences in *Česke Slovo*. 1 March. *Schweik* begins appearing in instalments.
		April. Grosz and Herzfelde prosecuted for *Gott mit uns*.
21 April. Piscator's Proletarian Theatre closes.		25 April. *Ma* names Moholy-Nagy, 3 Witzlebenstrasse, its Berlin representative.
May. Erich Weinert first appears in Leipzig cabaret 'Die Retorte'. 1 May. Mayakovsky *Mystery - Bouffe*.	8 May. Southern Syncopated Orchestra at Théâtre des Champs-Elysées. 17 May. Prokofieff *Chout*, Paris, dir. Larionov and Stravinsky. 27 May. Programme of Strauss waltzes at Schönberg's 'Verein' in Vienna.	
18 June. Cocteau *Les Mariés de la Tour Eiffel* at Théâtre des Champs-Elysées. Music by 'Les Six'. July. Jean Epstein arrives Paris. In Petrograd TEO begins charging for theatre seats.	6 June. Swedish Ballet perform Claudel–Honegger *L'Homme et son désir*, Paris. 9 June. Stravinsky *Piano-Rag* and Satie pieces at last 'Verein' concert, Vienna.	? June. *Der Gegner* 1920/21 no. 8/9 prints letter from Novembergruppe opposition, including Dix, Grosz, Schlichter etc.
Also in 1921: Granovsky starts Jewish Theatre, Moscow. Eisenstein involved in productions at Proletkult studio. Cirque Médrano reopens in Paris.	31 July/1 Aug. First Donaueschingen Festival with chamber works by Hindemith, Křenek, Berg, Hába.	Aug. Last issue of *Littérature* (no. 20). Kurt Wolff to Werfel on 'sterility' of German writing.
Sep. End of free tickets at the Bolshoi.		
15 Sep. Trude Hesterberg opens Wilde Bühne cabaret under Berlin Theater des Westens.	Oct. Berg finishes *Wozzeck*.	Oct. First use of term 'mass communication'.
Nov. Mayakovsky *Heroic Exploit* (agitka) dir. Foregger, Riazan. 28 Nov. Stanislavsky and Moscow Art Theatre perform Berlin.		7 Nov. First issue of *Sowjet Russland im Bild*, precursor of *AIZ*.

Dec. Moscow Bourse reorganized.

4–7 Dec. Fusion of bulk of USPD with KPD.

8 Dec. Seeckt talks with Russians.

End of year. Lunacharsky appoints Kandinsky to plan reorganization Moscow Academy of Arts.

Branches of Inkhuk set up Petrograd under Tatlin, Vitebsk under Malevitch. Lissitzky leaves for Berlin.

3–31 Dec. Man Ray show Galerie Six, Paris.

Dec. Inkhuk lectures:
8th: Kemény on new German art.
22nd: Stepanova 'On Constructivism'.
26th: Kemény on Obmokhu.
Also Malevitch on Vitebsk work.

1922

Jan. Krupp gets concession to build tractor factory in S. Russia.

17 Jan. Lenin directives re film.
 Radek arrives Berlin.

31 Jan. Rathenau foreign minister under Wirth.

10 Feb. Radek meets Seeckt.

Mid-Feb. Lenin-Lunacharsky talk about film.

Feb.–March. Soviet government financial crisis.

15 March. Agreement for manufacture of Junkers aircraft in Russia.

10 April. Genoa conference. Lloyd George, Barthou, Chicherin etc.

16 April. Treaty of Rapallo between Germany and Russia establishes diplomatic relations and a common economic front.
 Genoa conference breaks up.

1 May. For first time Soviet May Day slogans omit mention of world revolution.

24 June. Murder of Rathenau.

During 1922:

 E. J. Gumbel *Vier Jahre politischer Mord*

29 July. Secret general agreement between Russia and Germany signed Berlin.

24 Sep. USPD rump fuses with SPD.

Jan. Proletkult loses its government subsidy. Lets off its Moscow theatre (by May).

3 Jan. 'Congrès de Paris' announced in *Comoedia*.

5 Feb. Breton public statement against Tzara.

13 Feb. Protest meeting Closerie des Lilas.

14 Feb. First regular broadcast from Writtle.

19 March. First Novembergruppe evening with writers and musicians.

April. Litkens murdered in Crimea.

5 April. Ozenfant tells Breton Congrès de Paris is off.

11 May. 2LO starts broadcasting.

29–31 May. Düsseldorf artists' conference, with Lissitzky, Van Doesburg and Richter as 'Constructivist Fraction'.

Summer. IAH sends Grosz to Russia for five months.
 Milhaud visits Schönberg.

July–end Aug. Dadaists meet at Imst/Tarrenz, Tyrol: Tzara, Arps, Ernsts, Eluards, Josephsons.

End Sep. Dada–Constructivist meeting Weimar, followed by Dada events Jena, Dresden, Hanover with Arp, Tzara, Van Doesburg, Hausmann.

7 Jan. Van Doesburg at Weimar 'been sowing the poison of the new spirit'.

Feb.–March. *De Stijl* publishes Van Doesburg lecture 'The Will to Style'.

During 1922:

 Le Corbusier Ozenfant house
 Georg Schrimpf in Italy contacts *Valori Plastici*.
 Jancu returns Bucharest.
 Kunstblatt enquiry 'Ein Neuer Naturalismus?'

30 March. Inkhuk lecture by Arvatov.

Also in 1922:

 Kassák and Moholy-Nagy *Uj Müveszek Könyve*
 Kozintseva and Schwitters show at Sturm Gallery.
 AKhRR is founded.

1 May. Gropius memorial to fallen workers unveiled at Weimar.

May. Graeff 'Für das Neue' in *De Stijl 5*.

June. Schlemmer at Bauhaus notes reaction against Utopia: 'not cathedrals but machines for living'.

4 July. Third Kahnweiler sale, Paris.

Sep. Kandinsky joins Bauhaus.

Theatre and film	Music, ballet, opera	Writing and publication

Dec. FEKS manifesto.

6 Dec. Wiéner concert Salle des Agriculteurs, Paris, with Stravinsky's *Sacre* on Pleyela and Billy Arnold's band.

16 Dec. Prokofieff plays his 3rd Piano Concerto, Chicago, cond. Stock.

22 Dec. Crommelynck *Le Cocu magnifique*, Théâtre des Champs-Elysées, dir. Lugné-Poë.

30 Dec. Prokofieff *Love of Three Oranges*, Chicago.

> Also in 1921:
>
> Svevo *La Coscienza di Zeno*
> Dos Passos *Three Soldiers*
> Agatha Christie *The Mysterious Affair at Styles*
> Anna Akhmatova publishes her last book for twenty years.

1922

20 Jan. Honegger *Skating-Rink*, des. Léger, at Théâtre des Champs-Elysées.

1 Feb. Pitoëff takes over Comédie des Champs-Elysées from Gémier, having closed his Geneva theatre.

24 Jan. Walton/Sitwell *Façade* privately performed 2 Carlyle Square, London.

Feb. Southern Syncopated Orchestra second concert Théâtre des Champs-Elysées.

> During 1922:
>
> Flaherty *Nanook of the North*
> Chaplin *A Woman of Paris*
> Goll *Methusalem, der ewige Bürger*

13 Feb. Persymfans first concert, Moscow.

> During 1922:
>
> Sinclair Lewis *Babbitt*
> Rilke *Sonette an Orpheus*
> Grosz *Ecce Homo*
> Valéry *Charmes* including 'Le Cimetière marin'
> Joyce *Ulysses*
> Weber *Religions-Soziologie*

1 March. First of new series of *Littérature*.

2 March. Breton 'Après Dada' in *Comoedia*.

26 March. First Soviet films shown Germany by IAH: *Hunger in Sowjetrussland* and *Die Wolga hinunter*. Start of IAH film operations.

26 March. Hindemith *Sancta Susanna* at Frankfurt Opera.

> During 1922:
>
> Milhaud visits USA.
> King Oliver brings Louis Armstrong to Chicago.

March. *Isvestia* prints Mayakovsky poem 'On Meetings'.

Spring. Mayakovsky and Koltsov scheme for publishing from Riga.
Little Review Picabia number.

25 April. *Le Cocu magnifique* dir. Meyerhold, des. Popova, Moscow.

22 April. Schönberg *Fünf Orchesterstücke* cond. Caplet at Pasdeloup concert, Paris.

9–12 May. Four performances of *Pierrot lunaire*, Vienna.

April–May. Only two issues of *Veshch*, Berlin.

14 May. Bronnen *Vatermord* dir. Viertel, Berlin, Junge Bühne.

21 May. Dziga-Vertov's first *Kinopravda*.

13 May. Bartók *Bluebeard* and *Der holzgeschnitzte Prinz* at Frankfurt Opera.

End May. Kraus *Die letzten Tage der Menschheit*, revised edition, Vienna.

12 June. Meyerhold launches theory of 'biomechanics'.

3 June. Stravinsky *Mavra* and *Renard* des. Larionov, at Paris Opéra.

June. Inflation makes Werfel decide to publish in Austria.
Plievier speaks at Weimar youth hostel.

30 June. Toller *Die Maschinenstürmer*, Grosses Schauspielhaus, dir. Martin.

22 June. Antheil recital at Wigmore Hall, London.

July. Grosz *Mit Pinsel und Schere* pub. by Malik-Verlag.

30–31 July. Second Donaueschingen Festival includes Hindemith *Kammermusik no. 1*.

7–11 Aug. Modern music festival Salzburg leads to foundation ISCM.

29 Sep. Brecht *Drums in the Night*, Munich Kammerspiele.

20 Sep. Schlemmer's *Triadic Ballet* performed Stuttgart.

Sep. Last issue of *Der Gegner*. Axel Eggebrecht writes of 'end of the Bolshevik vogue'.
Littérature no. 4 is 'first surrealist number'.

Political events	The arts as a whole	Art and architecture

Political events

28 Oct. Mussolini marches on Rome and forms Fascist government.

Nov.–Dec. Fourth Comintern Congress. Reorganized to become more a Soviet instrument.

22 Nov. Cuno government, Germany. First with no SPD participation.
 Brockdorf-Rantzau to Moscow as first ambassador.

Dec. Lenin has a stroke. Tenth Congress of Soviets establishes USSR. School fees reintroduced.

1923

11 Jan. French occupy the Ruhr. German passive resistance starts a week later.
 Organization of 'Red hundreds' starts in KPD under Soviet supervision.

28 Jan. Eighth Congress of KPD at Leipzig elects Brandler leader and forms action committees against Fascism.

9 March. Lenin stroke. Loses speech.

April. Twelfth Party Congress in USSR.

May–July. Radek controls KPD policy.

26 May. French shoot Leo Schlageter in Ruhr.

1 June. Gesellschaft der Freunde des neuen Russland founded Berlin.

10 July. Italy dissolves non-Fascist parties.

11 Aug. Stresemann becomes Chancellor.

Sep. Borodin to Peking as Soviet emissary to Sun Yat-sen.

26 Sep. End of passive resistance in Germany.

12 Oct. KPD enters Saxon coalition. Reichswehr ultimatum follows.

23 Oct. Saxon government deposed. Hamburg Rising.

7 Nov. Date fixed by Soviet Politbüro for German Revolution.
8–9 Nov. Nazi putsch fails in Munich. Reichswehr not used.
20 Nov. Stabilization of the Mark.
23 Nov. Stresemann falls, succeeded by Marx.

The arts as a whole

18 Oct. BBC founded.

Nov. Mayakovsky pays first visit to Paris, meets Léger.

> Also during 1922:
> Ernst settles in Paris.
> Lunacharsky marries Natalia Rozenel.

14 Dec. J. C. Reith offered managership of BBC.

8 Jan. Kessler in Paris notes 'Reaction is the thing here, in art and literature too'.

Jan. Van Doesburg and Schwitters Dada tour of Holland.

Feb. Duchamp to Paris. Abandons all aesthetic activity.

End March. Changes at Bauhaus. Moholy-Nagy succeeds Itten. Schreyer to leave in Oct.

April. *Noi* publishes manifesto by Futurists supporting Fascist government.

7 April. Breton tells *Journal du Peuple* he will stop writing and close down *Littérature*.

6 July. Last Dada evening organized by Zdanievitch at Théâtre Michel. Cocteau poems, Richter and Sheeler films, Tzara *Le Coeur à barbe* disrupted by Breton and friends. Tzara then sues Eluard.

Sep. Becher in *Frankfurter Zeitung* proclaims adhesion to KPD.

> Also in 1923:
> Institut für Sozialforschung founded at Frankfurt.
> *Na Postu* founded, Moscow.

28 Nov. Gropius's flat in Weimar searched by army.

Art and architecture

Oct. IAH and Education Commissariat sponsor First Russian Art Exhibition, Van Diemen Gallery, Berlin. 237 paintings, 300 graphic works.

Nov. Le Corbusier's 'Plan Voisin' at Salon d'Automne.

Dec. Moholy-Nagy and Kemény 'The Dynamic-Constructive System of Forces' in *Der Sturm*.

> During 1923:
> Vogeler to Moscow with Sonia Marchlewski, daughter of founder of MOPR (Red Aid), to which he gives his Worpswede house.

March. Novecento group formed.
 Kemény joins KPD.
 Charchoune and Boguslavskaya show at Sarja Gallery, Berlin.

May. Fourth and last Kahnweiler sale, Paris.

Summer. Grosse Berliner Kunstausstellung includes Lissitzky 'Prounenraum' and paintings by Puni and Charchoune.

July–end Sep. Bauhaus Exhibition, Weimar. 'Art and Technology – a new unity'. *De Stijl* puts on a rival show, Jena.

> Also in 1923:
> Foundation of ASNOVA
> Le Corbusier *Vers une architecture*
> Hartlaub letter re 'Neue Sachlichkeit' show
> Flechtheim becomes Grosz's dealer.
> Museum of Modern Western Art, Moscow, founded under B. Ternovetz.

Nov.–Dec. Constructivist show at Von Garvens gallery, Hanover, includes Lissitzky, Moholy-Nagy, Baumeister, Schlemmer.

Theatre and film	Music, ballet, opera	Writing and publication

End Oct. Abel Gance film *La Roue* at Gaumont, Place Clichy, Paris. Cendrars and Léger collaborated, Honegger wrote music.

Oct. Novembergruppe present *Pierrot lunaire* under Scherchen in Berlin Hochschule für Musik.

7 Nov. Factory siren concert at Baku.

18 Nov. Weill *Zaubernacht*. Theater am Kurfürstendamm.

Oct. First issue of *The Criterion* includes Eliot 'The Waste Land'.

Nov. Breton 'Entrée des médiums' in *Littérature* no. 6.
3 Nov. Brecht marries Marianne Zoff.
15 Nov. Death of Proust.

Dec. René Clair editor of *Film* for Hébertot (for two years).
 Moscow Art Theatre at Théâtre des Champs-Elysées.

20 Dec. Cocteau *Antigone* at Théâtre de l'Atelier.

14 Dec. Milhaud conducts *Pierrot lunaire* at Wiéner concert, Théâtre des Champs-Elysées.

26 Dec. Stravinsky *Mavra* and *Wind Symphony* at Wiéner concert.

Also in 1922:

 Marina Tsvetaeva emigrates.
 Shklovsky leaves Russia for two years.

1923

During 1923:

 Proletkino formed.
 Blue Blouses agitprop group founded in Moscow.
 L'Herbier *L'Inhumaine* with sequences by Léger
 Karl Grune *Street*

During 1923:

 Prokofieff settles Paris.
 Shostakovitch graduates Petrograd Conservatoire.
 Ellington *Blind Man's Buff*
 First two-sided discs issued by Victor.

3 Jan. Death of Hašek.

Jan. First issue of *Merz*, Hanover.

Feb. Barbusse joins French Communist party.

23 Feb. Martinet/Tretiakoff *The Earth in Turmoil* at Sohn Theatre, Moscow, dir. Meyerhold.

6 March. Tairoff's Kamerny Theatre starts fortnight's season Théâtre des Champs-Elysées.

13 March. Romains *M. le Trouhadec*, Comédie des Champs-Elysées.

7 April. Kamerny Theatre starts Berlin season at Deutsches Theater.

May. Dziga-Vertov *Kinopravda 14* with animated titles by Rodchenko.

May. Ostrovsky/Tretiakoff *Enough Simplicity in Every Wise Man*, dir. Eisenstein at First Workers' Theatre, Moscow.

8 July. Molnár *Liliom* at Comédie des Champs-Elysées, dir. Pitoëff.

Also in 1923:

 Erich Weinert joins 'Küka' cabaret, Berlin, with Rosa Valetti et al.

23 March. De Falla *Retablo*, Seville.

15 April. Kandinsky wants Schönberg to direct Weimar Musikhochschule.

24 May. Wiéner and Benedetti play *Le Boeuf sur le toit* at Théâtre des Champs-Elysées.

11 June. Stravinsky *Les Noces*, Paris, chor. Nijinska, des. Goncharova.
14 June. Satie presents the Ecole d'Arcueil at Collège de France.
17 June. Hindemith *Marienleben* at Third Donaueschingen Festival.

March. First issue of *LEF*, Gosizdat, Moscow.

During 1923:

 Trotsky *Literature and Revolution*
 Arvatov *Iskusstvo Klassy*
 Rilke *Duino Elegies*
 Dorothy Sayers *Whose Body?*
 Rowohlt publishes Emil Ludwig.

June–July. *LEF* includes Eisenstein article 'Montage of Attractions'.

July. First issue of *G*, ed. Richter with Graeff and Lissitzky.

16–19 Aug. Bauhaus Week, Weimar and Jena, includes *Triadic Ballet*, two Scherchen concerts and *Mechanisches Kabarett*, music Stuckenschmidt.

2–7 Aug. ISCM festival, Salzburg, includes Ravel Sonata for Violin and Cello.

4 Oct. Antheil Paris recital.

Sep. *G* no. 2. Mies van der Rohe an editor.

12–24 Oct. Moscow Art Theatre again at Théâtre des Champs-Elysées.

Autumn. René Clair shooting *Paris qui dort*.

3 Nov. Georg Kaiser *Nebeneinander*, dir. Viertel, des. Grosz, at Lustspielhaus, Berlin.

18 Oct. Koussevitzky concert Paris. Stravinsky Octet and Prokofieff Violin Concerto.

25 Oct. Milhaud *La Création du monde* and Cole Porter *Within the Quota* at Théâtre des Champs-Elysées.

5 Nov. Prokofieff recital Théâtre des Champs-Elysées.

Nov. Henry Ford's autobiography published in Germany.

6 Dec. Chesterton *The Man who was Thursday*, dir. Tairoff, des. A. Vesnin, Moscow Kamerny Theatre.

Dec. Weill leaves Berlin Academy.

4 Dec. Death of Barrès.

Political events	The arts as a whole	Art and architecture

13 Dec. Borodin becomes adviser to Kuomintang.

27 Dec. Soviet Politbüro criticizes Radek for reliance on KPD right wing.

1924

11 Jan. Presidium of Comintern calls SPD 'a section of German fascism in a socialist disguise'.

21 Jan. Death of Lenin.

1 Feb. Labour government in Britain recognizes USSR.

Feb. New Thuringian Landtag elected. SPD out of Weimar provincial government.

1 March. Ban on KPD (since 22 Nov.) lifted.

1 April. Hitler five-year sentence for putsch (but is released on 20 Dec.).

7 April. Ninth Congress of KPD. Frankfurt elects Maslow and Ruth Fischer leaders, sets up Rote Frontkämpferbund under Thälmann.

4 May. Reichstag elections. 32 Nazis, 95 nationalists, 100 SPD, 62 KPD/USPD.

11 May. French elections won by Radical and Socialist 'Bloc des Gauches'. Communists increase from 9 to 25. Herriot government follows.

10 June. Matteotti murdered by Fascists.

17 June–8 July. Fifth Comintern Congress. Trotsky and Radek *not* elected to executive. Souvarine expelled.

1 Sep. Dawes plan for reparations settlement comes into force after approval by Reichstag.

10 Oct. Zinovieff letter addressed to British CP.

6 Nov. British Labour government falls.

Dec. Krasin to Paris as ambassador after recognition of USSR.

7 Dec. Reichstag elections. 14 Nazis, 103 nationalists, 131 SPD, 45 KPD/USPD.

During 1924:

First German publication of Lenin: *Party Organization and Party Literature*.

Feb. Künstlerhilfe sale in aid of IAH, supported by Grosz, Nagel, Kollwitz.

16 Feb. Grosz and Herzfelde prosecuted for *Ecce Homo*.

20 March. Gropius told by provincial government not to renew teachers' contracts.

10 May. Sorbonne lecture by Marinetti.

22 May. Sorbonne lecture by Milhaud.

13 June. Rote Gruppe set up in Berlin with Grosz chairman, Heartfield secretary. Members include Dix, Schlichter, Griebel, Nagel.

16 July. Ernst Toller leaves gaol after serving full five years.

1 Aug. IAH takes over Russ film co., Moscow, to form Mezhrabpom-Russ.

Sep. Thuringian government gives notice to Bauhaus staff.

Autumn. Hébertot at Théâtre des Champs-Elysées in financial difficulties. Sublets Comédie to Jouvet. Is sued by unpaid artists.

12 Oct. Mendelsohn arrives New York. Meets F. L. Wright 5 Nov. Oct. Breton publishes Surrealist Manifesto.

21 Dec. Erich Mühsam leaves gaol.

29 Dec. Bauhaus announces its dissolution as from 1 April 1925.

During 1924:

Ernst May becomes chief town planner, Frankfurt. Bruno Taut architect to GEHAG building society. *ABC* founded, edited by Emil Roth, Hans Schmidt, Mart Stam. Le Corbusier and Jeanneret build La Roche house, Paris. A Russian art exhibition is held in New York.

25 May. Death of Lyubov Popova.

Aug. Léger visits Italy with Léonce Rosenberg.

Sep. Léger at Vienna Theatre Exhibition.

18 Oct. First Universal German Art Exhibition in Historical Museum, Moscow, organized by IAH and supervised by Nagel. 501 works by 126 artists. A special section devoted to the Rote Gruppe.

14 Dec. Romains *Knock* and *Amédée* at Théâtre des Champs-Elysées.

1924

1 Jan. Ostrovsky *The Forest* dir. Meyerhold, Moscow.

1 Jan. Kroll-Oper opens as branch of Berlin State Opera, with obligation to provide seats for Volksbühne.

6 Jan. Poulenc *Les Biches* at Monte Carlo, des. Laurencin.

March. Tretiakoff *Gas Masks*, dir. Eisenstein in Moscow gasworks.

12 Feb. Gershwin *Rhapsody in Blue* at Whiteman concert, New York.

March. First issue of *Blok*, Warsaw, edited by Miecysław Szczuka et al.

19 March. Brecht/Marlowe *Edward II* dir. Brecht, des. Neher at Munich Kammerspiele.

18 March. Förster patent a quarter-tone piano.

26 March. Čapek *RUR* dir. Komisarjevsky at Comédie des Champs-Elysées.

24 April. *L'Histoire du soldat* presented by Théâtre Beriza at Théâtre des Champs-Elysées. Paris premiere.

2 May. Gantillon *Maya* at Studio des Champs-Elysées.

8 May. Honegger *Pacific* 231 at Koussevitzky concert, Paris.

May. Oskar Kanehl tried for endangering the peace by his poems.
E. Varga *Rise and Fall of Capitalism* pamphlet.

17 May. Soirées de Paris (Comte de Beaumont) programme includes Tzara *Mouchoir des Nuages* and Milhaud *Salade*.

22 May. Stravinsky Piano Concerto at Koussevitzky concert, Paris.

26 May. Paquet *Fahnen* dir. Piscator at Berlin Volksbühne.

31 May–6 June. Second ISCM Festival, Prague, includes premiere of Schönberg's *Erwartung*.

15 June. Soirées de Paris programme includes Satie *Mercure*.

20 June. Milhaud *Le Train bleu* at Théâtre des Champs-Elysées.

During 1924:

Mann *Der Zauberberg*
Forster *A Passage to India*
Kisch *Der rasende Reporter*
Léon Moussinac joins French CP.
Gertrud Alexander ceases to be chief arts critic of *Die Rote Fahne*.
Walter Mehring moves to Paris.

20 July. Fourth Donaueschingen Festival includes Schönberg op. 24.

June. Last issue of *Littérature*.

27 July. Death of Busoni.

End July. Ernst Friedrich completes *Krieg dem Kriege*, book of war horrors, for Freie Jugend, Berlin.

Autumn. Brecht and Zuckmayer become dramaturgs at Deutsches Theater, Berlin.

6–9 Aug. ISCM Salzburg includes Weill *Frauentanz*.

Also in 1924:

Ödön von Horváth moves to Berlin.
Keaton *The Navigator*
Murnau *Der letzte Mann*

15–18 Sep. Hindemith and Scherchen organize celebrations Schönberg's 50th birthday, Frankfurt.

29 Aug. Büchergilde Gutenberg founded by German printers' union.

Early Oct. Eisler Piano Sonata op. 1 performed Vienna.

Oct. SPD's Bücherkreis issues its magazine.

10 Oct. Koussevitzky début as conductor Boston Symphony Orchestra.

End Oct/early Nov. First private showing of Léger/Dudley Murphy *Ballet mécanique*.

16 Oct. Křenek *Zwingburg* at Frankfurt Opera.

Nov. Mayakovsky in Paris hears from Lili Brik that Gosizdat is killing *LEF*.

22 Nov. Piscator/Gasbarra *Revue Roter Rummel*, music Meisel. Electoral agitation production for KPD, with Weinert, Neukrantz.

16 Nov. Janáček *The Cunning Little Vixen*, Brno.

30 Nov. First issue of *AIZ*, published by Neuer Deutscher Verlag for IAH.

1 Dec. Kabarett der Komiker founded by Kurt Robitschek in Berlin.

4 Dec. Satie/Picabia *Relâche* at Théâtre des Champs-Elysées.

1 Dec. First issue of *La Révolution Surréaliste*.

1925

Political events	The arts as a whole	Art and architecture

28 Feb. Death of Ebert.

Jan. LEF conference, Moscow. De Maré takes over lease of Théâtre des Champs-Elysées.
Feb. Police try to shut Red Aid children's home in Heinrich Vogeler's house, Worpswede.
5 March. Dessau town council discusses the Bauhaus.

During 1925:

> Soviet modern architects found OSA.
> Dix moves to Berlin on Nierendorf's advice.
> Grosz and Herzfelde *Die Kunst ist in Gefahr.*

12 March. Death of Sun Yat-sen.

21 March. Fifth plenum of Comintern Executive accepts Stalin's view that capitalism is stabilized.

24 March. Karl Raichle arrested for play *Der rote Schmied.*

During 1925:

> Arp applies for Swiss nationality and is turned down by cantonal council.
> Gruppe 1925 formed with Döblin and Becher on committee.

29 March and 26 April. German presidential election. Hindenburg 14.65%, Marx (centre party, supported by SPD), 13.75%, Thälmann 1.93%.

April. Chirico exhibition at L'Effort Moderne.

10 April. Herriot government falls. Painlevé premier.

April–May. Swedish Ballet dissolved. De Maré proposes opera–music hall in Théâtre des Champs-Elysées and withdraws to Grasse.

26 April. Hindenburg president.

Spring. OST group is formed in Russia, led by Shterenberg.

30 May. General strike in Shanghai. Chinese boycott British goods.

June. Miró exhibition at Galerie Pierre.

Also in 1925:

> Martinet and other Trotsky supporters leave French CP.
> Twenty-nine Kapp conspirators amnestied.

15 June. Cocteau returns to the Catholic church.

13 June. Lissitzky returns to Russia.

18 June. CC of Soviet CP resolution on literature (published *Pravda* 1 July).

14 June–13 Sep. Neue Sachlichkeit Exhibition at Mannheim.

July. 195,000 unemployed in Germany.

Summer. Exposition des Arts Décoratifs 1925, Paris.

15 July. Attack on Chirico in *La Révolution Surréaliste.*

12 July. Tenth KPD Congress Berlin. Meeting on agitprop.

29 July. Comintern executive summons Thalheimer, Neumann, Fischer etc. to be reprimanded for anti-Moscow policies.

16 Aug. IAH meeting Berlin: 'Hands off China!'.

10 Aug. Soviet Trade Delegation, Berlin, see Mendelsohn re commission to build dyeworks Leningrad.

5–16 Oct. Locarno conference, Russia not invited.

14 Oct. Bauhaus reopens at Dessau.

12 Oct. Soviet–German commercial treaty.

18 Oct.–22 Nov. Neue Sachlichkeit show at Dresden. Subsequently Chemnitz, Erfurt, Dessau, Halle and Jena.

31 Oct.–1 Nov. KPD conference Berlin condemns Left and Right. Scholem removed from CC, Fischer and Maslow from Politbüro. Thälmann chairman of latter.

Nov. First Surrealist Exhibition at Galerie Pierre, Paris.

9 Nov. SS founded.

4 Nov. Lissitzky lectures at Vkhutemas on international architecture.

25 Nov. In Reichstag KPD moves expropriation of German princes.
27 Nov. Briand becomes French premier.

9 Dec. IG Farben is formed.

29 Dec. Lissitzky to run architecture dept. of Vkhutemas and new 'photo-mechanical laboratory'.

Theatre and film	Music, ballet, opera	Writing and publication

During 1925:

Muenzenberg *Erobert den Film!*

Jan. Last issue of *LEF*.

27 Feb. *Coriolanus* dir. Engel, des. Neher at Deutsches Theater.

15 Feb. Police confiscate Becher's *Vorwärts du Rote Front!* poems.

19 March. CC of Soviet CP authorizes making of six 1905 anniversary films, including *Potemkin* and *Mother*.
31 March. Eisenstein starts shooting *Potemkin*.

21 March. Ravel *L'Enfant et les sortilèges*, Monte Carlo.

26 March. Mayakovsky contracts with Gosizdat for 4-volume collected works.

During 1925:

Milhaud *Esther de Carpentras*
Stravinsky *Serenade in A major* written for recording.
Armstrong starts recording with Hot Five.
Eisler moves to Berlin.

During 1925:

Kafka *Der Prozess*
Dos Passos *Manhattan Transfer*
Fitzgerald *The Great Gatsby*
Gide *Les Faux-Monnayeurs*
Feuchtwanger *Jud Süss*

28 April. Eisenstein *Strike* (Proletkino) shown Moscow.
 Shaw *Saint Joan* dir. Pitoëff, Théâtre des Arts.

3 May. Novembergruppe 'Der absolute Film' with *Entr'acte, Ballet mécanique*, works by Richter and Eggeling etc.

15–19 May. Third ISCM Festival, Prague, includes Martinů *Half-Time*.

13 May. *Hamlet* at Volksbühne, des. Schlemmer.

21 May. Busoni *Dr Faustus* Dresden opera.

28 May. Mayakovsky arrives Paris en route Mexico and USA.

5 June. Cocteau *Orphée* dir. Pitoëff, des. J. Hugo, at Théâtre des Arts.

23 May. Honegger Concertino for piano, Paris.

11 June. Weill Violin Concerto, Paris.

18 June. Police confiscate Becher's *Der Leichnam auf dem Thron*.

17 June. Auric *Les Matelots* at Théâtre de la Gaiété Lyrique, Paris.

July. Tenth KPD congress criticizes *Der Knüppel*.

12 July. *Trotz alledem!* in Grosses Schauspielhaus. KPD pageant, dir. Piscator, des. Heartfield, music Meisel.

1 July. Death of Satie.

27 July. Mayakovsky arrives USA (till 28 Oct.).

20 Aug. Kestenberg in Vienna engages Schönberg as professor at Berlin Academy for five years.

20 Aug. Arrest of Becher for literary high treason.

3–8 Sep. ISCM at Venice includes Grosz *Jazzband*, Eisler *Duo*, Grünberg *Daniel Jazz*.

18 Sep. Fallada gives himself up for embezzlement.

18 Sep. Deutsche Oper, Berlin, reopens under Bruno Walter, Dessau assistant conductor.

Oct. Tschichold edits special issue of *Typographische Mitteilungen* on 'Elementare Typographie'.

Autumn. Brecht leaves Deutsches Theater to work freelance. Reich settles in Moscow.

Nov. Max von Schillings leaves State Opera, Berlin.

14 Nov. Mayakovsky in Berlin en route USSR.

Also in 1925:

Chaplin *The Gold Rush*
Pabst *Die freudlose Gasse*
'Parfumet' agreement of US firms with UFA. Start of quota system in Germany.

Also in 1925:

Release of first electrical recordings.

Also in 1925:

Paulhan becomes editor of *NRF*.
Clarté founded.
AIZ reaches circulation of 450,000.

3 Dec. Gershwin Piano Concerto, New York.

19 Dec. Prometheus-Film founded by IAH.

21 Dec. *Potemkin* shown Moscow.

22 Dec. Zuckmayer *Der fröhliche Weinberg*, Theater Schiffbauerdamm.

14 Dec. Berg *Wozzeck* cond. Kleiber, Berlin State Opera.

End of year. Rote Hilfe pamphlet *Politische Justiz gegen Kunst und Literatur*.

Political events	The arts as a whole	Art and architecture

1926

Jan. Stalin tells Comintern executive KPD should try and win over the workers.

20 Jan. Luther (SPD) becomes German chancellor.

During 1926:

MASch set up in Berlin under Duncker and Schmidt-Radványi. Discussions on formation of a single writers' federation in USSR. 'Ring' formed of some twenty-five modern German architects.

During 1926:

Vkhutemas renamed Vkhutein. Richard Döcker: Waiblingen hospital, Stuttgart. Loos House for Tzara, 15 Avenue Junot, Paris. Hanna Höch moves to Holland.

17 Feb. Sixth plenum of Comintern executive criticizes extreme Left.

23 Feb. Lissitzky and Ladovsky team up for a housing competition.

March. Togliatti joins Comintern secretariat.

20 March. Chiang Kai-shek coup, Canton.

March. Lunacharsky lectures in Berlin. Toller visits the USSR (till May).

25 March. *AIZ* competition for amateur photographers.

16 March. Last public statement by Rote Gruppe.

22 March. Grosz tells Kessler he has resumed painting.

29 March–4 April. Grosz show at Flechtheim gallery.

24 April. Soviet–German neutrality pact (Treaty of Berlin).

29 April. Borodin in Canton makes terms with Chiang.

May. Marx becomes Chancellor. Hindenburg allows use of red-white-black flag.
12 May. Pilsudski coup in Poland.

20 June. German plebiscite on expropriation of princes. 36.4% for.

13 June. Unveiling of Mies van der Rohe 'Revolutionsdenkmal' for KPD.

Also in 1926:

Young Communists in Germany (KJVD) set up First Agitprop Group under Maxim Vallentin.

May. Lissitzky to Germany to work on Dresden show. Proposes to Sophie Küppers in Hanover and is commissioned to design abstract gallery there.

June–Sep. Dresden International Art Exhibition. Soviet section includes Lissitzky abstract room and works by OST artists.

15 July. Briand falls. Poincaré becomes premier (till 1929).

10 Aug. French franc devalued.

8 Sep. Germany admitted to League of Nations.

Summer–autumn. Work on Bauhaus buildings. Feininger's house ready in July.

9 Oct. Seeckt resigns as German C. in C. after a Hohenzollern revealed to be serving.
Oct. Trotsky and Zinovieff expelled from Politbüro.

Oct. Bauhaus under Anhalt education authorities, becomes 'Hochschule für Gestaltung'.

Nov. Mussolini abolishes the Opposition.

26 Nov.–31 Dec. Soviet CP Fifteenth Party Congress. Debate on 'Socialism in One Country'.

Nov. Land government threaten to remove Heinrich Vogeler's frescoes from his former house. Protest led by Eduard Fuchs. They are covered over instead.

4 Dec. Opening of Bauhaus new buildings at Dessau.

5 Dec. Death of Monet, aged 86.

1927

29 Jan. Marx again Chancellor. SPD in opposition.

31 Jan. End of allied control of Germany.

10–15 Feb. Anti-colonial conference Brussels with Barbusse, Muenzenberg, Toller, Goldschmidt, Holitscher etc.

Jan. Breton, Aragon, Eluard, join French CP.

27 Jan. Lissitzky and Sophie Küppers marry in Moscow.

Theatre and film	Music, ballet, opera	Writing and publication

1926

Theatre and film	Music, ballet, opera	Writing and publication

During 1926:

Ruttmann *Berlin*
Lang *Metropolis*
Mezhrabpom-Russ is reorganized as Mezhrabpom-Film.

1 Jan. Leningrad Society for New Music founded under Igor Glebov (Asafiev).

10 Jan. Schönberg arrives to teach in Berlin.

12 Jan. Shostakovitch Symphony no. 1, Leningrad Philharmonic, cond. M. Chalko.

28 Jan. Weill marries Lotte Lenya.

Jan.–March. Mayakovsky lecture tour of USSR.

14 Feb. Brecht *Baal*, dir. Brecht, des. Neher, Junge Bühne.

19 Feb. Holländer revue *Laterna Magica* at Renaissance-Theater.

20 Feb. Paquet *Sturmflut* dir. Piscator, Volksbühne. With use of film.

27 Feb.–15 March. International Theatre Exhibition, New York, organized by *The Little Review* and designed by Kiesler.

18 Feb. Prokofieff *Love of Three Oranges*, Leningrad Academic Theatre, dir. Radlov, des. Dmitriev.

March. Milhaud visits the USSR.

3 March. Schönberg writes to Zemlinsky condemning Eisler for levity.

27 March. Weill/Kaiser: *Der Protagonist*, Dresden Opera, cond. Busch.

4 Feb. Becher *Levisite* seized by police.

March. Karl Korsch starts independent monthly *Kommunistische Politik* (and is expelled from KPD in May).

26 March. Fallada sentenced in Kiel to two years' imprisonment.

24 March. Berlin censors ban *Potemkin* at Reichswehr request.

Spring. Eisenstein in Berlin working with Meisel on *Potemkin* music.

29 April. *Potemkin* Berlin premiere after ban lifted.

May. Ninth congress DATB. Communist groups take part on Duncker's advice and form Left opposition.

27 April. Walton *Façade* at Chenil Gallery, London.

3 May. Berlin State Opera closed for rebuilding.

4 May. Lambert *Romeo and Juliet*, Monte Carlo.

23 June. Weill Violin Concerto at ISCM festival, Zurich.

24–25 July. Donaueschingen Festival. Music for mechanical instruments and brass bands by Hindemith, Toch, Stuckenschmidt. Richter *Filmstudie*.

Spring. Traven *Das Totenschiff* starts publication of his novels by Büchergilde Gutenberg.

12–28 July. Renewed ban on *Potemkin*.

July. Mayakovsky and Shklovsky work on A. Room film *The Jew on the Land*.

11 Sep. Schiller *Die Räuber* dir. Piscator, Volksbühne.

25 Sep. Brecht *Mann ist Mann* dir. Geis, des. Neher, Darmstadt.

Aug. Kestenberg offers Kroll-Oper to Klemperer.

30 Sep. First Klemperer concert in Berlin.

Also in 1926:

Kafka *Das Schloss*
Dreiser *An American Tragedy*
Becher *Maschinenrhythmen*
Muenzenberg founds *Welt am Abend*, Berlin evening paper.

Also in 1926:

Eisler teaches Klindworth-Scharwenka Konservatorium and applies to join KPD.
Stuckenschmidt takes over music side of Novembergruppe.

Oct. First issue of *Die Arena*. Universum-Bücherei is founded in Berlin by IAH.

Nov. First Soviet–German co-production by Prometheus, Alexander Razumny's *Überflüssige Menschen,* shown Berlin.

Holländer/Schiffer revue *Hetärengespräche*, Kleines Theater, Berlin.

9 Nov. Hindemith *Cardillac* at Dresden Opera.

28 Nov. Bartók *The Miraculous Mandarin*, Cologne Opera. Banned following premiere on Adenauer orders.

1 Nov. *AIZ* becomes a weekly.

? Dec. Mayakovsky applies to CC to restart *LEF*.

29 Dec. Death of Rilke aged 51.

1927

14 Jan. Prokofieff plays his 3rd Piano Concerto in Moscow with the Persymfans.

10 Feb. Křenek *Jonny spielt auf*, Leipzig Opera.

1 Jan. First issue of RFB journal *Der Rote Führer.*

During 1927:

Traven *Schatz der Sierra Madre*
German translations of Gladkov *Cement*, Loos *Gentlemen Prefer Blondes*
Malevitch *The Non-objective World*
Proust *Le Temps retrouvé*
Brecht *Hauspostille*

Mid-March. Gropius working on Totaltheater for Piscator.

2 March. Weill/Goll *Royal Palace* and Falla *Retablo* at Kroll-Oper, cond. Kleiber.

Political events	The arts as a whole	Art and architecture
2–7 March. Eleventh Congress of KPD at Essen decides central organization of agitprop groups and calls for 'Roter Kulturkampffront'.	4 April. Appeal to Hungarian government by Communist fraction of Reichs verband bildender Künstler headed by Vogeler and Gehrig-Tarsis.	March–April. 'Neue Sachlichkeit' show at Nierendorf's gallery, Berlin. 29 March–30 Sep. 55 works by Malevitch in Grosse Berliner Kunstausstellung at Novembergruppe's invitation.
5 April. Italian–Hungarian friendship treaty. 18 April. Chiang splits with the Communists.	Easter. Meeting of 'worker-photographers' at Erfurt.	May. Le Corbusier gains first prize in Palais des Nations competition but is disqualified on a technicality. Summer. Werkbund Exhibition, Stuttgart. Opening of Weissenhofsiedlung, supervised by Mies van der Rohe.

Political events:

2–7 March. Eleventh Congress of KPD at Essen decides central organization of agitprop groups and calls for 'Roter Kulturkampffront'.

5 April. Italian–Hungarian friendship treaty.

18 April. Chiang splits with the Communists.

15–18 July. General strike in Vienna.

22 Aug. Execution of Sacco and Vanzetti.

27 Dec. All-Union CP congress expels Trotsky from party as a deviationist.

The arts as a whole:

4 April. Appeal to Hungarian government by Communist fraction of Reichs verband bildender Künstler headed by Vogeler and Gehrig-Tarsis.

Easter. Meeting of 'worker-photographers' at Erfurt.

Summer. First Exhibition of Architecture of the Present Day at Vkhutemas, organized by OSA and designed by Gan. Includes a Bauhaus section.

Oct. Théâtre des Champs-Elysées leased to Jefferson Davis Cohn as a cinema.

15–16 Nov. First international conference of Revolutionary writers, Moscow, founds IVRS. Becher, Lask, Holitscher, Weiskopf attend.

Art and architecture:

March–April. 'Neue Sachlichkeit' show at Nierendorf's gallery, Berlin.

29 March–30 Sep. 55 works by Malevitch in Grosse Berliner Kunstausstellung at Novembergruppe's invitation.

May. Le Corbusier gains first prize in Palais des Nations competition but is disqualified on a technicality.

Summer. Werkbund Exhibition, Stuttgart. Opening of Weissenhofsiedlung, supervised by Mies van der Rohe.

> Also in 1927:
>
> Baumeister sports pictures
> Dix to Dresden Academy
> Nierendorf gallery
> 'Bildnisgestaltung' show
> Lissitzky designs Typographical Exhibition, Moscow, and Abstract room in Hanover art gallery.
> Léger gives a painting to Museum of Modern Western Art.
> Magritte moves to Paris.

Nov. Kollwitz pays first visit to USSR.

27 Dec. Committee of five ambassadors appoint Nénot chief architect of Palais des Nations, Geneva.

1928

Political events:

19 Jan. Groener succeeds Gessler as Reichswehr minister, following Phoebus scandal.

> During 1928:
>
> Brazilian economy collapses due to over-production of coffee.

22 April. Union of the Left wins French elections.

May. Chinese Red Army founded Hunan province.

12 May. Mussolini disenfranchises two-thirds of Italian electorate.

20 May. Reichstag elections. 12 Nazis, 73 nationalists, 153 SPD (biggest since 1919 Assembly), 54 KPD.

20 June. Hermann Müller (SPD) Chancellor, heading 'Grosse Koalition' (till 1930).

The arts as a whole:

13 Jan. Volksverband für Filmkunst founded under H. Mann presidency.

4 Feb. Gropius announces intention to resign Bauhaus in favour of H. Meyer.

1 April. Hannes Meyer succeeds Gropius.

30 April–10 May. First Congress of Proletarian Writers founds RAPP.

28 May. Gorki arrives Moscow, met by Bukharin, Lunacharsky etc.

Summer. Lissitzkys travelling, visit Tschichold, May, Mondrian, Ehrenburg. Soviet CP resolution on literature.

> Also in 1928:
>
> AEG experiments with tape recording.
> RCA buys the Victor Company.

Art and architecture:

30 Jan. Working Party of German Communist Artists founded, with Heartfield, Keil, Gehrig-Tarsis etc.

Feb. Léger show at Flechtheim gallery, Berlin.

March. Invitations sent out for La Sarraz meeting of architects (June).

May. Beckmann show at Flechtheim gallery.
First All-Union congress of AKhRR, renamed AKhR.

19 June. *Die Rote Fahne* reports foundation of ARBKD.

25–29 June. La Sarraz architects' meeting sets up CIAM.

30 March. Public meeting in Berlin Herrenhaus against non-political stance of Volksbühne is backed by Toller, Piscator, Jessner, Tucholsky etc.

22 March. Eisler starts as music critic for *Die Rote Fahne*.

10 April. Antheil recital at Carnegie Hall includes his *Ballet mécanique*.

10 May. Mayakovsky press conference Berlin.

During 1927:

Sven Noldan *Der Weltkrieg*
Pabst *The Love of Jeanne Ney*
The Jazz Singer with Al Jolson
Short film *Arbeitersport* made by Prometheus.
Holländer/Seeler revue *Rund um die Gedächtniskirche* at Theater am Kurfürstendamm.

30 May. Stravinsky/Cocteau *Oedipus Rex*. Théâtre Sarah Bernhardt, sponsored by Princesse de Polignac.

Also in 1927:

Hindemith moves to Berlin.
Milhaud *Le Pauvre Matelot*, Théâtre de la Monnaie, Brussels.

7 June. Prokofieff *Le Pas d'acier*, chor. Massine, Paris.

13 June. Berg *Wozzeck* at the Leningrad Opera.

14 June. Glière, *The Red Poppy* ballet, Moscow Opera.

Also in 1927:

Lily Becher becomes editor of *AIZ*, claims 265,000 circulation.
New LEF appears.
First issue of *Sov'etskoe Kino*

3 Sep. Piscator opens own 'Piscatorbühne' in Berlin with Toller's *Hoppla, wir leben!*

5 Oct. 'Blue Blouses' agitprop group start tour of Germany at IAH invitation.

Nov. Eisler becomes musical director of KJVD First Agitprop Group.

17 July. Baden-Baden Festival: Hindemith *Hin und Zurück*, Weill/Brecht *Mahagonny*. Film music by Hindemith to Richter *Vormittagsspuk*, by Eisler to Ruttmann *Opus III* etc., financed by Tri-Ergon.

Sep. *Leipziger Neueste Nachrichten* send Kästner to Berlin as a result of 'Abendlied' poem.

12 Oct. Becher indicted.

6 Nov. *Jonny spielt auf* at Städtische Oper, Berlin, dir. Martin.

19 Nov. Kroll-Oper under Klemperer opens with *Fidelio*, des. Dülberg.

Mid-Oct. Friedrich Wolf moves to Stuttgart.

28 Dec. Alfred Barr meets Tretiakoff and Eisenstein in Moscow.

Dec. Eisler *Zeitungsausschnitte* op. 21 performed Berlin.

4 Dec. Ellington's band opens at the Cotton Club.

Dec. Last issue of *Clarté*.

1928

23 Jan. *Adventures of the Good Soldier Schweik* dir. Piscator, des. Grosz at the Piscatorbühne (till 12 April).

Jan. Prokofieff *Chout* at Kiev Opera: only Soviet production.

10 Jan. *AIZ* holds first literary evening, Berlin, featuring Heinrich Mann.

18 Feb. Weill/Kaiser *Der Zar lässt sich photographieren*, Leipzig.

14 March. Eisenstein *October* first showing.

25 Feb. *Oedipus Rex, Mavra* and *Petrouchka* at Kroll-Oper, cond. Klemperer.

Feb. Giedion completes foreword *to Bauen in Frankreich, Eisen, Eisenbeton.*

March. *Melos* inquiry re 'Zeitoper'.

8–9 April. Tenth Congress of DATB, Berlin. Communists take over. A. Pieck chairman, Balázs artistic dir.

27 April. Stravinsky *Apollon Musagète*, Washington.

21 April. Lili Brik in Berlin.

24 April. Mussorgsky *Pictures at an Exhibition* des. Kandinsky, Dessau.

27 May. Prokofieff *Le Pas d'acier* suite, Moscow.

4 May. Mayakovsky to write a play for Meyerhold.

May. Schiffer/Spoliansky *Es liegt in der Luft* at Komödie, with Dietrich.

29 May. Berlin State Opera moves back to own building.

Spring. Kästner *Herz auf Taille*.
Pressa exhibition opens Cologne. Soviet pavilion des. Lissitzky, visited by Gorki, Kisch.

June. First Piscatorbühne bankrupt, loses its theatre.

June. *Der Protagonist* and *Der Zar lässt sich photographieren*, Frankfurt.

Also in 1928:

Junge Bühne wound up.
Disney *Steamboat Willie*
Chaplin *The Circus*

30 June. *Cardillac* at Kroll-Oper, cond. Klemperer, des. Dülberg.

Summer. Tretiakoff takes over editorship *Novy LEF*.

Political events	The arts as a whole	Art and architecture
14 July. German amnesty law. Case against Becher dropped, Hölz released 18 July.		
17 July–1 Sep. Sixth Comintern Congress. Emphasis on war threat and struggle against Socialists.	Autumn. 'October' group of artists in USSR formed with Lissitzky, Eisenstein, Dziga-Vertov, Ginsburg, Deneika, Kurella. Against AKhR.	Aug. ARBKD meets. Sep.–Oct. Werkbund exhibition 'Der Stuhl' at Stuttgart.
Sep. Tolstoy centenary.		
1 Oct. Nominal start of Soviet Five-Year Plan.	1 Oct. First Plenum of RAPP.	
4–16 Oct. Failure of German plebiscite against building a battle-cruiser.	Oct. KPD sets up a cultural secretariat.	Oct. Second full meeting of ARBKD, with three reps. from AKhR.
6 Oct. Chiang president of China.		
20 Oct. Hugenberg becomes chairman of DNVP (Nationalists).	19 Oct. BPRS founded, on lines of RAPP, as section of IVRS.	

Also in 1928:

 AHAG exhibition, Zehlendorf, Berlin
 Russians set up Central Office for Foreign Consultation in Matters of Building.
 Dali meets the Surrealists.
 Breton publishes *Le Surréalisme et la peinture*.

Political events	The arts as a whole	Art and architecture
30 Dec. KPD opposition formed, with Brandler, Thalheimer, Walcher etc.	22–28 Dec. All-Union CP conference on literature, resolution 'On the Provision of Books to the Mass Reader'.	

1929

Political events	The arts as a whole	Art and architecture
5 Jan. Royal dictatorship established in Jugoslavia.	Jan. Voronsky arrested as Trotskyite.	
		25 Jan. ARBKD discussion meeting, addressed by Kemény. Break with AKhR.
31 Jan. Trotsky banished, goes to Turkey.		2 Feb. CIAM at Basel choose minimal cost housing as theme for second congress.
9 Feb. Start of reparations conference, Paris.		
	26 Feb. Kampfbund für deutsche Kultur founded by Alfred Rosenberg.	

During 1929:

 VOPRA set up.
 Werkbund exhibition Breslau 'Wohnung und Werkraum'

Political events	The arts as a whole	Art and architecture
9–10 March. International anti-fascist conference, Berlin, with Barbusse.	7 March. *Die Rote Fahne* appeals against 'Kulturreaktion'.	

During 1929:

 Kodak develop 16mm. colour film.
 Lunacharsky resigns and is succeeded by Bubnov, after Gorki has said his education policy diverges from Stalin's line.
 The Graf Zeppelin flies round the world.

Also in 1929:

 Richter helps found German League for Independent Film.

Political events	The arts as a whole	Art and architecture
23–29 April. Sixteenth Party Congress, Moscow, approves Five-Year Plan.		

Theatre and film	Music, ballet, opera	Writing and publication

<table>
<tr>
<td></td>
<td>

Also in 1928:

Oedipus Rex and *Les Noces* performed in Leningrad.

</td>
<td></td>
</tr>
</table>

Theatre and film

Aug. Statement on sound film by Pudovkin and Alexandrov.

31 Aug. Brecht/Weill *The Threepenny Opera*, dir. Engel, des. Neher at Theater am Schiffbauerdamm.

1 Oct. Vallentin's KJVD agitprop group renamed 'Das Rote Sprachrohr'.

16 Oct. Weisenborn *U-Boot S4* at Volksbühne, dir. Leo Reuss.

23 Oct. Bruckner *Verbrecher*, dir. Hilpert at Deutsches Theater.

Oct. Granovsky's Moscow Jewish Theatre plays in Berlin.

28 Nov. Feuchtwanger *Die Petroleuminseln* at Staatstheater, dir. Fehling, des. Neher, mus. Weill.

2 Dec. Lampel *Revolte im Erziehungshaus*, first production of Gruppe Junger Schauspieler.

16 Dec. *Hoppla, wir leben!* at Theatre of the Revolution, Moscow, dir. Fedorov (100 performances).

Music, ballet, opera

5 Sep. Legal produces *Salome* at Kroll-Oper with Neher sets. End of Klemperer–Dülberg monopoly of production and start of second phase.

11–15 Sep. ISCM Festival Siena includes *Façade*, *Les Noces*, de Falla Harpsichord Concerto and E. F. Burian's 'Voice-Band'.

16 Oct. *L'Histoire du soldat* at Kroll-Oper, dir. Geis, des. T. Müller.

19 Oct. Honegger *Le Rugby*, Paris.

31 Oct. *Carmen* at Kroll-Oper, dir. Legal, des. Neher.

2 Dec. Schönberg Variations for Orchestra, Berlin Philharmonic.
 Křenek triple bill at Kroll-Oper, dir. Legal.

14 Dec. Hauer Symphony at Klemperer concert.

Writing and publication

Aug. Erich Knauf becomes chief editor for Büchergilde Gutenberg.

Oct. *Die Neue Bücherschau* enquiry about working-class reflections in literature and art.

7 Oct. Universum-Bücherei first literary event, Theater am Nollendorfplatz, features Toller.

<table>
<tr>
<td>

Also in 1928:

Isherwood *All the Conspirators*
Seghers *Aufstand der Fischer von Santa Barbara*
Ludwig Renn *Krieg*
Friedrich Wolf joins the KPD. Writes *Kunst ist Waffe*.
Auden visits Berlin.
Weiskopf arrives from Prague to be 'Feuilleton' editor *Berlin am Morgen*.

</td>
</tr>
</table>

End of year. Karl Schroeder becomes chief editor of SPD Bücherkreis.

1929

1 Jan. *Arbeiterbühne* reappears under editorship Alfred Raddatz.

8 Jan. Dziga-Vertov *The Man with the Movie Camera* premiere Kiev.

Early Jan. Berlin premiere of *Storm over Asia*, attended by Pudovkin.

17 Jan. German censor bans *Salamander*, Prometheus/Mezhrabpom co-production of script by Lunacharsky.

13 Feb. Mayakovsky *The Bedbug* dir. Meyerhold, des. Rodchenko, mus. Shostakovitch, Moscow.

14 Feb. *Der lebende Leichnam.* Prometheus/Mezhrabpom co-production, dir. F. Ozep with Pudovkin in main part.

5 March. Lampel *Giftgas über Berlin* single performance at Theater am Schiffbauerdamm, dir. Brecht with Gruppe junger Schauspieler.

20 March. Anderson *What Price Glory?* ad. Zuckmayer, dir. Piscator, des. Neher, Berlin.

Mid-March. *Hunger in Waldenburg*, script Lania, dir. Jutzi for Volksfilm-Verband and Theater am Schiffbauerdamm.

30 March. Fleisser *Die Pioniere von Ingolstadt* at Theater am Schiffbauerdamm, dir. Geis and Brecht, with Lorre, Lenya etc.

March. *10 Jahre Komintern* by Das Rote Sprachrohr, with Eisler's Comintern Song.

1 Jan. RAPM publishes first issue of *Proletarian Musician*.

8 Feb. Klemperer concert includes *Sixth Brandenburg*, Weill *Kleine Dreigroschenmusik*, Hindemith Violin Concerto and Stravinsky *Pulcinella* suite.

11 Feb. *Tales of Hoffmann* at Kroll-Oper, dir. Legal, des. Moholy-Nagy, cond. Zemlinsky.

March, 'Kampfbund' lecture by Alfred Heuss attacking Křenek and Weill.

<table>
<tr>
<td>

During 1929:

Stuckenschmidt becomes critic of *BZ am Mittag* vice Weissmann.
Decca company founded.
Lehár *Land des Lächelns*
Nick/Kästner *Leben in dieser Zeit*, Breslau radio

</td>
</tr>
</table>

13 April. Brand *Maschinist Hopkins* cond. Drach, Duisburg Opera.

27 April. Klemperer concert includes Hindemith Concerto for Orchestra.

29 April. Prokofieff *The Gambler*, Brussels.

Jan. Universum book club journal renamed *Magazin für Alle*.

<table>
<tr>
<td>

During 1929:

Remarque *Im Westen nichts Neues*
Kästner *Emil und die Detektive*
Ottwalt *Ruhe und Ordnung*
Hemingway *A Farewell to Arms*
Saint-Exupéry *Courrier Sud*

</td>
</tr>
</table>

20 Feb. Mayakovsky signs contract with Malik-Verlag, then on to Paris and Nice.

14 March. Isherwood leaves London for three years in Berlin.

April. First issue of *Literaturnaya Gazeta*.

5 April. Fallada marries Anna Issel.

10 April. Brecht marries Helene Weigel.

Political events	The arts as a whole	Art and architecture

1 May. Berlin police fire on demonstrators. *Rote Fahne* and RFB subsequently banned.

May. Opel sells out to General Motors.

8–15 June. KPD congress denounces SPD as 'social-fascist' and votes to split trade unions by a 'Rote Gewerkschafts-Opposition'.

June. AEG sells 25% share to GEC.

27 July. Briand succeeds Poincaré as premier.

6–13 Aug. Reparations conference at The Hague. Young Plan accepted. Allies to leave the Rhineland by June 1930.

26 Sep. Sklarek scandal. Mayor of Berlin resigns. Some arrests.

3 Oct. Death of Stresemann.

24 Oct. 'Black Friday'. Wall Street crash, initiating world economic crisis and withdrawal of loans to Germany.

17 Nov. Prussian elections.
 Bukharin removed from Politbüro.

30 Nov. Second Zone of the Rhineland evacuated.

21 Dec. Hilferding (SPD) resigns as finance minister.

18 May–17 June. Werkbund exhibition 'Film und Foto', Stuttgart.

19 Aug. Death of Diaghileff.

Late Aug. IATB formed, Moscow, with A. Pieck, Lode, Wangenheim, Balázs as German reps.

2–7 Sep. La Sarraz meeting of cineastes.

Oct. KPD sets up IfA as central supervisory body for 'workers' culture'.

3 Oct. Meeting to found REF at Polytechnic Museum, Moscow.

4 Dec. *Pravda* leading article on proletarian literature supports RAPP.

May. Neue Sachlichkeit show at Stedelijk Museum, Amsterdam.

Summer. The Eluards visit Dali in Spain.

9 Aug. Death of Zille.

1 Oct. Schlemmer leaves the Bauhaus for Breslau Academy.

> Also in 1929:
>
> Moholy-Nagy *Vom Material zur Architektur* (first version of *The New Vision*)
> Lurcat *Architecture*
> Giedion *Befreites Wohnen*

Dec. Last issue of *La Révolution Surréaliste* with Breton's Second Manifesto.

1930

23 Jan. Frick becomes education minister in Thuringian cabinet. First Nazi in such a post.

Feb. King Carol begins personal rule in Rumania.

6 Feb. Austro-Italian friendship treaty.

23 Feb. Horst Wessel shot in Berlin street brawl.

March. German industrialists (including Krupp and AEG) send delegation to USSR.

27–30 March. Hermann Müller resigns. Brüning Chancellor, SPD in opposition. End of parliamentary rule in Germany.

Jan. Jessner resigns from Berlin Staatstheater and is succeeded as Intendant by Legal.

Mid-Jan. REF decides to enter RAPP following *Pravda* article.

March. RAPP campaign against Litfront.

9 March. Ermilov article in *Pravda* 'Some Manifestations of Petty-Bourgeois "Leftism" in Literature' attacks Mayakovsky.

1 April. Frick 'Ordinance against Negro Culture'.

Mid-April. Schulze-Naumburg becomes head Weimar Applied Art School vice Bartning.

3 Feb. CIAM committee for third congress (Stam, Schmidt, Bourgeois, Giedion) meet at Le Corbusier's.

21 April. Mühsam *Sacco und Vanzetti* dir. Lindtberg for November-Studio.

> Also in 1929:
>
> Kozintsev/Trauberg *The New Babylon*, with Shostakovitch music.
> Tissé makes *Frauennot-Frauenglück* for Praesens.
> Piscator publishes *Das politischer Theater*.

Aug.–Nov. IAH arranges Soviet tour by Das Rote Sprachrohr.

31 Aug. (Brecht)/Weill *Happy End* at Theater am Schiffbauerdamm.

Autumn. 'Die Katakombe' opens, Berlin, including Busch, for whom Eisler writes songs. Martin becomes Intendant of the Volksbühne.

6 Sep. Mehring *Der Kaufmann von Berlin*, dir. Piscator, des. Moholy-Nagy, mus. Eisler. Sole production of Second Piscatorbühne.

3 Oct. End of Second Piscatorbühne.

9 Oct. Wolf *Cyankali* at Lessingtheater with Gruppe junger Schauspieler.
Tretiakoff *Roar, China!* trs. Lania at Frankfurt Schauspielhaus.

13 Nov. Balázs/Tetzner *Hans Urian geht nach Brot*. Gruppe junger Schauspieler.

23 Nov. Credé *§218* is first production of Piscator Collective, opening at Mannheim.

1 Dec. *Das Rote Sprachrohr*, on return, initiates competition of agitprop groups.

30 Dec. Prometheus film *Mutter Krausens Fahrt ins Glück*, dir. Jutzi, at Alhambra, Berlin.

22 May. Weill/Brecht *Berliner Requiem*, Frankfurt Radio.

8 June. Hindemith *Neues vom Tage*, dir. Legal, des. T. Müller, cond. Klemperer, at Kroll-Oper.

18 June. Klemperer concert includes first Berlin performance of *Les Noces*.

End July. Baden-Baden Festival includes Weill/Brecht *Lindberghflug* and Eisler/Weber *Tempo der Zeit* for radio: and Hindemith/Brecht *Lehrstück*. Start of Brecht's didactic period.

Aug. Eisler and Busch meet during Piscatorbühne rehearsals.

27 Sep. Triple bill at Kroll-Oper: *L'Heure espagnole*, *Le Pauvre Matelot*, *Angélique*, dir. Gründgens, des. Neher.

6 Dec. Stravinsky *Capriccio*, cond. Ansermet, Paris.
Klemperer concert includes *Lindberghflug*, Hindemith Cello Concerto and *Les Noces*.

12 Dec. Lambert/Sitwell *The Rio Grande*, Manchester.

2 May. Mayakovsky returns to Moscow.

May. Brecht meets Benjamin.

1 July. Glebov's book on Stravinsky published Leningrad.

1 Aug. First issue of *Die Linkskurve*.

Aug. Rowohlt meets Fallada on Sylt and gives him a job.

21 Sep. Start of sentencing of Communist journalists. Fritz Gabler of Jena *Neue Zeitung* gaoled for two years.

18 Oct. Karl Bobach of Chemnitz *Kämpfer* gaoled for one year.

5 Nov. M. Schneider of Cologne *Sozialistische Republik* gaoled for eighteen months.

> Also in 1929:
>
> Thomas Mann awarded Nobel Prize for literature.
> Weinert joins KPD.

1930

Jan. Film of *Revolte im Erziehungshaus*, dir. Asgaroff, scr. Solski.

12 Jan. Gruppe junger Schauspieler start tour of Germany and Switzerland with *Cyankali*.

Feb. German premiere of Eisenstein *The General Line*.

16 March. Mayakovsky *The Bath House* at Meyerhold's theatre.

April. Meyerhold Theatre plays *Roar, China!* etc. in Berlin.
Gruppe junger Schauspieler play *Revolte* and *Cyankali* in Meyerhold Theatre, Moscow.

13 Jan. Shostakovitch *The Nose*, Maly Theatre, Leningrad.

4 March. Křenek. *Leben des Orest* at Kroll-Oper, dir. Legal, des. Chirico and Otto.

9 March. Weill/Brecht *Aufstieg und Fall der Stadt Mahagonny* Leipzig Opera.

30 March. W. Grosz *Achtung, Aufnahme!!*, Frankfurt Opera.

Feb. Osip and Lili Brik to Berlin.

April. Marchwitza succeeds Gábor on editorial board *Linkskurve*. Wittfogel joins.

Political events	The arts as a whole	Art and architecture

During 1930:

Schmeling becomes world heavyweight champion.

14 April. Mayakovsky kills himself.

6 May. 'Junge Volksbühne' members split off from Volksbühne.

May. Ernst May lectures in Moscow.

14 May–13 July. Werkbund section in Salon des Artistes–Décorateurs at Grand Palais, Paris. Des. Gropius and Moholy-Nagy. Schlemmer first meetings with Mondrian and Arp.

2 June. Suicide of Pascin in Paris.

30 June. Last Allied troops leave the Rhineland (Third Zone).

End June. First IATB congress, Moscow.

16 July. Presidential authority under Article 48 of Weimar Constitution used to pass Brüning's budget.

8 July. Soviet painting exhibition in Berlin Sezession. 302 works, organized by VOKS. Kemény favours OST against AKhR.

18 July. Reichstag dissolved.

21 July. Litvinov Soviet Foreign Minister.

1 Aug. Hannes Meyer sacked as director of Bauhaus.

25 Aug. New Polish government under Pilsudski. Measures against the Left.

Autumn. Prussian State Budget makes no provision for the Kroll-Oper in 1931.

14 Sep. Reichstag elections. 107 Nazis, 41 nationalists, 143 SPD, 77 KPD. Nazis gain 95 seats and become second biggest party.

Oct. Meyer becomes head of WASI, successor to Vkutein now placed under Heavy Industry Commissariat.

Oct. Severing (SPD) again Prussian Minister of the Interior with Grzezinski as police president.

Oct. Volksbühne makes Kroll-Oper take off *Neues vom Tage*.

Nov. Schulze-Naumburg in Weimar removes works by Barlach, Klee, Kandinsky, Schlemmer.

8 Oct. Ernst May and Frankfurt planning team leave for Moscow.

11 Nov. Anti-communist laws in Finland.

6–15 Nov. IVRS congress at Kharkhov, addressed by Averbakh. Becher and Marchwitza elected to presidium.

Oct.–2 Nov. ARBKD show 'An der Front des 5-Jahr-Plans' includes work from October group.

12 Dec. Allies evacuate the Saar territory.

14 Nov. MBRKh (International Bureau of Revolutionary Artists) formed Moscow with Uitz, Kurella, Grandjouan.

27–29 Nov. CIAM congress again on minimal housing, Brussels.

9 Dec. Stam lectures on Magnitogorsk plan, Moscow.

25 Dec. State of emergency throughout Germany.

1931

15 Jan. Grzezinski bans annual ceremony at Mies's Revolution monument.

?Jan. Piscator briefly gaoled for back entertainment tax.

27 Jan. Laval becomes French premier.

20 Jan. Tretiakoff lectures in Berlin Russischer Hof on 'The Writer and the Socialist Village'. During his German tour he meets Brecht, Eisler, Heartfield etc.

Feb. Mosley founds his New Party.

During 1931:

Shterenberg is accused of 'Formalism'.
Belling elected to Prussian Academy.

19 Feb. Arrest of Wolf and Dr Kienle-Jacubowitz on abortion charges. Wolf released on 28th.

20 March. Death of Hermann Müller.

14–15 March. IfA national congress, Leipzig.

28 March. Emergency decree.

Spring. ARBKD becomes B(und)RBKD.

April. Right parties abandon Frick and cancel his measures.

2 April. Grzezinski bans use of agitprop at political meetings.

Spring. Stahlhelm presses for dissolution of Prussian Landtag.

Spring. Visits to Russia. Becher (April–June), Ihering (May–June), Piscator (arrives April), Otto Katz (ditto), Wolf (arrives 18 May), Heartfield (stays a year), Eisler (June–July).

25 April–31 May. Photomontage exhibition, Berlin. Kunstgewerbe Museum, with Soviet section including Lissitzky, Rodchenko etc. organized by VOKS.

11–12 May. Collapse of Vienna Kreditanstalt.

Theatre and film	Music, ballet, opera	Writing and publication

3 April. Piscator Collective takes over Wallner-Theater, Berlin, with §218.

18–21 April. Eleventh Congress of ATBD (ex-DATB) Dortmund, representing c. 300 groups.

23 May. Film Cyankali dir. Hans Tintner. Westfront 1918 dir. by Pabst, scr. Vadja and Lampel, for Nero-Film.

14 June. A. Herzog Krach um Leutnant Blumenthal at Theater am Schiffbauerdamm with Spielgemeinschaft Berliner Schauspieler.

> Also in 1930:
>
> The Blue Angel
> Das Flötenkonzert von Sanssouci
> Tauber Das Land des Lächelns, film
> Clair Sous les toits de Paris
> Vitaphone goes over to sound-on-film. Tobis and Western Electric divide the European market.

31 Aug. Plievier Des Kaisers Kulis dir. Piscator, des. T. Müller at Lessing-Theater (later Wallner-Theater). Toller Feuer aus den Kesseln dir. Hinrichs, des. Neher, at Theater am Schiffbauerdamm.

Oct. Piscator in Moscow re film plans.

Nov. Wolf Matrosen von Cattaro at Volksbühne, dir. G. Stark.

16 Nov. IfA film section formed.

28 Nov. Bill-Belotserkovsky Mond von Links, Piscator Collective.

11–21 Dec. 'Kolonne Links' IAH agitprop group, tours Württemberg.

Dec. Berlin premiere of Milestone's All Quiet on the Western Front. Banned 11 Dec. 'for reasons of national prestige'.

6 May. Milhaud/Claudel Christophe Colomb, Berlin State Opera.

25 May. Antheil Transatlantic at Frankfurt Opera, dir. Graf, cond. W. Steinberg.

7 June. Schönberg Erwartung and Die glückliche Hand at Kroll-Oper, dir. Rabenalt, des. Schlemmer and Otto.

23 June. Weill/Brecht Der Jasager ('school opera') Berlin.

> Also in 1930:
>
> Columbia History of Music begins.

1–6 Sep. ISCM festival Lille includes Walton Viola Concerto and Mossolov The Steel Foundry.

20 Oct. Nazis throw stink-bombs at Frankfurt performance of Mahagonny.

Nov. Eisler visits Russia.

10 Dec. Eisler/Brecht Die Massnahme, Berlin, with Arbeiterchor cond. Rankl.

13 Dec. Stravinsky Symphony of Psalms, Brussels.

12 April. Fritz Hampel ('Slang') of AIZ gaoled for two years for report on the Reichswehr (sentence increased by 18 months on 2 May).

May. Linkskurve attack on Meyerhold. Wittfogel series on Marxist aesthetics begins.

June. Arbeiterbühne renamed Arbeiterbühne und Film with support of Volks-Film-Verband.

Mid-year. Tschichold begins designing books for the Bücherkreis.

24 July. Stibi, editor of Düsseldorf Die Freiheit, gaoled for two years for giving away military secrets.

Autumn. Brecht, Benjamin, Ihering and Brentano plan a magazine Krisis und Kritik.

> Also in 1930:
>
> Rosenberg Mythos des 20ten Jahrhunderts
> Bauer Stimmen aus dem Leunawerk
> Türek Ein Prolet erzählt
> Marchwitza Sturm auf Essen (Rote Eine Mark-Roman)
> Auden Poems
> Dos Passos 42nd Parallel
> Waugh Vile Bodies

1931

15 Jan. Wolf Tai Yang erwacht dir. Piscator, des. Heartfield, Wallner-Theater.

6 Feb. Mann ist Mann dir. Brecht at Staatstheater. Seen by Tretiakoff.

17 Feb. Glebow Inga at Wallner-Theater. Last production of Piscator Collective.

19 Feb. Dreigroschenoper film dir. Pabst, scr. Lania, Vadja, Balázs.

5 March. Zuckmayer Der Hauptmann von Köpenick dir. Hilpert at Deutsches Theater.

20 March. Horváth Italienische Nächte. Theater am Schiffbauerdamm.

March. Pudovkin in Hamburg preparing Deserter.

May. 'Die Brücke' political cabaret founded Berlin with Busch, Genschow etc.

20 Feb. Klemperer concert includes Symphony of Psalms.

23 Feb. Madam Butterfly dir. Curjel, des. Moholy-Nagy, cond. Zemlinsky, at Kroll-Oper.

8 April. Shostakovitch op. 27 Le Boulon ballet, Leningrad.

20 April. Falstaff dir. Klemperer and Natasha Satz at Kroll-Oper.

May. Munich festival of new music: Orff, Egk, Fortner etc.

Jan. AIZ publishes photos of 65 imprisoned journalists.

Feb. Bredel writes from gaol he expects release on 16 Feb. 1932 and hopes to go to Moscow.

March. Kläber is in Moscow.

Political events	The arts as a whole	Art and architecture

Political events	The arts as a whole	Art and architecture
	28 May. RAPP conference. Wolf attends.	June. 'Proletarian building' exhibition, Berlin, H. Meyer lectures.
23 June. North German Wool Mills bankrupt.	Summer. Comintern send Lukács to work in Berlin.	E. May lectures CIAM congress on 'The Socialist City' (Magnitogorsk, Kuznetsk etc.).
	25 June–2 July. IATB presidium meets Moscow. Piscator paper 'On the International Workers' Theatre'.	
11 July. Darmstadt National Bank stops payments.		
12 July Dresdner Bank collapses. All banks closed till 5 Aug.		Aug. Bruno Taut moves his office to Moscow.
24–25 Aug. Macdonald forms National Government.		
15 Sep. Invergordon naval mutiny due to pay cuts.		
18 Sep. Japan invades Manchuria.	3 Oct. Weinert arrested, then prosecuted for subversive records. Case dropped but four records banned and nine public appearances forbidden.	
11 Oct. Harzburg Front. Alliance between Hitler, Hugenberg, the Stahlhelm, Seeckt, Lüttwitz.		13 Oct. Hannes Meyer lectures at MASch, Berlin.
	24 Oct. Mezhrabpom-Film announces it will employ Piscator, Richter, Balázs, Kisch etc.	31 Oct.–1 Nov. First national congress of BRBKD.
5 Nov. Bank für Handel und Industrie collapses.		
Nov. Nazis win majority on Dessau town council.		

Also in 1931:

Richter starts work on *Metall*.
Dziga-Vertov tours Germany.

Political events	The arts as a whole	Art and architecture
9 Dec. Spain becomes a republic.		
		Dec.–Jan. Heartfield show in Moscow House of Artists.

1932

Political events	The arts as a whole	Art and architecture
	20 Jan. Prometheus goes out of business.	Early in year. Moscow exhibitions of Kollwitz and Vogeler.
12 Jan. Second Soviet Five-Year Plan starts.	21 Jan. Dessau town council dissolves the Bauhaus.	
28 Jan. Japanese occupy Shanghai.		
7 March. Death of Briand.	March. Association des Ecrivains et Artistes Révolutionnaires founded Paris, without the Surrealists. Tzara joins.	
10 April. Presidential election. Hindenburg 19.4 million votes, Hitler 13.4m, Thälmann 3.7m.	April. All teachers at Essen Folkwang school sacked.	
13 April–14 June. SA banned.		
24 April. Landtag elections: Prussia (Nazis 8m, SPD 4.7m, KPD 2.8m); Bavaria (1.2m, 0.6m, 0.26m), etc.	23 April. CC of Soviet CP decree dissolving all existing artistic organizations.	
10 May. Ossietzky gaoled for revealing secret Lufthansa subsidy.	May. Brecht to Moscow. Meets Tretiakoff.	Spring. Grosz goes to teach in New York.
May. Freyberg (Nazi) becomes premier of Land Anhalt.		
29 May. Landtag elections Oldenburg. Nazi vote is twice that of SPD and KPD.		
1 June. Von Papen becomes Chancellor vice Brüning. Allows SA. Denounces 'Kulturbolschewismus'.		
5 July. Salazar premier of Portugal.		

Theatre and film	Music, ballet, opera	Writing and publication

4 June. Olyesha *Conspiracy of Feelings* at Meyerhold Theatre, banned after a few performances.

June. Bihalji-Merin (Biha) voted off *Linkskurve* board by Left opposition.

> Also in 1931:
>
> *City Lights. A nous la liberté. Le Million*

3 July. Last performance at the Kroll-Oper.

Mid-year. *Arbeiterbühne und Film* ceases to appear.

23–28 July. ISCM Festival Oxford and London includes Webern Symphony and Hindemith's *Wir Bauen eine Stadt*.

Aug. Dziga-Vertov *Enthusiasmus* shown Berlin. Banned in Oct.

14 Aug. New Kampfkomittee für die Freiheit des Schrifttums protests at banning of Neukrantz *Barrikaden am Wedding*.

18 Sep. Kataev *Avantgarde* (i.e. *Squaring the Circle*) by Gruppe junger Schauspieler.

8 Oct. *Berlin-Alexanderplatz* dir. Jutzi.

Oct. Schutzverband Deutsche Schriftsteller move to expel Communist opposition.

Oct. Meyerhold theatre closes for repairs.

23 Oct. Stravinsky Violin Concerto, Berlin Radio (first performance).

> Also in 1931:
>
> Kästner *Fabian*
> Fallada *Bauern, Bonzen und Bomben*
> Saint-Exupéry *Vol de Nuit*

2 Nov. Horváth *Geschichten aus dem Wienerwald*, Deutsches Theater

27 Oct. Shostakovitch *The Age of Gold*, op. 22, ballet, Leningrad Academy.

17 Nov. *Kameradschaft*, dir. Pabst, scr. Otten, Lampel, Vadja, for Nero-Film.

6 Nov. Shostakovitch Third Symphony, op. 20, Leningrad.

Nov. Lukács in *Linkskurve* criticizes Bredel's novels.

20 Nov. *Wir sind ja sooo zufrieden*, Junge Volksbühne revue by Brecht, Weinert, Weill, Eisler etc.

> Also in 1931:
>
> Rachmaninov is banned as 'decadent' in USSR.
> HMV starts 'Society' special recordings.
> RCA issues 33⅓ rpm discs but they are a failure.

9 Dec. *Niemandsland* dir. Trivas, mus. Eisler.

22 Dec. Wangenheim *Die Mausefalle*, dir. Wangenheim, des. Lex-Nerlinger, mus. Wolpe. With Truppe 31.

21 Dec. *Mahagonny* dir. Brecht and Neher, des. Neher, cond. Zemlinsky at Theater am Kurfürstendamm.

1932

12 Jan. Brecht/Eisler *Die Mutter*, dir. Dudow, des. Neher, for Gruppe junger Schauspieler.

6 Jan. Ravel *Concerto for the Left Hand*, Vienna.

28 Feb. Becher tells IVRS he cannot publish in Germany.

31 March. *Kuhle Wampe* banned by censors. Appeal to top board (9 April).

10 March. Weill/Neher *Die Bürgschaft* dir. Ebert, des. Neher, cond. Stiedry in Städtische Oper. Followed on 13 March by Wiesbaden (Rankl) and Düsseldorf (Horenstein).

11 April. Brecht *Die heilige Johanna der Schlachthöfe* on Berlin Radio.

Mid-May. Soviet premiere *Kuhle Wampe*.

2–26 May. Eisler in USSR, works on Ivens's film *Komsomol* (*Die Jugend hat das Wort*) about Magnitogorsk. Plans an opera with Tretiakoff.

30 May. *Kuhle Wampe* dir. Dudow, scr. Brecht, Ottwalt, mus. Eisler, in Atrium cinema, Berlin.

June. Plön Musik-Tag organized by Hindemith.

July. Lukács in *Linkskurve* attacks Ottwalt for reportage and montage.

Political events	The arts as a whole	Art and architecture

20 July. Papen dissolves the (SPD) Prussian government under Article 48. Becomes State Commissioner.

End July. Murders of two distributors of *AIZ*.

July. Nagel takes Kollwitz's works to USSR for sixtieth birthday exhibition. Another is held in Wedding (Berlin).

31 July. Reichstag elections. 230 Nazis, 37 nationalists, 133 SPD, 89 KPD. Nazis have 38% of the seats.

22 Aug. SPD abstains in Dessau town council crucial vote on the Bauhaus.

Aug. Gumbel forbidden to teach.

26 Aug. Nazi Land government in Thuringia.

27–29 Aug. Amsterdam conference of intellectuals against war, with Barbusse, Rolland etc.

30 Aug. Goering president of Reichstag. Nazi members wear uniform.

12 Sep. Reichstag dissolved.

14 Sep. Germany walks out of first Hague Disarmament Conference.

Autumn. Weinert indicted for *AIZ* poem 'Ein Ochse meldet sich' as insult to Reichswehr.

25 Oct. Supreme State Court legalizes Papen's dissolution of Prussian government.

26 Oct. Meeting of writers in Gorki's flat guided by Stalin.

29 Oct.–3 Nov. First plenum of central organizing committee of Soviet writers.

6 Nov. Reichstag elections. 196 Nazis, 52 nationalists, 121 SPD, 100 KPD. Nazis now 34%.

9–14 Nov. Second plenum of IATB changes name to International Association of Revolutionary Theatres (MORT). Piscator elected to Presidium (with Wolf, Wangenheim, Moussinac etc.) and Secretariat (with A. Pieck).

4 Dec. Schleicher succeeds Papen after Hitler refused chancellorship.

1933

30 Jan. Hitler Chancellor with Papen deputy. Frick at Interior, Hugenberg Economics and Agriculture. Goering minister without portfolio.

12 Jan. Grosz emigrates to US.

15 Feb. Purge of Prussian Academy of Arts.

24 Feb. SA and SS are made 'auxiliary police'.

Feb. Goering objects to Munch's paintings in National-Galerie.

27 Feb. Reichstag Fire. KPD forbidden (28th).

3 March. Arrest of Thälmann.

5 March. Reichstag elections. 288 Nazis, 120 SPD, 81 KPD (who are subject to arrest).

12 March. Hindenburg abolishes the Republican flag.

13 March. Goebbels Minister for Propaganda.

20 March. Dachau concentration camp opened.

1 April. Boycott of Jewish firms begins.

10 April. Bauhaus in Berlin closed. Nazis organize a 'Kultur-bolschewismus' exhibition.

8 April Dix sacked from Dresden Academy.

26 April. Gestapo founded.

Theatre and film	Music, ballet, opera	Writing and publication
Summer. Wangenheim and Truppe 1931 visit Switzerland.		End July. Breuer of SDS arrested:
		Aug. Last issue of *Der Sturm*. Walden emigrates to USSR.
		10 Aug. 'Slang' of *AIZ* released under amnesty, dies from heart attack.
		22 Aug. Wolf's publishers reject his play *Bauer Baetz* 'under present conditions'.
	Sep.–Oct. Eisler in USSR elected to committee of International Music Bureau.	7 Oct. SDS Berlin meeting for thirtieth anniversary of Zola's death banned by police.
18 Oct. Wangenheim *Da liegt der Hund begraben* des Lex-Nerlinger, mus. Wolpe, at Theater am Schiffbauerdamm.	28 Oct. Stravinsky *Duo Concertante*, Berlin Radio (premiere).	
Nov. *Matrosen von Cattaro* at WZPS theatre, Moscow, dir. Diky, trs. Vishnevsky. On 14 Nov. they give Wolf a banquet.		
18 Nov. Horváth *Kasimir und Karoline*. Leipzig Schauspielhaus.		
Dec. Premiere of *Die Jugend hat das Wort* (*Komsomol* or *Song About Heroes*), dir. Ivens, mus. Eisler. Mezhrabpom.	12 Dec. Prokofieff *Sur le Borysthène*, Paris Opera.	
23 Dec. Hay *Gott, Kaiser und Bauer* dir. Martin, at Deutsches Theater.		Dec. Last issue of *Die Linkskurve*.

> Also in 1932:
>
> Seghers *Gefährten*
> *30 Neue Erzähler des neuen Deutschland*
> Fallada *Kleiner Mann was nun?*
> Tretiakoff *Den Schi-Hua* (German version)
> Auden *The Orators*

27 Nov. Renn arrested at MASch for 'literary high treason'.

1933

4 Feb. Wangenheim *Wer ist der Dümmste?*, des. Otto, mus. Wolpe, with Truppe 1931.	18 Feb. Weill/Kaiser *Silbersee* cond. Brecher, Leipzig Opera. Also at Magdeburg and Erfurt.	
	21 Feb. Second performance at Erfurt broken up by Nazis.	
28 Feb. The Brechts go to Prague.		28 Feb. Mühsam arrested.
	11 March. Ebert and Stiedry sacked from Städtische Oper.	
Spring. Volksbühne dissolved.	23 March. Weills arrive in Paris.	
20 April. Johst *Schlageter* opens reorganized Staatstheater (contains the line about culture and the revolver).		

Select bibliography

Lives and times

Among the many memoirs of the 1920s are certain books which convey the social precariousness and frequent sense of personal disillusionment and despair that are essential to any understanding of the arts in that period. Illuminating as they do the lives of several key figures, they perhaps provide the best way into the times. For instance:

ANTHEIL, George *Bad Boy of Music*. Doubleday, New York, 1945. Hurst and Blackett, London, 1947

EHRENBURG, Ilya *Men, Years, Life*. World Publishing Co., Cleveland; Macgibbon and Kee, London; 1963–4

GRAF, Oskar Maria *Prisoners All* trs. Margaret Green. Knopf, New York, 1928 (German original: *Wir sind Gefangene*)

GROSS, Babette *Willi Muenzenberg*. Eine politische Biographie. Deutsche Verlags-Anstalt, Stuttgart, 1967. (Author is writing from her own experience.)

GROSZ, George *A Little Yes and a Big No*. The Dial Press, New York, 1946. (The German original *Ein kleines Ja und ein grosses Nein*, better written and containing some extra material, appeared from Rowohlt, Hamburg, in 1964.)

HAY, Julius *Geboren 1900*. Erinnerungen. Chr. Wegner, Hamburg, 1971

HERZFELDE, Wieland, *Immergrün*. Aufbau, E. Berlin, 1950; Rowohlt (paperback), Hamburg, 1964; also included in his volume *Unterwegs*, 1961

HÖLZ, Max *Vom Weissen Kreuz zur Roten Fahne*. Malik, Berlin, 1929

JUNG, Franz *Der Weg nach unten*. Aufzeichnungen aus eine grossen Zeit. Luchterhand, Neuwied, 1961.

KESSLER, Count Harry *The Diaries of a Cosmopolitan*. Weidenfeld and Nicolson, London; Holt, Rinehart, New York (under title *In the Twenties*); 1971. (German original: Insel, Frankfurt, 1961)

KESTENBERG, Leo *Bewegte Zeiten*. Möseler, Wolfenbüttel, 1961

RIBEMONT-DESSAIGNES, Georges *Déja jadis*. 10/18, Paris, 1973

SCHLEMMER, Tut (ed.) *The Letters and Diaries of Oskar Schlemmer*. Wesleyan University Press, Middletown, Conn., 1972

THIRION, André *Revolutionaries without Revolution*. Cassell, London, 1976. (French original: Laffont, Paris, 1972)

TOLLER, Ernst *I Was a German*. Morrow, New York; John Lane, London; 1934. (German original: *Eine Jugend in Deutschland*, Querido, Amsterdam, 1933.) Also his *Justiz*. Erlebnisse. E. Laubsche Verlagsbuchhandlung, Berlin, 1927

VOGELER, Heinrich *Erinnerungen* ed. Erich Weinert. Rütten & Loening, E. Berlin, 1952

WILDE, Harry *Nullpunkt der Freiheit*. Desch, Munich, 1965. (Biography of Theodor Plievier, a friend and contemporary of the author, who was himself involved in the agitprop movement)

WOLF, Friedrich *Briefe*. Eine Auswahl. Aufbau, E. Berlin, 1958. Also his *Briefwechsel*. Aufbau, 1968

Catalogues of 1977

The four major and numerous minor 1920s exhibitions held in West Berlin in the autumn of 1977 produced a number of substantial catalogues containing not only hundreds of reproductions but also invaluable documentary material and several pioneering articles on matters covered more cursorily in this book. They represent a new concentration of effort such as has not previously been seen in either half of the country. Though many of the 'fringe' catalogues are also useful (such as the Laden-Galerie's *Die Kunst der Massen*, dealing with Communist artists 1919–33), the indispensable ones are:

Tendenzen der Zwanziger Jahre. 15 Europäische Kunstausstellung, Berlin, 1977. Dietrich Reimer, W. Berlin. (Covers the four main exhibitions)

Wem gehört die Welt? Kunst und Gesellschaft in der Weimarer Republik. Neue Gesellschaft für Bildende Kunst, W. Berlin, 1977. (Contains articles e.g. on foreign architects in the USSR, the ARBKD, 'Sachlichkeit' in Russia, the book clubs, agitprop theatre, worker–photographers, Prometheus, Hanns Eisler, the workers' radio movement)

Theater in der Weimarer Republik ed. G. Erken, D. Rückhaberle and C. Zieschke. Kunstamt Kreuzberg and Institut für Theaterwissenschaft, Universität Köln, 1977. (Two-thirds devoted to historical material, with sections on the press, film, music, the IAH, the workers' sport movement and *Die Linkskurve*)

Political history

A small selection from a massive coverage of the period:

Instant
GUMBEL, E. J. *Vier Jahre politischer Mord*. Statistik und Darstellung der politischen Morde in Deutschland von 1919 bis 1922. Verlag der neuen Gesellschaft, Berlin, 1922. (Also published by Malik, 1922.) Also his *Denkschrift des Reichsjustizministers*, Malik, Berlin, 1924, and *Verräter verfallen der Feme!* Opfer, Mörder, Richter, 1919–1929, Malik, Berlin, 1929. (Gumbel's facts, in themselves a political factor at the time, are no longer seriously queried.)

OLDEN, Rudolf *Warum versagten die Marxisten?* Europäische Merkur, Paris, 1934. (A short devastating critique of both SPD and KPD)

The Weimar Republic
BRACHER, K. D. *Die. Auflösung der Weimarer Republik*. Eine Studie zum Problem des Machzerfalls in der Demokratie. 2. Auflage, Ring, Stuttgart, 1957

HEIBER, Helmut *Die Republik von Weimar* (dtv-Weltgeschichte des 20. Jahrhunderts, Band 3). DTV, Munich, 1966

ROSENBERG, Arthur *A History of the German Republic*. Methuen, London, 1936

Cultural
BULLIVANT, Keith (ed.) *Culture and Society in the Weimar Republic*. Manchester University Press, 1978

GAY, Peter *Weimar Culture*. The Outsider as Insider. Harper and Row, New York, 1968. Secker and Warburg, London, 1969

LAQUEUR, Walter *Weimar*. A Cultural History 1918–1933. Putnam, New York; Weidenfeld and Nicolson, London; 1974

International
CARR, E. H. *History of Soviet Russia*. Macmillan, New York and London, 1950– . (Also available as Penguin paperbacks. Used extensively in the present work for its account of Comintern policy particularly with regard to Germany.)

CARSTEN, F. L. *Revolution in Central Europe 1918–1919*. University of California Press, Berkeley; Temple Smith, London; 1972

JOLL, James *Europe Since 1870*. An International History. Weidenfeld and Nicolson, London, 1973

KINDER, H. and HILGEMANN, W., eds. *DTV-Atlas zur Weltgeschichte*. Band 2. DTV, Munich, 1966

The arts

General accounts and reference works
HÜTT, Wolfgang *Deutsche Malerei und Grafik im 20ten Jahrhundert*. Henschel, E. Berlin, 1969

LEYDA, Jay *Kino*. Macmillan, New York; Allen and Unwin, London, 1960. (Standard work on the Russian cinema)

ROTHE, Wolfgang (ed.) *Die deutsche Literatur in der Weimarer Republik*. Reclam, Stuttgart, 1974

RÜHLE, Günther *Theater für die Republik 1917–1933*. Fischer, Frankfurt, 1967 (Theatre criticisms and explanatory comment)

RÜHLE, Jürgen *Literature and Revolution*. Praeger, New York; Pall Mall Press, London; 1969. (Shortened from the German original, Kiepenheuer und Witsch, Cologne, 1960)

SCHMIDT, Diether *Manifeste, Manifeste 1905–1933*. Verlag der Kunst, Dresden, n.d. (?1965). (Artists' statements)

SLONIMSKY, Nicholas *Music Since 1900*. Dent, London, 1938. 3rd edition, Coleman-Ross, New York, 1949. (Invaluable chronology)

VOGT, Paul *Geschichte der deutschen Malerei im 20. Jahrhundert*. DuMont Schauberg, Cologne, 1972

Université de Saint-Etienne *Travaux VIII*. Le Retour à l'ordre dans les arts plastiques et l'architecture 1919–1925. (Actes du second colloque d'Histoire de l'Art Contemporain, Février 1974.) Quatre Chemins – Editart, Paris, 1975. (Deals very intelligently with post-1919 changes in the visual arts throughout Europe.)

The arts and politics

ALBRECHT, F. (ed.) *Deutsche Schriftsteller in der Entscheidung*. Wege zur Arbeiterklasse 1918–1933. Aufbau, E. Berlin, 1970. (Centres on Becher)

CAUTE, David *Communism and the French Intellectuals*. Macmillan, New York; Deutsch, London; 1964

FÄHNDERS, Walter and RECTOR, Martin *Zur proletarisch-revolutionären Literaturtheorie 1919–1923*. Hanser, Munich, 1971. (Anthology of German critical and polemical articles)

FITZPATRICK, Sheila *The Commissariat of Enlightenment*. Soviet Organisation of Education and the Arts under Lunacharsky, October 1917–1921. Cambridge University Press, 1970. (A unique and fundamental piece of research into the revolutionary administration of the arts)

FÜLÖP-MILLER, René *The Mind and Face of Bolshevism*. Putnam, London and New York, 1927. (Remains more alive and informative than many later studies)

GALLAS, Helga *Marxistische Literaturtheorie*. Kontroversen im BPRS. Luchterhand, Neuwied, 1971. (Especially re *Die Linkskurve*)

KLEIN, Alfred et al. (eds.) *Aktionen Bekenntnisse Perspektiven*. Aufbau, E. Berlin, 1966. (Miscellany dealing with the reaction after 1929, writers' attitudes to the USSR, and the tribulations of Becher)

KOLINSKY, Eva *Engagierter Expressionismus*. Politik und Literatur zwischen Weltkrieg und Weimarer Republik. Metzler, Stuttgart, 1976

Dada, Surrealism

NADEAU, Maurice *The History of Surrealism*. New York, 1965, Cape, London, 1968. (Two-volume original, Paris, 1945)

BALL, Hugo *Flight Out of Time*. Viking, New York, 1974. (German original: Duncker und Humblot, Munich and Leipzig, 1927). (Diary notes by a founder of Zurich Dada)

Dada and Surrealism Reviewed. Arts Council of Great Britain, 1978. (Exhibition catalogue of the Hayward Gallery, London)

HUELSENBECK, Richard (ed.) *Dada*. Eine literarische Dokumentation. Rowohlt, Hamburg, 1964. (A later compilation)

RUBIN, William S. *Dada, Surrealism, and their Heritage*. New York Graphic Society, 1968. (Exhibition catalogue of Museum of Modern Art)

SANOUILLET, Michel *Dada à Paris*. Pauvert, Paris, 1963. (A basic work, illuminating also on the origins of Surrealism)

The Novembergruppe

KLIEMANN, Helga *Die Novembergruppe*. Gebr. Mann, W. Berlin, 1967. (A useful, if not very impressive record)

Constructivism

BANN, Stephen (ed.) *The Tradition of Constructivism*. Thames and Hudson, London, 1974

BOJKO, Szymon *Graphic Design in Revolutionary Russia*. Praeger, New York; Lund Humphries, London; 1972

QUILICI, Vieri *L'architettura del constructivismo*. Laterza, Bari, 1969. (Contains various Russian texts of the time)

See also the catalogues of the Galerie Gmurzynska, Cologne.

Die neue Sachlichkeit

LETHEN, Helmut *Neue Sachlichkeit 1924–1932*. Studien zur Literatur des 'Weissen Sozialismus'. Metzler, Stuttgart, 1970. (A partial view)

SCHMIED Wieland *Neue Sachlichkeit und Magischer Realismus in Deutschland 1918–1933*. Fackelträger, Hanover, 1969. (With many illustrations unfamiliar outside Germany)

L'Oeil, no. 206–7, Paris, 1972

The Bauhaus

FRANCISCONO, Marcel *Walter Gropius and the Creation of the Bauhaus at Weimar*. University of Illinois Press, 1971. (Well researched; informative about the Arbeitsrat and its relation to the Bauhaus)

HÜTER, Karl-Heinz *Das Bauhaus in Weimar*. Akademie-Verlag, E. Berlin, 1976. (Detailed account of the school's relation to the politics of the time, based on new research)

WINGLER, H. M. *The Bauhaus*. MIT Press, Cambridge, Mass., and London, 1969. (Still the standard work; from the German original published by Rasch, Bramsche, 1962)

Architecture and design

BENTON, Tim et al. *Design 1920s*. (Course A 305, units 15–16). Open University Press, Milton Keynes, 1975

BENTON, Tim *The New Objectivity*. (Ibid.' units 11–12). (Economical, clear and well illustrated, these are the best books on the subject available in English.)

KOPP, Anatol *Town and Revolution*. Thames and Hudson, 1970. (On Soviet architecture in the 1920s)

LANE, Barbara Miller *Architecture and Politics in Germany 1918–1945*. Harvard University Press, Cambridge, 1968. (Especially useful on Berlin housing and the GEHAG)

Das neue Frankfurt, V Jahrgang, 2/3 and 4/5, 1930. (The results of five years of rebuilding in that city)

SHVIDKOVSKY, O. A. (ed.) *Building in the USSR 1917–1932*. Praeger, New York; Studio Vista, London; 1971. (Symposium derived from *Architectural Design*, London, no.2, 1970, a special issue on Soviet architecture)

Photography

GRAEFF, Werner *Es kommt der neue Fotograf!* Hermann Reckendorf, Berlin, 1929. (Discussed in chapter 15)

ROH, Franz, and TSCHICHOLD, Jan *foto-auge oeil et photo photo eye*. Wedekind, Stuttgart, 1929. (A classic)

WILLMANN, Heinz *Geschichte der Arbeiter-Illustrierten Zeitung 1921–1938*. Dietz, E. Berlin, 1975

Film

DZIGA-VERTOV *Schriften zum Film*. Hanser, Munich, 1973

KRAKAUER, Siegfried *From Caligari to Hitler*. Princeton University Press, 1947

KÜHN, Gertraude et al. (eds.) *Film und Revolutionäre Arbeiterbewegung in Deutschland 1918–1932*. Henschel, E. Berlin, 1975. (Particularly re Muenzenberg's film operation and the ensuing pictures)

RICHTER, Hans *Filmgegner von heute — Filmfreunde von morgen*. (Companion volume to Graeff's book, above)

Theatre

AUFRICHT, Ernst-Josef *Erzähle, damit du dein Recht erweist*. Propyläen, W. Berlin, 1966. (Memoirs of Brecht's main impresario)

BABLET, Denis *Les Révolutions scéniques du XXe siècle*. Société Internationale d'Art XXe Siècle, Paris, 1976. (Massive collection of photographs and designs)

GREGOR, J. and FÜLÖP-MILLER, R. *The Russian Theatre*. Lippincott, Philadelphia, 1929. Harrap, London, 1930. (German original: Amalthea, Zurich, 1928. Photos and designs relating to the Russian theatre from Diaghilev to the mid-20s)

HOFFMANN, L. and HOFFMANN-OSWALD, D. *Deutsches Arbeiter-Theater 1918–1933*. Henschel, E. Berlin. 2nd edition 1972. (Selection of texts, from the Proletarian Theatre to Agit-prop)

GROPIUS, Walter (ed.) *The Theater of the Bauhaus*. Wesleyan University Press, Middletown, Conn., 1961. (German original, ed. O. Schlemmer: *Die Bühne im Bauhaus*, Langen, Munich, 1925)

REICH, Bernhard *Wettlauf mit der Zeit*. Henschel, E. Berlin, 1970. (Recollections containing interesting accounts of Brecht and Piscator in both Berlin and Moscow)

Papers relating to the Théâtre des Champs-Elysées are in the Bibliothèque de l'Arsenal, Paris. (See Rt 2910 and 2913)

Music

Ballets Suédois 1920–1925. Musée d'Art Moderne de la Ville de Paris, 1970. (Catalogue)

CURJEL, Hans *Experiment Kroll-Oper 1927–1931*. Prestel, Munich, 1975. (Very well illustrated, comprehensive account)

KŘENEK, Ernst *Über neue Musik*. Verlag der Ringbuchhandlung, Vienna, 1937. (A series of lectures)

STERN, Dietrich (ed.) *Angewandte Musik der 20er Jahre*. Argument, W. Berlin, 1977. (On utilitarian or applied music: a symposium by younger scholars)

Publishing

Der Malik-Verlag 1916–1947. Deutsche Akademie der Künste, E. Berlin, 1966. (Exhibition catalogue compiled and introduced by Wieland Herzfelde)

Rowohlt-Almanach 1908–1962. Rowohlt, Hamburg, 1962. (Complete list of books published)

Individual figures

A selection of biographies, monographs and catalogues – omitting those memoirs already listed under 'Lives and times' above:

BRECHT. VÖLKER, Klaus *Brecht Chronicle*. Seabury Press, New York, 1975. (Detailed chronology of his life and work)

COCTEAU. STEEGMULLER, Francis *Cocteau: A Biography*. Little, Brown, Boston; Macmillan, London; 1970

DIX. LÖFFLER, Fritz *Otto Dix. Leben und Werk*. Verlag der Kunst, Dresden. 2nd edition 1967

EISENSTEIN. SETON, Marie *S. M. Eisenstein*. Wyn, New York; Bodley Head, London; 1952. Grove Press, New York, 1960

EISLER. BETZ, Albrecht *Hanns Eisler*. Edition text + kritik, Munich, 1976

FALLADA. MANTHEY, Jürgen *Hans Fallada in Selbstzeugnissen und Bilddokumenten*. Rowohlt, Hamburg, 1963

GROPIUS. GIEDION, Sigfried *Walter Gropius:* Work and Teamwork. Architectural Press, London, 1954

GROSZ. Hess, Hans *George Grosz*. Studio Vista, London, 1974. Macmillan, New York, 1975.
LEWIS, Beth Irwin *George Grosz*. Art and Politics in the Weimar Republic. University of Wisconsin Press, Madison. 1971

HAESLER. HAESLER, Otto *Mein Lebenswerk als Architekt*. Henschel, E. Berlin, 1957

HAŠEK. FRYNTA, Emanuel *Hašek, The Creator of Schweik*. Artia, Prague, 1965
PARROTT, Cecil *The Bad Bohemian. A Life of Jaroslav Hašek*. Bodley Head, London, 1978

HEARTFIELD. HERZFELDE, Wieland *John Heartfield*. Verlag der Kunst, Dresden. 2nd edition 1971
SIEPMANN, Eckhard *Montage. John Heartfield*. Elefanten Press Galerie, W. Berlin, 1977

HINDEMITH. BRINER, Andreas *Paul Hindemith*. Atlantis, Zurich; Schott, Mainz; 1971
SKELTON, Geoffrey *Paul Hindemith. The Man Behind the Music*. Gollancz, London, 1975
STROBEL, Heinrich *Paul Hindemith*. Schott. Mainz. 3rd edition 1948

KÄSTNER. ENDERLE, Luiselotte *Erich Kästner in Selbstzeugnissen und Bilddokumenten*. Rowohlt, Hamburg, 1966

LÉGER. GREEN, Christopher *Léger and the Avant-Garde*. Yale University Press, New Haven, 1976
Léger and Purist Paris. Tate Gallery, London, 1970. (Catalogue with texts by John Golding and Christopher Green)

LEONIDOV. ALEKSANDROV, P. and KHAN-MAGOMEDOV, S. *Ivan Leonidov*. Strojizdat, Moscow, 1971

LISSITZKY. LISSITZKY-KÜPPERS, Sophie *El Lissitzky*. Thames and Hudson, 1968. (References are to the German original, Verlag der Kunst, Dresden, 1967)

LUKÁCS. RADDATZ, F. J. *Georg Lukács* in Selbstzeugnissen und Bilddokumenten. Rowohlt, Hamburg, 1972

LICHTHEIM, George *Lukács*. Viking, New York; Fontana London; 1970

MALEVITCH. ANDERSEN, Troels *Malevitch catalogue*, Stedelijk Museum, Amsterdam, 1970
MALEVITCH, K. S. *Essays on Art* (ed. T. Andersen), Rapp and Whiting, London; Dufour Editions Inc., Chester Springs, Pa.; 1969

MAY. BUECKSCHMITT, Julius *Ernst May*. Alex Koch, Stuttgart, 1963

MAYAKOVSKY. *Lettres de Maïakovski à Lili Brik*. Gallimard, Paris, 1969
WOROSZYLSKI, Wiktor *The Life of Mayakovsky* trs. from the Polish by B. Taborski. Orion Press, New York, 1970. Gollancz, London, 1972

MEYER. SCHNAIDT, Claude *Hannes Meyer*. Tiranti, London, 1965 (Bilingual edition)

MEYERHOLD. BROWN, Edward (ed.) *Meyerhold on Theatre*. Methuen, London; Hill and Wang, New York; 1969
MEYERHOLD, V. *Ecrits sur le théâtre* ed. and trs. Béatrice Picon-Vallin, La Cité, L'Âge d'Homme, Lausanne, 1975

MILHAUD. MILHAUD, Darius *Notes without Music*. Dobson, London, 1952. Knopf, New York, 1953

MOHOLY-NAGY. MOHOLY-NAGY, Lucia *Marginalien zu Moholy-Nagy/Moholy-Nagy, Marginal Notes*. Scherpe, Krefeld, 1972 (Bilingual edition)
MOHOLY-NAGY, Sibyl *Moholy-Nagy*. Experiment in Totality. 2nd edition. MIT Press, Cambridge and London, 1969

MURPHY. TOMKINS, Calvin *Living Well is the Best Revenge*. Two Americans in Paris 1921–1933. Deutsch, London, 1972

PICABIA. SANOUILLET, Michel *Picabia*. Editions du Temps, Paris, 1964

PISCATOR. PISCATOR, Erwin *Das Politische Theater*. Facsimile of the 1929 edition in his *Schriften 1*, Henschel, E. Berlin, 1968. English-language edition to be published by Avon Books, New York, and Eyre Methuen, London (?1979)
WILLETT, John *The Theatre of Erwin Piscator*. Eyre Methuen, London, 1978

PIOËFF. HORT, Jean *La Vie héroïque des Pitoëff*. Pierre Cailler, Geneva, 1966.

SCHOENBERG. STUCKENSCHMIDT, H. H. *Schoenberg: His Life, World and Work*. Calder, London, 1977. (Original German edition, Atlantis, Zurich, *c.* 1974)

SCHWITTERS. SCHMALENBACH, Werner *Kurt Schwitters* DuMont Schauberg, Cologne, 1967. Thames and Hudson, London, 1970
LACH, Friedhelm *Der Merzkünstler Kurt Schwitters*. DuMont Schauberg, Cologne, 1971

STRAVINSKY. STRAVINSKY, Igor *Chronicles of My Life*. Gollancz, London; Simon and Schuster, New York (under title *An Autobiography*); 1936. (French original, Denoel et Steele, Paris, 1935)

TATLIN. ANDERSEN, Troels *Vladimir Tatlin*. Moderna Museet, Stockholm 1968. (Catalogue)

TAUT. JUNGHANNS, K. *Bruno Taut 1880–1938*. Henschel, E. Berlin, 1970

TRETIAKOFF. TRETJAKOV, Sergej *Die Arbeit des Schriftstellers*. Aufsätze Reportagen Porträts. Rowohlt, Hamburg, 1972. (Selection ed. Heiner Boehncke)
MIERAU, Fritz *Erfindung und Korrektur*. Akademie-Verlag, E. Berlin, 1976

TUCHOLSKY. SCHULZ, Klaus-Peter *Kurt Tucholsky* in Selbstzeugnissen und Bilddokumenten. Rowohlt, Hamburg, 1959

TZARA. *Europe*, Paris. Special Tzara number July–August 1975

VAN DOESBURG. JAFFÉ, H. L. C. *De Stijl*. Thames and Hudson, London, 1970
Basel Kunsthalle exhibition catalogue 1969

WEILL. DREW, David (ed.) *Über Kurt Weill*. Suhrkamp, Frankfurt, 1975. (See also companion volume of Weill's *Ausgewählte Schriften*.)

WEINERT. PREUSS, Werner *Erich Weinert Bildbiografie*. Henschel, E. Berlin. 2nd edition 1976

WOLF. POLLATSCHEK, Walther *Friedrich Wolf*. Reclam, Leipzig, 1974

Prose, poetry and plays

Only a small part of the creative literature and reportage dealt with in the book has been translated into English, and much of that is out of print. Here is an attempt to list it:

BRECHT, Bertolt *Poems 1913–1956*. Eyre Methuen, London, 1976. (Also paperback in 3 vols.)

DÖBLIN, Alfred *Berlin Alexanderplatz* trs. E. Jolas. Secker and Warburg, London, 1975

EHRENBURG, Ilya *Life of the Automobile*. Urizen Books, New York; Pluto Press, London; 1977

FALLADA, Hans *Little Man. What Now?* trs. Eric Sutton. Putnam, London; Simon and Schuster, New York; 1933. Reissued by Howard Baker, London, 1967

FEUCHTWANGER, Lion *Success* trs. Edwin and Willa Muir. Literary Guild, New York; Martin Secker, London; 1930

GLADKOV, Fyodor *Cement* trs. A. S. Arthur and C. Ashleigh, Lawrence, London, 1929

HAŠEK, Jaroslav *The Good Soldier Švejk* trs. Cecil Parrott, Heinemann, London; 1973. Penguin, 1974

ILF, Ilya and PETROV, Yevgeny *Diamonds to Sit On* trs. E. Hill and D. Mudie. Methuen, London, 1930. Under title *The Twelve Chairs*, trs. John Richardson. Muller, London, 1965
The Little Golden Calf trs. Charles Malamuth. Farrar and Rinehart, New York; Grayson and Grayson, London; 1932

ISHERWOOD, Christopher *Mr Norris Changes Trains*. Hogarth Press, London, 1935. Under title *The Last of Mr Norris*. Morrow, New York, 1935
Goodbye to Berlin. Hogarth Press, Lon-

don; Random House, New York; 1939. (Republished together as *The Berlin of Sally Bowles*, Hogarth Press, 1975)

KÄSTNER, Erich *Emil and the Detectives*. Doubleday, New York, 1930 (trs. May Massee). Cape, London, 1931 (trs. Cyrus Brooks)

Fabian. The Story of a Moralist trs. Cyrus Brooks. Cape, London; Dodd, Mead, New York; 1932. Unger, New York, 1945

Let's Face It. Selected verse, ed. Patrick Bridgwater. Cape, 1963

MAYAKOVSKY, Vladimir *The Bathhouse*. In A. R. MacAndrew (ed.): *20th Century Russian Drama*. Bantam, New York, 1963

The Bedbug. In Michael Glenny (ed.): *Three Soviet Plays*. Penguin, Harmondsworth, 1966

Mystery-Bouffe. In G. R. Noyes: *Masterpieces of the Russian Drama*. New York, 1933

PLIEVIER, Theodor *The Kaiser's Coolies* trs. Margaret Green. Knopf, New York, 1931. Trs. William P. Clarke, Faber, London, 1931

The Kaiser Goes, the Generals Remain trs. A. W. Wheen. Faber, London, 1932. Macmillan, New York, 1933

REED, John *Ten Days that Shook the World*. Boni and Liveright, New York, 1919. Martin Lawrence, London, 1926 and 1932. Penguin, 1966

REMARQUE, Erich Maria *All Quiet on the Western Front* trs. A. W. Wheen. Little, Brown, Boston; Putnam, London; 1929. Mayflower (paperback) 1968

The Road Back trs. A. W. Wheen. Little, Brown, Boston; Putnam, London; 1931

RENN, Ludwig *War* trs. Edwin and Willa Muir. Martin Secker, London; Dodd, Mead, New York; 1929

After War trs. E. and W. Muir. Martin Secker, London; Dodd, Mead, New York; 1931

SEGHERS, Anna *The Revolt of the Fishermen* trs. Margaret Goldsmith. Matthews and Marrot, London, 1929. Longmans Green, New York, *c.* 1930

TOLLER, Ernst *Hoppla!* trs. Hermon Ould. Benn, London, 1928. Also trs. in his *Seven Plays*. John Lane, London, 1935

TRAVEN, B. *The Death Ship*. Knopf, New York, 1934. Cape, London, 1940. Panther, London, 1974

The Bridge in the Jungle. Knopf, New York, 1938. Cape, London, 1940. Penguin, Harmondsworth, 1975. (This and the foregoing were written by Traven in English. Several other novels by him have been translated from the German, whether by Basil Creighton for Chatto and Windus before 1939 – notably *The Treasure of the Sierra Madre*, 1934, Panther, 1974 – or for Hill and Wang, New York, since the 1950s.)

TUCHOLSKY, Kurt *What If?* Selected writings of Kurt Tucholsky. Funk and Wagnall, New York, 1963, 1967

The World is a Comedy. A Tucholsky anthology, ed. Harry Zohn. Sci-Art Publishers, Cambridge, Mass., 1957

TRETIAKOFF, Sergei *Chinese Testament*. Simon and Schuster, New York; Gollancz, London; 1934. (Translation of *Den Shi-Chua*)

Roar, China! Martin Lawrence, London, 1931. (Translation of *Rycie, Kitai!*, Moscow, 1926, Berlin, 1929

WOLF, Friedrich *The Sailors of Cattaro* trs. Keene Wallis, French, New York, 1935

A good cross-section of new German prose writing towards the end of the period can be found in *30 Neue Erzähler des neuen Deutschland* which Wieland Herzfelde edited for the Malik-Verlag and published in 1932.

Periodicals

Among those generally worth consulting are *ABC* (Basel), *Anbruch* (Universal, Vienna), *Arbeiterbühne und -Film* (the DATB journal, reprint by Gaehme Henke, Cologne, 1974), *Bulletin de l'Effort Moderne* (edited by Léonce Rosenberg from his Paris gallery), *L'Esprit Nouveau, Die Form* (published by the German Werkbund), *Das Kunstblatt* (Potsdam, taken over in the later 1920s by J. M. Spaeth, Berlin, who also published *Die neue Bücherschau*), *LEF* and *Novy LEF* (Moscow), *Die Linkskurve* (Berlin), *Melos* (Schott, Mainz), *Merz* (Hanover), *Musik und Gesellschaft* (Wolfenbüttel), *Das neue Frankfurt* (Englert und Schlosser, Frankfurt), *Neue Jugend* (photo-reprint by Rütten und Loening, E. Berlin, 1967), *De Stijl* (reprint by Atheneum, Amsterdam, 1968) and *Wasmuths Monatshefte* (the main German architectural magazine). Others are mentioned in specific chapters.

Acknowledgments

Illustrations

Akademie der Künste der DDR, East Berlin: pp. 152 *top*, 215. Arts Council of Great Britain: p. 130 *bottom*. Atlantis Verlag, Zurich: p. 161 *right*. Aufbau Verlag, Berlin, pp. 173, 196. Bayerische Staatsgemäldesammlungen, Munich: p. 113. Bibliothèque Nationale, Paris: p. 31. British Library, London: pp. 75 *bottom*, 84, 96, 143 *top*, 181. Busch-Reisinger Museum, Harvard University: p. 138. Camera Press, London: p. 36. Curjel, Hans, Prestel Verlag, Munich: pp. 161 *left*, 165. Dansmuseet, Stockholm: pp. 58, 62, 91 *bottom*, 94. Delaunay, Sonia, Paris: p. 169. Deutsche Fotothek, Dresden: p. 188. Galerie der Stadt Stuttgart: p. 116. Galerie Gmurzynska, Cologne: pp. 39 *bottom*, 75 *top*, 102 *bottom*, 107, 141 *bottom*. Hessische Landes- und Hochschulbibliothek, Darmstadt: p. 152 *bottom*. Kunsthalle, Hamburg: p. 108 *bottom*. Kunsthalle, Mannheim: pp. 11, 115 *top*. Lenin Library, Moscow: p. 37. Lichtbildverlag, Dr Franz Stoedtner: pp. 100 *bottom left*, 125, 182. Lissitzky-Küppers, Sophie, Nowosibirsk: pp. 39 *top*, 217. Lord's Gallery, London: p. 168 *top*. Mansell Collection, London: p. 73 *left*. Marconi Company, London: p. 69 *top*. Moholy-Nagy, Hattula, Zurich: p. 23 *bottom*. Moholy-Nagy, Lucia, Zurich: pp. 80 *bottom*, 212. Montagu, Ivor: p. 148. Musée Fernand Léger, Biot: p. 22. Musée National de l'Art Moderne, Paris: p. 170. Museum of Contemporary History, Budapest: p. 48. National Film Archives, London: pp. 100 *top left*, 105, 109, 147 *top*, 183, 192, 207, 214. Nationalgalerie, East Berlin: p. 203. Nationalgalerie, West Berlin, photo J. Anders: p. 83. Nationalmuseum, Stockholm: p. 43. Novosti Press Agency: p. 35 *top*. Öffentliche Kunstsammlung, Basel: p. 65. Österreichische Nationalbibliothek, Vienna: p. 56. Piccadilly Gallery, London: p. 52 *bottom*. Paul Popper, London: p. 45. Radio Times Hulton Picture Library, London: pp. 35 *bottom*, 71, 176. Richter, Mrs Hans, Locarno: p. 27 *bottom*. Royal Institute of British Architects: p. 131. Schweizerische Theatersammlung, Berne: p. 32. B. Schott Söhne, Frankfurt am Main: p. 68. Society for Cultural Relations with the USSR, Huntley Carter photos: pp. 40, 41, 87 *bottom*, 88 *top*. Springer, Axel, Hamburg: p. 103. Theatermuseum, Cologne: pp. 87 *top*, 157, 165, 166, 190, 207. Victoria and Albert Museum, London, photos J. R. Freeman: pp. 52 *top*, 64, 66, 77, 91 *top*, 92, 93, 171. Wallraf-Richartz Museum, Cologne: pp. 112 *top*, 115 *bottom*, 189 *left*. Zentralinstitut für Kunstgeschichte, Munich: pp. 199, 221.
The rest of the photos come from the author's collection of contemporary publications.

Sources of poems translated in the text

Brecht, Bertolt (p. 101): from his *Poems 1913–1956*, Eyre Methuen, London, 1976
Feuchtwanger, Lion (p. 99): from his *PEP*
Gastev, A. K. (p. 42): from Boris Thomson: *The Premature Revolution*, Weidenfeld, London, 1972
Grosz, George (p. 29): from *Neue Jugend*, Berlin, Feb.–Mar. 1917
Kästner, Erich (pp. 101 and 174): from his *Gesammelte Schriften I*, Atrium-Verlag, Zurich, 1959
Lichtenstein, Alfred (p. 22): from his *Gedichte*, Georg Müller, Munich, 1919
Schiffer, Marcellus (p. 111): from the anthology *So weit die scharfe Zunge reicht*, Scherz, Munich, 1964

Tucholsky, Kurt (pp. 22 and 51): from his *Gesammelte Werke* Band I, copyright © 1960 by Rowohlt Verlag GmbH, Reinbeck bei Hamburg
Warschauer, Frank (p. 101): from the anthology *Um uns die Stadt*, Sieben Stäbe Verlag, Berlin, 1930
Zuckmayer, Carl (p. 23): from his *Als wärs ein Stück von mir*, Fischer, Frankfurt, 1966

The author is very grateful to Dr Klaus Budzinski, Dr Marta Feuchtwanger, Mary Gerold-Tucholsky, Peter M. Grosz and the various publishers concerned for giving the necessary permissions.